**Taekwondo
&
World
Martial
Arts**

Taekwondo & World Martial Arts

Hollym
Carlsbad, CA and Seoul

Taekwondo & World Martial Arts

Copyright © 2025 by Kyu-seok Lee
All rights reserved.

First published in 2025
by Hollym International Corp., Carlsbad, CA, USA
Phone 760 814 9880
www.hollym.com **e-Mail** contact@hollym.com

 Hollym

Published simultaneously in Korea
by Hollym Corp., Publishers, Seoul, Korea
Phone +82 2 734 5087 **Fax** +82 2 730 5149
www.hollym.net **e-Mail** hollym@hollym.co.kr

ISBN 978-1-56591-531-2
Library of Congress Control Number 2025941511

Printed in Korea

CONTENTS

	Preface	6
1	Boxing	9
2	Wrestling	27
3	Savate	47
4	Capoeira	71
5	Muay Thai	95
6	Pentjak-silat	113
7	Escrima (Arnis)	131
8	Wushu	149
9	Karate	175
10	Judo	205
11	Sumo	231
12	Ssireum	249
13	Taekwondo (Special Thesis)	267

Preface

As with Taekwondo in Korea, there are many traditional martial arts in other countries which reflect their own cultures and histories. Every martial art has been shaped and developed into its present form by encountering those of their neighbors. Even today, through international sporting events, martial arts are being exchanged and are continuously evolving.

Although Taekwondo is widely practiced all around the world, continuous investment in research and development is needed since no single martial art has dominated the world forever; many have appeared and disappeared, and then reappeared in different forms.

This book illustrates how certain martial arts have come into their present forms and how they are cherished by their practitioners. By understanding other martial arts, we learn about ourselves—how far we have come to date and where we are at present. Most important of all, it can help guide us in the direction we want to go from here. I firmly believe the martial arts introduced in this book will help us develop the art of Taekwondo, or any other martial arts for that matter, into a better martial art and provide us a new vision for the future.

I sincerely hope that this book will serve as a source of inspiration for future scholars and students in the fields of taekwondo and other martial arts, encouraging deeper interest and active research.

Finally, I would like to express my deep gratitude to Professor Ha Young Kim of Gachon University and Senior Director Ji-young Kim of the Asian Taekwondo Union for their valuable advice and assistance.

July 21, 2025
Prof. Kyu-seok Lee

Boxing
Western Art of Fighting

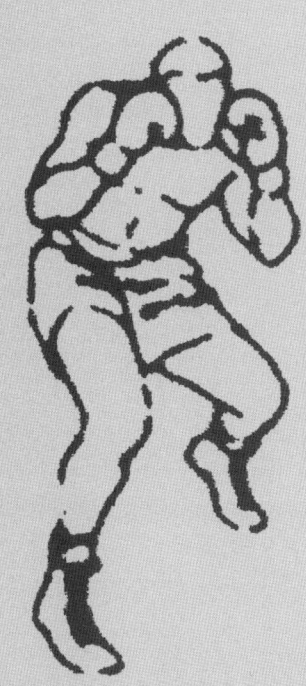

What is Boxing?

Definition
Techniques
Training Methods
Injury
Competition

History

Origin
Early Modern Era
Modern Era

1. What is Boxing?

1) Definition

Boxing is an ancient martial art combining hand, controlled aggression, evasiveness, and bone-crushing force. The term boxing derives from the box shape of the closed hand, or fist, which in Latin is *pugnus* (or pugilism and fisticuffs).[1] Pugnus also derives from the Greek *pugme*, meaning "fist."

Boxing has been called the Manly Art of Self-defense. Romantics have referred to it as the "sweet science." Law enforcement officials have cited it as the most corruption-ridden of all sports. Medical people say it can cause brain damage. Whatever view you take, the ancient sport of boxing has attained wide popularity throughout the world. Almost every country has amateur boxing, and the sport is prominent in the Olympic Games. Most nations also have professional boxers.

The philosophy of boxing is simple: "Hit and don't get hit." Despite the simplicity of this premise, over the centuries the art has been developed to such a degree that it is often referred to as a science—"the sweet science." Boxing is both an art and a science, as boxers learn strategic moves and techniques, undergo expert coaching and training, practice in specialized facilities with special equipment, and follow a special diet.

Boxing is often likened to a chess game because boxers think several steps ahead. Boxers employ feints and gambits, sometimes allowing themselves to be hit in order to deliver a knockout blow, as chess players sacrifice a piece in order to reach checkmate or gain a positional advantage.[2]

The boxer's goal is to "stop" his opponent. The vulnerable organs and bones are primary targets and boxers aim for the solar plexus, liver, kidneys, and ribs.

1 Thomas A. Green (Ed.) (2001). Martial Arts of the World: An Encyclopedia. Vol 1: A–Q. ABC CLIO. p. 44.
2 Thomas A. Green (Ed.) (2001). p. 47.

2) Techniques

a) basic stance

There are a number of different kinds of stances used by boxers. However, the traditional stand-up (erect) stance still prevails among most amateur and professional boxers. It is also the most effective stance for beginners as they learn the fundamentals.

In this stance, your left foot is in front of the right for a right-handed boxer and slightly turned in (the opposite for a left-handed one). The distance between the two feet should be whatever gives you a comfortable and balanced feeling. Your left foot should be flat on the floor, while you keep the heel of your right foot off the floor. Distribute your weight evenly between both feet. The key element to your basic stance in the ring is balance.

The upper part of your body should be turned slightly to the left, affording your opponent a smaller target to hit. Your right hand should be high, reasonably close to your chin, while your left is just below eye level. Always keep your left elbow in close to your body to protect yourself from body blows.

This basic stance is perhaps the only constant for you in the ring. No matter what other positions you are forced into during a bout, return to this as soon as possible. The reason is simple: You will then be ready to defend yourself or to go on the offensive.[3]

b) movement (footwork)

Movement in the ring should be as fluid as possible. You may glide around the ring by sliding the soles of both shoes along. If you are to move backwards or to the right, then you move the right foot first. If you want to move forward or to the left, then move the left foot first.

One good exercise to develop proper movement and avoid leg crossing involves moving around in a circle. You slide your feet as you go, first in a circle to the left, and then in a circle to the right. Stop quickly and move back in the opposite direction from time to time. You can fake moving left and go right, or the other way around.[4]

[3] Al Bernstein (1978). Boxing for Beginners. Contemporary Books, Inc. pp. 23–28.
[4] Al Bernstein (1978). p. 31.

Do not get caught completely flat-footed in the ring. Your movement from a flat-footed stance is difficult at best. Always keep at least one heel up while gliding, so that you can pivot away at the appropriate time.

Bobbing and weaving As a beginner you need to master bobbing and weaving, the side-to-side and up-and-down movement of the body that is useful both for defense and offense. Bobbing and weaving is the art of slipping and sliding punches. It is also called "ducking" or "avoiding." Bobbing and weaving makes you harder to hit because you are a moving target.[5]

c) offense

Boxers only use their hands for offense and land their punches with three knuckles—those of the middle, ring, and little fingers. The knuckle of the ring finger—the middle of the three—is the "aiming knuckle." The boxer's own nose is the "target finder" or "sight" through which the fists are fired. Punches in boxing are thrown from the shoulders. Power is derived not so much from the muscles as from the joints and ligaments.

It is a well-known phrase that you cannot win without a good defense in sports. But, in boxing, there is no way you can win without a good offense. To win a fight, you must either knock out your opponent or outpoint him. In short, you must be able to punch and nothing is more important to a boxer than mastering the fundamental punches.

Jab If there is one punch that defines boxing, it is the jab. It is a straight punch thrown from the shoulder with a short step forward. Starting from the basic stance, you deliver the left jab by extending the left arm straight from the shoulder and twisting your glove at the point of impact.[6] Though it looks easy, learning to throw a jab quickly in great repetition needs skill. Most punches start off the jab. Muhammad Ali may be the best known and perhaps most proficient jabber because of his hand speed.[7]

For most fighters the jab is the beginning point of their attack. Beginners traditionally practice only the jab from four to six months before learning the other punches.

5 Floyd Patterson (1974). Inside Boxing. Contemporary Books, Inc. p. 201.
6 Al Bernstein (1978). p. 34.
7 Al Bernstein (1978). p. 37.

Thus the jab is the boxer's primary indicator or measuring device of skill level in the art. The jab is a range finder, or means of determining and establishing the distance between the boxer and the opponent. An effective jab can score points, keep an opponent off-balance, and even set him up other punches—it is used to set up the KO (knockout) punch: "one-two punch"—left jab, straight right.[8]

Right cross The right cross is thrown from the basic boxing stance with the right hand up high at shoulder level. Turn at the waist as you deliver this punch, stepping forward with your left foot and shifting your weight from the ball of your right foot to an almost straightened left leg.

Your body weight should shift along with the punch so that you can put as much power as possible into the punch. The right cross is a knockout punch for a right-handed boxer. At the point of impact, rotate the fist counterclockwise with the full twisting force of the hips. The right cross is usually the second half of the classic one-two combination of punches.

Hook The left hook has a special place in boxing history, simply because it is said to be the last punch to be developed in boxing. The left hook is a difficult punch to deliver. To begin the action of the left hook, lean forward and slightly to the left. Then bring a left hook across your body, keeping your elbow as tight to your body as you can, turning your left hip and shoulder to the right as you bring your left around with your fist turned inward toward you.

The left hook should be delivered in a whipping fashion and in as small as arc as possible. A wide looping left hook is easy to block or avoid and leaves you wide open for a counterpunch from your opponent. Delivered in crisp, quick, compact fashion, the left hook can be a devastating punch.[9] Boxers are often taught to end every combination with a left hook.

Uppercut The uppercut is primarily used in infighting because it does not require much room to throw the punch. It is a way to get through your opponent's inside defense without leaving yourself open for a counterpunch.

In order to throw the uppercut, bend your knees and throw the punch in an

8 Thomas A. Green (Ed.) (2001). p. 49.
9 Al Bernstein (1978). p. 40.

upward motion from floor to ceiling, but in a short arc. Start from the waist and bring the punch straight up to your opponent's jaw or ribs. If you are throwing a right uppercut, concentrate your weight on your right foot, and for the left uppercut, on the left foot.[10]

Combinations A combination is simply two or more punches strung together in a pattern. The first combination any fighter learns is the one-two combination, which consists of a jab followed quickly by a right cross (straight). Timing is important here. You jab and as you bring your left arm back, immediately fire a right cross. The action should be a quick one-two motion. Good boxers have incredible hand speed. A natural

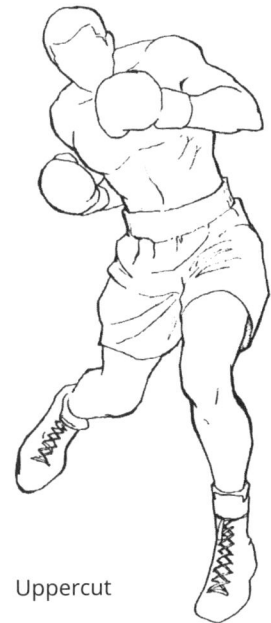

Uppercut

follow-up to the one-two is to add another punch to it—a left hook onto the end of the one-two.[11] Many combinations can be taught and created, but the key thing to remember is that they all come from the basic punches mentioned above.

Infighting Infighting is the art of fighting at close range. It is one of the best weapons of the average or short boxer. Bobbing and weaving is an effective tactic for the infighter. You can duck in close to your opponent and come up punching. Short punches, hooks to the head and to the body, uppercuts and straight, short digs to the body are the tools of the good infighter. Use your weight to press against your rival. The secret of good infighting is to keep your opponent off balance.[12]

Feinting A feint is an outright lie. You make your opponent believe you are going to hit him in one place, he covers the spot and your punch lands on the other side. Remember, the hand is quicker then the eye. Being able to get your opponent to look for one thing, and then doing another is feinting. It can be used to draw punches from your opponent.

10 Al Bernstein (1978). p. 40.
11 Al Bernstein (1978). pp. 41–42.
12 Floyd Patterson (1974). pp. 35–36.

Fighting out of a crouch This is an effective method for a fighter who is short or of average height. The crouch makes your body a smaller target, and exploding out of the crouch is an effective offense. It is a good offensive weapon for someone who can move fast and has proper balance.[13]

d) defense

There are only two options open to you in stopping punches by your opponent. You can slip the punch or block it.

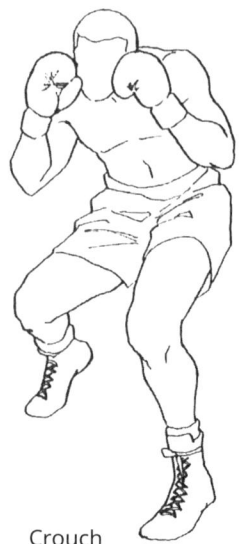
Crouch

Slipping punches It is more difficult than it appears. You can slip a punch in either direction—on the inside or the outside line.[14] On the inside you would be slipping a right hand by moving to the right, and on the outside by moving to the left. On the inside line you will be able to counter better, but you may be more vulnerable to actually getting hit by a blow. On the outside you are more likely to avoid the blow, but you will probably not be in good position to counter.

Slipping punches also can mean leaning back to avoid a blow. Few boxers are capable of doing this well without either getting tagged with a punch or getting off balance enough to ruin their tempo in the ring. For the novice boxer, leaning back can be a dangerous maneuver.

The advantage that slipping punches have is that you have both hands free to counterpunch your opponent. The danger is obvious; if you miscalculate and do not slip the punch entirely, you have no defense.[15]

Blocking punches Blocking a punch provides more protection, but leaves you only one hand to counterpunch with. The

Slipping a punch

13 Floyd Patterson (1974). p. 39.
14 Al Bernstein (1978). p. 46.
15 Al Bernstein (1978). p. 47.

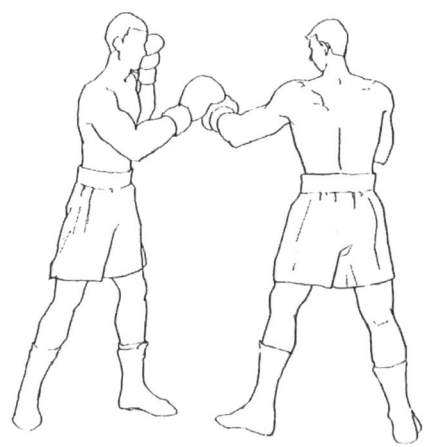

Blocking a punch

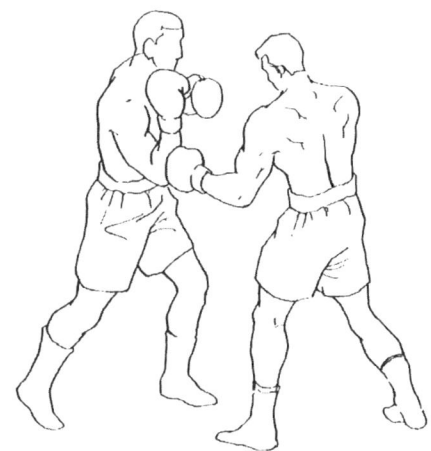

Blocking a punch with elbow

first rule for blocking punches is to use two hands. This is commonly done by beginners but it has two disadvantages. First, some part of your body is unprotected because you are using both hands to protect elsewhere. Second, you will not have a hand free to counterpunch.[16] Another expression used for blocking a punch is "picking it off." If your opponent throws a left jab, for instance, you would probably use your right to pick it off. You could leave your glove open and shove it to the outside and you can counter inside the punch.

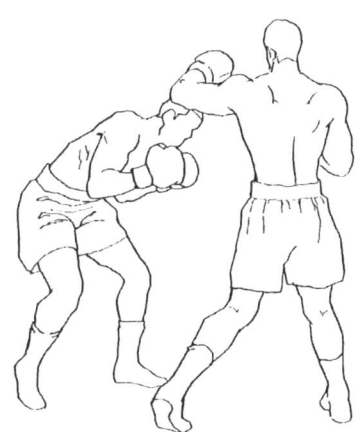

Duckling a punch

If a left hook is delivered to the body, you block it with your arm or elbow. If the punch is directed at your head, then you move your arm up and use the glove to catch the blow. To block the straight right cross, use your left arm in a sweeping motion, pushing the punch to the outside if you can. The right cross is a good punch to slip whenever possible. If you do block it to the outside, however, you will be able to counter with your own right and then follow up with a left sometime before your opponent can set himself right again.[17]

16 Al Bernstein (1978). p. 48.
17 Al Bernstein (1978). p. 50.

Ducking punches Ducking a flurry of punches is also a very effective defensive ploy. Crouch fighters frequently duck punches.

Counterpunching Counterpunching is the way you go onto the offensive from being on the defensive. Remember, any time your opponent throws a punch, he creates an opening for you. Counterpunching is the art of exploiting these openings and turning them to your advantage. For example, if your opponent is throwing a left jab at your face, you could block his left jab with your right glove and throw a left jab.[18]

Clinch Desperate situations call for desperate solutions. Clinching means holding your opponent's arms so that he cannot strike a blow. By moving in on your opponent and pinning both of his arms to your body with your arms entwining them on the outside, you can gain additional time to get a breather. Gaining time can be especially crucial when you are hurt or tired.

3) Training Methods

Boxing may be distinguished from many other martial arts by practicality and intensity. Hard training takes place outside the gym in the form of running and cross-training, and inside the gym in the form of sparring, floor work, and exercises.

a) roadwork
Roadwork or running is an important element in training. Endurance is the single most important commodity for a fighter; therefore, roadwork is essential in building stamina.[19] It also develops mental toughness, aerobic and anaerobic capacity, and the lower body. Boxers typically run early in the morning before any other training. Even in the bareknuckle era, boxers ran up to 150 miles a week.

b) full-contact sparring
It is perhaps the way boxers train that contributes most to its effectiveness as a

18 Floyd Patterson (1974). p. 47.
19 Al Bernstein (1978). p. 11.

martial art. Nothing can replace the conditions and experiences of real combat. In sparring boxers learn what it is like to be hit, how to adjust and recover from it, and how to feign injury and well-being.

c) cylindrical hanging bag

It is a sand-filled leather or canvas bag weighting up to 150 pounds that boxers hit for up to 30 minutes (ten three-minute rounds) every day. Punching the heavy bag most simulates next to sparring the experience of punching another person, and it provides invaluable training in learning to put together skillful punches with maximum force.

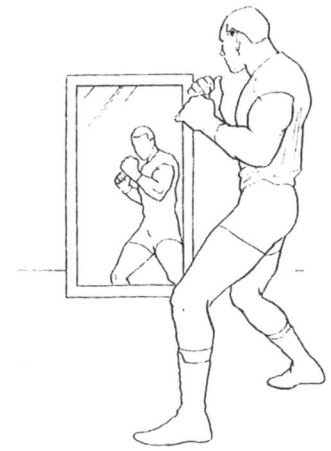

Shadow boxing in front of a mirror

d) shadowboxing

It is a unique element of boxing training comparable to the Asian martial arts. You are boxing with an imaginary opponent in the middle of the ring or in front of a large mirror, visualizing your opponent and going through all the motions of fighting, punching in combination, slipping and blocking punches, and moving forward, back, and from side to side. Especially, by practicing in front of a mirror you are allowed to see possible flaws in the way you deliver your punches.[20]

e) rope-jumping

Skipping rope is also a good way to gain endurance and to help build stamina and agility.[21]

f) speed bag

It is a teardrop-shaped bag hung from a swivel that is used to develop hand-eye coordination, timing, arm strength, endurance, and rhythm.

20 Al Bernstein (1978). p. 34.
21 Al Bernstein (1978). p. 13.

g) punch pads (or punch mitts)

Trainers use these padded mitts (similar to a baseball catcher's mitt) to diagnose and correct slight errors in form in the way their boxers throw punches and combinations, and to instill conditioned responses.

h) medicine ball

Training partners take turns throwing the heavy leather medicine ball into each other's stomachs in order to psychologically prepare themselves for body blows while developing the arms, legs, endurance, hand-eye coordination, and leverage.

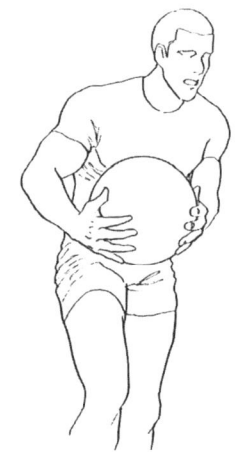

The medicine ball used to harden the muscles of the torso

i) exercise (or calisthenics)

They are usually done to conclude training for the day. Several varieties of sit-ups, crunches, and leg lifts strengthen the stomach muscles and abdomen. Pull-ups, push-ups, and dips develop the arms, back, latissimus dorsi, and chest. Some also undergo light weight training and massage.

4) Injury

There is no doubt that boxing is a dangerous activity that can result in death or brain damage. But is it any more dangerous than other risky sports? For example, the chance of fatality in boxing is 1.3 per 100,000 participants. However, the fatality rate in college football is 3 per 100,000, motorcycle racing 7, scuba diving 11, mountaineering 51, hang gliding 55, skydiving 123, and horse racing 128. In fact, the fatality rate is low in boxing compared to other sports and is continuing to decrease.[22]

Brain damage also is a risk of boxing. Martland introduced the term "punch-drunk" into medical literature in 1928 when he described its occurrence in boxers; however, it may occur in anyone subjected to repeated blows to the head, and it has

22 Robert C. Cantu, et al (1995). Boxing and Medicine. Human Kinetics. p. xi.

been reported in those who participate in soccer, football, rugby, and horse racing.[23] Martland defines punch-drunk as follows:[24]

> *"The early symptoms of punch drunk usually appear in the extremities. There may be only an occasional and very slight flopping of one foot or leg in walking, noticeably only at intervals; or a slight unsteadiness of gait or uncertainty in equilibrium. These may not seriously interfere with fighting… Many cases remain mild in nature and do not progress beyond this point. In others a very distinct dragging of the leg may develop, and with this there is a general slowing down in muscular movements, a peculiar mental attitude characterized by hesitancy in speech, tremors of the hands, and nodding movements of the head… Later on, in severe cases, there may develop a peculiar tilting of the head, a marked dragging of one or both legs, a staggering, propulsive gait with the facial characteristics of the Parkinsonian syndrome, or a backward swaying of the body, tremors, vertigo and deafness. Finally, marked mental deterioration may set in, necessitating commitment to an asylum."*

5) Competition

For the safety of boxers, the Association International de Boxe Amateur (AIBA), the international body governing all amateur bouts, requires all boxers to wear gum shields (so called "mouth piece") and head gear at all times.

There are twelve weight divisions as follows:

Division	Weight	Division	Weight
Light Fly	Below 48kg	Welter	67kg
Fly	51kg	Light Middle	71kg
Bantam	54kg	Middle	75kg
Feather	57kg	Light Heavy	81kg
Light	60kg	Heavy	91kg
Light Welter	63.5 kg	Super Heavy	Above 91 kg

23 Robert C. Cantu, et al (1995). Boxing and Medicine. Human Kinetics. p. xi.
24 Robert C. Cantu, et al (1995). Boxing and Medicine. Human Kinetics. p. 3.

All amateur boxing matches have three rounds of three minutes and one-minute rest between all rounds. If both parties agree beforehand, they may have four rounds of three minutes or five to six rounds of two minutes; however, there has to be one-minute rest between all rounds.

There is one referee presiding over the match in the ring and five judges to record the scores of the boxers.

If a fighter is knocked to the floor and cannot regain his feet in ten seconds, he loses. If he is cut badly or is otherwise injured or unable to defend himself, the referee may end the bout and declare him the loser. Normally, if a fighter is knocked down three times in one round, the fight is ended and he loses.

If the fight does not end prematurely, the winner is decided by the votes of the two judges and the referee, or by three judges alone. A fight may also end in a draw.

Amateur and professional boxing have a few differences. Major differences are as follows: amateur boxing has fewer rounds than professional boxing and amateur boxers are required to wear headgear.

2. History

1) Origin

Boxing predated the ancient Greeks and Romans. It is mentioned in the ancient Hindu epic the Mahabharata;[25] however, the origins of the art traditionally have been traced to ancient Greece. About 900 B.C., the Greeks employed a form of boxing in which sitting opponents wore leather thongs and fought to the death. Both Homer and Virgil poeticize the art in their epics, and designs on ancient Greek pottery feature boxers in action.

Olympic boxing debuted at the 23rd Olympiad in 688 B.C. Boxing matches in ancient Greece bore little resemblance to those held today. These ancient bouts were technically different. Competitors were not limited to blows with the closed fists, but

25 Thomas A. Green (Ed.) (2001). p. 45.

free to use open-hand strikes as well as feet, elbows, knees or even head to achieve victory. In a legendary bout, a champion by the name of Damoxenus defeated his opponent, Crvegas, by means of a straight-fingered strike that pierced his body.[26] Leg strikes, like kicking with one's knees, shins, and feet, were also permitted. As a result, many of these bouts probably looked more like modern kickboxing than boxing.

Contrary to today's standards, in ancient times there were few, if any, rules governing boxing matches. For example, there were no weight divisions, no time limits, no scoring, and no ring or bell. The person left standing at the end of the match won.

Ancient Greek and Roman pugilists (boxers) developed the art of using the fists to pommel their opponents while wearing leather thongs and binders, known as himantes and sphairai, wrapped around the hands and wrists.[27] They were originally used to protect the wrists and fragile bones in the hands. However, the leather thongs also known as cesti were twisted so as to inflict greater injury. The first famous Greek boxer, Theagenes of Thaos, champion of the 450 B.C. Olympics, is said to have won 1,406 battles with the cesti, killing most of his opponents.

When Rome conquered Greece, a more deadly weapon called the cestus was introduced to these bouts and the opponents stood rather than sat. The cestus was studded with metal, and the art of boxing was reduced to a gladiatorial spectacle.[28] Centuries later, the cestus was banned deploring the waste of life and fights with bare fists only were allowed.[29] Later that was banned, too, and boxing disappeared until 18th century England.

2) Early Modern Era

When James Figg opened his boxing school in London in 1719, the art of boxing had been dormant for over a thousand years—since the fall of the Roman Empire. James Figg, a swordsman and the first modern boxing champion, was the central figure in this renaissance.[30] Figg taught young aristocrats the art of self-defense by applying the precepts of modern fencing—footwork, speed, and the straight lunge—to

26 Cezar Borkowski and Marion Manzo. The Complete Idiot's Guide to Martial Arts. An Alpha Books/Prentice Hall Canada. p. 16. See also, Thomas A Green (Ed.) (2001). p. 110.
27 Thomas A Green (Ed.) (2001). p. 45.
28 Thomas A Green (Ed.) (2001). p. 45.
29 Gene Brown (1979). Boxing: The New York Times Encyclopedia of Sports. Vol. 7. p. viii.
30 Thomas A. Green (Ed.) (2001). p. 45.

fisticuffs. Thus, Western fist fighters learned to throw straight punches, the basis of modern boxing, from fencers.

Despite the connection with fencing, boxing encounters during this early modern era were largely unstructured and highly uncivilized. Boxers fought bare-knuckle (without gloves), and wrestling, choking, throwing, gouging, and purring (stomping on one's opponent with spiked boots) were commonplace.

By the end of the 17 century Daniel Mendoza, a British-Portuguese Jew, refined the art by incorporating footwork, choreographed combinations, lateral movement, and fighting from crouch.[31] At 5 feet 7 inches, and scarcely over 160 pounds, Mendoza's unique strategies enabled him to defeat much larger men and lay claim to the championship of England.

The art began to be refined when Figg's successor, Jack Broughton, known as the "Father of Boxing," drafted the first set of rules in 1741 after killing an opponent in the ring. According to "Broughton's Rules," a square was established in the center of the fighting ring (a circular border of spectators) to which fighters were to return after a knockdown, which marked the end of a "round." The down man was given thirty seconds to get back up; it was illegal to hit a down man, and wrestling below the waist was not allowed. Broughton also advocated the use of gloves in training.

"Broughton's Rules" remained in effect until the Pugilists Protective Association issued the "London Prize Ring Rules" in 1838. Further revisions of these rules in 1858 and 1866 banned choking and head butting. In 1866, a new set of rules was issued that completely revolutionized the art of boxing and that serves as the basis for the governance of the sport today.

The "Queensbury Rules," named for the marquis of Queensbury, consisted of twelve clauses in order to reduce acts of barbarism: prohibiting wrestling altogether, mandating a 24-square-foot ring, three-minute rounds with a one-minute rest period after each round, and ten seconds to get up after a knockdown, and the use of gloves instead of bare knuckles; however, the rules still did not limit the number or length of rounds.

Suffice to say that the art of boxing, as we know it today, has largely been attributed to the "Queensbury Rules" and "London Prize Ring Rules" inspired by Jack Broughton's Rules.[32] However, these rules were not used until an 1872 tournament in London, and bare-knuckle fights continued until 1889.[33]

31 Thomas A. Green (Ed.) (2001). p. 46.
32 Thomas A. Green (Ed.) (2001). p. 45.
33 Gene Brown (1979). p. viii.

3) Modern Era

Since the Queensbury Rules were introduced in 1866, boxing began to be modernized. The rules were applied to amateur boxing at first; soon, professional boxing started to adopted them. In 1867, in the interest of safety and fairness, weight classes were first introduced in all amateur boxing championships: heavy (over 156 pounds), middle (134–156 pounds), and light (under 134 pounds).[34]

In 1880, the Amateur Boxing Association (ABA) was formed and subsequent revisions on the existing rules were made and four additional rules were adopted. The revisions limited the number of rounds to twenty, set the minimum glove weight at six ounces, required medical checkups of all boxers, and introduced a scoring system of points.[35] Thus, judges were to record the points boxers make in the ring during the bouts. In its first championships held in London in 1881, there were four weight divisions: feather, light, middle, and heavy. In 1884, a bantam division was added.

By this time, there was occasional boxing in the United States. Because fights were generally illegal, they were staged on barges and farms and anywhere else to escape law-enforcement officials. Many fighters were from England.

The first American heavyweight champion was Paddy Ryan. In 1880, he knocked out Joe Goss, the English champion, near Colliers Station, West Virginia. The fight lasted 87 rounds and took almost an hour and a half. In those days, boxing matches were held barehanded in America and a round ended when one contestant was knocked down or fell to the canvas floor; a tired fighter would end a round and gain a break simply by going down without being hit.[36]

In the same year, Harvard University included boxing in its athletic curriculum and by the 1940s boxing was very popular among university students and there were some hundred universities practising boxing on their campus. An aggressive nature of boxing may have appealed to the masculine Americans and boxing prevailed in America.

The Queensbury Rules were first applied in America was when John L. Sullivan of Boston, the second American heavyweight champion, defended his title against James J. Corbett in 1892 in New Orleans. The bout was fought with gloves and Corbett

34 Thomas A. Green (Ed.) (2001). p. 45.
35 Thomas A. Green (Ed.) (2001). p. 46.
36 Gene Brown (1979). p. viii.

knocked Sullivan out in 21 rounds.[37]

In 1904, boxing was first adopted in the modern Olympic Games held in St. Louise and it became an official event in 1920. In 1946, the Association Internationale de Boxe Amateur (AIBA) was established and since then all amateur boxing matches have been held in compliance with the rules of AIBA.[38]

In 1921, the National Boxing Association (NBA) was established in Rhode Island. It dealt with the governance and control of professional boxing activities with limited jurisdiction in the United States.[39] In 1962, the name was changed to the World Boxing Association (WBA) to give professional boxing universal appeal. In the following year, a new organization called the World Boxing Council (WBC) representing 11 countries around the world was formed in Mexico City to protest American dominance in the WBA. Another international body representing professional boxing, the International Boxing Federation (IBF), was established in 1983 and since then each weight division has produced three world champions.

Reference

Books

Bernstein Al (1978). Boxing for Beginners. Contemporary Books, Inc.

Borkowski, Cezar and Manzo, Marion. The Complete Idiot's Guide to Martial Arts. An Alpha Books/Prentice Hall Canada.

Brown, Gene (1979). Boxing: The New York Times Encyclopedia of Sports. Vol. 7.

Cantu, Robert C. et al. (1995). Boxing and Medicine. Human Kinetics.

Green, Thomas A. (Ed.) (2001). Martial Arts of the World: An Encyclopedia. Vol 1: A–Q. ABC CLIO.

Patterson, Floyd (1974). Inside Boxing. Contemporary Books, Inc.

Web Sites

www.naver.com

www.wbaonline.com

37 Gene Brown (1979). p. viii.
38 www.naver.com
39 www.wbaonline.com

Wrestling
Ancient Combat Art

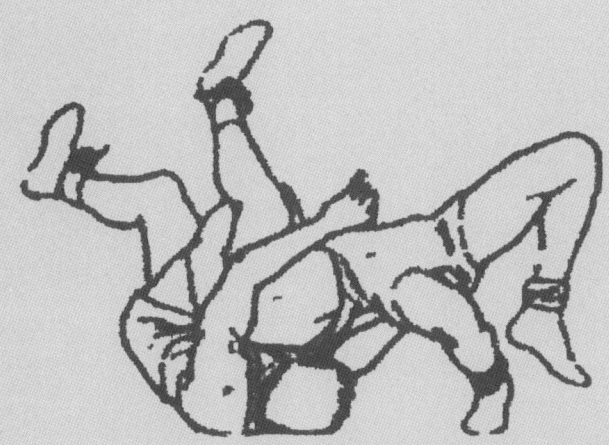

What is Wrestling?

Definition
Forms
Styles
Techniques
Competition

History

Origin
Prehistoric Times
Ancient Greek and Roman Period
Middle Ages in Europe
Modern Periods

1. What is Wrestling?

1) Definition

Wrestling is considered the world's oldest martial art and sport. It dates back to 708 B.C., when it debuted at the 18th Olympic Games in Greece.[1] Today, wrestling, at its core, is an attempt to force an opponent to submit by using holds, throws, takedowns, trips, joint locks, or chokes; however, strikes or percussive blows are not allowed in sport wrestling.[2]

Wrestling in any form is a struggle between opponents that demands the ability not only to outmaneuver, but to outthink an opponent. Physical strength, although important, has always been secondary to the ability to move quickly and efficiently and to set up an opponent for a throw or hold. It has been said that wrestling matches are more like games of chess than combats, and successful wrestlers have always relied on their ability to think several moves ahead.[3]

2) Forms

There are several forms of wrestling which have existed as follows: sportive (or amateur), combative, religious, and entertaining (or professional) forms.[4]

a) sportive (amateur)

The practitioners compete for points before judges and must play within a set of prescribed rules. Many of these sportive forms are unique to a particular culture or civilization, while other forms have gained worldwide acceptance and have been introduced into Olympic competition.

[1] Cezar Borkowski and Marion Manzo (1999). The Complete Idiot's Guide to Martial Arts. An Alpha Books/Prentice Hall Canada. p. 15.
[2] Thomas A, Green (Ed.) (2001). p. 710.
[3] Thomas A, Green (Ed.) (2001). p. 712.
[4] Thomas A, Green (Ed.) (2001). p. 711.

b) combative

Wrestling is a martial art distinct from a sport. Combative wrestling is used for self-defense purposes in environments where there are no rules. Contemporary martial arts practitioners use combative forms of wrestling, and the police and military forces of many nations employ wrestling to supplement armed combat. The fact that wrestling is an effective method of self-defense is often overlooked in modern society. If you consider techniques such as disarms and powerful throws, wrestling should not be characterized simply as a sport.

c) religious

Sacred forms of wrestling are used as religious ceremonies or only practiced during religious festivals or holidays. The Greeks and Romans dedicated wrestling competitions to Zeus (Roman Jupiter), the king of the gods, attesting to the importance of the activity. In Japan, sumo matches were held to determine the will of the gods concerning bountiful crops.[5] There are even forms of wrestling that are only used for secular holidays and festivals.

d) entertaining (professional)

From the 19th century in Britain and the United States, wrestling became a professional spectator sport and at the same time a form of entertainment that the public enjoy to watch. It was played in gambling houses for betting and it helped generate revenues for music halls and saloons. The wrestlers were there for the money and as a result they began putting up a good show for more money. If betting was high enough, then wrestlers and promoters went so far as to fix the results.[6] During the 20th century, the new medium of television was perfect to broadcast wrestling matches to the great many viewers in their living rooms. The action was limited to a small, well-lit area, and television, with its close-ups, could satisfy the audience's desire for violence and blood.[7]

5 Thomas A, Green (Ed.) (2001). p. 729.
6 Thomas A, Green (Ed.) (2001). p. 736.
7 Thomas A, Green (Ed.) (2001). p. 741.

3) Styles

Wrestling is a martial art and sport that transcends national boundaries and cultural identities. Hundreds of recognized regional styles of wrestling exist in the world. A small listing includes the following: trente, from Romania and Moldavia; kokh, the national wrestling system of Armenia; Georgian jacket-wrestling, which resembles judo in many respects; dumug, one of the better-known wrestling systems from the Philippines; schwingen, the national wrestling system of Switzerland; tegumi, a wrestling system from the island of Okinawa; lutte Parisienne, the French combat wrestling system that is often associated with the art of savate; and Corsican wrestling, from the Mediterranean island of Corsica.

Even though there are numerous types of wrestling all around the world, only two official amateur wrestling systems exist today that may be defined as "international styles." They impose a rule structure that is uniform in application and that is intended to allow wrestlers from all nations to participate: "Greco-Roman" and "freestyle." Both types are Olympic events.[8]

Wrestling was included in the first modern Olympic Games in Athens in 1896 and has become the focus of the Games. Greco-Roman derived from ancient Greek and Roman wrestling is the original Olympic style. Twelve years after the modern Olympic Games resumed, a second category called "freestyle" known as "catch-as-catch-can" at the time, was added to the wrestling slate in St. Louis in 1908. This from of wrestling was much less restrictive and was popular at 19th century festivals in Britain and the United States. By the 1890s the style preferred in North America was catch-as-catch-can.[9]

a) Greco-Roman wrestling

Greco-Roman allows only the upper body to be used; the legs cannot be employed to sweep the opponent, nor can they be touched for grabs or takedowns. Both forms of wrestling are similar in that competitors attempt to pin their opponents by forcing the shoulders to touch the mat. Greco-Roman is the most popular style in Europe. However, Greco-Roman is not much appreciated in the English-speaking world. Due

[8] Thomas A, Green (Ed.) (2001). p. 718.
[9] Thomas A, Green (Ed.) (2001). p. 737.

to the lack of worldwide acceptance of this style, however, there is talk at the present time of removing this category from Olympic competition.[10]

b) freestyle

Freestyle wrestling is practiced worldwide and is a sport. In North America, high school and college students compete in freestyle wrestling tournaments with modified rules, such as changes in the time allowed to pin an opponent.[11]

4) Techniques

In general, the wrestling techniques consist of holds, throws, takedowns, trips, joint locks, and chokes.[12]

Holds They are attempts to immobilize an opponent by either entangling the limbs or forcing the shoulders to touch the mat, placing an opponent in a dangerous position.

Throws They are attempts to toss a person across either the hips or shoulders, using the body as a fulcrum.

Takedown They are attempts to unbalance an opponent, such as by grabbing both of the legs with the arms, once again forcing a fall to the ground.

Trips They are attempts by a wrestler to use legs to sweep one or both of the opponent's legs out, forcing a fall to the ground.

Joint locks They are immobilizing locks against a limb of the opponent, such as the elbow or knee, which attempt to hyperextend the joint beyond its normal range of motion, forcing the opponent to either surrender or risk losing the limb.

Chokes They are attempts to cut off either the air supply or blood supply, or both,

10 Thomas A, Green (Ed.) (2001). p. 718.
11 Thomas A, Green (Ed.) (2001). p. 718.
12 Thomas A, Green (Ed.) (2001). p. 710.

to the head, once again forcing the opponent to either surrender or suffer black out.

There are thousands of techniques in wrestling that depend on the implementation of these movements. Experienced wrestlers of any style, therefore, have a great number of techniques and combinations that they may use in combat.

The most important techniques first to be learned by beginners are takedowns and the techniques are well summarized by Bob Douglas, a captain of the U.S. 1968 Olympic Team as follows:[13]

> *"Dealing with takedowns is the first step in becoming a champion... First, a takedown man must have motion, the ability to move his feet; second, the ability to step into his opponent; third, the ability to get past the opponent's defense. These three items cannot work as separate units but must be coordinated in order to insure success."*

The following are the most basic takedown techniques needed to be mastered by successful wrestlers as provided by Bob Douglas in his book, *Wrestling - the Making of a Champion: The Takedown*.[14]

a) stance

Your head should be cocked back on your shoulders with your chin up. Your hands should be in your lap with your elbows close to the sides of your body. Your back should be arched, knees bent, hips aligned, feet shoulder-width apart, toes pointing out.

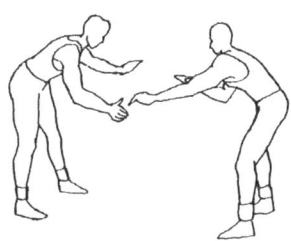

Open stance

b) penetration

It is moving in the direction of your opponent. This is done by two techniques: the step-in and the drop step.

c) the tie-up

It is the first step for any set-up. Set-ups are devices to bait your opponent into making technical errors,

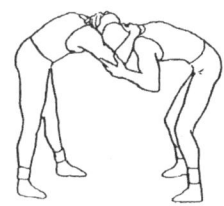

Closed stance

13 Bob Douglas (1972). Wrestling-the Making of a Champion: the Takedown. Cornell University Press. p. xiii.
14 Bob Douglas (1972). pp. 1–162.

such as raising his head, pulling back, reaching, or stepping. The tie-up should be made quickly, while changing control points to get the opponent into motion. It is best made at a distance that will enable you to keep your elbows bent. Place your feet no more than two feet from his. The tie-up should be made quickly, while changing control points to get the opponent into motion.

d) double leg tackle

It is a flying tackle similar to a football tackle. It begins from a staggered or drop step position. In the first move, your front leg steps between your opponent's legs, or at least in that direction, in an attempt to split his legs with your advancing foot. Your head should be on the same side of the opponent's body as your back foot, and should lead your body in, while your shoulder makes the first contact with his body.

e) fireman's carry

The fireman's carry technique is similar to the double leg tackle penetration. Begin with a long step between your opponent's leg. Place your head under the arm that you are attacking or controlling. Your free arm will go under his crotch, thus catching the leg above the knee. The stepping leg will go deep into the crotch, touching the mat in a keeling position. Your rear leg will drive and pivot and also come to kneeling position. This pivoting action straightens your back, lifting your opponent off the mat while pulling his captured arm down. From this position take your opponent over your head and throw his shoulder down to the mat.

f) duck-under

It can be described as putting your head behind your opponent's arm. This is done from a number of tie-ups which in themselves constitute the set-up. The techniques used are stepping and squatting while getting your opponent to move his arm away from the side you plan to go under. The breakdown depends upon the position of your opponent's body.

g) single leg tackle

Penetration should carry you directly to the leg you are attacking, keeping your head inside the leg. At this point you should be on your knees. It is important to keep your opponent's weight on his free foot, which can be accomplished by standing up or by bringing your outside leg up and driving across.

h) near arm and opposite leg takedown

The near arm and opposite leg takedown is actually a combination of two other takedowns. The arm is controlled as in a fireman's carry. The penetration is executed as in a single let tackle that goes across the body. In this technique the arm that is controlled is taken in the direction of the opposite knee. Your head stays to the inside of your opponent's leg. The arm that is attacking his leg will lift it up. The controlling arm in the fireman's carry position will pull down on his arm, moving in a circular motion, throwing the opponent on his back.

i) arm drag

For a successful arm drag the arm has to be controlled above the elbow, turning the arm across and toward the opposite knee. This motion will expose the leg and entire right side.

j) foot kicks

They are techniques used to break your opponent's balance by kicking one foot across his center of gravity. The important point to remember is that his weight has to be removed from the foot you plan to kick. The set-up is used to remove the weight.

k) head snap

Its technique is an effective move from a collar tie-up. The head snap is particularly useful when your opponent has elbow control, either while standing or on his knees. The head snap is executed with a whip like motion by snapping your elbow past your opponent's chin while snapping your wrist. The result of the snapping creates an angle and puts you in a position to go behind.

l) the shuck

It is a technique to create an angle of advantage which places you to the side of your opponent.

m) high crotch takedown

It affords two methods of penetration. The first is a "foot step." This is done by bringing your outside foot as close to your opponent's outside foot as possible. The second technique is a drop step. Both techniques require placing the knee down on the mat between your opponent's legs. Both also require moving off the knee

and coming to your feet again for the second move, which will be the same as in a double leg or single leg, depending upon the position you find your opponent in.

n) ankle pick-ups

It requires a back step to the side. The stepping leg will be on the side of the hand that attacks the ankle. You must place the controlled portion of your opponent's body over his ankle. The controlled portion is pulled down and placed at an angle over the foot, so that your opponent cannot remove his foot. Your head must remain at the same level as the controlled portion. Once you reach the ankle, do not attempt to pick it up. Instead, push the controlled part of your opponent's body over his ankle.

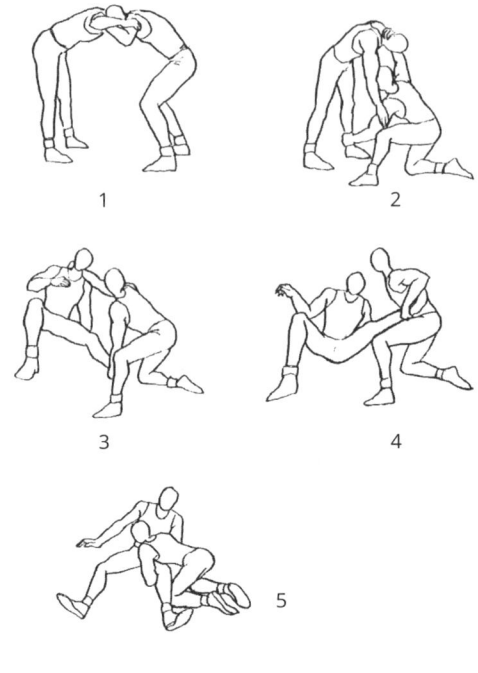

Heel pickup

o) headlock

It is accomplished by turning your hips into a position that carries your opponent off-balance while you control his head.

p) head and arm control

The head and arm tie-up is sometimes called a front headlock. It is often used after countering a fireman's carry on a single leg attempt. Your arms are locked around the head and one arm of your opponent. Your shoulder should be applying pressure to the back of his neck. The trick is to keep his head down and to control the arm. In the grip, the palm of your outside hand should be facing up. It is important to stay off your knees and to keep all your weight resting on your opponent's neck and back.

5) Competition

Description Wrestling is a hand-to-hand contest between two opponents in which each attempts to beat the other by pinning him on his back, with both shoulders touching the mat for one second. If neither wrestler pins the other, either may still win on a decision by scoring more points than his opponent.

Weight division In wrestling, the participants are matched according to weights. There are 7 weight categories in Olympic wrestling (55 kg and under, 60, 66, 74, 84, 96, and 120kg).

Time limit The time limit for Olympic Games is 6 minutes; two periods (3 minutes for each period). When neither player succeeds in making a fall during the entire two periods, another period of 3 minutes is allowed.

To start the match, the referee has both wrestlers come forward from their corners of the mat. While the wrestlers are still on their feet, the referee signals the start of the first period. When the match begins, the two wrestlers try to take one another to the mat by a takedown.

Clinch If after the first period neither wrestler has scored a fall, a coin is flipped to determine which wrestler then has the choice of top or bottom position for the beginning of the second period. Contestants start from a starting position on the mat. The underneath wrestler tries to escape or reverse his opponent while the top wrestler attempts to ride and break his opponent down so he can secure a pin hold. If no fall occurs a minute after the clinch starts, time is called and the top wrestler loses one point. Then the bout continues with the wrestlers taking the position in reverse of that in which they started the second period.

Starting position underneath

Referee position on the mat The defensive wrestler assumes a position in the center of the mat facing the referee. Both his knees are on the mat and his hands must be at least 30 centimeters in front of his knees, lower legs parallel and knees

not more than shoulder width apart. The offensive wrestler takes a position on his knees to the side of his opponent. His arm is held loosely around his opponent's waist, with the palm of his hand on the other's navel. The offensive wrestler's other hand is placed loosely on the back of his opponent's near elbow. His leg must not touch his opponent's legs. Wrestling then begins with the referee's whistle.

Starting position on top

Position of advantage The "position of advantage" means simply that one wrestler has gained control over his opponent. To be awarded points for gaining "advantage," he must be on top and behind his opponent. The determining factor, however, is control. Under some conditions, it is possible for the man in control to be beside or even under his opponent.

Out-of-bounds When wrestlers go out-of-bounds, they are brought back to the center of the mat. When this occurs if neither wrestler has the advantage, both start on their feet in a neutral position. If one contestant has the advantage, he is placed in the starting position on the mat in the offensive position.

Scoring system A wrestling match is won either by a "fall" or a "decision." A player can be given from one to five points when he successfully delivers a technique relative to the points. If a player gets 10 points more than his opponent, then he is declared a winner by technical fall.

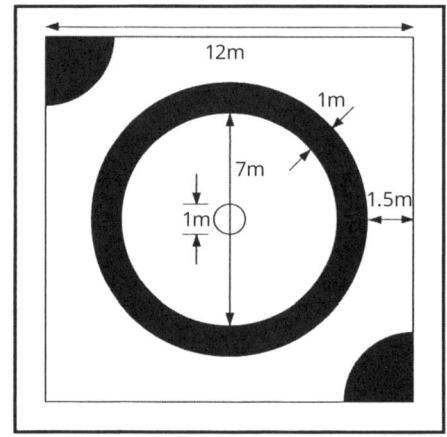

Wrestling ring

2. History

1) Origin

There is no universal agreement as to the origin of wrestling. No one knows how or when wrestling became a formal activity. Western combat traditions tend to link the origin of wrestling with classical Greek and Roman civilizations. However, it is certain that wrestling existed in all human societies.

Many of the basic wrestling moves have been genetically imprinted in humans as instinctual methods of self-defense. Even the closest human relatives in the animal kingdom such as gorillas, chimpanzees, and orangutans have been observed to throw their fellows when playing in moves that are remarkably similar basic wrestling throws. Like humans, these mammals also have an opposable thumb and four fingers that are ideally suited to grasping and holding. From this observation we can conjecture that cavemen may have wrestled with one another both in play and in combat. Therefore, contemporary wrestling has emerged under diverse cultural influences.

2) Prehistoric Times

Although western combat traditions generally suggest that the origins of wrestling started in one of the classical civilizations such as the Greeks and Romans, the first written records of the activity come from the Near Eastern civilizations of Babylon and Egypt, East Asia, and South Asia. From Egypt, in fact, there comes a clear "textbook" of wrestling and fighting methods recovered from the tomb of Beni-Hassen. Various throws, holds, and takedowns are clearly illustrated through drawings and descriptions. The book dates back at least to 1500 B.C. and it is one of the oldest textbooks in the world.[15]

Even earlier records dating back to the ancient Near Eastern civilizations of Sumer (3500 B.C.) and Babylon (1850 B.C.) attest to wrestling as being one of the oldest

[15] Thomas A, Green (Ed.) (2001). pp. 712–713.

human activities. For example, the Babylonian Epic of Gilgamesh clearly describes wrestling techniques used by the hero and his antagonists. In East Asia, Mongolia and China both developed indigenous wrestling systems. Murals of grappling techniques paid tribute to the art in fifth-century B.C. China. In South Asia, beginning with the early civilizations of the Indus River valley (2,500–1,500 B.C.), there are pictographs and illustrations of figures who are clearly wrestling.[16]

3) Ancient Greek and Roman Period

The Greeks developed advanced martial art systems in boxing, wrestling, and most notably, the pankration (a kind of all-in fighting where all techniques were legal).[17] Wrestling was not the "Greco-Roman" variant of today, but divided roughly into three main categories.[18]

The first type involved groundwork wherein the participants had to get opponents into a joint lock or hold. In the second variant, the participants had to throw each other to the ground, much as in Japanese judo or Chinese shuaijio (shuai-chiao), the oldest continuously practiced wrestling system in the world.[19] The third type was a combination of the two; thus, all kinds of throwing techniques using legs, shoulders, and hips, as well as an assortment of foot sweeps (off-balancing maneuvers) and neck restraints. What makes wrestling different from other forms of Greek martial arts such as boxing or the "all-out" fighting system of pankration is that it does not allow blows with fists or feet.[20] Not until around 1,000 B.C., however, were wrestling techniques and descriptions of champions systematically recorded in written forms

16 Thomas A, Green (Ed.) (2001). p. 713.
17 In the pancration (meaning all power), the purpose was to get the opponent to admit defeat by any means possible. The only forbidden techniques were eye-gouging and biting. This meant that practitioners could use punches, kicks, wrestling holds, joint locks and choke holds, and throws in any combination required to insure victory. It is the great ancestor of the "Ultimate Fighting Championship." Thomas A, Green (Ed.) (2001). p. 110.
18 Thomas A, Green (Ed.) (2001). p. 110.
19 Thomas A, Green (Ed.) (2001). p. 713.
20 Pankration (Greek; all powers), a Greek martial art utilizing both striking and grappling, was created almost 3,000 years ago. Pankration was an all-out form of fighting. The competitors were allowed to do anything except biting and eye-gouging. Punches and open-hand strikes with the hands, kicks, all types of throws and take-downs, joint locks and choke holds—all of these techniques were legal in a pankration bout. The goal of the pankration match was to get the opponent to signal defeat Failing this, it was expected that one opponent would be knocked out or choked to unconsciousness. The art had an extensive influence on Western martial arts, and possibly on Asian arts as well. See Thomas A, Green (Ed.) (2001). Martial Arts of the World: An Encyclopedia. Vol. 1: A–Q. ABC CLIO. P. 410.

in Western cultures most notably by the Greeks.[21]

Wrestling debuted at the 18th Olympiad in 708 B.C.[22] and boxing debuted at the 23rd Olympiad in 688 B.C.[23] When the Olympic Games were initiated, wrestling was one of the original events. When pankration was added at the 33rd Olympiad in 648 B.C.,[24] all three Greek unarmed combat systems were in place as Olympic events.[25]

Besides being included in the Olympics, wrestling was practiced at all athletic festivals, including those that were local. It was also mandatory for Greeks preparing for armed combat to study the rudiments of wrestling, boxing, or pankration. Olympic Games, which honored the Greek deities, were ostensibly a religious form of expression. The sportive and military applications, however, were obvious. Wrestling, therefore, addressed three different spheres of life in the Greek world: religion, sport, and military training.[26]

The Romans conquered the Greeks in approximately 146 B.C. Although they admired and copied Greek athletic preparation, the art of wrestling as a sport never became popular in the Roman world. The Romans preferred the blood sports of the empire, such as fights between gladiators or animals. As a result, wrestling suffered a loss of prestige.[27]

When Christianity became the official religion of the Roman empire in the 4th century, organized sports and high-level athletic techniques such as wrestling declined as well. However, wrestling continued to be practiced most notably for combat training until the fall of the Eastern Roman Empire (Byzantium). Since the fall, the authority of the Eastern Orthodox Church prevented wrestling from obtaining status as a sport. The Greek love of wrestling had come to an end.[28]

Contemporaries of the Romans, however, maintained wrestling systems. The Celts were notable in this regard. At least two styles of Celtic wrestling still exist: "Cornish wrestling," particularly in the British area of Cornwall, and "Breton wrestling," practiced in the French area of Brittany.[29]

21 Thomas A, Green (Ed.) (2001). pp. 713–714.
22 Cezar Borkowski and Marion Manzo (1999). p. 15.
23 Cezar Borkowski and Marion Manzo (1999). p. 16.
24 Cezar Borkowski and Marion Manzo (1999). p. 17.
25 Thomas A, Green (Ed.) (2001). p. 714.
26 Thomas A, Green (Ed.) (2001). p. 714.
27 Thomas A, Green (Ed.) (2001). p. 715.
28 Thomas A, Green (Ed.) (2001). p. 715.
29 Thomas A, Green (Ed.) (2001). p. 715.

4) Middle Ages in Europe

After the fall of the Roman Empire, the feudal kingdoms of the Middle Ages did not stop developing martial arts in the West. Especially powerful Germanic and Celtic warrior tribes prospered and they developed the use of a vast array of weaponry and European warriors were well trained in unarmed combat.[30] During the medieval period, masters-at-arms were known at virtually every large village and various wrestling systems, both combative and sporting, appeared in the city-states and nations.

Unarmed techniques were included throughout the German Kunst des Fechtens (art of fighting) and it taught the art of wrestling and ground fighting known as Unterhalten (holding down).[31] The typical German Fechtmeister (fight-master) was well versed in close-quarters takedowns and grappling moves that made up what they called Ringen am Schwert (wrestling at the sword), as well as disarming techniques called Schwertnehmen (sword taking).

In the 14th and 15th centuries, German fighting guilds systematically taught wrestling techniques as part of their curricula. The Fechtbuch (fighting book) of Hans Talhoffer offers several pages of illustrations on "getting inside the opponent" techniques which show unarmed soldiers how to move within the fighting range of a weapon and remove it from the armed opponent. Several other Fechtbuchs in the Middle Ages clearly show methods of throwing, takedowns, and arm locks that indicate that wrestling as a combat art was in use in Europe in the Middle Ages.[32]

The Italians, as well, developed wrestling styles and grappling systems for combat. In one of the most famous treatises of the late Middle Ages, the Collecteanea, the first published work on wrestling, the Italian master Pierre Monte describes wrestling as the foundation of all fighting,[33] and states that any form of weapons training must include knowledge of how to disarm.[34]

His systematic curriculum of techniques and escapes was presented as a martial art, not as a sport, and he emphasized physical conditioning and fitness.[35] His style advocated counterattacks rather than direct aggressive attacks. He taught to strike

30 Thomas A, Green (Ed.) (2001). pp. 111–112.
31 Thomas A, Green (Ed.) (2001). p. 112.
32 Thomas A, Green (Ed.) (2001). p. 715.
33 Thomas A, Green (Ed.) (2001). pp. 112 & 716.
34 Thomas A, Green (Ed.) (2001). p. 716.
35 Thomas A, Green (Ed.) (2001). pp. 112–113.

the openings made by the opponent's attack, and he advised calculating the temperament of the opponent. He also stressed the importance of being able to fall safely and to recover one's position in combat. He criticized the wrestling techniques of the Germans, in which he believed the practice of fighting on the ground was dangerous.[36] This evidence shows that various schools and theories of wrestling existed in Europe during this time.

Monte's practical yet sophisticated grappling techniques collectively called Gioco Stretto (usually translated as "body work") are described and illustrated in numerous Italian fighting manuals and are in many ways very similar to those of certain Asian systems.[37]

In Scandinavia, as early as A.D. 700–1,000, wrestling called for competitors to grasp their opponents by the waist of their pants and attempt to throw them. The person who fell to the ground first would lose. This reflected the idea that a person once thrown on a battlefield would be at the mercy of an enemy with a weapon. This wrestling tradition persisted in one of the last outposts to be settled by the Vikings: Iceland. Today, this wrestling style still exists in the Icelandic sport of Glima (meaning "flash" in Icelandic).[38]

Participants wear a special belt known as a climubeltae which consists of a wide belt worn around the waist with two smaller belts worn around the thighs. Competitors attempt to throw their opponents by grasping the climubeltae, and the person who falls first or is thrown so as to touch the ground with any of part of his or her body above the knee loses.[39] Sports using belts around the waist and thighs and touching the ground with any part of body above the knee are very similar to Japanese sumo and Korean ssireum to some extent. This art form of wrestling has been revived in Scandinavia and is practiced at festivals reenacting and celebrating Viking culture around the region.

Farther east, in Russia, the ancient chronicles of the country, most notably the Lay of Ignor's Campaign, describe warriors using wrestling techniques as part of their training. This would seem to indicate that Russian warriors developed wrestling as an armed combat skill for use in battle. The Mongols invaded Russia in the thirteenth century, and later the Russians moved into former Mongol-dominated regions as the

36 Thomas A, Green (Ed.) (2001). p. 716.
37 Thomas A, Green (Ed.) (2001). p. 112.
38 Thomas A, Green (Ed.) (2001). p. 716.
39 Thomas A, Green (Ed.) (2001). p. 716.

Mongolian Empire began to fall apart. This move brought the Russians into contact with many different peoples—many with their own styles of wrestling in Central Asia. As a result, regional styles evolved. For example, traditional Siberian wrestling resembles Japanese sumo and Korean ssireum in many aspects.[40] The Russians developed their own system for the entire former Soviet Union in the 1930s: "sambo" (an acronym in Russian for "Self-Defense without Weapons").[41]

5) Modern Periods

After the overthrow of the old Russian Empire and as part of the development the Soviet Union, the Russians developed their own form of wrestling for the entire nation. Sambo was intentionally created from the native fighting and wrestling techniques of the Russians, those of the more than 300 nationalities of the Soviet Union, and elements of Japanese Judo.[42]

From modern Greco-Roman wrestling, several powerful throws were incorporated into sambo, most notably those using the hips. Leg techniques were added from freestyle wrestling. The idea of grasping the belt in sambo for use in throwing the opponent may have been borrowed from the Icelandic sport of Glima. In addition, native Russian techniques such as arm and leg locks were also incorporated into this system. Kodokan judo was also blended into the system.

After all, sambo is recognized as a syncretic martial art that borrowed techniques from several styles. Sport sambo allows throws, holds, leg and arm locks, and takedowns. Combat styles (military and self-defense sambos) also exist.[43] Although striking is not permitted in sport sambo, it is used in military sambo and self-defense techniques. Today, even after the fall of the Soviet Union, sambo enjoys international popularity—especially in the regions of East Europe once under the rule of the Soviet Union.[44]

The United States developed its own systems of wrestling as well. Many early English settlers brought with them their native systems such as the Cumberlan/Westmorland and Cornish/Devonshire styles.[45] In the north of England and Scotland,

40 Thomas A, Green (Ed.) (2001). p. 716.
41 Thomas A. Green (Ed.) (2001). p. 507.
42 Thomas A, Green (Ed.) (2001). p. 509.
43 Thomas A, Green (Ed.) (2001). pp. 509–510.
44 Thomas A, Green (Ed.) (2001). pp. 716–717.
45 Thomas A, Green (Ed.) (2001). p. 717.

the wrestling style most commonly used was Cumberland and Westmorland. In this style, the wrestlers locked hands behind each other's backs and then each tried to throw the other to the ground or make him break his grip.[46] Judges at these events were known for their precise and exacting compliance with rules.

In the south of England, other styles were more popular. Cornish wrestlers, for example, wore short jackets, and gripped one another's sleeve and shoulders as in modern judo. A standard trick involved trapping the right arm and then back-heel tripping. Devonshire wrestlers wore straw shinguards and clogs, and were allowed to kick one another in the shins. Otherwise their techniques were similar to Cornish wrestlers.

In the 19th century, a Lancashire style known as "catch-as-catch-can" wrestling,[47] originally from England, became popular in America.[48] Unlike Cornish and Devonshire wrestlers, Lancashire wrestlers wore only underwear, and the players started well apart with their knees bent and hands outstretched. Although kicking, hair pulling, pinching, and the twisting of arms and fingers were prohibited, almost anything else was permitted, even the hold to the neck.

The catch-as-catch-can form of wrestling was a combat/sport form of wrestling in which most holds and throws/takedowns were allowed. It is an ancestor of international (or Olympic) freestyle.[49] From the 14th Olympic Games held in London in 1948, the name "catch-as-catch-can" has changed to the present "freestyle." From this catch-as-catch-can tradition, in the later 19th century and the beginning of the 20th, professional wrestling became an established sport in the country.[50]

In 19th century Britain, professional wrestling was a gambling sport akin to boxing and horse racing for the amusement of gamblers.[51] Standard venues for mid-19th century wrestling in North America included music halls and saloons. The entertainment in the better clubs included dance revues, comedy acts, and wrestling matches. The wrestlers were there for the money rather than to hurt one another, and as a result they began "working" the crowd to give them a good show. However, if betting was involved, then sometimes wrestlers and promoters went so far as to fix results.[52]

During the 20th century it became a kind of muscular theater performed either live

46 Thomas A, Green (Ed.) (2001). p. 735.
47 Thomas A, Green (Ed.) (2001). p. 735.
48 Thomas A, Green (Ed.) (2001). p. 717.
49 Thomas A, Green (Ed.) (2001). p. 735.
50 Thomas A, Green (Ed.) (2001). p. 717.
51 Thomas A, Green (Ed.) (2001). p. 735.
52 Thomas A, Green (Ed.) (2001). p. 736.

or on television. These productions were often hypocritical, greedy, ruthless, reactionary, homophobic, racist, and vulgar. However, the change simply reflected the desires of the audience. A former professional wrestler, Robert "Kinji" Shibuya, reflected in 1999, "The meaner I acted in the ring, the richer I walked out of it."[53] Audiences for professional wrestling are huge. By the mid-1980s wrestling had become the third most popular spectator sport in North America.[54] (American football and automobile racing were first and second). Wrestling has even greater popularity in Japan.

Once wrestling has become a form of entertainment, a question is raised: "Is wrestling theater in a squared circle, the Shakespeare of sport?" That is the most probable explanation. However, there is still no easy way to explain why millions of people enjoy watching professional wrestling and yet dislike watching amateur wrestling.

Gene Tausk, a contributor to Martial Arts of the World: An Encyclopedia, concludes as follows:[55]

"At the beginning of the twenty-first century, it is safer to assume that wrestling will continue to grow in popularity throughout the world. The fate of specific cultural forms of wrestling is unknown; perhaps as the world narrows into a global village these forms of wrestling will cease to be practiced. Yet, even with this possibility, the growth of wrestling as a world sport and method of combat will continue."

Reference

Books

Borkowski, Cezar and Manzo, Marion. The Complete Idiot's Guide to Martial Arts. An Alpha Books/Prentice Hall Canada.
Douglas, Bob (1972). Wrestling-the Making of a Champion: The Takedown. Cornell University Press.
Green, Thomas A. (Ed.) (2001). Martial Arts of the World: An Encyclopedia. Vol 1: A–Q. ABC CLIO.
Green, Thomas A. (Ed.) (2001). Martial Arts of the World: An Encyclopedia. Vol 2: R–Z. ABC CLIO.

53 Thomas A, Green (Ed.) (2001). p. 735.
54 Thomas A, Green (Ed.) (2001). p. 743.
55 Thomas A, Green (Ed.) (2001). pp. 718–719.

Savate
Martial Art of France

What is Savate?
Definition
Characteristics
Techniques
Training Methods
Competition
Grading System

History
Origin
Early Modern Era
Modern Era
Abroad

1. What is Savate?

1) Definition

The word *savate* originally means "boot" or "shoe" in French. Savate is a synthesized martial art which uses punches and kicks. Although it has a reputation as a punching and kicking style, it also includes grappling and weapons.[1] Two separate sports have derived from savate: the first as a form of sport kickboxing called *boxe francaise*, and the second a form of fencing with sticks called *la canne de combat*.

Savate is an indigenous martial art of France and southwestern Europe. It developed from the fighting techniques of sailors, thugs, and soldiers and has many elements in common with certain Asian martial art systems and Americanized kickboxing.[2] The term *chausson*, which refers to the "deck shoe," or "slipper" worn in practice rooms, might be a more appropriate name to many practitioners.

French boxing today combines the style of punching evolved in English boxing with the kicking techniques of savate. Internationally, there are other names for savate: boxe francaise (French boxing), savate boxing, and French savate.

2) Characteristics

According to Bernard Plasait, Professor of French Boxing, former French Boxing Champion of France, and President of the National Commission of Boxe Francaise (CNBF), there are three main characteristics of savate: realistic, educative and moral, and sportive and artistic.[3]

a) realistic
French Boxing is a martial art whose techniques are geared toward unarmed combat or self-defense by natural means.[4] Its techniques are founded on experience

1 Thomas A. Green (Ed.) (2001). Martial Arts of the World: An Encyclopedia. ABC Clio. Vol. 2: R–Z. p. 519.
2 John Corcoran & John Graden (2001). The Ultimate Martial Arts Q & A Book. p. 198.
3 Bernard Plasait (1986). De la Boxe Francaise: Savate Canne Chausson. p. xvii.
4 Bernard Plasait (1986). p. xviii.

and scientific study, and are based on proven traditions and constant improvement. Therefore, it is a living method which is in constant evolution and permanent progress.

Techniques are performed using all arms and legs, which offer a maximum number of offensive and defensive options. French Boxing does include such traditions as the breaking of boards or the prearranged patterns of attack and defensive skills called *kata* in judo and *karate* or *pumsae* in taekwondo. Savateur (savate practitioners) believe it is useless to study self-defense techniques in limited situations since those exact situations never in fact arise in that particular way in real fighting situations.

Rather, French boxers try to master staying alert and vigilant in order to judge the opportune time to deliver the appropriate choice of attack. Thus, if you mastered only certain reflexive movements, they would leave you open to the dangers inherent in real fighting situations. The ideal defense can only be realized by the total assimilation of savate's entire combat method or methods. Therefore, the practice of savate gears its practitioners towards real life combat sills and situations by preparing them for the expected as well as the least expected blows.

b) educative and moral

In terms of education, savate rejects all movements that are not in line with its notions of efficiency.[5] This principle is believed to make it not only an excellent method of self-defense, but also an exceptional means of education. Its practitioners work to combine elegance with practicality while engaging in the harmonizing of thought and action. Savateurs practice to develop not only physically, but also morally. Throughout their training they end up fostering individual and social qualities.

In terms of physical education, savate offers much of the benefits found in other martial arts, but offered in the form of a sport. Its foundation involves the equilibrium and extension necessary to both balance oneself while at the same time extending to defend oneself, or attack one's opponent. The result is well-balanced muscle development, along with the honing of psych-motor skills, both of which are integral to one's physical self-mastery.

From the point of view of intellectual and moral development, savate can also be of educational value. Competition forces its practitioners to exercise their intelli-

5 Bernard Plasait (1986). p. xix–xxi.

gence. One must invent a strategy, imagine tactical combinations, instantly calculate the opportunity for an attack, and at the same time judge the strategy and intentions of one's opponent. Not only does one have to guess, perceive, and anticipate, but one has to also appreciate distances, trajectories, and speeds, while adapting to the changing environmental parameters. All of this requires mastery of many spatio-temporal factors along with a fluid and nimble mind.

French boxing also favors the nurturing of the highest moral values: the will and perseverance to accept the hardship required in training, courage to confront the blows of one's opponent, faith that one will be able to overcome difficulties, loyalty to one's friends and teacher, and honesty. In the end, the loser learns to overcome his defeat and the winner learns to rise above his victory; and both salute each other in respect.

c) sportive and artistic

Aside from being a form of self-defense, savate is considered to be a competitive sport and a means of corporal expression[6] that is both effective and artistic to the eye. It is practiced equally by adults and children, as well as by men and by women. It works to discharge one's natural nervous energy and aggression by force of hand and foot. Competition transforms the savagery of violence into a disciplined force that strives to break the instinct of violence. For this reason, children especially have a lot to gain by taking up the study of savate.

In competition, engagement does not equal animosity. Your adversary is not your enemy, but rather a partner and friend, who is there to help you further develop your skills.[7] Both competitors strive for victory, but are encouraged to do so in accordance with a strict set of rules being enforced for the safety of both.

Although gloves, a protective cup and a mouth-guard are worn by competitors during competitions, there are undoubtedly injuries and infractions that occur. Yet, the spirit of courtesy is by far dominant, and the intention is not to injure, but to learn. In fact, competition is set up by matching two competitors of equal size and skill, with equal chance of winning in the most pure form of chivalry.[8] Therefore, when its spirit is adhered to and the rules are followed, boxe francaise is not a dangerous sport, but rather a source of joy and progress to its practitioners, many of

6 Bernard Plasait (1986). p. xxii
7 Bernard Plasait (1986). p. xxii.
8 Bernard Plasait (1986). p. xxii.

whom consider it an art.

Artistically, savate has been likened to a dance by some of its practitioners, in that there is a fluid and constant movement back and forth between competitors. Although this could give the impression that the movements are executed along the lines of some pre-existing choreography, that couldn't be further from the truth. In the general rhythm of savate, there is beauty in the play of extension and disequilibrium, the harmonizing of attack and defense, and the gracefulness of the jumps and incisive blows. It is by these measured movements and rhythm that savate has been likened to dance. However, it must be noted that, unlike dance, there are no gratuitous movements, or moves performed solely for aesthetic reasons. All movements are performed expressly with the dual aims of efficiency and education in mind, but given its inherent rhythm it often resembles a veritable ballet.[9]

3) Techniques

The fighting method of savate is mainly based upon kicking. It exhibits a variety of kicks and kick deliveries.

a) kicks

Savate employs many of the kicks found in other martial arts such as front kicks,

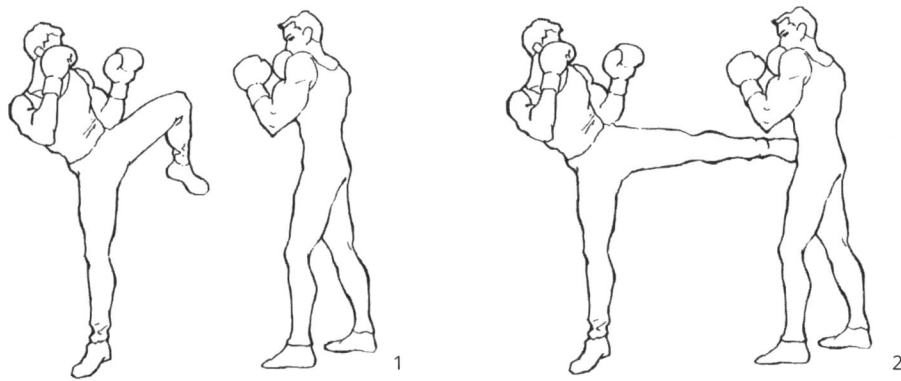

Fouette

9 Bernard Plasait (1986). p. xxiv.

side kicks, the whip or roundhouse kicks, reverse kicks, turning kicks, and a variety of leg sweeping kicks. Even some are strictly exclusive to savate.

Most of the kicks performed in savate can be executed with both legs, either to the head or the body, and with one foot firmly planted on the ground or while jumping. In fact, many of the kicking techniques used in competition are a free-flowing combination of all these, such as the back leg turning round house kick, or the jumping reverse kick to the body.

Since shoes are worn, the tip of the shoe (toes) is a common striking point, yet the heel, edge, and instep are also commonly used.

Fouette Fouette, a spiraling kick that is vaguely similar to a roundhouse kick of taekwondo, is one of the trademark kicks of savate. The blow may be aimed at the head, legs, or trunk but is always struck horizontally from the side.[10]

Coup de bas Coup de bas, a low kick, is another popular kick. This may be aimed at either of an opponent's legs below the knee. It is always carried out with the back foot and with the inside edge of the foot. It is frequently used primarily as a feint to gauge an opponent's reaction and to open him up for another attack. Occasionally, savateurs will initiate their attacks with a high kick, only to target the legs with the downward trajectory of the missed kick.[11]

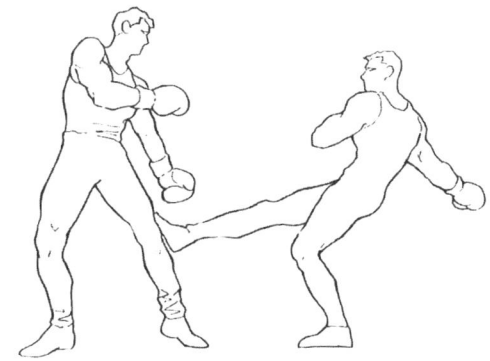

Coup de bas

Chasses Chasses, similar to a side kick of taekwondo, may be aimed at the opponent's legs, trunk, or head. Chasses means driving out or forcing away. When aimed at an opponent's leg the kick is termed chasse bas or low chasse. Raise the front leg to touch the chest, turning sideways by pivoting on the supporting foot, and then bring down the raised foot on your opponent's knee or thigh.[12]

10 Philip Reed & Richard Muggeridge (1984). Boxe Francaise Savate: Martial Art of France. Paul H. Crompton Ltd. p. 14.
11 John Corcoran & John Graden (2001). p. 198.
12 Philip Reed & Richard Muggeridge (1984). pp. 10–11.

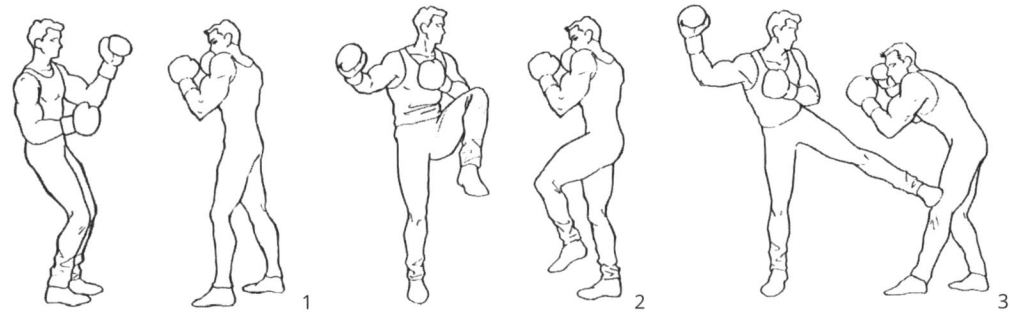

Chasses

Main a sol Main a sol, a "hand on the ground," involves kicking the opponent in the stomach or chest with both feet while turning your body away from him and doing a hand stand.[13]

Revers Revers, similar to the back whip kick in taekwondo, is made by turning your body. Pivot on both feet and then the back leg will be crossed over the front leg. Now lift the back leg and swing it round to strike your opponent with the sole. The revers can be delivered at high level to the head (revers figure), to the body (revers median), or to the legs (revers bas).[14] However, revers bas aims at an opponent's supporting leg while he/she attacks with a fouette (roundhouse kick).[15]

Front-leg kicks Front-leg kicks are snapped out and used as jabbing and probing blows, which are used more to open up a combination than to knock out the opponent.

Apart from the standard variety of kicks used, there are several kicks that are particular to savate. These kicks came from the some of the original founders of the art, and were of great effectiveness for self- defense on the street. Most of these kicks have been banned from use in modern competition, because of the level of danger.[16] Although they have been banned from competition, most are still taught for histori-

13 Bernard Plasait (1986). p. 127.
14 Philip Reed & Richard Muggeridge (1984). p. 18.
15 Philip Reed & Richard Muggeridge (1984). p. 21.
16 Bernard Plasait (1986). p. 120.

cal and practical self-defense reasons.

b) hand strikes

Although kicking is what distinguishes savate from its English cousin, it is important to recall that Charles Lecours, one of the founders of savate and student of Michel Casseux, saw the impracticality of maintaining a system that relied solely on punching. Therefore, he worked to integrate both kicking and punching into a combined and effective martial art form, that has continued to evolve until today, by the addition of such things as arm locks.

The standard punches found in savate are the same that can be seen in Ancient English Boxing, and its widely popular descendant, American Prize fighting. These include the jab, the hook, the uppercut, and the straight punches. In savate there is a distinction between the hook, which is a short, tight inside punch, and the swing punch, which is similar in nature, but has a wider trajectory and is used from mid-long distance. All these are performed by either hand and often in varied combinations.

Given their back and forth dance-like qualities, combinations form the base of French Boxing matches. They can be performed by the hand, the feet, or a mix of both hands and feet. An example of a standard savate combination is—a straight left jab to the face, followed by a straight right cross to the face, and completed with a back leg straight front kick to the body.[17]

When using combinations, instructors advise always using longer strikes following shorter ones, which allows a for a more natural sequence, and inter-changing the target areas to keep the opponent of balance. Once again, this brings us back to the principles of balance and extension in performing techniques, and it touches on the notions of effectiveness and education, which are at the base of savate as a martial art.

c) weapon systems

After mastering bare-handed techniques, the student is introduced to the weapon system, called *la canne et baton* or *canne d'armes*. The savateur is taught in the following order: *la canne* (walking stick), *couteau* (knife), *larga* (cutlass or bowie), double canne, *baton* (heavy staff), *rasoir* (straight razor), firearms, and *fouet* (whip).[18]

17 Bernard Plasait (1986). p. 123.
18 Thomas A Green (Ed.) (2001). p. 523.

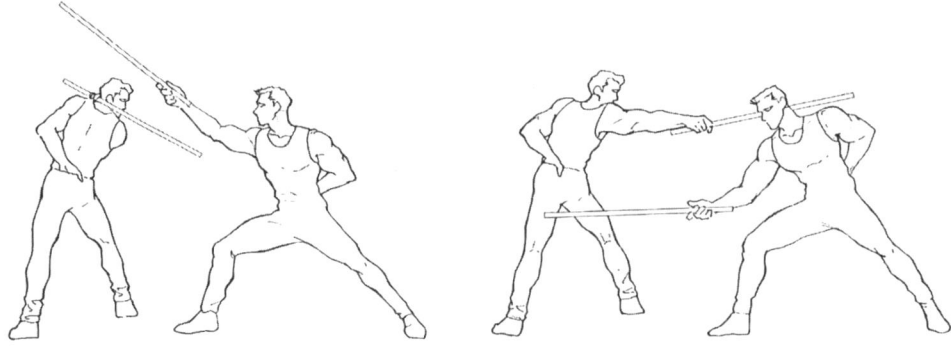

La baton

Weapons are practiced against similar weapons, as in canne versus canne, against other weapons, as in canne versus couteau, and against unarmed foes. All of the weapons can be and are expected to be combined with the striking or kicking techniques as well as with grappling.

d) other techniques

Lutte parisienne Along with the weapon techniques, the grappling techniques of lutte parisienne are introduced through a series of two-person exercises. Derived from Western wrestling, this grappling system was first introduced in savate when the police in Paris started arresting those fighting with hands or feet in the street. At the time, the ones found guilty of street fighting were enlisted in the army for a long time. Lutte parisienne was codified into savate in order to hide the kicking and punching techniques of savate from the eyes of law enforcers.[19]

Lutte parisienne emphasizes powerful projection throws and pinning techniques as well as choking and neck-breaking techniques. However, the techniques are designed to damage, not restrain, the opponents, and to allow the savateur's speedy escape.

Zipota Later, the techniques of zipota are introduced. Zipota teaches one how to handle multiple opponents.

19 Thomas A. Green (Ed.) (2001). p. 521.

Panache The term literally means "plume." It is used to mean "swagger or flourish." It began with the savateurs in the police force who actively use clothing and other everyday objects to again a quick advantage in a fight. It has earned the name of "the art of malice." For example, hats, vests, overcoats, scarves, and briefcases are used to distract or damage an assailant.[20] These days the savateurs even learn how to use a chair to drive an intruder out of their homes.

4) Training Methods

In training, all technical movements must follow one simple rule. Basically, French boxing savate rejects movements that are not conceived with the goal of education and effectiveness in mind.[21] Although keeping a strict formal style of training takes away from one of the arts most admirable qualities, that is its creativity. So, training must follow a disciplined routine, but it must also be taught in a way that maintains its liveliness and creativity.

All movements are learned by way of analysis and synthesis. First comes the stage of carefully breaking down each movement into its basic parts and its practical purpose. Then after time passes, the work of sensing the movement allows one to reconstitute it into one single movement.[22] So, the learning of techniques involves knowing them by careful analysis, and then synthesizing them by constant repetition. This allows one to perform them quicker without getting as tired.

This aspect of training is broken down into three types of practice. First is line practice. This involves analysing movements in order to anchor them into the spirit of the students, and also to train the body in the basics of proper posture. Then, there is repetition practice or training. This is an entire area of training dedicated to unifying techniques and making them more automatic. This training can be done at different rhythms. Last, there is sensation practice. This is a whole area devoted to creating a mental representation of the movement, or a psycho-motor schema. Work in this area is performed in line with proper muscle focus (contraction and de-contraction) and psychic concentration.[23]

20 Thomas A. Green (Ed.) (2001). pp. 521 & 523.
21 Bernard Plasait (1986). p. 141.
22 Bernard Plasait (1986). p. 21.
23 Bernard Plasait (1986). p. 21.

It is not enough to possess good tools. One must also be able to put these tools to good use. For this, French boxing uses a progressive and controlled system of sparring with a partner. In this type of training the practitioner learns to put the new techniques he/she has learned to good use, and also to master his fear and other emotions.

This area can also be broken down into three types of practice. First, there is elemental combat practice. The aim is to help the student become more automatic in the back and forth nature of boxing. Students must, through the development of fundamental movements, gain an understanding of the combinations which are an important part of the conversation of the battle. Attacks are sincere, blocks and parries are clean, and all blows are controlled without being too weak and thus ineffective.

The second area is directed attacks. This is practice focused on correcting form and technique problems that arises in practical combat situations. Lastly, there is free attack practice. This is non-conventional training aimed at developing efficiency, and giving the student a real sense of what combat is like.

Training in boxe francaise progresses in a logical manner. It starts at the initiation, or beginner stage (from the first lesson until the blue glove level). Here the students acquire "basic shaping" in attitudes, movements, and fundamental techniques. The teacher instructs students in all the movements of French Boxing while trying to keep them in their basic context of combat.

Then there is the apprentice stage (from the blue glove to the yellow glove stage). Here there is further study, assimilation, and realization of movements, attitudes and techniques at a functional level. Also, one gains control of one's equilibrium, and a sense of real combat distance.

Lastly, there is the stage of mastery (Starting from the yellow glove level onwards). Here the student learns to come up with and work on his own personal style. Also, students prepare for actual combat by working on and mastering the special techniques, which include special kicks and combinations.[24]

24 Bernard Plasait (1986). p. 22.

5) Competition

The sport of French boxing is a subtle game of attacking, defending, and counterattacking. Most competitors possess the same arsenal of punches and kicks to use, but the more skilled fighters are those who are able to penetrate the defense of the opponent and land their blows. This is done by the use of feints, or the action of drawing the opponent into thinking you are attacking with a particular technique, while then attacking with another one. How well you use successful offensive strategies help distinguish your level of expertise from that of the opponent within a fight.

For one to be successful in competition, one must also always be aware of proper distances when attacking or defending. Therefore, savateurs often become very skilled at sensing, or being aware of distance and the appropriate technique to use at that distance. For example, from close range low kicks, hooks, and uppercuts are preferred; while otherwise, jumping kicks, side kicks, and certain specific savate kicks are used.[25]

Defensively, practitioners use a variety of techniques, all of which also depend on proper distance. For example, neutralizations are used to stop an attack by striking the opponent's forearm when he punches. But, savate does not allow neutralizations by use of the legs. There are also a variety of straight forward blocks and parries employed, as well as counters and stops, which are used to stop an attack at the time of its launching.[26]

All competition or training sessions are started by practitioners saluting each other. The salute is performed by the practitioner standing at attention with both arms held straight down by the sides of the body. From

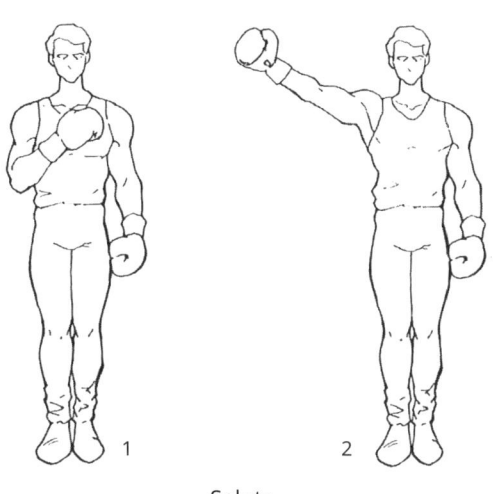

Salute

25 Bernard Plasait (1986). p. 52.
26 Bernard Plasait (1986). pp. 54–55

here, the right glove is raised across the body and comes to rest in contact with the left side of the chest. Then, the right arm is extended straight out to the right of the body, and stops so that the glove is at about the height of the head. From here, fighters assume the guard position. This is the common position from which they can either attack or defend. In the guard position, both hands are held high, and in front of and close to the body, in order to guard the head and other vital areas. The most important point is that it should be done in a way in which the individual is comfortable.[27]

Sport savate promotes three categories of competition that are analogous to American sport Karate tournaments: Combat (full contact), Pre-combat (medium contact), and Assault (light contact).[28]

In Combat savate, savate resembles muay thai of Thailand: blows are delivered at full power and a decision may be made on points or by "hors combat" where one fighter is unable to continue. Even though knees, elbows, and head butts are not allowed in the sport version of savate, these techniques are still present in the non-sport version of savate.

Pre-combat is similar to Combat savate except that the system of scoring points differs and fighters wear protective gear such as shin-pads and casques (headguards). Decisions are based on accumulative point total: knockouts are prohibited.

Assault is judged purely on technical skill and the force behind all blows is limited so that both boxers can make progress without risk of injury or being judged "hors combat." Assault savate is akin to point tournaments.

6) Grading System

Thanks to Jeseph Charelemont, French Boxing has defined grades, distinguished by colors worn on the wrist band of the glove like taekwondo and karate. Technical progress of boxe francaise practitioners is judged according to eight technical grades: blue, green, red which is considered equal to a first-degree black belt, yellow, and three ranks of silver.[29]

27 Bernard Plasait (1986). p. 50.
28 Philip Reed & Richard Muggeridge (1984). p. 4. And also see, John Corcoran & John Graden (2001). p. 198.
29 Thomas A. Green (Ed.) (2001). pp. 522–523.

Technical grade	Color of the glove
1st degree	Blue
2nd degree	Green
3rd degree	Red
4th degree	White
5th degree	Yellow
6th degree	Silver 1st degree
7th degree	Silver 2nd degree
8th degree	Silver 3rd degree

The series of colored gloves are given out by the teacher or monitor at the level of the individual clubs. The series of coloured gloves represent the amount of time the student has been studying, from start to present. Students can start to compete in the form of combats at the red glove level, but only with the permission of his/her instructor.

A student attaining the level of yellow gloves is considered to know all the strikes of boxe francaise, and is then allowed to present himself for competition to obtain his bronze gloves. At this time the student is allowed to attain the silver glove 1st degree. The tests to obtain the degrees of silver gloves are administered by a federal jury in accordance with clearly defined rules found in annex 1 of the Federal Code.[30]

Although students have silver gloves, they are not considered capable of teaching savate. Specialized training is required and those who pass each phase of the training are recognized with a different color of sash indicating a different teaching rank: purple for initiateur (one who initiates), maroon for aide moniteur (assistant monitor), black and green for moniteur (monitor), and orange for coach.[31]

The students with silver gloves may also attempt the Monitor or Assistant Monitor's Exam, providing that he/she is at least of sixteen years old.[32] After the student has passed the Monitor's Exam, a minimum of two years is required for him or her to attempt the testing of the Federal Instructor Exam 1st degree. Also, obtaining the level of silver gloves 1st degree also allows the student to take the State Sports Educator Exam 1st degree.

Those who hold the honorific titles of professeur (professor) wear a black and red

30 Christian Guillaume & Dominique Georges (1984). Boxe Francaise Savate. Sedirep. p. 166.
31 Thomas A. Green (Ed.) (2001). pp. 523–524.
32 Christian Guillaume & Dominique Georges (1984). p. 166.

sash, maitre (master) red sash and grande maitre (grand master) white or pure white sash respectively. The non-technical grade levels of "vermillion" (bright reddish-orange) and "gold" gloves are awarded to those who have given great service to the sport, or have shown great dedication to its advancement.

It is absolutely mandatory, especially if one participates in a competition, stage or exam, to wear on the left breast of one's uniform the patch corresponding to one's technical grade.

Savateurs are also classified and named as follows: eleves (students), disciples, and donneurs (teachers). Unless he or she has earned a teaching rank, the person below the silver glove is called an eleve and the silver gloves and instructors below moniteur are recognized as disciples. Moniteurs and higher ranks are considered donneurs.[33]

2. History

1) Origin

In order to discuss the origins of French Boxing one could enter into the long-standing debate of who it was that first closed his fist and used it to strike someone else. This would take us from pre-historical accounts through to the well-documented styles of the ancient Greeks and Romans.[34]

While the exact origins of savate are unclear, a hardcore street-fighting version of it existed at least as early as the 1700s. In the 1700s a poem describes a savateur (a practitioner of savate) as part angel and part devil.[35] In the mid-1700s, the term chausson, from the type of shoe worn on board ship, was being used to describe the fighting techniques of French, Spanish, and Portuguese sailors. As time passed, the more northern style of foot fighting was called savate while the southern style was called chausson. Chausson was more a form of play or sport, while savate was more

33 Thomas A. Green (Ed.) (2001). p. 524.
34 Bernard Plasait (1986). p. xxx.
35 Thomas A Green (Ed.) (2001). p. 519.

combative.[36]

Although English Boxing focused solely on the use of hands in combat, fighting methods throughout several provinces in France employing the use of the feet were slowly emerging by the 18th century. It was here, on the streets of France, that savate first came into existence.

At the end of the 18th century, French sailors are known to have adopted a specialized style of fighting using very high kicks, sometimes with a hand on the ground for balance. This may have developed from contact with martial arts in the East; certainly it is known to have been practiced aboard ships and no doubt in brawls in the waterfront bars of ports such as Marseilles, because by the time it had spread to Paris this kicking style had become known as "Savate Marseillaise."[37] Later, savate became more systemized as more advanced kicking techniques, footwork, and open-hand blows were added.

In the early 19th century, savate was well established, with many French nobles receiving instruction in the art. The banning of swords in Paris to restrict dueling caused a great increase in interest in savate by the nobility and upper class. The use of la canne (the cane) and the baton (walking stick) for self-defense and to settle disagreements became common, and many noted swordsmen took up la canne and savate.[38]

However, the birth of savate is widely accredited to Michel Casseux (b. 1794) since he was the first to systematize and teach the varied kicks and punches widely used in the rough neighborhoods of Paris.[39] He codified the techniques of savate into fifteen kicking techniques and fifteen cane techniques.[40] Casseux, who was a flamboyant character known as "pisseux" of the streets, had many opportunities to hone his fighting skills in the rough slums of Paris, and it was he who first began to classify all the kicks of modern day savate.

In 1820, he opened a salle (training hall) of savate in Paris, and his lessons attracted a number of students from fashionable society including Alexandre Dumas, Lord Henry Seymour, the Duke of Orleans and the artist Gavarni.[41] The Duke of Orleans was a noted duelist and he is credited with introducing many rapier, saber, and

36 John Corcoran & John Graden (2001). p. 248.
37 Philip Reed & Richard Muggeridge (1984). p. 6.
38 Thomas A Green (Ed.) (2001). p. 520.
39 Bernard Plasait (1986). p. xxxiv / See also, Christian Guillaume & Dominique Georges (1984). p. 16.
40 Thomas A. Green (Ed.) (2001). p. 519.
41 Philip Reed & Richard Muggeridge (1984). p. 6. / Also see, Thomas A. Green (Ed.) (2001). p. 520.

court sword techniques into la canne. Savate became so popular that Napoleon III mandated its use in training soldiers.[42]

Besides kicks this early form of savate involved striking open-handed blows rather than throwing punches. Savate also retained a dual nature as a fighting and self-defense system and as a sport, since both formal and informal matches were frequent. Moreover, through its association with the French upper class, savate began to shed its image as a hooligan pastime. By the mid-1800s, savate underwent even more refinement, borrowing much from English boxing—including the use of gloves.

One of Michel Casseuex's most famous students was a man named Charles Lecours (b. 1808), who in fact is considered "the true founder of modern French Boxing." After he was beaten in a bout with an English boxer, Owen Swift, Lecour decide to master the techniques of boxing himself. He came to London to take up the art of English boxing and took lessons from the foremost boxers of the day. After attaining mastery in the art of using fists, he returned to France in 1830 and he opened his own salle where he taught a combination of boxing and savate under the new name, la boxe francaise (French boxing).[43]

Lecours was the one who introduced the punching style to savate. In this way, by allying the fist with the foot, he created what we today know as the art of French boxing. Many other masters, such as Louis Vigneron, Charles Ducros, and Mirabeau, have come along and added to the art, but it is Casseux and Lecours who are accredited with its founding. As street robbery was commonplace, la boxe francaise quickly became popular and soon a number of teachers were offering lessons, often together with instruction in the use of la canne which is still taught alongside French boxing today.

2) Early Modern Era

By the 1850s, full-contact savate fights flourished all over France, especially in Paris. Unfortunately for the practitioners, in 1856 (the year of her son's birth), Napoleon III's wife, the Empress Eugenie, asked for a ban on all fights. Even the name of la boxe francaise and especially savate had to be concealed under the cryptic name *adresse*

42 Thomas A Green (Ed.) (2001). p. 520.
43 Philip Reed & Richard Muggeridge (1984). p. 6.
 Also see, Bernard Plasait (1986). p. xxxiv & Christian Guillaume & Dominique Georges (1984). p. 17.

francaise (French adroitness or skill). This sounded more gracious and less bloody. So, except for underground fights, the practice of fighting became more like gymnastics.[44]

Born in 1839, Joseph-Pierre Charlemont began his martial arts career as a soldier. He taught boxe francaise and la canne to recruits until France's war with Prussia in 1870. Following the French defeat, he supported the republican cause, la Commune, in the struggle against the monarchists. When monarchist forces took Paris, he went to exile in Belgium. There he opened a highly successful boxing school in Brussels and published his first book on French boxing technique. After the Third Republic was established in 1877 in France, Charlemont received an amnesty and returned to Paris.

By the late 1870s, savate became very popular in France. Charlemont systematized the teaching of boxe francaise, la canne, and baton (cane and walking stick), and lutte parisienne (Parisian Wrestling) into grades.[45] Charlemont also developed the glove system to rank his students; colored sashes or colored cuffs on the gloves were used. The present-day rules are based on his methods, and his name, "le maitre (master) Charlemont," holds a place in boxe francaise to compare with that of the Marquis of Queensberry in English boxing.[46]

In the early 1900s the popularity of boxe francaise savate, codified by Joseph Charlemont, started to grow dramatically. Suddenly, the schools were full. The Charlemont Academy in Paris that opened in 1877 was so popular that all the members of the nobility took classes there. Amazing for the era, Joseph Charlemont and his son Charles enrolled men and women as well transforming a street self-defense method into a truly graceful and elegant art.[47]

However, it was Joseph Charlemont, the father of modern savate, who synthesized the art into the form recognized today. Charlemont, an extraordinary innovator and visionary, blended a patchwork of fighting methods such as boxing, wrestling, and chausson, as well as the use of the sword and cane.

[44] John R. Little & Curtis F. Wong (2000). Ultimate Martial Arts Encyclopedia. Contemporary Books. p. 40.
[45] Thomas A. Green (Ed.) (2001). p. 521.
[46] The Queensbury Rules in 1866 named for the Marquis of Queensbury, revised the rules of the long standing "London prize ring rules" prohibited wrestling altogether, mandated a 24-square-foot ring, implemented the use of gloves as mandatory, created official weight categories, and broke the fights down into three-minute rounds with a one-minute rest in between each. Many of these rules are still maintained in some form today by both (English) boxing and savate alike. Thomas A. Green (Ed.) (2001). p. 46.
See also, Bernard Plasait (1986). p. xxxii.
[47] Philip Reed & Richard Muggeridge (1984). p. 7. / John R. Little & Curtis F. Wong (2000). p. 40.

The inclusion of the sword and cane, which were the constant companions of the French nobility, suggests that Charlemont wished savate to remain a high-class endeavor rather than the street-fighting method that it had once been.

3) Modern Era

At the beginning of the twentieth century, French Boxing was said to have been in its golden age. It had reached its highest point of development. The first world amateur championships were held, even though at that time outside of the French there were only some Swiss and Belgians who participated. Regardless, it was clear that it had become a national sport. French savate continued to prove itself throughout the years, but its growth was stifled by the following two world wars.

Up to the First World War, boxe francaise was at the height of its popularity and it produced several eminent fighters such as Victor Casteres, Georges Carpentier, and Charlemont' son Charles. Georges Carpentier was the champion of 1907 and he turned to English boxing and won the world title. At the time English boxing was becoming established in France and even tended to eclipse boxe francaise by 1914. But the war hit the French boxing far harder.[48]

After the First World War, French Boxing gained global exposure as a demonstration sport in the 1924 Paris Olympics and the stage was set for it to take off.[49] Unfortunately, the timing could not have been worse for the fledgling sport. For one reason, the event took place between two world wars that changed the face and attitudes of the entire globe. Also, at that time the interest of the public was firmly behind the already well-established English Boxing "big events," which played to the mood of the times, in terms of their spectacularism and big money prizes. Furthermore, the war took a grave toll on the resource of teachers within France, which further led to its decline, and its near extinction.

Despite the success of demonstrations at the Olympics, it only enjoyed a brief recovery before dying out almost completely under the German occupation in 1940. However, it was the interest in Asian martial arts after World War II that helped revive savate.

48 Philip Reed & Richard Muggeridge (1984). p. 8.
49 Christian Guillaume & Dominique Georges (1984). p. 23.

The most outstanding player between the wars was le comte Pierre Baruzy. He won the overall French championship eleven times. At the end of the Second World War, Pierre Baruzy succeeded in preserving the legal existence of French Boxing by reconstituting la commission de B.F. (the Commission of French Boxing) into la federation francaise de boxe (the newborn French Federation of Boxing). In 1965, after twenty years of fighting for its survival several of its ardent practitioners managed to breathe life back into the ailing sport by creating le comite national de boxe francaise (C.N.B.F.: The National Committee of French Boxing). They managed to find refuge under the wing of la federation francaise do judo (F.F.J.D.A.: The French Federation of Judo), and within five years they were administratively integrated into this formidable bureaucratic machine.[50]

This move proved essential, for in less than ten years they managed to do more for the development of French Boxing than had been done in the previous fifty years. The C.N.B.F. underwent a period of structuration and research, which bore fruit in the areas of techniques, judging, hierarchy of grades, instructor training, implementation of the sport into schools and Universities, and also in the domain of International competition.[51]

In 1971, there was a fight between two factions in the C.N.B.F., namely the "educative/academic" mainstream, and the more radical "hardliners." This row led to the creation of the National Federation of French Boxing (F.F.B.F.), which proclaimed its definitive independence by leaving the umbrella of the French Federation of Judo, and it also led to the split of French Boxing from that of savate.

Eventually, in 1975, these differences were mediated when the Minister of Youth and Sports stepped in. In 1976, the F.N.B.F became officially the Federation of French Boxing-Savate and Assimilated Disciplines, and by 1978, both savate and French Boxing was once again re-unified and forever buried the hatchet.[52] Eventually this organization, based in France, became la federation internationale de B.F. Savate (F.I.B.F.S.: The International Federation of French Boxing-Savate), and it remains so today.

50 Christian Guillaume & Dominique Georges (1984). p. 24.
51 Christian Guillaume & Dominique Georges (1984). p. 25.
52 Christian Guillaume & Dominique Georges (1984). p. 43.

4) Abroad

As was mentioned earlier, savate went through many difficult times in its history, and therefore was not widely introduced to other countries. Historically, savate was only recognized outside of France in Belgium and Italy. After the founding of the International Federation of French Boxing-Savate in 1985 the sport has managed to gain a wider acceptance in many countries around the world. Although there have been slight changes made to the art in different countries, everyone recognizes its origins, codes and rules as originating from France. Now, it is the role of the International federation to make sure that savate is taught and practiced according to the same technical regulations. This is to guarantee that everyone around the world is speaking the same language, at least in the ring.[53]

These days the sport of French Boxing has been growing quite a lot in Holland, where before mainly only kick-boxing was practiced. In England there are a few schools, but due to a lack of assistance and qualified instructors, its growth has been very slow. Around Europe, there has been a steady growth of the sport in countries such as Germany, Spain, Yugoslavia, Portugal, Greece and Switzerland.

Outside of Europe, many believe Africa to be the place with the greatest potential for growth of the sport. Many instructors have attested to the great enthusiasm and physical talent of the African students, but because of the lack of facilities and international exchanges, it still remains rather undeveloped. The sport in Africa circles around the countries of Senegal, Ivory Coast, Cameroon and to some extent Tunisia, all of which are French speaking countries.[54]

Thanks to the personal initiative of some instructors, French boxing-savate is now being practiced in New York, Chicago and Los Angeles, and it has become quite well known throughout the United States. In Canada, there has been a growing number of practitioners obtaining licenses and its future looks quite promising in the years ahead.

53　Christian Guillaume & Dominique Georges (1984). p. 43.
54　Christian Guillaume & Dominique Georges (1984). p. 46.

Reference

Books

Borkowski, Cezar and Manzo, Marion. The Complete Idiot's Guide to Martial Arts. An Alpha Books/Prentice Hall Canada.

Corcoran, John & Graden, John (2001). The Ultimate Martial Arts. Q & A Book.

Green, Thomas A. (Ed.) (2001). Martial Arts of the World: An Encyclopedia. Vol. 1: A–Q. ABC CLIO.

Green, Thomas A. (Ed.) (2001). Martial Arts of the World: An Encyclopedia. Vol. 2: R–Z. ABC CLIO.

Guillaume, Christian & Georges, Dominique (1984). Boxe Francaise Savate. Sedirep.

Little, John R. & Wong, Curtis F. (2000). Ultimate Martial Arts Encyclopedia. Contemporary Books.

Plasait, Bernard (1986). De la Boxe Francaise: Savate Canne Chausson. Sedirep.

Reed, Philip & Muggeridge, Richard (1984). Boxe Francaise Savate: Martial Art of France. Paul H. Crompton Ltd.

Capoeira
Brazilian Martial Arts

What is Capoeira?
Definition
Cultural Values
Characteristics

Techniques
Styles
Basic Techniques
Training Methods
Grading System
Initiation Rite

History
Origin
Early Modern Era
Modern Era
Abroad

1. What is Capoeira?

1) Definition

Capoeira is a Brazilian martial art which employs a lot of striking techniques relying heavily on kicks. Head-butts and hand strikes using the open hand complete the unarmed arsenal of the *capoeirista* (capoera practitioner). Although there are some grappling maneuvers, takedowns are the trademarks of capoeira utilizing the legs in either tripping or sweeping motions. It also has weapon techniques such as the use of the razor and knife.

Etymologically speaking, no one knows for sure where the word capoeira comes from. Some believe that the word *capoeira* (pronounced *Ka-po-air-a*) came from the Bantu word *kapwera* (to fight).[1] Others say the root *ca* or *caa* in native Brazilian languages means forests or woods referring to African slaves who escaped from their white masters and practiced in the bush.[2] Alternatively, the Portuguese words *capao* (cock) and capoeira (cage for cocks) have been used to link the word to cockfighting in poultry market common in Rio de Janeiro where slaves performed capoeira. Consequently, there is no explanation for the origin of the term that can be universally accepted.

The question the spectators asked themselves when they first viewed at the performance of capoeira illustrates the colorful nature of this art: Is this a martial art or a dance? Or perhaps is it just a game? According to Nestor Capoeira, the author of the *Little Capoeira Book*, the answer is that it is all three, and much more.[3] Although capoeira began as a style of fighting, Brazilians today call it "a game that is played and not fought."[4]

Historically speaking, capoeira has been practiced for several centuries by African Americans in Latin America. Since their ancestors were from Africa, there are some elements in capoeira that are typically African. It is essentially an African-Brazilian

1 Debora Martins. "Capoeira: The Forbidden Sport" in John R. Little & Curtis F. Wong (Ed.) (2000). Ultimate Martial Arts Encyclopedia. Contemporary Books. p. 42.
2 Thomas A. Green (Ed.) (2001). Martial Arts of the World: An Encyclopedia (Vol. 1: A–Q). ABC CLIO. p. 61.
3 Nestor Capoeira (1995). The Little Capoeira Book. North Atlantic Books. p. 29.
4 Debora Martins (2000). p. 42.

system of unarmed combat which is based on self-defense techniques. It is a synthesis of fights, dances, and musical instruments from different African regions developed on Brazilian soil, probably in Salvador, the capital of the state of Bahia, during the slave years of the 18th century.[5]

2) Cultural Values

Capoeira is the cultural outcome of the oppressed black Brazilians who were once freemen but were eventually forced into slavery. It was developed and evolved in Brazil, sometime in the 18th and 19th centuries by men enslaved in Africa and brought to Brazil. It was further developed by men living in the underworld of banditry and on the margins of an extremely unfair society during the 19th and 20th centuries.[6]

From the very beginning, capoeira had to struggle to survive, since all African cultural activity was repressed in the 1800s. To avoid the confrontation with those who wielded power and made the laws, capoeiristas learned to go with the flow of things.

These values are clearly shown in the techniques of capoeira. For instance, a capoeirista does not block a kick; on the contrary, he goes along with it, thus avoiding the blow, and then counterattacking if possible. A capoeirista does not confront a man face to face, but rather pretends to be a coward, to ask for mercy—and then to hit the opponent when he lowers his guard. They learned the guerrilla way of fighting against a stronger and more established army.[7]

The enslaved capoeiristas learned the value of lies and deceit, of ambush and surprise, and of treachery and treason. They knew nothing of honesty, truth, and fair play when facing the enemy. According to Nestor Capoeira, "Such concepts are luxuries that are not available when you are a slave to a master who goes to church in the morning and at night rapes young women in the slave quarters, not even considering them to be human beings but simply *pecas* (literally pieces, or units with some economic value)."[8]

[5] Nestor Cpoeira (1995). p. 4.
[6] Nestor Cpoeira (1995). p. 36.
[7] Nestor Cpoeira (1995). p. 36.
[8] Nestor Capoeira (1995). p. 37.

On the other hand, for capoeiristas, life is not simply a matter of winning or surviving—it involves the joy of being alive. So, music, dance, creativity, improvisation, poetry, philosophy, and fun are part of capoeira. As life has many battles and struggles on the one hand, there are music and dance on the other. Sometimes one has to be rational and objective and at other times one needs to be poetic, fun, and unpredictable, if one is to savor the best of life. These two contradicting forces of life are well expressed in the culture of Capoeira. This is why the lethal strikes of capoeira are accompanied with music, songs, and dance.

3) Characteristics

The difference between capoeira and other martial arts is that capoeira is African-Brazilian in its origin—neither Asian nor European! Capoeira has its own spirit and tradition.

a) musical

Berimbau

Capoeira can be referred to as a "musical martial art" since there are musical accompaniments and songs essential to its practice. As two participants at a time enter the play circle called *roda* (pronounced *ho-duh*) and play with each other, the game (*jogo*) is controlled by the music throughout. While music is played, everyone sings and claps their hands as the two players perform in the middle. Songs involve a chant (leader-and-response) pattern.[9] The lyrics of the songs comment on capoeira in general and famous capoeiristas, and also invoke the protection of their saints.[10]

Capoeira's leading musical instrument is the *berimbau*. It is a very simple instrument made up of a piece of bow-shaped wood, a wire, and a gourd attached to the bottom end to give resonance. A drum called *atabaque*, a tambourine called *pandeiro*,

9 Thomas A. Green (Ed.) (2001). p. 64.
10 Gabriela B. Tigges (1990). The History of Capoeira in Brazil. An Unpublished Doctoral Thesis. Brigham Young University. p. 4.

and double cow bells called *agogo* are also used.[11]

The person playing the berimbau controls the style and speed of the game.[12] The rhythm of the berimbau energizes the capoeiristas to move faster or slower, or rougher or smoother. Capoeira songs are sung in Portuguese, and they reflect the cultural origins of capoeira and the actions that are occurring within the roda. Within this music-filled circle, the capoeiristas skillfully perform their art by demonstrating a complex process of kicks, leg sweeps, flips, and handstands.

b) acrobatic

Second, capoeira is an acrobatic "dance martial art." Although today it is recognized as a fighting art and sport of Brazil, capoeira contains many elements of dance. Many circular kicks are used in capoeira, along with many dance movements. Because dance has been an important part of African culture, it has influenced capoeira by making it appear like a dance. Some even say that capoeira looks like break dancing since it has breakdance-like movements which include headspins.[13]

c) African

One of the most interesting characteristics of capoeira is the rehearsal of combat movements through dances. Unlike the prearranged combat patterns of Japanese or Korean systems (*kata* or *pumsae*), the Afro-Brazilian system uses drums and stringed instruments to create a rhythmic beat for fighting. Employing dances in combat training is part of African heritage. This type of training was central to the development of African martial art systems. For example, the armies of the Angolan queen Nzinga Mbande were trained through dance accompanied by traditional percussion instruments.[14]

According to Thomas A. Green, the editor of *Martial Arts of the World*, learning martial arts through the rhythm created by percussion instruments has several advantages. First it "developed an innate sense of timing and effective movement for the practitioner."[15] In addition, those movements helped the warriors to develop effective footwork. In a non-literate African culture, this type of direct transmission

11 Debora Martins (2000). p. 42.
12 Gabriela B. Tigges (1990). p. 3.
13 Debora Martins (2000). p. 46.
14 Thomas A. Green (2001). pp. 3–4.
15 Thomas A. Green (2001). p. 4.

through music allowed for consistent and uniform training without the need for written communication. Green concludes that this type of training is replicated today in the Afro-American martial art, capoeira.[16]

African warriors practiced a ritual folk dance called *n'golo* (dance of the zebra). This name came about because the dancers imitated the zebra's fighting movements. As the zebra balanced on its front legs, its hind legs kicked. These quick leg movements are common in the capoeira of fighting.

d) holistic

Capoeira is also a holistic martial art.[17] Capoeira offers to its students training in physical strength, endurance, and self-defense, along with a knowledge of the music, culture, and traditions of Black Brazilians. The capoeiristas feel the pulsating music and work the whole body—they use their legs, arms, head, and knees, and also the floor. It is "famous for the balance and flexibility of its gymnastics, the strength and grace of its dance, the speed and trickery of its fight, and the intoxicating rhythms of its music."[18] These elements are all blended to create a unique theatrical game and fighting system.

Mestre Delei (Narciso Wanderlei de Oliveira), who owns an academy in Florida, USA, says that capoeira has something of every martial art form and neatly summarizes the characteristics of Capeira as follows:[19]

> *"Capoeira is a complete martial art. It isn't like boxing where you use hands, or taekwondo where you use mostly legs, or karate where you use legs and arms but are fixed. Kungfu which has beautiful moves but not force... So, capoeira, in my opinion, is a complete martial art..."*

16 Thomas A. Green (2001). p. 4.
17 Debora Martins (2000). p. 48.
18 Debora Martins (2000). p. 48.
19 Debora Martins (2000). p. 48.

2. Techniques

1) Styles

Today's capoeira falls into two main styles: Angola and Regional. Capoeira Angola is the older of the two and uses more groundwork. It is essentially the pure form of the art used by the enslaved originators of capoeira.[20] It relies more on low kicks, sweeps, and trips played to a slower rhythm.[21] Mestre (Master) Pastina was the foremost proponent of Capoeira Angola. It is thought to have been developed by Africans brought to Brazil from Angola.[22]

Capoeira Regional is a new way to study capoeira that originated in the late 1920s to early 1930s.[23] During that period, Mestre Bimba (Manoel dos Reis Machado) opened his school named Centro de Cultura Fisica e Capoeira Regional and started teaching more structured and systemized capoeira. Bimba innovated Capoeira Regional both to reflect and to defend against Asian martial arts introduced to the Brazilian soil at the time.[24]

Mestre Bimba was accused of incorporating elements of other martial arts, particularly karate and jujutsu, and also boxing and catch-as-catch-can (a form of wrestling popular in the USA) into his style of capoeira.[25] For instance, he formalized exercises containing a series of basic movements (*sequencias*), connected strikes (*golpes ligados*), uniforms cosisting of white trousers and T-shirts, and colored belts indicating rank (*cordaos*). Technically speaking, it contains more movements, including upright techniques, than the original and is considered to be the sport form of the art. Unlike Capoeira Angola which was still played on the streets, Mestre Bimba taught his art in a training hall setting for the first time.

In a rough parallel with the common split in the Asian martial arts, the Angola style would be the traditional classical method while the Regional would be considered

20 John Corcoran and John Graden (2001). The Ultimate Martial Arts Q & A Book. Contemporary Books. p. 240. See also, Gabriela B. Tigges (1990). p. 53.
21 Thomas A Green (Ed.) (2001). p. 9.
22 Gabriela B. Tigges (1990). p. 2.
23 Thomas A Green (Ed.) (2001). p. 63.
24 Gabriela B. Tigges (1990). p. 2.
25 Thomas A Green (Ed.) (2001). p. 63.

the modern, eclectic version of the art.

2) Basic Techniques

Capoeira is an athletically demanding martial art whose predominant techniques are kicks executed from the ground. Many of them are embodied in spectacular cartwheels, somersaults, and handstands. Using their hands to support themselves, capoeiristas launch circular and straight kicks as well as sweeps from a fluid, rapidly changing handstand position. Since the hands are usually in contact with the ground, there is little or no blocking with the arms in capoeira. Capoeiristas avoid kicks with evasive footwork or by dropping to the floor with an escape technique.

Capoeiristas rarely use hand strikes.[26] The underlying development of the techniques used in capoeira has both practical and philosophical reasons. Because slaves were often chained by their hands, they had to resort to other types of strikes to fight. And from a philosophical standpoint, in African culture, the hands were not used for destructive purposes. Hands were only used for creative purposes like hunting, harvesting, or building.

a) basic elements of movements

There are three basic elements of movement in capoeira:[27]

Ginga *Ginga* is Capoera's fundamental movement and also the basic step of capoeira which places one foot forward in a lunging move with the opposite hand forward smoothly and the other back.[28] The step forms a triangle on the ground.[29] The step rapidly shifts with feet back and forth alternating in time to the tempo of the musical accompaniment in a dancelike action. Carneiro commented that "The ginga of a Capoeira, supported by the *chulas* (songs), the sound of the berimbau (musical instrument) and the tamberine, give the game the appearance of a dance."[30]

Ginga is an open form of "swing and flowing" movements that sets capoeira apart

26 Cezar Borkowski and Marion Manzo (1999). The Complete Idiot's Guide to Martial Arts. Prentice Hall Canada. p. 261.
27 Nestor Capoeira (1995). pp. 61–70.
28 Thomas A. Green (Ed.) (2001). p. 8.
29 Gabriela B. Tigges (1990). p. 64.
30 Gabriela B. Tigges (1990). p. 17.

Ginga

from all other martial arts. There is a wide variety in the execution of ginga which incorporates twisting, bobbing and footwork. What makes the ginga special as compared to other martial arts stances is that it puts capoeiristas in constant motion, making them a very frustrating target for an opponent. From the ginga the capoei-

rista can move from aerial techniques to low squatting postures accompanied by sweeps or tripping moves. This way the player can hide, dodge, feint and attack.

As a general rule, the ginga in capoeira Angola is very free and individualistic. The ginga in Regional, on the other hand, is very structured, and its basic steps can actually be shown in a diagram.

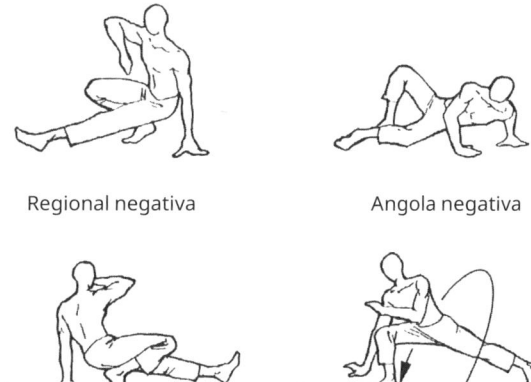

Regional negativa

Angola negativa

1

2a

Coming up from the negativa with a role

2b

Another way of standing up from the negativa

Negativa and role

Negativa and role The *negativa* and the *role* are forms of movement on the ground and can be used as defensive and counter-attack techniques. The negativa is a defensive movement. The role (pronounced "ho-lay") is a counter-attack movement. These are another distinguishing feature of capoeira.

Going to the ground is part of the web of unexpected movements that distracts the opponent. By going to the ground, the capoeirista can "lure his opponent into thinking that he is vulnerable and not realizing that a trap has been set for the opponent. There exists a great number of kicks and takedowns meant to be used specifically in such situations."[31]

Regional negativa is more erect whereas in Angola it is usually closer to the ground. The role is employed as the change of movement from the negativa to the ginga or coming up from the ground to a standing position. In the diagram you may see two different ways of standing up from negativa.

Au (pronounced "ah-ooo") It is a form of upside-down movement known in

31 Nestor Capoeira (1995). p. 65.

Capoeira 81

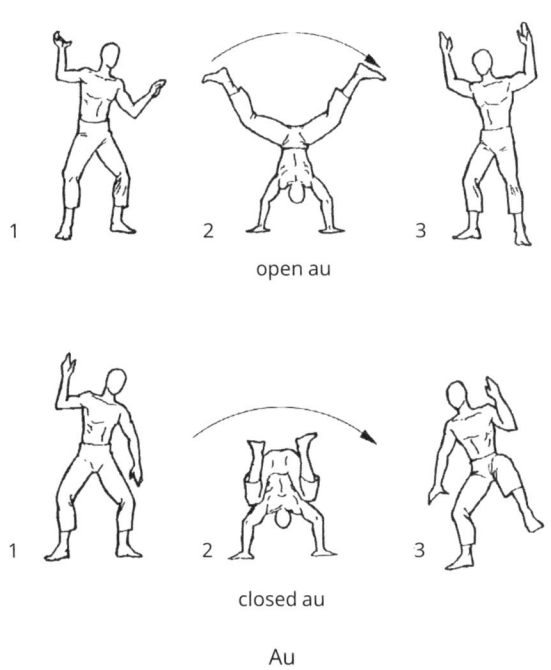

open au

closed au

Au

English as the cartwheel. By learning the *au*, the novice capoeirista learns how to find his balance while in motion upside-down. By encircling your opponent, you can leave him dizzy, make him hesitate, lose his center of balance, and even open his guard.

Nestor Capoeira, the author of *The Little Capoeira Book* comments, "The au can be an extremely effective way of approaching an opponent, or fleeing under certain circumstances. The au and upside-down movements in general make the capoeirista very unpredictable, for it enlarges the spectrum of movement possibilities."[32] As one can see in the diagram, an open au is associated with Capoeira Regional while a closed au with the Angola tradition.

b) defensive movements

In capoeira, the idea is not to block kicks but to avoid them altogether. Evasion rather than blocking is used for defense.

Cocorinha It is an evasive movement with the weight evenly distributed on both feet. One of the hands protects the head, while the other can touch the ground lightly. This is typical of the traditional Capoeira Regional.

Resistencia It is similar to the *cocorinha*, only in this case the weight is distributed unevenly between the feet, and the torso leans a little to one side. It is executed when the opponent is already very close.

32 Nestor Capoeira (1995). p. 69.

Queda de quatro Unlike the cocorinha the player dodges, moving away his torso and face while keeping his feet in the same location. From this position the capoeirista usually stretches out one of his legs and moves into a negativa; then he executes a role. It is typical of capoeira Angola.

c) basic kicks

Armada The player rotates his head and torso about 180 degrees and to acquire

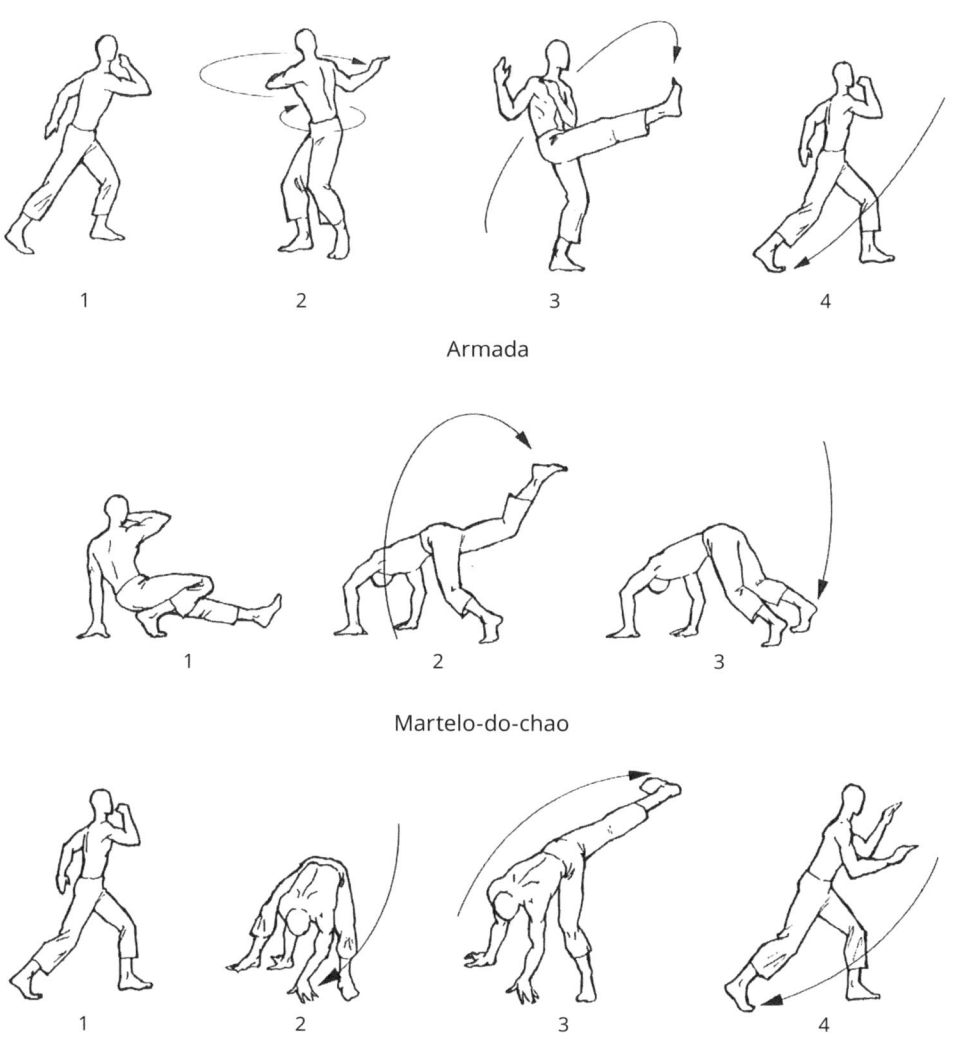

Armada

Martelo-do-chao

Meia lua de compasso

speed; there is a corresponding spin from the feet. Then raise your leg fully extended and released as if the torso pulls the leg like a spring towards your opponent's head.

Martelo-do-chao This is a kick that is released from the negativa position. Frequently used as a means of attack from the ground against an opponent who is standing. It is more typical of Capoeira Angola.

Meia lua de compasso Along with the *rasteira* (one of the takedown techniques), the *meia lua de compasso* is one of the trademarks of capoeira. It is also one of the most efficient and deadly kicks. The kick usually begins from the standing ginga position, then put your two hands on the ground and lift your extended leg, striking the opponent's face with the heel. It can also be used effectively starting from the negativa on the floor. It is similar to a back round-house kick in taekwondo.

d) takedowns

Takedowns are the most refined, the most efficient, and the most dangerous part of capoeira for the opponent. The skillful capoeirista takes the following proverb to heart: "The harder they come, the harder they fall." Takedowns are found in higher levels of capoeira.

Rasteira Along with meia lua de compasso, this sweep is one of capoeira's trademark movements. When one understands the rasteira, he or she is very close to understanding the philosophy behind capoeira. The rasteira represents shrewdness over strength. It is executed when the capoeirista is attacked quickly and violently. Intuitively, he or she goes into the rasteira, simultaneously dodging the attack and pulling the support leg of the aggressor. When the rasteira is properly executed, the attacker usually falls on his back.

Rasteira

Banda The *banda* is frequently used against the martelo or similar direct kicks. The capoeirista set his or her foot behind the opponent's support leg and usually twist their body to generate enough torque to sweep that foot off the ground.

Banda por dentro This is used if you are attacked by a martelo or a similar kick. When the attacker steps in with his right leg and throws a martelo with his left leg, instead of backing up, you may swiftly step in with your right leg behind your left leg and use your left leg to violently pull the attacker's right leg from under him; at the same time you push the attacker in the chest or the chin.

3) Training Methods

In most schools of capoeira, students form a *roda* (circle) when they start training. Roda means a "wheel" in Portuguese. An assistant beats a drum to provide a rhythm and students may clap to keep the beat, or jump into the circle and perform the techniques when they feel the need to do so.[33]

Music, especially percussive music, is vital to capoeira training. Since capoeira is as much a dance as method of fighting, the rhythm of the music determines the timing and flow of the match. Tambourines, cowbells, and a berimbau (a bow with an attached gourd that produces a percussive sound) are among the favored instruments for bolstering the fighting spirit of the combatant.

4) Grading System

Capoeiristas wear white pants held by a *cordano* (cord). Just like in Eastern martial arts, the color of the cordano represents the student's level of expertise. The cordano system is not a uniform—different local clubs (grupos) use different colors to indicate rank or level of experience.[34] However, the organizations following the Angola tradition do not use belts, or white uniforms, at all.[35]

[33] Jennifer Lawler (2003). Martial Arts for Dummies. Wiley Publishing, Inc. p. 294.
[34] Debora Martins. p. 45.
[35] Thomas A. Green (Ed.) (2001). p. 63.

5) Initiation Rite

When a student is committed to capoeira, he must go through the *batizado* (baptism) ceremony. Gabriela Tigges puts it, "Baptizado is the ceremony in the academy when the student, after having learned the basic steps and sequences, is allowed by his teacher to play for the first time accompanied by the berimbau. The life of the Capoeira begins with the Baptizado ceremony."[36] The baptizado was first introduced by Mestre Bimba.[37]

During this event the student is given an *apelido* or *nome de guerra* (nickname) as part of the batizado initiation. The name is chosen for the student "that reflects a characteristic of that person, his physical type, personality, the neighborhood he lives in, his profession, his clothes, or an artistic ability."[38] The name becomes the identification of the capoeira in his academy and in all capoeira circles. This practice of giving a capoeirista an apelido was invented by Mestre Bimba. It was originally intended to prevent the police from discovering the real identity of the capoeirsta in the old days.[39]

3. History

1) Origin

The origins of capoeira are recorded only in traditional legends and invariably focus on the African influence. There are many theories on the origins of this highly acrobatic, dancelike Brazilian martial art. Among practitioners and historians there are two opposing theories as to whether capoeira is the New World development of an African martial art or a system originating in the New World with African influences.

36 Gabriela B. Tigges (1990). p. 17.
37 Gabriela B. Tigges (1990). p. 66.
38 Gabriela B. Tigges (1990). p. 66.
39 Debora Martins. p. 47.

The triangle of slavery route: Portugal, Brazil & Angola

There are even suggestions that some of the kicking techniques are derived from French savate via European seamen whose ships docked in Brazilian ports.[40]

However, all these hypotheses have one common ground; that is, capoeira is believed to have originated and been invariably associated with the slave experience. Slaves were transported from Africa to South America from the beginning of the sixteenth century until slavery was abolished in 1888. The slaves came from various cultural regions of Africa and they were dropped off in the states of Recife, Bahia, and Rio de Janeiro in Brazil.[41]

Black slavery started with the appearance of the Portuguese in Brazil in 1500. Upon their arrival, the colonists subjugated the Brazilian Indians in order to furnish the Portuguese with slave labor. The Indians died quickly in captivity or fled to neighboring regions. The Portuguese then began to import slave labor from Africa. Hundreds and thousands of free men and women were captured in Africa, loaded onto slave ships, and sent to Central America.[42] The Africans brought with them their culture—religion, arts, music, dance, fighting traditions, and so forth.

Some oral traditions say that out of the oppression, inflicted on them by their white masters, tribes that had been once strangers and enemies in their native Africa came

40 Thomas A. Green (Ed.) (2001). p. 61. Thomas A. Green, the author of *Martial Arts of the World: An Encyclopedia* continues in his book, "The high arcing kicks of chausson (savate) and its practice of kicking with one hand on the floor for balance are believed to have been incorporated into Brazilian capoeira. Great similarities are seen in the techniques, salute, and dress of the old practitioners of chausson and capoeira. The presence of chausson players among the sailors in Salvador, Brazil, has been established, and French cultural influence was strong in Brazil in the 1900s." Thomas A. Green (Ed.) (2001). p. 520.
41 Debora Martins. p. 43.
42 Nestor Capoeira (1995). pp. 4–5.

Map of Bahia

gather to fight for their freedom. The slaves, tired of their captivity, rebelled against their tobacco and sugar plantation owners.[43] According to them, capoeira was born out of such a background—multi-cultural African cultures synthesized on Brazilian soil and probably in Salvador, the capital of the state of Bahia.

Others insist that the vehicle of music and dance that characterizes the practice of capoeira evidently shows the slaves' intentions to disguise the techniques as dance movements with added music and ritual from their Portuguese and Dutch masters. Fortunately, the highly acrobatic nature of Capoeira was able to fool and even amuse the plantation owners by leaping, tripping, and kicking their opponents. However, there is some dispute against this theory and it raises a question as to whether Capoeira was originally a fighting system forced to masquerade as a dance form. This theory believes that Capoeira was originally a dance that later evolved into a fighting method against oppressors.

We do not know which is true. However, many oral traditions claim that the practice of capoeira helped those slaves who had escaped and survived to defend themselves from the groups of armed men who sought to apprehend and return them to captivity.[44] The former slaves established a new African community in the bush. They later named this society Palmares because of the large number of palm trees they found.[45]

43 Debora Martins. pp. 43–44.
44 Thomas A. Green (Ed.) (2001). p. 62.
45 Debora Martins. p. 43.

Debora Martins, the author of *Capoeira: The Forbidden Sport* concludes,[46]

"Capoeira became their weapon and their symbol of freedom. With it they were able to cause considerable damage to the white man. They were able to beat both Portuguese and Dutch armies on various occasions. These armies were ambushed by unexpected attacks. Using the swift and tricky movements of capoeira, the slaves were able to defeat the experienced and well-trained Portuguese and Dutch soldiers."

Unfortunately, there have been few documents regarding this matter; therefore, the origins of capoeira are shrouded in mystery. Since capoeira was developed on Brazilian soil, particularly in Rio de Janeiro and Recife, and probably in Salvador, the capital of the state of Bahia, it would be an outcome of different fighting traditions that were possibly intermingled under the regime of slavery primarily during the nineteenth century.[47]

2) Early Modern Era

In 1808, the Portuguese King Dom Joao VI and his court arrived in Brazil fleeing Napoleon Bonaparte's invasion of Portugal and things began to change. The newcomers believed that it was necessary to destroy a people's culture in order to control their thoughts and behaviors.

In 1814, the Brazilian monarchy aggressively attempted to eradicate the practice of capoeira and other forms of African culture such as music and dance. Whether as a dance or, worse still, a fighting method, capoeira became a cultural embarrassment in Brazil. Its practice became punishable by stiff prison sentences, so capoeiristas went underground with their art.

Confirming this version of a more violent early Capoeira, a letter in 1821, from the Military Commission of Rio de Janeiro to the War Ministry, complains of "capoeira Negroes arrested by the military school for disorderly conduct." The letter recommends public punishment as a deterrent, and states that "there have been six deaths attributed to the before-mentioned Capoeiras as well as several knife injuries."[48]

46 Debora Martins. p. 44.
47 Nestor Capoeira (1995). p. 4.
48 Nestor Capoeira (1995). p. 7.

Capoeira at that time had little in common with the capoeira that is practiced today. For example, in his book, *Voyage Picturesque et Historique dans le Bresil* published in Paris in 1824, the German artist Rugendas observed the following:[49]

The negroes have yet another war-like past-time, which is much more violent—capoeira: two champions throw themselves at each other, trying to strike their heads at the chest of the adversary whom they are trying to knock over. The attack is avoided with leaps to the sides and with stationary maneuvers which are equally as skillful, but in launching themselves at each other it so happens that they strike their heads together with great force, and it is not rare that the game degenerates into a fight, causing knifes to be brought into the picture, and bloodying the sport.

Also, absent from Rugendas' description are the acrobatic jumps, the ground movements, the leg blows, and the musical instrument called the berimbau, which had not yet been incorporated into the game of capoeira at the time.[50] In those days, capoeira was accompanied only with the *atabaque* (similar to the conga drum), handclapping and singing, as shown in Rugendas' drawings. As time went by, this early capoeira described by Rugendas evolved and changed into the modern form.

If the acrobatic jumps, ground movements, and leg blows were not included in capoeira at this time, one should be reminded that the French influence was strong in Brazil and that seamen from Europe who practiced chausson (savate) were present in Salvador, Brazil. According to Kevin P. Menard, one of the contributors to the encyclopedia, *Martial Arts of the World*, capoeira master Bira ("Mestre Acordeon") Almeida said in a 1996 personal communication with him that a connection between the arts is probable and "that Chausson is one of the grandparents of Capoeira." This signifies that fancy acrobatic, quick leg movements and one hand on the floor for balance are believed to have been incorporated into Brazilian capoeira around this time.[51]

With the signing of the Golden Law in 1888 slavery was abolished, and some slaves returned to Africa. Those who remained could not establish a place for themselves within the existing socio-economic order. Because of their skills in capoeira, a few

49 Nestor Capoeira (1995). p 7.
50 The berimbau is a one-stringed instrument with a gourd attached and today it is often considered indispensable in dictating the rhythm and nature of the game—slower or faster, more combative or playful, treacherous or harmonious, etc. See Nestor Capoeira (1995). p. 8.
51 Thomas A Green (Ed.) (2001). p. 520.

capoeiristas were lucky and got jobs as bodyguards for politicians, but those less fortunate became dangerous gang members—they quickly descended into criminal circles and capoeira along with them.[52]

During the transition from the Brazilian Empire to the Brazilian Republic in 1890, these gangs were hired by both monarchists and republicans to trash the assemblies of their adversaries. Finally, the practice of capoeira was outlawed by the first constitution of the Brazilian Republic in 1892. Capoeiristas were viewed as a danger to the Brazilian government, causing the art to be illegal until 1920.[53] Anyone caught practicing capoeira was forced to leave Brazil. When the persecution against the capoeiratas increased, these men, uniformly from the lower strata of Brazilian society, retaliated by using blades on their feet and fortifying the capoeira kicks with the straight razor.

3) Modern Era

At the turn of the 20th century, capoeiristas were still often seen as criminals—experts in the use of kicks (*golpes*), sweeps (*rasteiras*), and head-butts (*cabecadas*), as well as in the use of blade weapons. Since altercations between capoeiristas and the authorities became more lethal and because the art was practiced almost exclusively by black Brazilians, capoeira came to be looked down on as a predatory, barbaric activity, the province of the criminal underclass.[54]

In this way capoeira has some parallels with savate, the French foot-fighting art that fell into disrepute due to the social standing of many of its practitioners. This reputation plagued capoeira for over a century, until Brazil finally acknowledged it as an important part of its national heritage.

Up until the practice of capoeira was outlawed in 1892, capoeira had been practiced exclusively in a violent form in Rio de Janeiro, and as a ritual-dance-fight-game in Bahia and Recife. Sometimes it was practiced in secret and in other places openly, in defiance of laws designed to abolish it.[55] The persecution and the confrontations with the police continued, and capoeira was slowly forced out of Rio and Recife, leav-

52 Nestor Capoeira (1995). p. 10.
53 Debora Martins. p. 45.
54 John Corcoran and John Graden (2001). p. 248.
55 Nestor Capoeira (1995). pp. 10–11.

ing the art only in Bahia.

Capoeira remained outlawed until 1934. Only then did it begin to emerge from the underground and to be practiced by individuals from more privileged social groups.[56] Even then, there was a stigma attached to Capoeira and its past as a fight system of slaves, outlaws, and bandits, and the stigma began to fade only in the 1960s and 1970s.

In 1937 the most important master of capoeira, Mestre Bimba, was invited by the Brazilian president to perform his art in the capital. After an outstanding performance, Mestre Bimba was granted official state recognition and his school became officially the first Brazilian capoeira school.[57] Years later the senate passed a bill that established capoeira as a national sport. In Brazil capoeira is practiced everywhere. You can find it in elementary schools, universities, clubs, and military academies.

4) Abroad

In the 1970s capoeira spread to the United States. Mestre Jelon Vieira and Loremil Machado (1953–1994) were among the first who taught in New York around 1974. They were young natives of Salvador with impressive capoeira credentials and taught regularly.[58] In 1978, Mestre Acordeon, one of legendary Mestre Bimba's (1900–1974) leading pupils, arrived in California and has been teaching consistently in San Francisco. Mestre Bimba published a book, *Capoeira: A Brazilian Art Form* (North Alantic Books, 1986) which was one of the first published on the subject in the U.S.[59]

Mestre Joao Grande of Angola capoeira, a former student of Mestre Pastinha (1890–1981), the foremost practitioner of the traditional Capoeira Angola style, came to the States in 1990 and opened his school in New York City. This was the first school in the States dedicated solely to the teaching of capoeira.[60]

The popularity of the art has been fostered by spreading all over the world in countries such as the United States, Germany, Australia, Denmark, New Zealand, Canada, Italy, Portugal, England, Spain, the Netherlands, and many others.

56 Nestor Capoeira (1995). p. 36.
57 Debora Martins. p. 45.
58 Nestor Capoeira (1995). p. ix.
59 Nestor Capoeira (1995). p. x.
60 Nestor Capoeira (1995). p. x.

Reference

Borkowski, Cezar and Manzo, Marion (1999). The Complete Idiot's Guide to Martial Arts. Prentice Hall Canada.

Capoeira, Nestor (1995). The Little Capoeira Book. North Atlantic Books.

Corcoran, John and Graden, John (2001). The Ultimate Martial Arts Q & A Book. Contemporary Books.

Green, Thomas A. (Ed.) (2001). Martial Arts of the World: An Encyclopedia. Vol. 1: A–Q. ABC CLIO.

Green, Thomas A. (Ed.) (2001). Martial Arts of the World: An Encyclopedia. Vol. 2: R–Z. ABC CLIO.

Lawler, Jennifer (2003). Martial Arts for Dummies. Wiley Publishing, Inc.

Martins, Debora. "Capoeria: The Forbidden Sport" in John R. Little & Curtis F. Wong (Ed.) (2000). Ultimate Martial Arts Encyclopedia. Contemporary Books.

Tigges, Gabriela B. (1990). The Histrory of Capoeira in Brazil. An Unpublished Doctoral Thesis. Brigham Young University.

Muay Thai
Thai Boxing

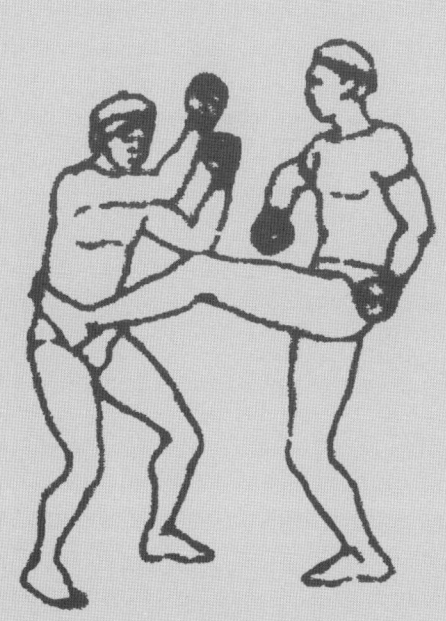

What is Muay Thai?

Definition
Rituals
Techniques
Training Methods
Competition
Ranking System

History

Origin
Modern Era
Muay Thai in Thailand

1. What is Muay Thai?

1) Definition

Muay thai, sometimes called Thai boxing, is a striking art for ring fighting that uses the fist, elbows, knees, and feet.[1] It is a form of combat practiced by people using various parts of the body—even its entire frame as weapons in the struggle.[2] Thai boxing is revered as one of the most brutal martial sport and an effective method of self-defense because it allows contestants to kick, knee, punch, and elbow anywhere on the body except the groin.[3] In this sense, muay thai is a powerful, occasionally brutal, form of combat; and it is a tough form of kickboxing and at the same time, a hugely popular spectator sport.

Muay thai, nicknamed "the science of eight limbs," uses both hands, both feet, both knees, and both elbows as weapons.[4] This means that you can use any of your "eight limbs" to strike your opponent during the match. In Thai boxing, no part of the body remains inactive. Physical strength as well as willpower and intellect are among the necessary qualities every boxer must possess. All boxers must also be agile in single combat, and without the use of weapons must be able to fight with ferocity.[5]

2) Rituals

Unlike other martial sports, muay thai has a ritual aspect of martial arts. The *wai khruu* is the ceremonial dance that all muay thai

Wai khruu

1 Thomas A. Green (Ed.) (2001). Martial Arts of the World: An Encyclopedia. ABC CLIO. p. 350.
2 Panya Kraitus & Pitisuk Kraitus (1988). Muay Thai: The Most Distinguished Art of Fighting. p. 15.
3 John Corcoran & John Garden (2001). The Ultimate Martial Arts Q & A Book. p. 188.
4 Jennifer Lawler (2003). Martial Arts for Dummies. Wiley Publishing, Inc. p. 275.
5 Panya Kraitus & Pitisuk Kraitus (1988). p. 15.

competitors perform before a fight. As a ceremony of paying homage to his teacher who has taught him the art of Thai boxing and parents who gave birth to the fighter,[6] the fighters dance to *si muay* (fight music), the traditional Thai music played in the ring. Songs (*sarama*) are played by a four-piece orchestra consisting of a Javanese clarinet (*pi Java*), drums (*klong kaek, kong*), and cymbals (*shing*).[7] The music is considered a symbol of deference and respect and it is an essential and inspiring part of every match. This shows the gentle nature of Thai boxing.[8]

3) Techniques

Front push kicks, roundhouse kicks, low kicks (leg kicks), and knee and elbow strikes are frequently used. Techniques are usually delivered at full power, occasionally sacrificing grace for brute force. The Thai roundhouse kick usually is thrown to go through the target.[9]

In contrast with taekwondo and karate, muay thai fighters are allowed to continue fighting after they have grabbed hold of each other and are into a clinch. A fighter's objective in clinch fighting is to gain control of the upper torso or neck of the opponent. Also referred to as neck wrestling, this allows a fighter to manipulate the foe off balance and deliver knee strikes to the body and head.[10] This is one of the favorite techniques used by Thai boxers pulling their opponent's head toward their knee and striking it repeatedly, leaving the unlucky recipient knocked out on the floor unconscious. Muay thai boxers generally have short careers.

In muay thai, about 30 techniques are used. If you compare this to the hundreds of martial art techniques in karate or taekwondo, you will see that Thai boxing has minimized the techniques necessary to win. In other words, the techniques are few in number, but their effectiveness is legendary.

a) fighting stance
There is only one stance, the fighting stance in muay thai. This is also called the

6 John Corcoran & John Garden (2001). p. 189.
7 Thomas A. Green (Ed.) (2001). p. 351.
8 Panya Kraitus & Pitisuk Kraitus (1988). p. 1.
9 John Corcoran & John Garden (2001). p. 189.
10 John Corcoran & John Garden (2001). p. 189.

neutral stance. For a right-handed fighter, the left leg leads and the right leg follows—vice versa for a left-hander. The fighter's body is slightly turned away from the target or opponent with the head held slightly forward and the chin tucked toward your chest. One leg is slightly behind the other, and the legs are about a shoulder's width apart for stability. Knees are only slightly bent for mobility. Your weight is evenly distributed on both legs.

Your hands should be fists, and they should be held high, guarding your face and body, with your elbows tucked to your ribs. Although you should work both sides equally in training, usually you start with your dominant leg as your back leg—your power leg.[11] Punching includes the basic five moves used in Western boxing; jab, cross, hook (*mat tong*), upper cut (*mat aat*), and overhead.

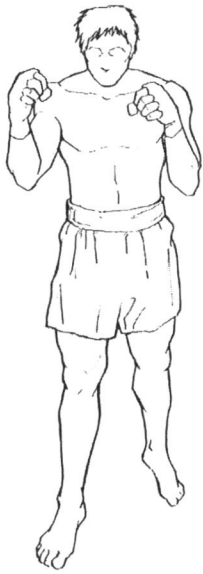

The fighting stance of Thai boxers

b) punches

The punches used in Thai boxing are similar to the punches used in boxing. You start with your hands up near your shoulders, and you pivot on your feet, turning your body weight into the punch to add power. This is different from traditional Eastern martial arts, where your hands start at your waist.

Jab The jab is done with your forward (non-dominant) hand. You simply punch forward from the shoulder, bringing your hand back to guard your head as quickly as possible. The jab is used to feel out the opponent—to see how he/she responds and not actually inflict damage or score points.

Cross The cross is a power punch. You use your backhand (dominant hand) to perform it. You bring your fist forward, extending your arm from the shoulder and turning your body into the punch.

11 Jennifer Lawler (2003). p. 282.

Hook The hook can be performed with either hand. Your arm starts in the hook position, with your elbow bent and your arm parallel to the floor. You turn your body into the hook instead of extending your arm. The bend (hook) in your elbow stays constant even on impact.

Uppercut The uppercut can be done with either hand. It impacts the opponent's ribs or the underside of his jaw. For this technique, you drop your hand slightly past shoulder level and then bring your fist up and under the target.

Overhand The overhand punch is a circular punch that comes up from the shoulder and down on top of the opponent's head. This technique is not commonly used and is most effective for taller fighters. It helps you get past an opponent's guard.

Other types of punches are used in muay thai: the swing and the spinning back fist.

Swing It is a long-range hook. French savate uses a similar punch, because of a similar need to close the gap from kicking range.

Spinning back fist This technique was borrowed from other martial arts and can be done with either hand. For this technique, you hit with the back of your fist rather than your knuckles. You extend your arm so that your elbow is only slightly bent, then rotate to the back (this builds speed) and smack your opponent's temple.

Head Solar plexus Ribs

c) elbows and knees

Elbow strikes are not be allowed in competition, but they are excellent self-defense tools. They can be delivered in many ways: horizontally, downward, upward, spinning, and driving. The horizontal elbow whips the point of the elbow across the target, usually to the side of the head, like a hook. The downward elbow technique first raises the point backward and then drops it downward. You may do this with a jump using the body's weight. Upward elbows are usually delivered like the uppercut. Spinning elbows are horizontal elbows with a body turn. Driving elbows come straight in like the boxing jab.[12]

Knee strikes may be used in muay boxing competition, and they are either straight, round, or jumping. You can simply drive your knee into your opponent's solar plexus (just below his rib cage and sternum) or an attacker's groin, or you can swing your knee from the side to attack the ribs and kidneys—usually delivered from the clinch. The jumping knee may be used against an opponent trapped in a corner.

d) kicks

Roundhouse This is the staple kick of your arsenal. The kick sweeps from the side to your target. It is directed at low, middle, and high targets. You use your shin or your instep as the striking surface. You can use this type of kick often to target your opponent's shin. Traditionally, you would condition your legs for these devastating shin strikes by kicking small trees.

During the opening round of a match, players may trade low roundhouse kicks to each other's legs to prove who is the better-conditioned fighter. Kicks to the legs are debilitating, limiting a fighter's mobility. Spectators then start their betting after the first round.[13] The low kicks are full force and committed.

Striking with the shin

12 Thomas A. Green (Ed.) (2001). p. 353.
13 Thomas A. Green (Ed.) (2001). p. 351.

Front kick For this kick, you strike directly in front of you. You fold your leg (chamber your leg by bending your knee) and then snap your leg forward, striking with the ball of your foot. It is usually used as a "stop hit" or pushing away technique to halt the opponent's forward progress.

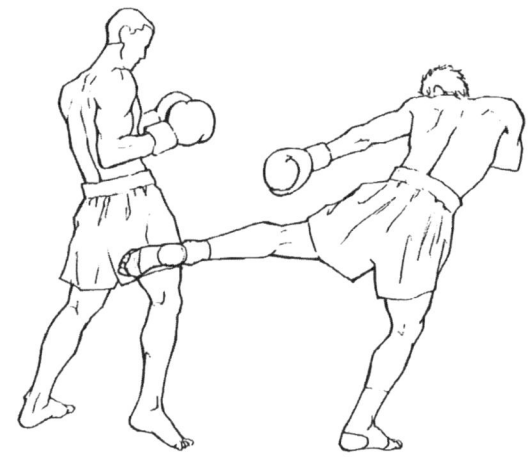

Round kick into the opponent's thigh

Side kick For this kick, you fold your kicking leg, then pivot on your supporting foot, and thrust your kicking leg forward, striking with the heel of your foot. There is no side kick in the traditional muay thai repertoire, but Japanese kickboxers who have converted from karate use this technique effectively.

Turn back kick This kick (also called the reverse kick or the reverse side kick) requires you to spin to the back as you fold your leg and then kick with the heel of your foot.

Spin kick This is a reverse whipping kick. This technique is seldom used in ring fighting.

e) leg sweeps and throws

Other techniques may be allowed in Thai boxing competition or may be taught in training as aids to self-defense. Most leg sweeps and throws in Thai boxing are straightforward and do not require difficult maneuvers. For example, one popular sweep just requires you to put your foot behind your opponent's foot and hook his foot out from under while you push.

4) Training Methods

All techniques are taught through repetition and drills of single moves preferred

over multiple, flashy techniques of other martial arts. Thai boxers rely on cross-training to become excellent fighters. So not only do they train in their sport, but they also do weight training, aerobic training, flexibility exercises, and other drills to help them maintain their edge. A boxer's training regimen includes stretching, calisthenics, weight lifting, rope skipping, running, swimming, shadowboxing, equipment drills with focus mitts, kicking pads, and heavy bags, and sparring.

a) weight training

Some kickboxers refuse to go near weights believing they get all the workout by hitting the heavy bags. Others swear by weight training, but say it must be done right. If you bulk up too much, you can interfere with your agility and speed, which are important to a kickboxer. Kickboxers often do a full-body weight-training workout per session, or they alternate upper body workouts with lower body workouts. They do not necessarily need complicated weight training regimens. A weight-lifting workout for 40 minutes twice a week is generally more than enough weight training for a kickboxer.

Weight training should not be done the day after a heavy contact kickboxing workout. Normally it is done after an aerobic kickboxing session. Heavy workouts should be followed by light workouts. This gives your muscles time to recuperate and gain strength. A full-body workout should include arms, shoulders, legs, and abdomen.

b) body conditioning

Weight training builds muscle mass, which helps in terms of sheer power. You can shove your competitor around the ring if you are bulkier than your opponent. But muscle endurance is what counts in kickboxing—not sheer strength. You have to keep lifting your hands to punch and your legs to kick. That is muscle endurance. This type of muscle endurance is achieved through body-conditioning exercises, which are essentially those exercises that use your own body weight as resistance. Professional kickboxers do hundreds of crunches, push-ups, and pull-ups every day or every week. If you have always dreamed of being a lean, mean human machine, with sharply chiseled muscles and sculpted abdominals, you have to start doing the same.[14]

14 Cezar Borkowski & Marion Manzo (1999). The Complete Idiot's Guide to Martial Arts. An Alpha Book. p. 217.

c) cardio training

In addition to weight training, most kickboxers improve their endurance and cardiovascular fitness through cardio training. This can be running, swimming, biking, countless rounds of rope skipping and even an aerobics class. Then you may have superb cardiovascular endurance.

d) flexibility training

In order to do the techniques with blazing speed, you have to have flexibility in your joints. If you feel stiff, you are not going to be able to launch that lightning-quick attack against your opponent to win the match. By improving your flexibility, you are actually improving the range-of-motion in a joint. This increases your agility.

Static stretches (no bouncing) can help you improve your flexibility, and hundreds of these exercises exist. Toe touches, open stretches, and the like can all help you improve your flexibility. You may also take a yoga class once a week to help improve your flexibility.

e) balance

You can always tell beginning kickboxers by how often they fall over trying to do a front kick. Maintaining your balance is essential in kickboxing, and it is something that you can even train to do. If you have no sense of balance at all, start moving through the following steps slowly:

① Stand near a wall, and place one palm on the wall.
② Bend your knee so that one leg is off the floor.
③ Stand in this position for thirty seconds. Relax and repeat with the other leg.
④ After it becomes a piece of cake, let go of the wall.
⑤ Stand in the middle of the room and bend your knee, so one leg is off the floor.
⑥ Hold the position for thirty seconds and then relax and repeat with the other leg.
⑦ Close your eyes when you stand on one foot. Your vision helps you keep your balance, but it is good to be able to keep your balance even if your eyes are closed.
⑧ After you can do that, try kicking with one leg. Now try kicking with one leg with your eyes closed. When you can manage all that, you will have a solid sense of balance.

f) training equipment

A special type of heavy bag, called a "banana bag," which is longer and heavier than a punching bag, is used for kicking. Other training equipment includes a speed bag, double-end bag, jump rope, timer, focus mitts, kicking pads, sparring gloves, head-gear, and medicine ball.[15]

5) Competition

A synopsis of more modern and seemingly humanized form of the rules follows:[16]

- You can use any of your eight limbs to strike your opponent including elbowing and kneeing.
- You must wear leather, padded gloves less than four and no more than six ounces, but your feet must be bare.
- A groin protector is worn and an anklet on each leg.
- Your ankle is reinforced with support wraps and your groin is covered with protective gear.
- The length of matches is 5 rounds of 3 minutes with a 2-minute rest period between rounds.
- A referee, positioned inside the ring, controls the bout while two judges outside the ring adjudges the winner. The center referee issues a ten count for knockdowns. Two judges score the fight on points.
- Three knockdowns in a single round can end the match.
- When there is a knockout or if the referee stops the bout, the match ends.
- There are 12 weight classes ranging from under 112 pounds to 175 pounds and over (112, 118, 122, 126, 130, 135, 141, 147, 150, 175 and over 175).
- Throwing, head butting (striking your opponent using your head), pitting, biting, hitting a downed opponent or striking while holding the ropes constitutes a foul.

15 Thomas A. Green (Ed.) (2001). p. 352.
16 Cezar Borkowski & Marion Manzo (1999). p. 217.
 See also. Donn F. Draeger & Robert W. Smith (1980). Contemporary Asian Fighting Arts. Kodansha International. p. 163.

6) Ranking System

Muay thai does not use the ranking systems of popular Japanese and Korean martial arts. In muay thai, it is said that the "belt is in the ring."[17] A fighter demonstrates his level of expertise through combat.

2. History

1) Origin

Muay thai began in Thailand several centuries ago. This long fighting tradition goes back at least to the Kingdom Siam in the mid-sixteenth century.[18] Thailand ("land of the free") was formerly known as Siam before it became a modern country.[19] However, no one knows for sure how muay thai started. Due to frequent warfare with neighboring countries such as Burma (Myanmar), Khmer (Cambodia), and Cham (Vietnam), recording accurate history was difficult and in A.D. 1767, the Burmese purportedly burned all Siamese records.[20] As a result, the precise information on the origin of muay thai is not available and reliable history dates only from the Bangkok era (1767–1932).

Thai boxing may have developed from Chinese martial arts since the Siamese state was resulted in the union of Chinese descendants and people of the Mon and Khmer tribes.[21] The Thai tribe (meaning "free") migrated in the 12th and 13th centuries from Juang-Xi, Sichuan and Hubei provinces in the south of China, into the present terri-

17 Thomas A. Green (Ed.) (2001). p. 352.
18 Cezar Borkowski & Marion Manzo (1999). p. 215.
19 Jennifer Lawler (2003). p. 287.
20 Thomas A. Green (Ed.) (2001). p. 350.
 Also see, Donn F. Draeger & Robert W. Smith (1980). p. 162.
21 Jennifer Lawler (2003). p. 216.
 See also, Donn F. Draeger & Robert W. Smith (1980). p. 161.

tory of Thailand.²² Thus, one can surmise that Thai boxing has its origin in Chinese boxing (kung-fu), but that it has changed a great deal in the course of its history.

The oldest historical document mentioning muay thai states that in 1560 the Thai prince Naresuan known as the "Black Prince" had a duel with the Burmese crown prince. The duel lasted several hours and Naresuan defeated him with his muay thai skills. The duel ended with the death of Burmese crown prince and as a result, at the loss of his successor and the martial display of Naresuan, the Burmese king Bayinnaung decided not to attack Thailand.²³

An old Thai legend has it that a historical boxing match was held in the Burmese city of Rangoon in 1774. A few years before this event took place, the ancient Thai capital of Ayuthya had fallen under the invading army of the Burmese (1667) and they had taken many Thai prisoners to the Burmese city of Rangoon. However, the contest was held during the seven-day celebration in honor of the pagoda where the Buddha's relics were preserved.²⁴ The Lord Mangra, king of the Burmese ordered a boxing match along with several folk-type spectacles such as costume plays, comedies and farces, and sword fighting matches.

A high-ranking Burmese nobleman led a Thai boxer named Nai Khanom Tom from Ayuthya to the Lord Mangra and the king allowed him to fight in the contest. The Thai boxer began dancing around his Burmese opponent and his act perplexed the Burmese spectators. When the signal for the match was given, Nai Khanom Tom rushed forward, elbowing and pummeling his opponent in the chest until the opponent collapsed. He defeated ten Burmese fighters one after another before Lord Mangra, thereby earning his admiration and his own freedom. He is considered the first Thai boxer and this episode is also mentioned in the history books of Burma beyond Thailand's borders even today.²⁵ There is an annual tournament honoring him nowadays.²⁶

Thai boxing reached its zenith during the reign of Pra Chao Sua at the beginning of the 18th century. King Pra Chao Sua whose nickname was "Tiger" was a great master of the art himself. He used to leave his palace secretly and attend local tournaments

22 Zoran Rebac (1987). Thai Boxing Dynamite: The Explosive Art of Muay Thai. Paladin Press. p. 9.
23 Zoran Rebac (1987). p. 9.
24 Panya Kraitus & Pitisuk Kraitus (1988). p. 22.
 See also, Thomas A. Green (Ed.) (2001). p. 350. & Zoran Rebac (1987). p. 9.
25 Panya Kraitus & Pitisuk Kraitus (1988). p. 22.
26 Zoran Rebac (1987). p. 9.

wearing a mask. He was a regular winner.[27] It was a period of great development for Thai boxing and it was taught as a subject in all schools and was a part of military training. Although cannons and firearms were introduced into the Siamese army in the early modern period, soldiers continued to revere the empty-hand combat skills of muay thai.

At this time, many of the Thai boxing teachers were Buddhist monks who apparently regarded it as only another subject in the educational system to be supervised and taught by them.[28] The match was fairly free fighting and there were no round or weight categories. All kinds of kicks and punches were allowed with few limitations: grappling, pulling hair, biting, the use of fingers, and kicking a downed opponent were the only actions ruled out. Combatants wrapped their forearms from the fist to the elbow in cotton, horsehide or hemp, and if both fighters agreed, they smear their fists with an adhesive and dip their wrapped knuckles into pots of ground glass, making it a most formidable weapon.[29] Genital protectors were made of coconut shells. Deaths occurred, although infrequently.

Training methods included punching and kicking banana or palm trees to strengthen fists and feet, kneeing and elbowing while swimming, and running long distances. Besides power kicking, there were more subtle practices such as kicking a lemon attached to a string for focus. A special diet, mainly vegetarian was an obligation. Some techniques from that period remain unchanged until today known as "King Tiger Techniques."[30]

In A.D. 1788, the seventh year of the reign of King Rama I, Thai boxers encountered European boxers (two French boxers and brothers) for the first time. The two boxers traveled by the river and challenged local boxers in several provincial cities for prizes of money. When they reached Rattanakosin (now Bangkok), the capital of Siam, they were never defeated once.[31] On hearing their challenge to Thai boxers in the capital through a high-ranking nobleman, Rama I placed 4,000 baht, a very large amount in those days for a bet. A boxer named Muen Phlaan associated with the Ministry of Defense was chosen for the bout and defeated the two French brothers easily. Excellent muay thai boxers could draw huge crowds of people. The kickboxers

27 Zoran Rebac (1987). p. 9.
28 Donn F. Draeger & Robert W. Smith (1980). p. 162.
29 Donn F. Draeger & Robert W. Smith (1980). p. 162.
30 Zoran Rebac (1987). p. 9.
31 Panya Kraitus & Pitisuk Kraitus (1988). p. 23.

often performed to honor the king.

2) Modern Era

Under traditional rules, boxers bound their hands with cotton cloth, dipped them in glue, and sprinkled them with ground glass. Glue and glass were eventually abandoned, but cotton bindings, rather than gloves, were used until 1929.[32] However, with modern modification in the rules, the first muay thai matches fought in a ring with boxing gloves and under the ten-point-must scoring system were held in 1935.

Following the Second World War, muay thai has enjoyed great popularity. New techniques borrowed from Western boxing include methods of pressing, slipping, the use of the left hand, and the jab and uppercut—all of which the old sport had been deficient in or lacked altogether. Its modified forms have made Thai boxing a more humane, attractive fighting sport.

In the mid- to late 1960s, after the 1964 Olympics, muay thai gained popularity in Japan. Japanese blended karate and muay thai techniques into an international kickboxing style. Japanese fighters, however, have not adhered to the traditions and rituals associated with the art as practiced in Thailand. Muay thai has become the forerunner of international kickboxing.

By the 1990s, kickboxing became the standard name of the sport. Today, many kickboxing events are held, not only in Thailand, but also throughout the world.[33] Although kickboxing comes in many different styles with slightly different approaches to the techniques, essentially, schools are broken into two categories:

Schools that emphasize conditioning Such schools include those that teach aerobic kickboxing and that teach contact kickboxing but do not push competition as the main purpose of training.

Schools that emphasize competition These kickboxing gyms train people to fight in amateur and pro competitions, and they clearly state that as their purpose.

32 Thomas A. Green (eel) (2001). p. 351.
33 John Corcoran & John Garden (2001). p. 189.

Some muay thai techniques, such as elbow strikes, are not allowed in other types of kickboxing competition. However, these techniques can be practiced for self-defense. It makes more sense to hit someone with your elbow than with your fist. You are less likely to hurt yourself.[34]

3) Muay Thai in Thailand

Betting and television have stimulated interest and spurred competition. Hundreds of new camps have been opened throughout Thailand. Currently, more than a few thousand professional boxers, ranging in age from eighteen to forty-five, train in several hundred camps (there are more than a hundred in Bangkok alone). The boxers train from two to three hours daily doing hard work, rope-skipping, swimming, ball and bag punching and kicking, shadow boxing, and sparring for six to eight rounds. The sparring is restricted to punching and the more dangerous blows are avoided. The sport is so arduous that few boxers continue for more than five years. Though the diet is better than in the old days (milk and eggs are now included) the training and the matches are no less demanding on the boxer.[35]

Muay thai is a tough form of kickboxing and at the same time, a hugely popular spectator sport. Modern Thai boxers are able to draw huge crowds. In Thailand, muay thai is the equivalent of pro football or pro baseball in the United States. It is the national sport of Thailand. Muay thai champions adorn major billboards and are sought after to endorse major products. Since it is deeply embedded in the culture, every province in Thailand has a boxing stadium and muay thai can be seen almost every night on Thai television.

The two largest stadiums presenting weekly bouts are Rajadamnern and Lumpini in Bangkok. Tourists cram these stadiums to see Thai boxing. They see a pre-fight ritual in which the boxers pay homage to their teachers and gods in a series of complex movements. The fight is accompanied by music from a four-piece ensemble of two drums, a Javanese pipe, and cymbals.[36]

These extravaganzas feature musical accompaniment in the form of drums, flutes and cymbals. Like the heartbeat of the audience, the tempo of the music increases in

34 John Corcoran & John Garden (2001). p. 191.
35 Donn F. Draeger & Robert W. Smith (1980). p. 163.
36 Donn F. Draeger & Robert W. Smith (1980). p. 164.

time with the pace of the match. The Thais who cannot get into these stadiums can participate by betting their *baht* (Thai currency) on matches you watch on television. This pastime appears to be as popular as the sport itself.[37]

Gambling is a large part of this sport. At the above mentioned two famous stadiums, gambling is legal. Both are located in metropolitan Bangkok, and indeed most of the spectators come for precisely that reason. The audience is free to stand and place cash bets among themselves before each fight and even before each round. This scene can remind onlookers of the New York Stock Exchange during heavy trading. Boxers must weigh 100 pounds to fight in one of these two stadiums, effectively barring children's competition.[38]

Contemporary muay thai has been accused of having a seedy side because betting is said to dehumanize the martial spirit of the fighters. In fact, some of the fighters are treated as sub-humans or animals by their promoters.[39]

The World Association of Kickboxing Organizations (WAKO), founded in 1973, today has eighty-four-member countries. Headquartered in Milan, Italy, WAKO has sanctioned hundreds of both amateur and professional kickboxing events by weight class in both male and female divisions. In 1974, another association called the Professional Kickboxers Association (PKA) was founded to promote kickboxing throughout the world. As the first official sanctioning organization, the PKA set the rules for amateur and professional competition.[40]

37 Cezar Borkowski & Marion Manzo (1999). p. 216.
38 Peter Vail, "The Sociocultural Context of Thai Boxing." UC Martial Arts Program Monograph. Winter 1997. Vol. III. p. 13.
39 Thomas A. Green (Ed.) (2001). p. 351.
40 Jennifer Lawler (2003). p. 281.

Reference

Borkowski, Cezar and Manzo, Marion (1999). The Complete Idiot's Guide to Martial Arts. An Alpha Books/Prentice Hall Canada.

Corcoran, John and Graden, John (2001). The Ultimate Martial Arts Q & A Book. Contemporary Books.

Draeger, Donn F. & Smith, Robert W. (1980). Contemporary Asian Fighting Arts. Kodansha International.

Green, Thomas A. (Ed.) (2001). Martial Arts of the World: An Encyclopedia. Vol. 1: A–Q. ABC CLIO.

Green, Thomas A. (Ed.) (2001). Martial Arts of the World: An Encyclopedia. Vol. 1: R–Z. ABC CLIO.

Kraitus, Panya & Kraitus, Pitisuk (1988). Muay Thai: the Most Distinguished Art of Fighting.

Lawler, Jennifer (2003). Martial Arts for Dummies. Wiley Publishing, Inc.

Rebac, Zoran (1987). Thai Boxing Dynamite: the Explosive Art of Muay Thai. Paladin Press.

Vail, Peter, "The Sociocultural Context of Thai Boxing." UC Martial Arts Program Monograph. Winter 1997. Vol. III.

Pentjak-silat
Native Fighting Art of Indonesia

What is Pentjak-silat?

Definition
Characteristics
Uniform and Grading System
Initiation Rite

Techniques

Styles
Unarmed System
Weapon System
Training Pattern

History

Origin
Modern Era

1. What is Pentjak-silat?

1) Definition

Pentjak silat is a native fighting art of Indonesia.[1] The term *silat* is generally agreed to mean "combat" or "fighting" and is commonly coupled with the modifier *pencak* (Indonesian) or *pentjak* (Dutch) meaning "regulated, skillful body movements in variations and combinations" in Indonesian.[2] Putting these two separate terms together, the complete meaning of pentjak-silat is "a fighting system with regulated, skillful body movements."

This indigenous Indonesian combat art was an amalgam of different traditions originally imported from India, China, and the Middle East.[3] Pentjak-silat's staples include strikes with both hands, kicks, throws, locks, and evasive movements. Malaysia also has a very similar system called bersilat that is believed to have originated from pentjak-silat.

The real emphasis of pentjak-silat is self-defense.[4] The students of pentjak-silat learn to take opponents to the ground by grabbing their legs or entwining their limbs around their opponents. A variety of weapons are integrated along with unarmed techniques in its curricula. Usually attacks are launched from very low stances, deep crouches, or even creeping positions. These are regarded as the "trademarks" of silat.[5]

However, orthodox pentjak-silat is a combat form. It was never considered or promoted as a sport. Some of the newly founded styles have attempted to posit rules and regulations to make certain aspects of pentjak-silat into a competitive sport. However, the majority of *gurus* (masters) stand categorically opposed to this trend, fearing the inevitable dilution of combat values.[6]

1 D. Draeger & R. Smith (1980). Comprehensive Asian Fighting Arts. Kodansha International. p. 177.
2 Thomas A. Green. Editor (2001). Martial Arts of the World: An Encyclopedia. Vol. 2: R–Z. p. 524.
 Also see, D. Draeger & R. Smith (1980). p. 178.
3 Thomas A. Green. Editor (2001). p. 525.
4 Cezar Borkowski and Marion Manzo (1999). The Complete Idiot's Guide to Martial Arts. An Alpha Books. p. 26.
5 Thomas A. Green. Editor (2001). pp. 524–525.
6 D. Draeger & R. Smith (1980). p. 182.

2) Characteristics

Almost all pentjak-silat techniques operate as "soft" or "elastic" styles of fighting—alert, responsive, and adaptive, ready to neutralize whatever aggression it is encountered. It has an easy, peculiar, pulsating tempo. The leading exponents of pentjak-silat can be defined as follows:

a) self-defense and combative

The primary purpose of pentjak-silat is always self-defense.[7] No conscious effort is made to make orthodox penjak-silat a system of physical education or a sport. Pentjak-silat is solely intended for instantaneous use in the emergencies of daily life; thus, pentjak-silat is practiced today by all classes of Indonesian society. Especially, people in the countryside take to it most readily; in the remotest jungle and on the most inaccessible island, almost every boy or girl you may encounter has some ability to demonstrate a particular style that is practiced in the region he/she lives in.[8]

Pentjak-silat is, quite obviously, founded on the harsh reality of possibly deadly hand-to-hand combat, and in its exercises, it imposes the rigors of a real combat situation upon trainees.

The spirit of combat must underlie all orthodox pentjak-silat training. Any other attitude negates the meaning of the art. For that reason, when a trainee trains with a partner, they are supposed to think and call each other an "enemy,"—neither "opponent" nor "partner."[9] Each should regard the other as someone who is trying to take his/her life.

b) use of weapons

Penjak-silat's technical fundamentals deal with the use of weapons since no combatant is ever required to enter combat relying only on his empty hands.[10] Therefore weapons of all kinds are studied and applied to combat situations. These weapons may be anatomic (fist, elbow, knee, foot), as in karate and taekwondo, or they may be implements (sword, stick, staff, club, knife, and others). The most important

7 H. Alexender, Q. Chambers, & D. Draeger (1970). Pentjak-silat: the Indonesian Fighting Art. Kodansha International. p. 12.
8 H. Alexender, Q. Chambers, & D. Draeger (1970). p. 16.
9 H. Alexender, Q. Chambers, & D. Draeger (1970). p. 16.
10 H. Alexender, Q. Chambers, & D. Draeger (1970). p. 13.

exponent in pentjak-silat is never, in fact, "empty-handed," since almost any object within his/her reach such as a chair, a bottle, or a stone, may become a weapon of expediency in an emergency.[11]

c) animal styles

Almost all pentjak-silat movements are based on characteristic movements of animals or people. Thus, it is not uncommon to find that the action of a particular style bears such titles as *pendeta* ("priest") and *garuda* ("eagle"), or more descriptive titles such as *madju kakikiri harimau* ("taking a tigerlike stance"), *lompat sikap naga* ("jumping in dragon style"), and *lompat putri bersidia* ("jumping like a princess and standing near").

d) low stances

Crouching stances and smooth movements into and out of low postures require the practitioner to be both extremely strong and flexible in his/her legs and hips—qualities that can be developed to their fullest only when he or she accepts pentjak-silat (or any martial art) as a way of life. However, Indonesians make daily use of the full squat posture, a posture that, as anyone who has tried it knows, requires well-developed and flexible leg muscles.[12]

e) evasive and defensive

All penjak-silat is traditionally evasive. Its characteristic responses to an attack are light, fast, deceptive movements; it seeks to avoid bone-crushing contact with the assailant's charge. Customarily, it does not oppose the force of the assailant but rather blends with it and directs it along specific channels where it may then be controlled, allowing the assailant to be eventually subdued.[13] Thus, by long tradition, it is usually defensive in application. This is the reason why the pentjak-silat practitioner prefers to await the attacker's

Pamur style

11 H. Alexender, Q. Chambers, & D. Draeger (1970). p. 32.
12 H. Alexender, Q. Chambers, & D. Draeger (1970). p. 14.
13 H. Alexender, Q. Chambers, & D. Draeger (1970). p. 14.

moves before taking action. However, this is not an absolute condition by any means.

3) Uniform and Grading System

Since pentjak-silat was intended for instantaneous use in the emergencies of daily life, the costume used in training is simply plain clothes that people wear every day.[14] This still remains true today. Other styles have developed special training suits incorporated with certain unique features because of different reasons such as economics, identities, and other conveniences. However, there is no overall standard in uniform.

In some schools, silat students wear no special uniform for the first six months of training. Then they wear a white belt or *bengkong* (sash) for approximately one year, followed by a green one at the intermediate level. Advanced students wear a yellow or red belt or sash. It can take seven to ten years to achieve a black belt or sash.[15] On Bali, an island in Indonesia to the east of Java, the Perisai Diri style adopted a belt ranking system modeled after other Eastern martial arts; however, these attempts have met strong resistance by traditional gurus (teachers).[16]

4) Initiation Rite

According to Donn Draeger, a martial art scholar, a boy wishing to train in pentjak-silat under a traditional teacher must go through an interview with his guru to qualify to train. In addition, he is required to offer five gifts to the guru at his "swearing-in" ceremony as follows:[17]

① A chicken whose blood is spread on the training ground as a symbolic substitute for blood that might otherwise come from the student.
② A roll of white cloth in which to wrap the corpse if a student dies in training.
③ A knife, which symbolizes the sharpness expected of a student.
④ Tobacco for the teacher to smoke during rest periods.

14 H. Alexander, Q. Chambers, & D. Draeger (1970). p. 16.
15 Cezar Borkowski and Marion Manzo (1999). p. 220.
16 Thomas A. Green. Editor (2001). p. 530.
17 D. Draeger & R. Smith (1980). pp. 179–180.

⑤ Some money to replace the teacher's clothes if they are ripped in practice.

Furthermore, new students have to place their hands on a holy book (usually the Koran) and swear an oath of allegiance to the guru and fellow practitioners—promising a bond that extends far beyond a business arrangement and that shares a blood relationship from that day forward.[18]

2. Techniques

1) Styles

There is no overall standard style for pentjak-silat. Each style has its own particular movement patterns, specifically in techniques and tactical rationale. Some martial arts scholars say that there are about 150 different pentjak-silat styles in the 3,000 islands of the Indonesian Archipelago[19]—others say there are more.[20] This expanse comprises the world's largest archi-pelago, extending between the Southeast Asian mainland and the Philippines to the north and Australia in the south. Through this vast region, pentjak-silat is to be found in various combinations and with various modifications over the centuries. However, to make it simple for the readers the different styles of pentjak-silat can be classified into the following geographical regions.[21]

All these modified styles have developed differently and now they have their own traditions and identities. These diverse styles are usually named after a geographical area, city, or district, after an animal, after a spiritual or combative principle, after a person, or after a physical action. All styles use hand and foot motions; however, the percentage of use of either one depends on the style and the tactics being used. A

18 Thomas A. Green. Editor (2001). p. 527.
19 D. Draeger & R. Smith (1980). p. 178.
20 Thomas A Green. Editor (2001). p. 526.
 See also, Cezar Borkowski and Marion Manzo (1999). p. 218.
 According to Cassimore Magda, the author of "The Devastating Art of Pentjak Silat" says there are more than 500 styles in Malaysia and perhaps 200 in Indonesia.
21 H. Alexender, Q. Chambers, & D. Draeger (1970). pp. 15–16.
 Also see, D. Draeger & R. Smith (1980). p. 179.

Geographical Area	Name of Style	Characteristics
Sumatra	Harimau* Menangkabau* Patai Baru Kumango	Foot and leg tactics
West Java	Tjimande* Serak* Tjingrik* Mustika Kwitang*	Hand and arm tactics
Central Java	Setia Hati* Perisai Sahkti Tapak Suji	Synthesis of arm and leg tactics
East Java, Bali & Mandura	Perisai Diri Pamur Bahkti Negara Tridharma	Synthesis of arm and leg tactics plus grappling methods

Note: The styles with asterisk (*) in the table above are mentioned in the following paragraphs.

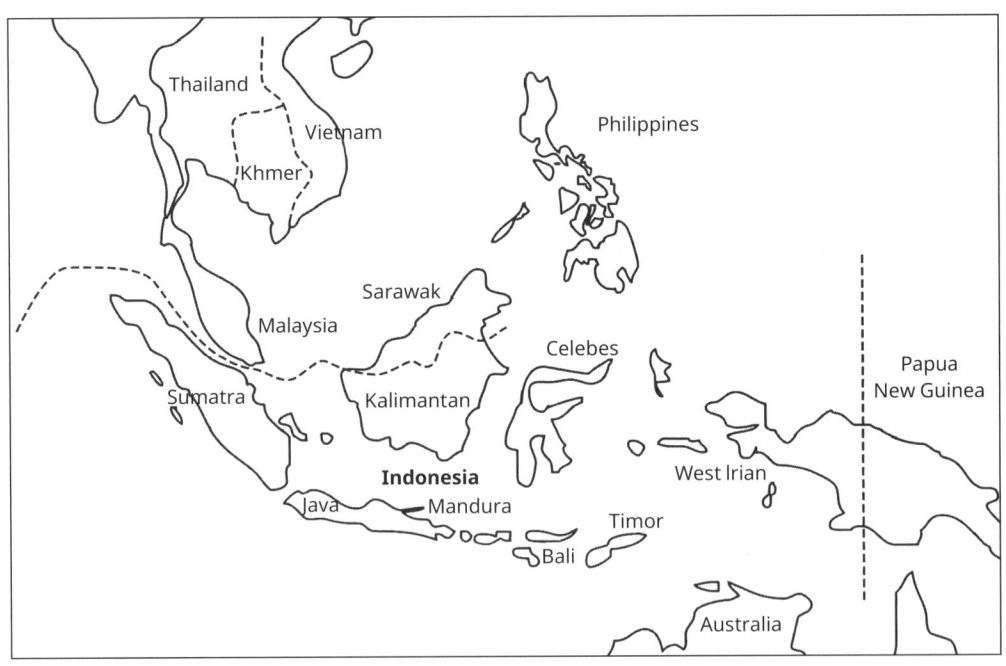

Southeast Asia

quite remarkable tactic is the one used by the *Harimau* (meaning "tiger") style from Sumatra.

In this method, the practitioner's movement pattern resembles the antics of a tiger, with grave emphasis on staying close to the ground using crouching, lying, sitting, and semi-squat positions.[22] The leg strength and flexibility required in this style are enormous and the Harimau stylists can use their hands like extra feet or their feet like extra hands. They start the fight from the ground position or trick their opponents into a trap, then take them to the ground.[23] The styles Tjimande, Serak, and Tjingrik that originated in West Java all demonstrate this fact.

On the other hand, many Javanese styles use a percentage weighting that is more balanced between hand and legwork. Many Javanese styles require the practitioner to move in close against the enemy in an upright position, then use various hand and foot moves to execute the techniques.

The name of a style taking after a physical action, for example, is Undukayam which is named after the footwork that mimics those of a hen scratching the ground. Seitia Hati from Central Java means "faithful heart" and represents a spiritual principle. Mustika Kwitang developed in West Java and is named after the Kwitang district in the city of Jakarta, the capital of Indonesia. Manangkebau is named after an ethnic group, the Menangkebau people. And Sterlak is named after a combative principle that means "to attack with strength."

Each style of pentjak-silat has its own curriculum, history, and traditions, some shrouded in secrecy and some open to the public. Rather than categorizing pentjak-silat's styles or schools by region, one can also examine them in terms of their core combative strategies. There are seven such strategies.[24]

① Use open palm techniques and strike with the flat surface of your hand.
② Employ ground fighting by using defensive and offensive techniques performed from a reclining position.
③ Place special emphasis on locking and grappling by restraining your opponent's limbs.
④ Rely on kicking, sweeping (knocking off-balance) and leg trapping by seizing and controlling your opponent's legs.

22 Cassimore Magda
23 Cassimore Magda
24 Cezar Borkowski and Marion Manzo (1999). p. 219.

⑤ Depend on natural breathing (a regular breathing pattern) and quick movements.
⑥ Use deep breathing (extended inhalation and exhalation) and strong, deliberate strikes.
⑦ Employ weapons like the *kris* (a long knife), *toya* (wooden staff), and the *pendang* (machete).

2) Unarmed System

As the world's largest archipelago, the islands comprising Indonesia have developed a variety of fighting methods and accompanying weapon systems. The unarmed component of pentjak-silat uses economical body movement and includes knee and elbow strikes, joint locks, and kicks and punches.

a) basic postures for combat

Every style of pentjak-silat has its own technical characteristics. By observing the posture an opponent has assumed, and his subsequent movements, an expert can tell immediately what particular style of pentjak-silat he/she is up against.

3) Weapon System

A wide variety of weapons are incorporated into the pentjak-silat systems;[25] thus it takes on a quality of realism that is lacking in solely empty-hand combative forms such as Korean taekwondo and Japanese karate. Although it is impossible to describe all the possible weapons in detail in this space, an account of some of them is necessary in order to understand the features of the art. In pentjak-silat, bladed weapons are particularly favored, and sticks of various lengths, projectiles and composite weapons are also found among the various styles.

a) blade

Edged weapons are quite prominent in pentjak-silat, particularly the kris. In addi-

25 H. Alexender, Q. Chambers, & D. Draeger (1970). pp. 31–32.

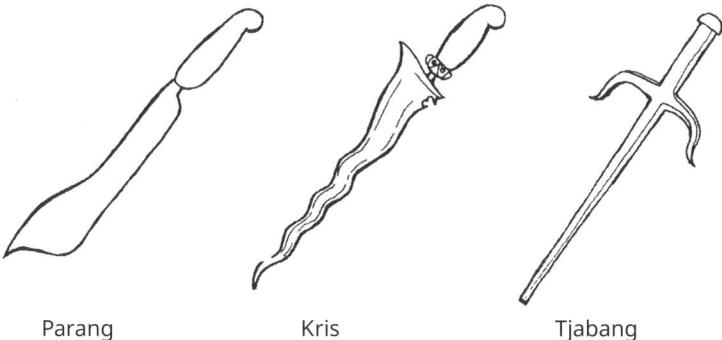

Parang Kris Tjabang

tion to the kris, pentjak-silat uses dozens of other fighting knives ranging in size from the rentjong to the parang. A few of the most common are in the following:[26]

Kris a double-edged stabbing dagger

Rentjong a knife with a pistol-grip handle and a blade of only a few inches

Parang a cleaver-like, single-edged knife with a blade as long as thirty-six inches

Pedang a long, sword like weapon, single-edged and somewhat akin to a cutlass or saber

Tjabang a short, trident-shaped weapon similar to the Okinawan sai. (The word tjagang means "branch" and the weapon is made of iron and has double tines fastened at the juncture of shaft and handle.)

Tombak a spear used throughout Indonesia

Although their prototypes may have originated outside Southeast Asia, weapons such as the kris and the tjabang are regarded as specifically Indonesian and Malayan.[27] Similar to capoeira,[28] pentjak-silat offers one of the best examples of the use of a

26 John Corcoran & John Graden (2001). The Ultimate Martial Arts Q & A Book. Contemporary Books. p. 244.
27 Thomas A Green. Editor (2001). p. 527.
28 Instead of using a knife, capoeiristas used to carry the straight razor. Landing any of the dervish-like kicks with a razor gripped between the toes would cause serious injury to an unsuspecting enemy. Even if the opponent was prepared, the scythelike circular kicks of a well-trained capoeirista could slash away while still keeping his or her own head and torso out of the way.

blade in combat. According to a witness, David Steele,[29] young boys in certain Sumatran villages would learn to carry the small rentjong knife between their toes by first practicing with a piece of wood under their curled toes. Later, the wood would be replaced by the handle of the rentjong, and the blade would be positioned between the big toe and the one next to it. The boys became so adept at carrying the blade in this manner that they could run barefoot without dropping the knife or injuring the foot. When it came time to use the rentjong, usually against a Dutch soldier, the knife would be thrust out with a hard kick to stab the opponent.

b) stick and staff

The chief weapons of this type are the tong kat and the gada, which are short sticks, and the gala and the toya, which can vary in length from five to about seven feet. These sticks and staffs are made of the rattan palm trees and hardwoods are also used.

c) projectile

Panah and anak panah (bow and arrow) the most important weapons in Indonesia.

Sumpit the blowpipe

The projectile type also includes weapons which can be thrown as well as used in bare-hand combat.

Tombuk a spear used in a fencing type of action that can be used for throwing

Piau a small knife for throwing

d) composite

Weapons in this type may have equal facility for a wide variety of actions.

The practitioners are expected to consider not only the weapons being used but also the climate, the time of day or night, and the terrain upon which the combat

[29] John Corcoran & John Graden (2001). p. 245.

occurs; these all combine to establish the prevailing emotional as well as physical atmosphere of the fight.[30] Trainees must always bear in mind that the weapons they are using are real objects capable of inflicting serious injury.

4) Training Pattern

Although there are hundreds of styles in pentjak-silat practiced in the Indonesian Archipelago, each has its own unique training methods and secret combat strategies. In general, training begins with instruction in unarmed tactics and progresses to armed techniques.[31]

Pentjak-silat has an additional peculiarity in that virtually all movements performed empty handed may be performed equally fluently and safely when the combatant is armed. This is true of many earlier forms of combat on the Asian continent and in Okinawa. Training varies but one representative training pattern is included in the following:[32]

① The *Jurus* are the fundamental anatomical weapons useful in attack and defense; they include fingers, knuckles, hand-edges, elbows, knees, hips, head and feet.
② *Langkah* is the posture and the foot position necessary for application of the jurus.
③ *Bunga* is the formal etiquette prior to engagement in training with a partner.
④ *Sambut* are sparring exercises against one or more opponents.
⑤ *Rahasia* is an advanced subject analogous to *tien-hsueh* (Chinese), *geupso* (Korean), and *atemi* (Japanese). Students learn the location of vital points on the enemy and how best to attack them.
⑥ Next students learn how to wield a variety of weapons including the knives, swords, sticks, staffs, and guns, as well as some unorthodox ones such as the ropes, the chains, handkerchiefs, and chairs.
⑦ *Kebatinan* (spiritual training) is the final stage in which students learn the secretive teachings of gurus.

30 H. Alexander, Q. Chambers, & D. Draeger (1970). p. 17.
31 Thomas A. Green. Editor (2001). p. 527.
32 D. Draeger & R. Smith (1980). pp. 180–181.

a) use of percussion music

Although it is not essential to the proper performance of pentjak-silat movements, percussion music frequently accompanies training exercises. This is done primarily for much the same reason that the musician makes use of a metronome, but with pentjak-silat the music has the further effect of heightening the emotional atmosphere of the training, rather as war drums affect tribal warriors.

b) no warming-up

Pentjak-silat, being a true fighting art, makes no use of warming-up or preparatory exercises, for it recognizes that under fighting conditions a man will have neither time nor opportunity to warm up. As actions preliminary to more energetic drills, pentjak-silat uses directly related and instantly convertible movements that are of silat value. Isolated actions or exercises of the calisthenic type are considered meaningless and unnecessary.[33] In fact, an exponent of pentjak-silat is trained to be ready to ward off an attack at any time; his body must be flexible enough to make an instantaneous response.

c) forms in dances

Pentjak-silat teaches specifically arranged set forms that are called *jurus*, *buha*, and *sumbuts*.[34] These patterns train the practitioner to constantly move into particular formations of footwork while executing their defensive weaponry. Indonesian native instruments are played to accompany the practitioner's movements and to influence rhythm in the practitioner's motions. Once these are mastered the practitioners then will incorporate several of the forms that have been practiced, and deliver them without any particular order or structure. This high level of performance is called kembangan which translates into "one's own expression."

The fact that percussion instruments are used as the background music in the practice of pentjak-silat and play the role of a training aid, it is often misunderstood and classified as a dance.[35] Also, another reason that supports this misunderstanding is that pentjak-silat is often performed at festivals and marriage ceremonies and that confuses the issue further. This is all due to the graceful and light movements which are inherent in the elements of pentjak-silat. However, one should never forget the

33 H. Alexender, Q. Chambers, & D. Draeger (1970). p. 14.
34 www.authenticbeladiri.com
35 D. Draeger & R. Smith (1980). p. 178.

fact that it consists of more rapid movements and destructive forces. Therefore, the percussion instruments employed in the practice of pentjak-silat should be understood as that of pumsae in taekwondo or kata in karate.

3. History

1) Origin

Most sources contend that the art originated on the Indonesian island of Sumatra, located just across the Strait of Malacca from the Malaysian Peninsula, during the period of the Menangkabu kingdom. According to Donn Draeger, the author of *Comprehensive Asian Fighting Arts* (1980), Sumatra is home to 23 silat styles and had a strong Muslim tradition.[36] He continues that pentjak-silat, however, is not only popular among the Muslim population; it is found within the Hindu population who are anti-Islamic mostly residing in Bali, and some Christians in the Celebes and on Java also practice it.[37] The art developed and proliferated from the seventh to sixteenth centuries, becoming a network of systematized arts by about the fourteenth century.

In surveying the martial arts of this region, Indonesia, Malaysia, and Singapore should be considered together. Most of them owe their origin to the great migrations (2500–1000 B.C.) from the mainland. While about one million people are, for the most part, of Malayan stock, they also include numerous ethnic groups—more than ten major ethnic groups—who are somewhat compartmentalized by language, religion, and custom. Hindus, Muslims, and Buddhists, coupled with the Dutch and English, have left their imprint. Geographic factors, in the form of the more than 3,000 islands that make up these countries, have also contributed to the cultural diversity of these people.[38]

According to the most common oral traditions, silat is believed to have been devel-

36 Cezar Borkowski & Marion Manzo (1999). p. 218.
37 D. Draeger & R. Smith (1980). pp. 178–179.
38 Cezar Borkowski and Marion Manzo (1999). p. 218.

oped by a Sumatran peasant woman named Bersilat.[39] While setting out to fetch water at a stream, this woman observed a tiger and a large bird (some other legends say a snake and a bird) fight. By observing the fight, the woman developed her own self-defense techniques copying the movements of the animals; thus, pentjak silat was born.[40] The narrative of this legend is very similar to that of the Chinese *taijiquan* (*tai chi chuan*). Therefore, if it is not of independent origin, the legend may have passed down from the animal styles of the Chinese martial heritage.[41]

Interestingly, young Indonesian and Malaysian women are encouraged to begin martial training at an early age. It is living tribute to the impact that this legendary female founder of silat had on the introduction of combative arts in the region.[42]

2) Modern Era

After having been forbidden by the Dutch in Indonesia, pentjak-silat went underground. Where it continued to flourish. It was again resurrected as an effective defense against by the Japanese occupation in World War II, and now it flourishes once again.

There were several attempts to unify the many styles of pentjak-silat. Various organizations have been founded to integrate the many styles of pentjak-silat. The Ikatan Pentjak-Silat Indonesia (IPSI) was established in 1947 to attempt to combine all styles. Under its direction a one-year course is compulsory for both boys and girls in the Muslim school system.[43] Another body, the Persatuan Pentjak-Silat Indonesia (PPSI), seeks a nationalized pentjak-silat. However, local pride appears to be stronger than the desire for a nationalized pentjak-silat.

There is a movement today to organize pentjak-silat on national and regional levels as a sport.[44] This attempt raises a problem of regulating the great diversity of styles. However, many traditionalists oppose the idea with a reason: if their art is developed as a sport, its combative vitality and values may get lost and eventually weaken the effectiveness of pentjak-silat as a fighting art. Also, pentjak-silat as a

39 Cezar Borkowski & Marion Manzo (1999).
40 John Corcoran & John Graden (2001). pp. 14–15.
41 Thomas A. Green. Editor (2001). p. 525.
42 Cezar Borkowski and Marion Manzo (1999). p. 218.
43 D. Draeger & R. Smith (1980). p. 182.
44 www.cassmagda.com

sportive combat art may present another problem of values. Traditional pentjak-silat is mostly defensive in attitude and physical expression: rarely do the practitioners attack first. They prefer to wait for the attack before they move into action. This characteristic is different from the values of sport since players in a match to attack to score points.

The values of sport are in contradiction with those of self-defense arts. In sports, players learn to be "good losers" whereas in self-defense arts such as pentjak-silat practitioners do everything not to lose because their personal safety or even their lives are on the line. The values of orthodox pentjak-silat are about protecting your life or the lives of your loved ones; this is why the majority of orthodox gurus oppose the idea of making their art a form of sport. Unless these two contradicting ideas are resolved, there will not be any competitions held in the near future.

Reference

Books

Alexender, H., Chambers, Q., & Draeger, E. (1970). Pentjak-silat: the Indonesian Fighting Art. Kodansha International.

Borkowski, Cezar and Manzo, Marion (1999). The Complete Idiot's Guide to Martial Arts. An Alpha Books/Prentice Hall Canada.

Corcoran, John and Graden, John (2001). The Ultimate Martial Arts Q & A Book. Contemporary Books.

Draeger, Donn F. & Smith, Robert W. (1980). Contemporary Asian Fighting Arts. Kodansha International.

Green, Thomas A. (Ed.) (2001). Martial Arts of the World: An Encyclopedia. Vol. 1: A–Q. ABC CLIO.

Green, Thomas A. (Ed.) (2001). Martial Arts of the World: An Encyclopedia. Vol. 1: R–Z. ABC CLIO.

Web Sites

www.cassmagda.com

www.authenticbeladiri.com

Escrima (Arnis)
The Filipino Art of Stick Fighting

What is Escrima?
Definition
Characteristics

Techniques
Styles
Weapon System
Training Methods
Competition
Grading System

History
Origin
Modern Era

1. What is Escrima?

1) Definition

Escrima (derived from *skirmish* in Spanish, meaning "fencing") is a Filipino martial art that teaches stick fighting. It is closely associated with the other Filipino martial arts, *arnis* and *kali*. Arnis and kali have similar techniques with escrima. Generally speaking, all three of these arts include the use of wooden sticks that are about 28 to 30 inches long and about three-quarters to an inch in diameter, singly and in tandem.[1] In addition, most variants of escrima, arnis, and kali incorporate bare-hand techniques and many more bladed weapons including the rope, spear, short stick, etc.

They were all developed in the Philippines but used different names in different regions: escrima is used in Visayas (the central region), arnis Luzon (the north), and kali Mindanao (the south).[2]

The Philippines

Etymologically, arnis is derived from the word *arnes* meaning "armor" or "harness."[3] It is a linguistic legacy of the Spanish who controlled most regions of the Philippines for about three hundred years until the turn of the twentieth century.[4]

Kali is an ancient Malayan word implying a large bladed weapon longer than a knife.[5] *Kalis* is a term which was shortened to kali for convenience. It is a fighting art which uses a long-bladed weapon or knife, stick or cane, and dagger. Kali is

1 Remy A Presas (). Modern Arnis: Philippine Style of Stick Fighting. p. 14.
 See also, Jennifer Lawler (2003). Martial Arts for Dummies. Wiley Publishing, Inc. p. 249.
 John Corcoran and John Graden (2001), The Ultimate Martial Arts Q & A Book. Contemporary Books. pp. 240–241.
2 Thomas A Green, Editor (2001). Martial Arts of the World: An Encylopedia. Vol. 1: A–Q. ABC CLIO. p. 423.
 See also, www.martial-way.com
3 Thomas A. Green, Editor (2001). p. 423.
4 Cezar Borkowski and Marion Manzo (1999). The Complet Idiot's Guide to Martial Arts. p. 220.
5 Remy A Presas (). Modern Arnis: Philippine Style of Stick Fighting. p. 10.

Holding the kris

sometimes referred to as the parent art of escrima and arnis.[6] Kali is orginally the pre-Hispanic martial art.

The most notable proponents of kali were the Moro (muslim) warriors who used the kris and other knives and caused devastating effect first against the Spanish,[7] then the American, and later against Japanese occupiers.[8] None of these invaders ever conquered the Muslims in the south region and failed to colonize Mindanao and Sulu.[9] Although the origins of kali are in dispute, it is believed to have derived from India.

The name arnis is commonly heard in the Philippines representing their ancient art of kali[10]; however, escrima is the most well-known name in the West.[11] In this book we are going to use one unified name "escrima."

2) Characteristics

Escrima is a close-combat system, thus skill in parrying and striking must be developed with the utmost dexterity. It puts emphasis on the use of the stick and hand-arm movements. Practitioners use the sticks to defeat their opponents. Some empty-hand techniques including kicking, punching, trapping, and grappling moves are taught as a supplement to the stick fighting. In addition to their sticks and knuckles, other weapons may also be taught, such as the sword and dagger. Some traditional schools also teach students how to use the shield and the spear. However, it is the stick that gets the most attention in most schools.

In contrast to other martial art traditions in which students progress from unarmed to weapon systems, in escrima armed training is taught before any hand-

6 John Corcoran andjolin Graden (2001). p. 241.
7 Remy A. Presas (). p. 10.
8 The kris is a double-edged dagger with a wavy, undulating blade, usually measuring between twelve and sixteen inches. With its origins in India, the kris is considered to be the national weapon of Indonesia. John Corcoran and John Graden (2001). p. 237.
9 Remy A. Presas (). p. 10.
10 Remy A. Presas (). p. 10.
11 Cezar Borkowski and Marion Manzo (1999). p. 221.

to-hand combat techniques. Cezar Borkowski and Marion Manzo, the authors of *The Complete Idiot's Guide to Martial Arts*, state, "Arnis (Escrima) is unusual in that you begin by understanding how to use the short stick and, at a more advanced level, learn empty-hand (unarmed) techniques."[12]

It is commonly known that escrima uses sticks instead of blades for safety purposes. However, the stick movements can directly be translated to bladed techniques. According to John Corcoran and John Graden, the authors of *The Ultimate Martial Arts Q & A Book*, "Stick and blade techniques represent two distinct yet complementary aspects of arnis (escrima) combat. Although the movements with each weapon are essentially identical, training with the stick alone doesn't adequately acquaint a student with the proper edge-to-target orientation necessary to make an effective cut with the blade."[13]

In escrima, the techniques are all done in the same way whether you are armed or unarmed. It does not matter which weapon you are using (stick, dagger, or empty hand), the movements with each weapon are essentially identical. This makes escrima an efficient system of fighting and distinct from other martial arts. All techniques are to be practiced with both the left and right hands in order to keep balance in the skills of *escrimadors* (escrima practitioners).

2. Techniques

1) Styles

Stick fighting has many schools and styles. Although each escrima school or style has a different approach to teaching escrima, essentially, there are two main approaches to stick fighting:

Attack the opponent's body effective but causes injuries

[12] Cezar Borkowski and Marion Manzo (1999). p. 221.
[13] John Corcoran and Jolin Graden (2001). p. 34.

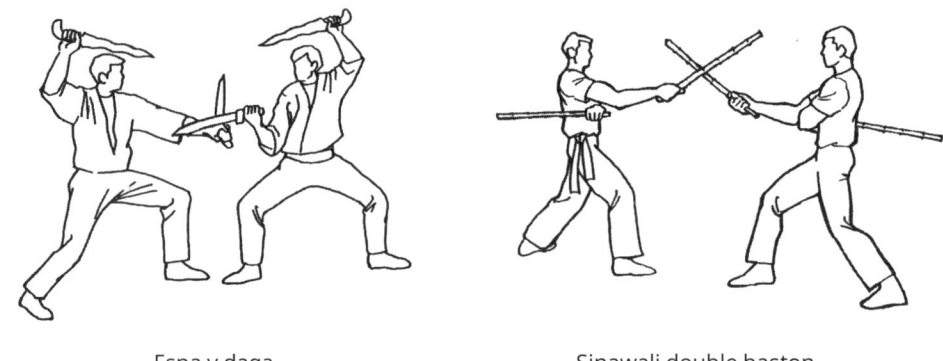

Espa y daga Sinawali double baston

Attack the opponent's stick less effective but causes fewer injuries

Some schools combine approaches, so that you learn to attack the weapon of an armed attacker and the body of an unarmed attacker.

As a fighting art, escrima has three different styles of systems. First, the *espada y daga* ("sword and dagger") in which a long wooden sword and a short wooden dagger is used. Second, the *solo baston* (single stick) in which a single long *muton* or baston (wooden stick or rattan cane hardened by drying or heating) is used. Last, the *sinawali*, a native term applied because the intricate movements of two mutons or bastons resemble the weave of a sawali (criss-cross fashion), the bamboo splits weave pattern used in walling and matting.

2) Weapon System

Depending on the style, the stick is usually made of hardwood or rattan (a special bamboo from the Philippines).[14] Some teachers feel that longer sticks are more effective and others feel that shorter sticks are more effective in close.

a) grip

To hold the stick correctly, you grip it an inch from the end with your fingers and

14 www.martial-way.com

thumb wrapped around your forefinger.[15] You should not hold your stick neither too tight nor too loose. In either case, you cannot maneuver the stick smoothly or you may drop the stick.

b) strike zones

In escrima, important concepts come in twelves. The twelve angles of attack are actually attacks to the twelve vital areas of the body. Among the twelve strikes, some are striking blows and others are thrusts. The twelve angles to defend against are as follows:[16]

Strike Number	Striking Area	Type of Striking
1	Left temple	striking
2	Right temple	striking
3	Left shoulder	striking
4	Right shoulder	striking
5	Stomach (solar plexus)	thrusting
6	Left side of the chest	thrusting
7	Right side of the chest	thrusting
8	Left knee	striking
9	Right knee	striking
10	Left eye	thrusting
11	Right eye	thrusting
12	Crown (top of the head)	striking

c) stances or positions

There are only a few stances used in escrima.

Attention stance Standing with feet at 45-degree angle, heels closed together, and hands holding the stick at the side and relaxed, this stand shows that you are paying attention used at the beginning or end of class.[17]

Salutation stance It is to show courtesy to your opponent. Start in the attention

15 Remy A. Presas (). p. 15.
16 Remy A. Presas (). p. 19.
 See also, Jennifer Lawler (2003). p. 253.
17 Remy Amador Presas (1994). Hie Practical Art of Esckrima (2nd edition). National Book. p. 21.

Straddle stance

stance by facing the opponent and taking a bow. Then bring your weapon up to your shoulder level and place your empty hand resting on your chest.[18]

The following stances are taken when you are preparing to fight. Your right hand holding the stick should be placed diagonally across your body. Your empty hand (not holding the stick) is supposed to guard your mid-section and is responsible for checking the opponent's hand or weapon.[19] The following descriptions of escrima stances are directly quoted from the Grand Master Remy Amador Presas's books who is also known as the Father of Modern Arnis.[20]

Open-leg stance Stand with legs spread apart about shoulder width with toes pointing slightly outward.

Straddle-leg stance Spread legs about twice the width of shoulders and bend knees outward, heels firmly planted and toes pointing straight forward. Distribute weight evenly on both legs.

For the following stances, your upper body should be turned slightly to one side—this gives your opponent less target area to attack.

Forward stance Move one leg forward at a distance about twice the width of the shoulders and about 30 degrees to the side and bend front leg at the knee with stick diagonally to the body and in fighting form. Rear leg is extended fully with both feet flat on the ground.

Backward stance Stand with one foot backward with rear foot toes pointing forward, to form an L-shape. The rear foot should point either left or right depending

18 Remy Amador Presas (1994). p. 6.
19 Jennifer Lawler (2003). p. 254.
20 Remy Amador Presas (1994). pp. 21–25.
 See also, Remy A. Presas (). pp. 26–27.

on what foot is in front. Rear knee should be a little bent and forced outward as in straddle-stance. Seventy percent of the weight of the body should be supported by the rear leg with 30 percent by the front leg.

Oblique forward stance This is executed by stepping either foot obliquely forward and obliquely to the left or to the right. The reverse of the oblique forward stance is executed with the withdrawal of either foot. In both movements, the L-shape position of the feet should be maintained.

d) body shifting

In general, body shifting is getting out of the range of an opponent's strike, especially thrusts by merely turning your upper body. It is used to evade an attack and reach a vantage point so that you can strike the opponent with utmost power.[21] Body shifting is thought to be more effective than simply blocking an attack since your opponent is swinging a stick at you and blocking an attack can still cause injury to you.[22]

e) footwork

Footwork help escrimadors move their whole body out of the range of an opponent's attack. Escrima practitioners learn to move in diagonals toward and away from the opponent in order to deflect linear strikes.

f) stick strikes

The following are the most fundamental ways you may strike with the stick as provided by Jennifer Lawler in her book, *Martial Arts for Dummies*:[23]

Full-power sweeping strike Strike all the way through your target.

Fast strike Pull the stick back (retraction) immediately after the strike instead of sweeping all the way through the target.

Whipping or fanning strike Striking horizontally, vertically, or on the diagonal.
Twirling strike Striking in an upward or downward movement.

21 Remy A. Presas (). p. 28.
22 Jennifer Lawler (2003). p. 256.
23 Jennifer Lawler (2003). p. 257.

g) blocking with the stick

There are six popular techniques that escrimadors can use to block a strike or thrust. The ability of a defender depends much on how he or she effectively parry or block the opponent's blow and counterattack. The blocking techniques are as follows:[24] inward block, outward block, rising block, downward-inward block, downward-outward block, and vertical block.

3) Training Methods

Muestrasion or pandalag This traditional training method teaches the artistic execution of offensive and defensive swings and strokes in repetitive drills.[25] This is often the most dancelike of the traditional learning methods.[26] Forbidden by the Spanish to practice indigenous martial arts, defiant Filipinos purportedly retained their fighting skills in secret by hiding them inside dance or play form.[27] Dance forms, alternately referred to as *sayaw* (dance), *anyo* (image), *santikan*, *moro-moro*, or *karenza* (apparently a corruption of the English word "cadence"), have existed in escrima for a long time.[28]

Sangga at patama or sombra tabak These are prearranged patterns of practicing strikes, thrusts, and parries (deflections). They may be thought of as similar to pumsae or kata (forms)—patterns of techniques used to improve the artist's footwork.

Larga muton or labanang totohanan This is spontaneous free-sparring (a form of mock combat in which partners attack, defend, and counterattack continuously). In every combative sport sparring or competition is necessary to measure the practitioner's ability in actual fighting. Two practitioners try to outmaneuver one another using all their techniques and skills. Although practitioners may wear padded safety equipment and only strike on another's sticks, this can still be dangerous. This is the

24 Remy A. Presas (). pp. 41–48.
 See also, Ernesto A. Presas (1996). Arnis: Presas Style & Balisong. p. 67.
25 Cezar Borkowski and Marion Manzo (1999). p. 221.
26 Remy A. Presas (). p. 11.
27 Thomas A. Green, Editor (2001). p. 423.
28 John Corcoran and John Graden (2001). p. 39.

ultimate phase of escrima training.

Many escrimadors also study traditional Filipino healing arts, such as hilot, probably because of the bruises they get during free-sparring.

4) Competition

In early days, escrimadors used banana stalk as a weapon in sparring sessions. In some regions of the Philippines, charcoal was applied on the stick so that a mark would be left out on the opponent if he/she was hit.[29] The old system of sparring was characterized by bruises and pains caused by injuries; there were no safe measures made. In some traditional escrima schools even today, strikes are targeted to any part of the body and protective gear is not allowed. The emphasis is still placed on self-defense in these schools.

In contrast, as escrima becomes more modernized, training takes a more sport approach. Protective headgear and padded gear resembling the equipment worn by fencers are used to ensure safety during training and competition. Also, the padded stick is used to avoid injury when participating in competition or sparring sessions.[30]

The International Philippine Martial Arts Federation promulgated rules for competitions. A match is divided into 3 sets. Each set lasts 2 minutes. The player who wins 2 sets out of 3 first is declared to be the winner of the match. The player who attains 5 points first in each set is declared the winner for the corresponding set. The contest area should have a surface area of at least 8 by 8 meters.[31]

The match commences upon the signal of the referee. Thrusting the cane to any part of the head and the neck shall not be given any score but be considered to be foul. A contestant who commits a foul 3 times shall be disqualified and his/her opponent automatically be declared as the winner. When the contest cannot be continued due to injury, the decision of the judge should be made against the player who is responsible for the injury. If the player injured is responsible for the injury, the other player wins. In case responsibility of the injury cannot be determined, the judges shall declare a tie.

29 Ernesto A. Presas (1996). p. 14.
30 Cezar Borkowski and Marion Manzo (1999). p. 221.
31 Ernesto A. Presas (1996). p. 14.

5) Grading System

Most traditional escrima schools do not award belt ranks, however some are beginning to follow the Japanese style of *kyu / dan* rankings. The ranking structure of escrima has students, fighters, and teachers. Teachers are also classified as instructors, masters, and grand masters. Among students the novices are called *likas*, or natural, the intermediate students *likha*, or creation, and the advanced students *lakan* (males) or *dayang* (females) meaning strength.[32] Ranks in escrima are as follows:[33]

Ranking System of Escrima

Color of Belt	Title
White	Likas
Brown (rimmed with blue)	Likha
1st	Isa
2nd	Dalawa
3rd	Tatlo
Black (rimmed with red)	Lakan (male) / Dayang (female)
1st dan	Isa
2nd dan	Dalawa
3rd dan	Tatlo
4th dan	Apat
5th dan	Lima
6th dan	Anim
7th dan	Pito
8th dan	Walo
9th dan	Siyam
10th dan	Sampu

Source: Remy A. Presas () Modern Arnis: Philippine Style of Stick Fighting, p. 159.

A fighter is an expert student on the way to becoming a teacher. The name for a teacher in Filipino is *guro*, from guru (Sanskrit; teacher). The grand master is simply

32 Thomas A. Green, Editor (2001). p. 433.
33 Remy A. Presas (). p. 159.

the grandfather of the school. Traditionally, one must reach age 50 or be acclaimed as a grand master.

Organized competitions have been held in the Philippines since 1949. Sanctioning organizations, such as the National Arnis Association of the Philippines (NARAPHIL) and World Escrima, Kali, Arnis Federation (WEKAF), sponsor national and international stick fighting events.

2. History

1) Origin

Geographically situated at the crossroads of Southeast Asia, the Philippines are located near the equator above Borneo and below Taiwan. The Philippines are composed of 7,107 islands and three major regions of the Philippine Archipelago, Luzon (north), Visayas (central), and Mindanao (south). Eighty-seven different dialects of Pilipino (Tagalong), the national language are remnants of immigration to and colonization of the Philippine islands and these historical facts have influenced native Filipino martial arts.[34]

In a prehistoric period, aboriginal Negritos (Aetas), a pygmy race, crossed over a land bridge from mainland Asia to become the first settlers of the Philippine islands. The bow and arrow was, and still is, their favorite weapon. Next waves of immigrants from the area now called Malaysia colonized the islands, around 200 B.C. At the time, the Malays migrated to the Philippines and brought with them the long knife. Their coming enriched the Filipino arsenal in the fighting arts. Besides their bows and arrows, the early Filipinos now also became experts in the use of bladed weapons, daggers, and spears.[35]

Extensive trade relations with China in the 9th century brought Tang Dynasty martial skills. During the Sung (960–1127) and Ming 1402–1424) dynasties migrations

34 Thomas A. Green, Editor (2001). p. 423.
35 Remy A. Presas (). p. 10.
 See also, D. Draeger & R Smitli (1969). Comprehensive Asian Fighting Arts. Kodansha International. p. 185.

to the Philippines were heavy, and large Chinese colonies were established in coastal areas.

A second Malay migration, which began in the 9th century and continued until the 13th century brought other bladed weapons. A third Malay migration came to the Philippine Archipelago around A.D. 1380 and continued until the middle of the fifteenth century. These peoples were Muslim fanatics, Moros, the ancestors of the present-day Muslim Filipinos of Mindanao and Sulu. They controlled the southern region and frequently captured or killed the Visaya tribes in the central region.[36] They favored bladed weapons, but were skilled with sticks, bows and arrows of various designs, as well as explosive projectile weapons from guns to cannons.[37]

In the fifteenth century the Malaccan Empire was established, and Mohammedanism began to spread to the southern Philippines. Chinese and Indo-Chinese forces resisted but were pushed back. When the Spaniards came to Luzon in 1570, they found Mohammedan Filipinos settled in communities with Chinese and Indo-Chinese. The mixed fighting methods resulting were even more efficient than before.

In the sixteenth and seventeenth centuries Spanish colonization was marred by native revolts. Fighting skills of the natives were well developed by this time and were respected by the Spanish. Spanish attempts to conquer the Moros and to colonize Mindanao failed. The freedom-loving Moros must be credited with the greatest experimentation, systematization, and martial use of the bladed weapon in the Philippines.

Bladed weapons abound, especially in Moroland, in the Sulu Archipelego. Each weapon is not necessarily accompanied by an organized system of fighting skills but rather is used to suit individual tastes and requirements. Common Moro knife weapons include: the *bolo, kalis, laring, balaraw, barong, gunong, kampilan, gayang, pira, punal, itak, banjal, bangkcon, lahot* and the *panabas*.[38] They are the most artistic knives in different sizes and styles. The standard types of the bladed weapons were the kris, bolo, and balaraw (a dagger-type knife). Using the Tagalog term of kalis, which implies a large bladed weapon, the term became shortened for conveniece simply to kali. Kali came to signify various systems which made use of knives.

Pigafetta, a chronicler and historian who recorded Captain Ferdinand Magellan's voyage, stated that on April 27, 1521, the native forces led by Lapu-lapu, a kali expert

36 Thomas A Green, Editor (2001). p. 425.
37 D. Draeger & R. Smith (1969). pp. 185–186.
38 Remy A. Presas (). p. 10.

defeated the great Spanish warriors with bladed weapons thus marking the Filipino's first victory against a foreign invader.[39] He also recorded that many of the natives carried a pointed short hardwood stick (the *tabak*) which had been further hardened by fire treatment, and was used in fighting. The tabak may have been the forerunner of the present muton or baston of the arnis system.

In 1564, the Spanish *conquistador* (conquest) Miguel Lopez de Legaspi landed in the Philippines. He was treated hospitably by the native chiefs he visited and was introduced to the Filipino's skill in combat, especially in kali. Legaspi was impressed with the natives' dexterity in arms and decided to befriend them fully. At the time kali was so popular as the sport of kings and of the members of the royal blood. However, the art was not confined to the elite alone. Ordinary people practiced it. Kali was a standard fighting technique when they revolted against the Spanish conquerors.[40]

The Spanish conquest of the Philippines started from 16th century and lasted for more than three hundred years. During this period, the Filipino martial arts were driven underground and only performed in public as dances and plays, which, ironically, were performed for the entertainment of the Spaniards.[41] Native dance rhythms supplied the form. Ancient native dances and plays employing bladed weapons were numerous and they can be seen today in the form of ritual dancing. However, some of the dances still have combat value very much in evidence in the traditional training method still used today.[42]

Kali declined in popularity as early as 1596 when the Spanish authorities discouraged the art and eventually banned its practice in 1764.[43] The Spaniards considered the art lethal or dangerous and they decreed that natives found practicing kali would be considered *tulisanes* (outlaws).

2) Modern Era

In 1853, the word kali was completely replaced by arnis. Arnis is the Tagalog

39 Remy A. Presas (). p. 11.
　See also, Thomas A. Green, Editor (2001). p. 426.
40 Remy A. Presas (). p. 11.
41 Jennifer Lawler (2003). p. 262.
42 D. Draeger & R. Smith (1969). p. 186.
43 Remy A. Presas (). p. 11.

orthographic translation of the Spanish arnes which was the colorful decorative "trappings" or "harnesses" worn by medieval soldiers. However, some regions in the Philippines still retain the word kali in their vocabulary for their ancient art. Thus, some regions in the Philippines still retain the word kali in their vocabulary for this art: The Ibanags have *pagkalikali*, the Pangasinenses *kalirongan*, the Visayans *kaliradman*, and the people of Panay and Negros Occidental *baston*, and the Pampangenos *sinalwali*.[44]

Currently, the best known and the most systematic fighting art in the Philippines is arnis *de mano*. The word arnis is a misleading Spanish name which means "harnesses" used by the moro-moro actors and de mano referring to the "hands." In 1637, the friars introduced the moro-moro, a socio-religious play dramatizing the triumph of the Christian Spaniards over the Muslim Moors of Granada, Spain. In the said play, Spanish soldiers fighting for Christianity were supposed to wear arnes, a Spanish word for the English harness.[45] The actor's hand movements equated to kali skills, but this was not understood by the Spanish overlords as they sat being entertained by the conquered native peoples.[46] With the introduction of the moro-moro, the Filipinos again had a chance to practice their art, thus interest in kali (arnis) was revived.[47]

Escrima sticks first appeared in the Philippines after the Spanish conquest; the native people, banned from possessing swords, learned to use sticks to defend against the sword. They learned how to strike the attacker's body (rather than the attacker's sword) with their sticks. Over the next three centuries of Spanish rule, the techniques of escrima changed because of the Spanish influence. Spanish techniques of fencing and swordsmanship, especially the Spanish system of sword and dagger fighting (*espada y daga*), found a special expression in escrima. One style of escrima also uses a sword and dagger.

For more than 300 years, Spanish colonial officials outlawed the practice of any martial systems in the Philippines. Defiant Filipinos continued to use their martial arts to defend their families and homes. In fact, martial arts were also an important means of expressing a unique Filipino identity, which is linked to the country's fight-

44 Remy A. Presas (). p. 12.
　See also, D. Draeger & R. Smith (1969). p. 187.
45 Remy A. Presas (). pp. 11–12.
46 D. Draeger & R. Smith (1969). p. 188.
47 Remy A. Presas (). pp. 11–12.

ing traditions and its fight for the independence of the nation.[48] Independence from Spain was declared on June 12, 1898.

After the Spanish-American War in 1898, the United States got Puerto Rico and the Philippines as booty. The U.S. forces fought a guerilla war against the Moros in Mindanao to claim the islands. Fierce resistance form the local Muslim tribes prevented the Americans from controling the region. Japanese imperial armed forces invaded the Philippines and occupied the islands from 1942 to 1945. Some of the two-handed stick fighting, such as *dos manos* in Doce Pares Escrima, were developed during this period to encounter Japanese swords.[49]

Much of escrima or arnis, in its current form, was developed in relatively recent years by the Doce Pares and the Presas groups. Not a major factor in actual combat since the onset of fully automatic firearms and high explosives, Escrima had nearly become extinct until it was reintroduced into the Filipino public and private high school institutions in 1969.[50]

The modern techniques underwent through improvements and gained wider acceptance when the National College of Physical Education offered modern escrima as a regular subject in Physical Eduaction to the students who major in this course. The students in the NCPE were mostly teachers from different schools in the country and this enabled escrima to gain a wider acceptance as these teachers in turn taught escrima to their students.[51]

Escrima today has experienced changes in the weapons used. Much of the antiquated techniques of the old arnis has been modernized to avoid injury to students. Although the art still makes use of the itak or bolo now and then, it has relied considerably on the use of the cane as a self-defense weapon. Escrima is engaged in more as a sport.

48 Cezar Borkowski and Marion Manzo (1999). p. 220.
49 Thomas A. Green, Editor (2001). p. 426.
50 Remy A. Presas (). p. 12.
 See also, John Corcoran and John Graden (2001). p. 34.
51 Remy A. Presas (). p. 12.

References

Books

Borkowski, Cezar and Manzo, Marion (1999). The Complete Idiot's Guide to Martial Arts.
 An Alpha Books/Prentice Hall Canada.

Corcoran, John and Graden, John (2001). The Ultimate Martial Arts Q & A Book. Contemporary Books.

Draeger, Donn F. & Smith, Robert W. (1980). Contemporary Asian Fighting Arts.
 Kodansha International.

Green, Thomas A. (Ed.) (2001). Martial Arts of the World: An Encyclopedia. Vol. 1: A–Q. ABC CLIO.

Lawler, Jennifer (2003). Martial Arts for Dummies. Wiley Publishing, Inc.

Presas, Ernesto A. (1996). Arnis: Presas Style & Balisong.

Presas, Remy A. (). Modern Arnis: Philippine Style of Stick Fighting.

Presas, Remy Amador (1994). The Practical Art of Esckrima (2nd Edition). National Book.

Web Sites

www.martial-way.com

Wushu

Chinese Art of Combat

What is Wushu?

Definition

Philosophy

Styles

Unarmed Traditions

Weapons

Techniques

Training Methods

Competition

Grading and Belt System

History

Origin

Modern Era

1. What is Wushu?

1) Definition

Kungfu (功夫) is the popular term for the martial arts of China meaning "human effort" or "special skill."[1] In Chinese, Chinese martial arts would be more appropriately called *chuanfa* (拳法: use of the fists) or *wushu* (武術: formerly, arts of combat). Wushu means "martial techniques" and is a more appropriate term for martial arts.[2]

The word wushu is now applied to a performance-oriented Chinese combat sport that emphasizes acrobatic techniques. Given the wide acceptance for the term kungfu in the West, however, even the Chinese have adopted this westernized name for their martial arts.[3] Other names for Chinese martial arts are *wugong* (martial skills, exercises), *kuoshu* (national technique), and *wuyi* (martial art, high-level skill).[4]

2) Philosophy

In Chinese martial arts, the Taoist philosophy underlies all that the martial artist is taught. Taoism is essentially the belief that two worlds exist. People in the physical world can occasionally experience the spiritual world; this contact can be sought through the use of meditation techniques.

A Taoist lives simply and seeks "enlightenment" or a true understanding of both the physical world and the spiritual world. The Tao is the underlying principle of life as well as the process of achieving harmony. According to the *Tao Te Ching*, an important book of Tao, "The Tao that can be talked about is not the true Tao." This makes it a bit hard to describe what exactly the Tao is.

When you perform a skill in harmony with its nature, you are practicing Tao. Thus,

1 Jennifer Lawler (2003). Martial Arts for Dummies. Wiley Publishing, Inc. p. 197.
 Also, see Cezar Borkowski & Marion Manzo (1999). The Complete Idiot's Guide to Martial Arts. Prentice Hall, Canada. p. 153.
2 John Corcoran & John Graden (2001). The Ultimate Martial Arts Q & A Book. Contemporary Books, p. 107. The Korean word for the characters wushu is musul and the Japanese's equivalent is bujutsu.
3 Cezar Borkowski & Marion Manzo (1999). p. 153.
4 John Corcoran & John Graden (2001). p. 107.

a Chinese martial artist pursues Tao through the practice of technical, harmonious skills.

The concept of yin-yang is fundamental to most Eastern philosophy. This is the idea that the world is made of conflicting yet harmonious elements that would not exist without one another. The concept of hot cannot exist without the concept of cold; day does not exist without night; soft would not be without hard. You can extrapolate from there. Understanding how yin-yang works helps the martial artist achieve correct balance in his/her life and warrior skills.

The concept of yin-yang helps the martial artist understand that everything has its place in the universe, and that everything is necessary, even your boss. The apparent conflict between two elements (for instance, you and your boss) is just the nature of the universe. By living a harmonious, balanced life, you reduce the conflict between these elements while accepting that such a conflict simply exists.

Yin refers to the elements in the universe that are considered destructive, passive, and feminine. Yang refers to the elements in the universe that are considered constructive, active, and masculine.

To achieve a balance of yin-yang, you have to practice moderation in all things. This is called "following the Middle Way." Instead of living in one extreme or the other—total deprivation or complete hedonism—you find a middle path, one of moderation, where you do not do everything you want and to heck with the consequences.[5]

2. Styles

As martial arts have been practiced over thousands of years, hundreds of Chinese martial arts have developed. Unfortunately, for those who wish to define the categories of kungfu clearly, a complete understanding of kungfu may take years of study.

Today, over 400 different kinds of kungfu do exist, with some resembling gymnastics, some including grappling techniques, some including full-contact techniques,

5 Jennifer Lawler (2003). p. 30.

and still others teaching unusual stances and esoteric movements. Some use weapons and the Chinese weapons vary widely from chain whips to paired swords to segmented staffs.[6]

All kungfu schools teach postures, guards, and fist and foot attacks, as well as forms (predetermined patterns of movement). The most famous schools such as the Shaolin school, the Wudang school, and the Emei school are each unique and varied in their respective approach to training, performance, and application. Some schools emphasize drilling techniques, some performance orientation, and others fighting applications.[7]

In order to get a grip, on all this you need to have some understanding of how these schools relate to each other—how they are similar and how they are different. Fortunately, they fall under a few central categories.

1) Unarmed Traditions

Even though they may sound artificial, kungfu styles are conveniently divided into different categories. Sometimes, they are classified as northern or southern style, with "northern styles" emphasizing foot techniques and "southern styles" emphasizing hand techniques. A distinction is also made between outer and inner kungfu styles. "External style" kungfu focuses on force and rapid movement and "internal style" kungfu focuses on chi and philosophical elements of training. These categories are, however, artificial since there are Northern styles that look like southern styles, and vice versa.[8]

Since the Yangtze River (Long River) crosses China from east to west, you may divide China into north and south regions. However, because of climatic and geographic factors, these two regions differ from each other. North of the river, you would find fertile fields, dry steppes and desert whereas in the south, it rains a lot and there are lots of rivers and waterways.[9] Thus, the differences in climate and geography affect the means of transportation that people use. When northerners travel they either ride on horses or walk while southerners ride on boats and a

6 Jennifer Lawler (2003). p. 14.
7 John Corcoran and John Graden (2001). p. 106.
8 Jennifer Lawler (2003). p. 198.
9 Cezar Borkowski & Marion Manzo (1999). p. 155.

lot often remain sitting. The differences are well described in the popular Chinese expression: "Southern boats, northern horses."

Human beings are part of Mother Nature and their physical developments are often affected by their environments. If you were a northerner, you would likely be tall, have long legs and be more slender than your southern neighbors. On the other hand, if you were a southerner, you might be shorter and have a stockier build and a stronger upper body. In the Chinese kungfu circle, this difference in physical type is summarized as "Fists in the south, kicks in the north."

a) northern styles

As the saying refers to, northern stylists typically make use of kicking techniques and footwork and rely on a variety of explosive (quick, dynamic) movements including acrobatic blows with their feet (where you would attempt to execute two, or even three, kicks while airborne). The martial art they developed took advantage of being tall and long-legged.

Northerners also use high stances coupled with low leg sweeps (off-balancing tactics), and postures balanced on one leg. Your kicks would be performed from kneeling, standing and jumping positions. You would strike with both a closed fist and palm of your hand. For the most part, you would shift out of the way of an attack, rather than relying on blocking or deflecting movements. You would place very little emphasis on grappling or locking tactics.[10] As a northern stylist, you would utilize long-range attacks requiring you to take one or several large steps to reach your target.

Northern Praying Mantis This is a kungfu style based on an insect. According to legend, the founder, Wong Long, watched the speed and strength of the praying mantis and tried to duplicate its powerful jaw movements. Northern Praying Mantis style is based on successive, rapid-fire techniques intended to overwhelm the opponent. The mantis claw, a grabbing motion that requires a powerful wrist and forearm, distinguishes this style, which uses both linear and circular techniques.[11]

b) southern styles

In contrast, the shorter, stockier neighbors take advantage of their anatomy: south-

[10] Cezar Borkowski & Marion Manzo (1999). pp. 155–156.
[11] Jennifer Lawler (2003). p. 198.

ern style typically emphasizes punching, chopping and grabbing techniques. As a southern stylist you would favor close or mid-range defensive tactics that require little or no movement to reach your target. You would be direct and circular, and most of the time you would deflect rather than intercept attacks. You would use kicks sparingly, generally aiming them at low targets, like the knees and shins. You might use a series of in-close techniques that could finish with an unbalancing, grappling or locking attack.

In relation to the distinction between the above two styles, there is a saying in China, "The Northern Kick subdues the Sea Dragon, the Southern Fist beats the Mountain Tiger."[12]

White Crane White Crane kungfu is also called Llama or Tibetan White Crane. Although this is a southern style, White Crane has footwork and kicks that seem more similar to northern styles. Purely a defensive system, White Crane practitioners never attack. It uses the opponent's force and energy against him.

The most obvious characteristic of White Crane style is how the practitioner keeps his arms outstretched for balance. One hand draws the opponent's attention while the other hand strikes.

The opponent never knows which hand is the "distracting" hand and which is the "attacking" hand because it can change in a moment. The White Crane practitioner allows little close physical contact and tries to keep out of range of the opponent as much as possible.

The White Crane practitioner strikes quickly and moves constantly, using low stances and circling techniques. The White Crane expert can kick high with great speed but only low kicks are used in combat; the side kick is especially popular.[13]

Wing Chun Wing Chun is another southern style of kungfu. In early China it was not uncommon for Buddhist nuns to be proficient at kungfu, just as Buddhist monks were. The popular Wing Chun style of kungfu was founded in China in the late 1700s by a Buddhist nun named Yim Wing Chun. She had received her instruction from another Buddhist nun named Ng Mui, who trained at the famed Shaolin Temple in the Henan province of China.[14]

12 John Corcoran and John Graden (2001). p. 113.
13 Jennifer Lawler (2003). pp. 203–204.
14 John Corcoran and John Graden (2001). p. 14

In characteristics, Wing Chun style uses simple, direct techniques and quick counterattacks. A straight, linear approach is used. Mostly hand techniques are used, and kicks are targeted only to the low area. Techniques allow a block and an attack in one movement.

The style emphasizes practical self-defense techniques rather than flashy, difficult maneuvers. Training methods include *mookjong* (the wooden dummy) and *chisao* (sticky hands) technique. The deceased famous martial artist and Hollywood action star Bruce Lee practiced this style and it is the only martial art he ever studied formally. Wing Chun teaches five ways of self-defense: joint locks, kicks, strikes, throwing, and weapons.[15]

c) external styles

External styles, or hard styles emphasize correct alignment as well, but rely on the use of muscular strength called *li*. These styles use hard, powerful techniques primarily executed in linear patterns. Although external style is used in reference to Chinese martial art systems, Japanese systems like karate and Korean systems like taekwondo are also considered to be external style.

External styles of kungfu are mainly derived from "Shaolin Fist," that is, martial arts that were developed at the Shaolin Temple.[16] They rely on physical conditioning: "The stronger you are, the more power you can unleash." If you practice external styles, you could develop large, rippling muscles and thickly callused knuckles, as a result of repeatedly striking heavy bags and padded posts. External styles are based on physical techniques, power, and strength. Force and speed are developed.[17]

d) internal styles

Internal styles, or soft styles, stress circular techniques that flow with soft fluidity. These styles are referred to as "internal" because they stress the use of *chi* or *qi*.[18] The internal styles emphasize the natural use of the body to produce *jing*—total body energy that stems from the intrinsic energy called chi. What is chi? Chi is simply the "life force" and "internal energy" that all creatures possess. Chi is dynamic and active. It exists in the abdomen and is tapped into through breathing techniques,

15 Jennifer Lawler (2003). pp. 202–203.
16 (The Shaolin school is one of the most well-known martial arts institution in the world. However, not all forms of kungfu began there.)
17 Cezar Borkowski & Marion Manzo (1999). p. 156.
18 John Corcoran and John Graden (2001). p. 19.

focus, and concentration, and by using the shout, *kiai* (*kihap*).[19]

Although some scientists believe there is no such things as chi, others believe it is bio-physical energy generated through breathing techniques, such as those practiced in the martial arts. Many martial artists believe that the development of chi is much more important than the development of physical techniques. They believe chi greatly enhances both the power of physical techniques and improves a martial artist's fighting skills.[20] The ability to focus on and harness this inner energy also helps handle problems and stresses that arise in everyday life.

If you were an internal stylist, you would be concerned with developing your chi. You could achieve this by practicing exercises like *nui gung* (內功). This involves focusing your energy "into the depths" of your opponent's body. When practicing nui gung, you would perform a series of repetitive movements, breathing techniques that originate in the *tan dien* (a point located 3 inches, or 8 centimeters, below your navel) and balance drills. These could improve your ability to concentrate and help you develop internal power.[21]

Tai chi (太極) or *chi kung* (氣功) which have soft, internal actions belong to the internal style of kungfu. Tai chi is a term for the Chinese philosophy of *yin* (陰) and *yang* (陽). As a student of internal systems, you would generally be required to make a greater time commitment than your external counterparts. Internal styles tend to be more defensive in nature, using soft, circular techniques.[22]

Breath out — Abdomen falls as *chi* flows out of *tan dien*

Breath in — Abdomen rises as *chi* flows into *tan dien*

Tai Chi Chuan Tai Chi Chuan (Supreme Ultimate Fist) is one of the most popular internal styles and one of the oldest martial arts in the world. It is so ancient that its

19 Jennifer Lawler (2003). p. 29.
20 John Corcoran and John Graden (2001). p. 19.
21 Jennifer Lawler (2003). p. 305. The concept of dan dien roughly corresponds with the Japanese concept of hara, the location of your chi in your abdomen, and the Korean concept of danjeon, your base or center from which all actions begin.
22 Jennifer Lawler (2003). p. 198.

origins have been lost. Nothing is known about its early history, although the Taoist Zhang San Feng, who lived during the Sung Dynasty (960–1279), is credited with creating Tai Chi Chuan.[23]

He based this system on his observation of a fight between a snake and a crane. The snake used relaxed, evasive movements and lightning-fast counterattacks to win the skirmish. Inspired by the reptile's loose but controlled movements, Zhang devised a combative form that relied on natural, reflexive techniques.[24]

Historically, Tai Chi was more martial in its approach than it is today. Nowadays, Tai Chi consists of slow, connected movements used mainly as a means for keeping the body in shape and relieving stress. Attention is paid to correct alignment and the flow of internal energy. There is an old saying, "The *yi* (理: intent) leads the *qi* (氣: energy) to *li* (履: actions)."[25]

Tai Chi is the world's most practiced style, not only of kungfu, but of any other martial art. Millions of people in China practice the slow-motion exercise of Tai Chi on a daily basis. The 1990s saw a tremendous surge of interest from America's seniors in the gentle style of Tai Chi.[26] Many Tai Chi adherents practice it for its proven health benefits. The *Journal of the American Medical Association* listed results of studies indicating the wonderful effects of regular Tai Chi practice on seniors' ability to balance.[27] Tai Chi is an excellent choice for older students or those with joint problems.[28]

However, the fundamentals of Tai Chi retain their martial purposes, including striking, kicking, grappling, and joint-locking. The techniques of Tai Chi are very much applicable in combat, both for the hand-to-hand and the weapons forms. Truly accomplished practitioners can also use its techniques in self-defense.

The three segments of Tai Chi practice are weapons training, push hands training, and forms (these are precise patterns of specific martial arts movements). The art emphasizes practicing moderation in all things, following the Middle Way—the Way of Balance and Harmony—instead of going from one extreme to another, such as extreme austerity or complete indulgence, and understanding the importance of yielding, thus allowing the attacker to defeat himself.[29]

23 Cezar Borkowski & Marion Manzo (1999). p. 308.
24 Cezar Borkowski & Marion Manzo (1999). p. 248.
25 John Corcoran and John Graden (2001). p. 107.
26 John Corcoran and John Graden (2001). pp. 103 &106.
27 John Corcoran and John Graden (2001). p. 110.
28 Jennifer Lawler (2003). p. 42.
29 Jennifer Lawler (2003). pp. 15–16.

Chi Kung (Qi Gong) Chi Kung means "energy (or breath) skills." Chi means "inner energy," and Kung means "work." Thus, Chi Kung is "inner energy work (or exercise)." Chi Kung exercises are not martial arts techniques in themselves, but they supplement the martial arts techniques. Most kungfu styles use some type of Chi Kung training. Notably, the internal styles such as Tai Chi, Ba Gua Chang (Eight Dagram Palm), and Hsing-I Chuan (Shape and Mind Fist) use Chi Kung as part of basic training and power development.[30]

Ba Gua This style emphasizes circular footwork enabling you to step behind an opponent to avoid an attack.[31]

Hsing-I Chuan It features techniques named after the elements, such as wood, air, fire, earth and so on.[32]

There are two types of Chi Kung. One focuses on cultivating general good health (improved circulation, increased range of motion) and an overall sense of well-being. Chi Kung exercises help release the negative energy that interferes with your ability to relax. Your ability to relax is crucial in terms of maintaining mental health, and also in making calm, effective choices when under stress.[33]

The other, called "Iron Body" kungfu, is devoted to the development of martial skill. During martial arts practice, Chi Kung breathing exercises help keep your blood oxygenated and improves endurance. If you become very good at Chi Kung, you could, at least theoretically, absorb and redirect power from an adversary.[34]

e) animal styles

In traditional kungfu, a number of styles have based their techniques on the unique movements of animals or even insects (for instance, Praying Mantis style). The founders of these styles each studied how a particular animal fought and determined what techniques they used to win. They converted certain animal movements into a human fighting system that humans can use.[35] Therefore, their styles

30 Jennifer Lawler (2003). pp. 110–111 & 204.
31 Cezar Borkowski & Marion Manzo (1999). p. 251.
32 Cezar Borkowski & Marion Manzo (1999). p. 251.
33 Jennifer Lawler (2003). p. 204.
34 Cezar Borkowski & Marion Manzo (1999). p. 154.
35 Cezar Borkowski & Marion Manzo (1999). p. 114. / See also, Jennifer Lawler (2003). p. 199.

mimicked the fighting movements of animals such as the tiger, snake, monkey, crane, and so on and insects such as mantis and mythical beings such as the dragon and phoenix.[36]

Monkey boxing

Tai Sing (Monkey style) It is known for its tumbling and rolling techniques, so artists must be flexible and agile. Kao Tze, who watched monkeys play fight, is the founder of this style. He discovered that the monkeys used five basic fighting patterns, and he attempted to duplicate them in his style.[37]

f) Choy Li Fut

This popular style was founded by Chan Heung in 1836 and originated from Shaolin kungfu. It is one of the comprehensive kungfu styles that combines northern and southern characteristics: power, speed, and balance. Its *kune* (forms) also include both Internal and External styles; the practitioner's hand is supposed to be like a rock—solid and strong and mature students begin to develop chi (internal energy). There are more than 100 forms in both unarmed and armed format and each form contains at least 100 movements. As a secret society, Choy Li Fut trained martial artists to fight against the imperial Manchurian army of the last Ching Dynasty in China. Coy Li Fut schools teach a full-contact combative style and some of its practitioners are formidable in martial arts competitions.[38]

2) Weapons

What is a weapon? A weapon can be considered any means used against an adversary. In general, weapons are considered to be implements used in combat, such as a sword or a staff.

Historically, the Chinese martial artist would carry at least three weapons: One was primary, another was hidden, and the third was a dart. All were useful for differ-

36 Cezar Borkowski & Marion Manzo (1999). p. 150.
37 Jennifer Lawler (2003). p. 200.
38 Jennifer Lawler (2003). pp. 200–202.

ent self-defense needs. The Chinese martial artist would be most skilled in the use of the primary weapon, such as a sword; he would keep a hidden weapon (such as a dagger tucked in the belt) to respond to surprise attacks; and he would carry a dart weapon (such as a sleeve arrow) for in-close fighting or for long-distance attacks.[39]

Chinese weapons are still used in kungfu styles, mostly during the performance of kune (forms). Dozens of weapons are practiced in Wushu. Some styles only use one or two, while other schools have many weapons in their arsenals, and sometimes several routines for each weapon. Pairs of Chinese broadswords are most often seen.

The primary weapons are the staff, spear, broadsword, and straight sword. Others can be grouped into single weapons like the tiger fork, double weapons like the deer-horn knives, and flexible weapons like the nine-section whip chain.

Weapons are divided into categories, such as bladed, stick/staff, projectile, and composite.[40]

a) bladed weapons

They include swords, knives, and halberds, all of which do damage through the use of the blade. Throwing weapons are not included in this category even if they have blades.

Daoshu (broadswords) Daoshu with one cutting edge has been a favorable weapon in China. Daoshu are still used in many Chinese martial arts forms. Daoshu, which are quite heavy, were used for horse-to-horse fighting.

Cern do (double sabers) Cern do promote coordination and ambidexterity. Cern do are a spectacular weapon as a trained practitioner keeps alternating each blade from a cut to a block in a windmill-like figure-eight pattern.[41]

Quando (or kwando) Quando is the north-

Daoshu Quando

39 Jennifer Lawler (2003). pp. 205–206.
40 Jennifer Lawler (2003). p. 160.
41 John Corcoran & John Graden (2001). pp. 243–244.

ern Chinese version of the European knight's halberd. Manipulating this heavy, oddly balanced weapon requires considerable strength and balance to maintain one's equilibrium. It was traditionally viewed as a great test of strength and kungfu skill.[42]

b) sticks and staffs

They are for blocking and striking. Spears and lances, which have long shafts, are considered part of this category even if they have a blade.

Wing Chun pole Wing Chun pole is a staff between nine and thirteen feet in length and it helps teach the correct use of the elbow, which, in turn, generates leverage and power. As a practical matter, the wing chun pole is too long and unwieldly to be a true combative weapon. However, it becomes an asset in strengthening a practitioner's arm and teaching optimal body alignment.[43]

c) projectile weapons

They are thrown or shot at a target, such as arrows.

d) composite weapons

They combine qualities of the preceding categories or achieve their means in an entirely different way. Weapons, such as chain whips, fall under this category.

Three-section staff

Three-section staff Three-section staff is a classical northern Chinese weapon which combines the offensive and defensive attributes of the staff and whip chain. Comprised of three pieces of hardwood, each slightly more than two feet in length and joined by short sections of chain. The three-section staff can be swung like a whip yet still impart the solid, bone-breaking impact of a staff.[44]

Chain whip Chain whip is made of chain links, which can be coiled and easily hid.

42 John Corcoran & John Graden (2001). p. 248.
43 John Corcoran & John Graden (2001). pp. 250–251.
44 John Corcoran & John Graden (2001). pp. 238–239.

You can strike, wrap, or sweep with a chain whip to block and disarm an opponent, much like a sword or staff does.

3) Techniques

Because so many styles exist, showing basic techniques common to all of them is impossible. In general, kungfu styles teach postures (stances), guards, blocks (which are often called "deflections" because they merely redirect the opponent's energy and are not full-power blocking techniques), fist attacks, and foot attacks.[45]

Although most people first think of the various weapons and unique hand formations, kungfu has a decided level of grappling techniques, throws, joint locks, and vital point striking within each style or form. The skills of *shuai-jiao* (Chinese wrestling) are very similar to Japanese Judo. The Chinese skills of *qinna* (or chinna) are very similar to Japanese jujutsu in the application of their controlling, choking, and joint-locking techniques.[46]

4) Training Methods

Because the art of kungfu is centuries old, practitioners have used many traditional training methods. Many styles use some type of conditioning methods while others use training devices such as sandbags, weights, and liniments. Also, a variety of other methods are found in the kungfu system. Some are still popular today and some have been abandoned for their dangerous uses. These methods are still in use:

Pai Shen It is a special body-conditioning exercise. Its method is to slap one's body with some degree of force in order to condition it to absorb strikes or impacts during combat.[47]

Iron hand or iron palm It is an extensive conditioning program to toughen the hand and enable a practitioner to use the hand as an awesome weapon. This exotic

[45] Jennifer Lawler (2003). p. 208.
[46] John Corcoran and John Graden (2001). p. 114.
[47] Jennifer Lawler (2003). pp. 112 & 114.

training method is particularly applied to the bare-handed breaking of objects.[48] Practitioners strike square bags filled with rice, beans or pebbles to condition their hands and arms.[49]

Chi Sao (Sticky hands) This Wing Chun exercise involves two people facing each other. They place their wrists and forearms together and then move their wrists in small circles, maintaining physical contact at all times. This exercise helps develop agility so that a practitioner learns to predict the opponent's next move. The partners work faster and faster, challenging each other to focus only on the experience at hand.[50]

Mookjong (Wooden training dummy) The Wing Chun wooden training dummy consists of an approximately human-size, upright post with various projections extending from it. Two projections resemble arms, and one resembles a leg. Practitioners use them to improve their blocking, catching, striking and kicking skills, as well as their timing and coordination.[51] Other projections may be placed at the midsection so that the different techniques can be attempted at various target areas. The training dummy allows you to use your techniques full power, and helps you toughen your muscles and bones.[52]

Jabbing the hands into beans

Mon Fat Jong This training dummy is the luxury edition: Springs recoil when you strike it so that you can see if you applied your techniques correctly and so that you can determine how much power you are generating.[53]

48 John Corcoran and John Graden (2001). p. 112.
49 Cezar Borkowski & Marion Manzo (1999). p. 157.
50 Jennifer Lawler (2003). pp. 199 & 205.
51 Cezar Borkowski & Marion Manzo (1999). p. 158.
52 Jennifer Lawler (2003). pp. 205.
53 Jennifer Lawler (2003). p. 205.

Chi Shing Chung (Striking posts) To build leg strength and to condition the legs, posts are sunk into the ground. The marital artist kicks them, eventually building enough muscle and conditioning his legs so that the artist can break the post with a kick.[54]

Mei Hwa Chuang They are posts that are driven into the ground and practitioners perform his techniques on the top of the posts. Performing a form or executing various techniques on the top of the posts enhances his or her balance and agility.

Chashi (Weight equipment) The chashi is a heavy block with a handle that builds arm strength. Traditional Chinese martial artists use it like a free weight.

5) Competition

Since wushu was demonstrated for the first time in the West at the 1936 Berlin Olympics, wushu appeared in the Asian Games as a competitive event numerous times. Now, the Pan American Wushu Federation is planning a campaign to have wushu included in the Pan Am Games in the near future.[55]

There are three distinct categories of events contested in a Wushu tournament.

The first category is competition *taolu* (routines), which include *changquan* (long fist), *nanquan* (southern fist), *taijiquan* (tai-chi fist), *daoshu* (broadsword play), *jianshu* (sword play), *gunshu* (staff play), and *qiangshu* (spear play). There are both compulsory and optional routines in various tournaments. Sometimes added are *nandao* (southern sabre), *nangun* (southern staff), and *taijijian* (tai-chi sword play). Competition routines have been created for four major styles of tai-chi boxing as well, including chen, yang, wu, and sun styles.

The second category, exhibition taolu, includes routines of other types, such as two-or three-person sparring routines, group routines, traditional boxing styles, and traditional weapons routines. Some tournaments open separate divisions for each of these. For example, they have a flexible weapons division for three-sectional staff, nine-sections whip, rope, dart, and so on.

Third, sanshou, also called sanda, is full-contact free-sparring according to vari-

54 Jennifer Lawler (2003). p. 206.
55 John Corcoran and John Graden (2001). p. 192.

ous rules. The bout takes place on a padded platform, and contestants win points for throws, strikes, and kicks, and knocking the opponent either off the platform or unconscious.[56]

Also, one category of competition in formal martial arts competitions in China is called *xiangsingquan*, or "imitative boxing."[57] The routines in this division include eagle claw boxing, praying-mantis boxing, monkey boxing, tiger boxing, snake boxing, *ditang* (tumbling) boxing, and drunken boxing.

6) The Grading and Belt System

Traditionally, most Chinese styles did not use belt-ranking systems. Since the late 1990s, and especially in Western countries, colored sashes or cotton belts have become very common in many schools. Ranking has been a welcome addition to the modern Chinese martial arts.[58]

However, many traditional teachers still avoid the ranking system entirely. Therefore, in many schools the level of ability does not reflect someone's ranking. The best thing to do is to work hard over a long period of time without inactive intervals. This is the only way to achieve kungfu.[59]

3. History

1) Origin

One can trace the roots of Chinese martial arts back to 3,000 B.C.[60] Over the thousands of years, hundreds of Chinese martial arts have been practiced and developed. Most

56 John Corcoran and John Graden (2001). p. 192.
57 John Corcoran & John Graden (2001). p. 114.
58 John Corcoran and John Graden (2001). p. 105.
59 John Corcoran and John Graden (2001). p. 115.
60 Cezar Borkowski & Marion Manzo (1999). p. 150.

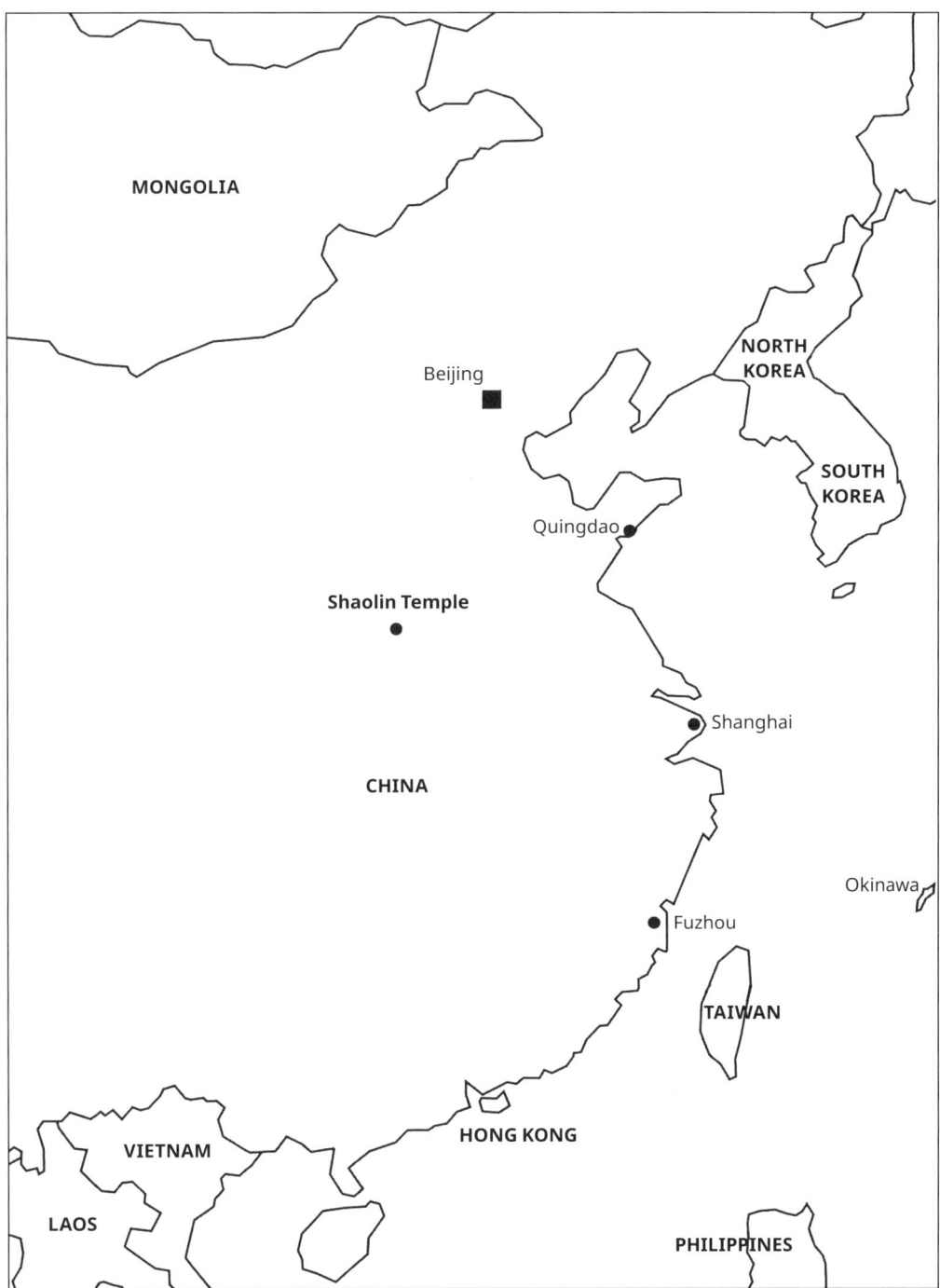

East China and environs

of them fall under the name kungfu (功夫), wushu (武術), or chuanfa (拳法).

Throughout its history, China fought off invaders and struggled with internal divisions. It is not surprising that methods of self-defense and even of attack were developed throughout the centuries of conflict.

During the Warring States period (春秋戰國時代: 475–221 B.C.), violence erupted throughout the country. The population of China at the time was estimated to be between 50 and 60 million. The war lords of various states launched military campaigns against their neighboring states to feed their subjects: tribe against tribe, nation against nation. At the time, many thousands of ordinary peasants and merchants learned martial arts techniques to protect themselves. Martial arts were no longer a privilege of the warrior class.

A freelance martial artist, Liu Pang, unsatisfied with the state of the country, became the leader of an army of like-minded followers. With a little help from his army, he overthrew the emperor and established himself as the first emperor of the Han Dynasty in 202 B.C.

During this era, a doctor, Hua-to, created a series of exercises based on the movements of animals. These exercises are thought to be the origin of many kungfu animal styles.

a) legendary Indian monk, Bodhidharma

According to the oral tradition, the legendary Indian monk Bodhidharma (Damo in Chinese) was invited to China by the emperor Wu Di in A.D. 527. The monk Bodhidharma (A.D. 460–534), who was believed to be the founder of Chen Buddhism (Zen in Japanese), was traveling throughout Asia to promulgate his religious doctrine at the time. After journeying throughout China, Bodhidharma came upon the Shaolin (Young Forest) Temple in Henan province in about A.D. 502.[61]

He found the monks at the Shaolin Temple very weak and sickly since they meditated a lot and exercised very little if at all. Thus, he decided to teach martial arts to the monks. Based on his experiences in India as a member of the Kshatriya cast (warriors), it was said that he wrote three instructional books on health and physical fitness for the monks.

His first book, *Yi Jin Jing* featured exercises to help monks develop external strength. Si Sui Jing was about meditation, breathing, and circulation, and Shi Bao

61 John Corcoran and John Graden (2001). p. 20.

Luo Han Shou (The Eighteen Hands of Lohan) consisted of choreographed defensive routines called kune (pumsae in Korean taekwondo and kata in Japanese karate).[62] The last book is believed to be the first manual of its kind in martial arts history. These books helped spread Chinese martial arts. Even if Chinese martial arts had been well-established before the arrival of Bodhidharma, it is true that at the Shaolin Temple monks learned and taught the martial arts.

There are few written records about Bodhidharma's life and death; therefore, his influence on the development of martial arts is mostly based on speculation. While his contribution to Chinese martial arts is largely based on educated guesses and interpretation, the role of the Shaolin Temple—more precisely Temples—is rooted in fact. This is why the Shaolin Temple located in the Henan province of China is considered the birthplace of today's martial arts.

b) one Shaolin Temple or many Shaolin Temples?

There were several Shaolin Temples across China. The most outstanding temples in the development of martial arts are the ones in Henan province in the north and the other in Fujian province in the south. The former was built in A.D. 495. by order of the emperor Xiao Wen during the Northern Wei Dynasty (A.D. 386–534). Since then, martial arts have been practiced there.[63] There is no recorded date for the construction of the latter.

In A.D. 621, the monks in the northern Shaolin Temple played a crucial part in overthrowing the government of the Sui Dynasty. Recruited by Li Shi-ming the first emperor of the Tang Dynasty, thirteen monks succeeded in toppling the old regime and established the new dynasty. In return, they receive a vast piece of land from the emperor and they were asked to train his soldiers. In its early days, the Shaolin monks made up a formidable army that was used by the emperor for both training purposes and warfare. This army of monks was said to number five thousand at one time.[64] Since then the Shaolin Temple in Henan became a center of political unrest and intrigue.

During the Manchurian rule of China (A.D. 1644–1911), the Shaolin Temple was burned down several times. Calls to "Overthrow the Qing and Restore the Ming" gave rise to Chinese nationalism and secret societies were organized against the tyranni-

62 Cezar Borkowski & Marion Manzo (1999). p. 152.
63 John Corcoran and John Graden (2001). p. 20.
64 John Corcoran and John Graden (2001). p. 20.

cal control by outsiders. The Shaolin Temple was also affected by this sentiment. The temple provided a sanctuary for resistance fighters during the early Qing Dynasty. The monks at the temple trained martial arts to the rebels. The ruling dynasty began to view the monks at the Shaolin Temple as a threat.[65]

In 1674, government soldiers burned the temple down. Many monks were executed and many not wishing to meet that fate fled the monastery and took their martial arts with them. Among the monks who fled the monastery in Henan province was Fang Zhonggong (also known as Fang Huishi), a master of Eighteen Monk Fist Boxing. Fang traveled as far as Fujian province in the southern part of China. Fujian is the closest province to Taiwan and there is a trading port named Fuzhou, the gateway to the Ryukyu islands (now Okinawa). Most reports say that Fang Zhonggong was the father of Fang Qiniang, the girl who grew up in Yongchun Village, Fujian and later developed Yong Chun White Crane Kung Fu.[66]

Along with Five Ancestors Kungfu, Monk, Dragon, and Tiger Fist Boxing, Fang Qiniang's White Crane would leave some influence on the development of kungfu styles in and around Fuzhou. One of these styles later served as the source for Goju-ryu Ryukyu (Okinawan) Karate.[67] However, the monks like Fang Zhonggong who fled the Ching Dynasty's persecution continued to teach martial arts across the country and even abroad.[68] This is how Chinese martial arts spread across China and throughout other parts of Asia.

Throughout Chinese history, kungfu styles were developed and passed along in secret. Kungfu was a secret practice because the motivation behind it sprang out of political or religious groups that were in opposition to the existing government as it was in the case of the Shaolin Temple. Although the Shaolin Temple has been destroyed and rebuilt on a number of occasions over the centuries, it is still in existence today and is now a popular tourist attraction. Monks are still trained in martial arts there.[69]

c) Wu Dang Shan, the other Temple

While the Shaolin Temple was the place to be for Buddhists and martial artists who

65 Cezar Borkowski & Marion Manzo (1999). p. 153.
66 Patrick McCarthy (1995). The Bible of Karate: Bubishi. Tuttle Publishing. p. 30.
67 Patrick McCarthy (1995). pp. 31–32.
68 Cezar Borkowski & Marion Manzo (1999). p. 153.
69 John Corcoran and John Graden (2001). pp. 20–21.

practiced external styles, their internal counterpart was the Wu Dang Shan monastery. This monastery consisted of more than 100 buildings along 72 peaks in Hubei province in central China. It was a hot spot for Taoists and followers of internal kungfu styles.[70]

As the fame of the Shaolin Temple and its martial monks increased, Wu Dang warriors began to suffer from an inferiority complex. They were jealous that their monastery was regarded as the "other" martial temple. The emperor Qian Long (1737–1795) exploited this rift. In fact, most of the army that burned the Shaolin Temple consisted of Taoists from the Wu Dang Shan monastery.[71]

It is believed that either Zhang San Feng or his disciples brought Tai Chi to the Wu Dang Shan monastery in the mid-fifteenth century. The monastery was the mecca for practitioners of internal styles for three centuries.

d) secrecy of Chinese kungfu

Kungfu was a way of protecting the Chinese nationalists in the event that they would be harassed or arrested by official decree. Little information on kungfu was written down and public demonstrations of kungfu were few and far between. Many styles may still remain secret due to political suppression or have been lost forever because they were not passed down. Secret societies trained the Chinese boxers (martial artists). The martial arts was a means to advance their political, religious, and even criminal aims. Some of these secret societies still exist

2) Modern Era

Over 400 different kinds of kungfu exist today. The kungfu types are all different from each other. Many styles of kungfu came with Chinese immigrants to America in the nineteenth and twentieth centuries. This was especially true after the suppression of the Boxer Rebellion (1900), and thousands of Chinese martial artists were forced to flee their country. Probably, the first kungfu practitioners in mainland America were the Chinese laborers who were imported to work in the gold rush camps in 1849. Although many qualified kungfu instructors were probably among these immigrants, they practiced their arts in secret and kept their knowledge exclu-

70 Cezar Borkowski & Marion Manzo (1999). p. 248.
71 Cezar Borkowski & Marion Manzo (1999). p. 248.

sively to themselves.[72]

At first, Chinese teachers continued to keep their arts secrets, teaching their methods to only a select few students who had proven to be ethical and trustworthy individuals. They refused to teach non-Chinese students for the good reason that the Chinese were already seriously oppressed, and giving the outsiders yet another tool of oppression would be foolish. But over time, this changed, and many non-Chinese began to learn and teach kungfu.

It was not until the late 1950s that kungfu was first taught to the American public. Three Chinese instructors opened their doors to all races. The first was, most likely, Jimmy H. Woo, who opened a kungfu school in El Monte, California, in 1959. Around the same time, Bruce Lee started teaching a small group of students in Seattle, Washington. Ark Y. Wong opened his Five Animals Kungfu School in Los Angeles, California, in 1964.[73]

It is martial arts superstar Bruce Lee who is credited with launching the kungfu craze of the 1970s. Initially, he was a Wing Chun practitioner for many years. He felt that it was somehow incomplete as a fighting system. He was purely interested in the defensive aspects of martial arts, so he developed a system of fighting that was, in essence, tailored by each individual to suit his needs. He advocated learning from many different martial arts and keeping only those techniques and tactics that work well for him. Finally, he founded Jeet Kune Do. Along the same lines, many martial artists begin training in a traditional martial art and then alter or modify it to better suit their needs.

It is estimated that there are now over 2,500 Chinese martial arts schools in the United States. Many non-Chinese martial arts schools and even fitness gyms have incorporated tai-chi programs into their existing curriculums.[74] Three major groups promote Chinese martial arts in the United States: the U.S.A.-Wushu Kung-Fu Federation, headed by Anthony Goh; the U.S. Chinese Kuo Shu Federation, led by Huang Chien-Liang; and the United Kung-Fu Federation of North America, directed by Wai Hong.[75]

Kunfu is not an internationally organized sport. Two major organizations, the International Wushu Federation (IWF) in Beijing and the International Chinese

72 John Corcoran and John Graden (2001). p. 9.
73 John Corcoran and John Graden (2001). p. 10.
74 John Corcoran and John Graden (2001). pp. 104–105.
75 John Corcoran and John Graden (2001). p. 109.

Kuoshu Federation in Taiwan, are in the process of developing an international body of countries to create world-class competition. The IWF has made substantial progress. Its congress contains over fifty-five countries and regions as members, and it has a working relationship with the International Olympic Committee. Most Chinese-style practitioners have high hopes that one day wushu will be included in the Olympic Games.

Reference

Books

Borkowski, Cezar and Manzo, Marion (1999). The Complete Idiot's Guide to Martial Arts. An Alpha Books/Prentice Hall Canada.

Corcoran, John and Graden, John (2001). The Ultimate Martial Arts Q & A Book. Contemporary Books.

Lawler, Jennifer (2003). Martial Arts for Dummies. Wiley Publishing, Inc.

McCarthy, Partrick (1995). The Bible of Karate: Bubishi. Tuttle Publishing.

Karate
Okinawan Empty-hand Art

What is Karate?

Definition
Philosophy and Goal
Techniques
Training Methods
Competition
Grading and Belt System

Styles

Old Styles
New Styles

History

Origin
Modern Era
Karate in the World

1. What is Karate?

1) Definition

The original term *kara-te* (唐手), meaning "Tang or China hand," was used to describe the indigenous martial arts of the Ryukyu Kingdom. (Since the Kingdom was annexed by Japan and became a prefecture of Japan in 1879, its name was changed to Okinawa.) The Ryukyu reading of the Chinese character for kara-te is *toudi*.[1] In short form, it is called *di* and more commonly *te* in Japanese.[2]

Although kara-te (toudi) is famous as a martial art from mainland Japan, it actually originated from Okinawa.[3] It was originally a blend of Chinese martial arts and indigenous Ryukyu fighting arts. The roots of the Ryukyu's indigenous martial arts can be traced back to as early as the 6th century. They emphasized striking arts such as hand and foot strikes including blocks, evasive movements, and basic grappling techniques.[4]

In 1933, however, the accepted translation for kara-te as "Tang or China hand" was changed to "empty hand" by Funakoshi Gichin, the founder of modern karate.[5] Funakoshi adopted the word "empty" (空) in replacement of "China" (唐) since the words, China and empty both are pronounced the same in the Japanese language. This was how "China hand" became "empty hand" literally meaning "bare-handed" martial art. In early 20th century, Japan was technically at war with China. In the eyes of the Japanese authority, the "China hand" was not tolerable

The Chinese characters for *toudi-jutsu* and karate-do

1 Patrick McCarthy (1995). The Bible of Karate: Bubishi. Tuttle Publishing. p. 34.
2 Patrick McCarthy (1995). p. 32.
 See also, John Corcoran & John Graden (2001). The Ultimate Martial Arts: Q&A Book. p. 3.
3 Jennifer Lawler (2003). Martial Arts for Dummies. p. 18.
4 Patrick McCarthy (1995). p. 44.
5 Jennifer Lawler (2003). p. 184.

and it was not appealing to the Japanese public.[6] The new translation, however, is a little misleading in the sense that karate does teach the use of weapons.[7]

2) Philosophy and Goal

The philosophy of Karate began to be developed as early as late seventeenth or early eighteenth century. Teijunsoku Uekata (1663–1734), a scholar of Chinese classics, a statesman from Ryukyu's Nago district, and a practitioner of di, said, "No matter how you may excel in the art of di and scholastic endeavors, nothing is more important than your behavior and your humanity as observed in daily life."[8] This early saying indicates that early karate practitioners cared about the philosophical or spiritual aspects of karate.

Funakoshi Gichin, the founder of modern karate also stated the philosophical properties of the martial arts as follows: "The ultimate aim of *karate-do* does not lie in victory or defeat, but in perfection of the character of its practitioners."[9] He also said, "There is no offense in karate." He continued, "You should never raise your hand against your opponent first. Only when it becomes absolutely necessary should you raise your hand. And even then, your intention should not be to kill or injure your opponent but only to block his attack. If he (attacker) continues, then you should take a stance that will clearly show that it would be best for him to stop."[10]

From these sayings, we can conclude that the ultimate goal of karate that Funakoshi had in mind is that it was not to be used in actual fighting but rather laid in peace keeping, controlling the self and character-building purposes.

According to Egami Shigeru, who has learned karate under both Funakoshi Gichin and the master's third oldest son Funakoshi Gigo, says, "… the sad truth is that many styles (of karate) teach only the fighting art and neglect the spiritual aspects. And the practitioners themselves, who offer lip service to the spirit of the art, have as their real objective the winning of matches. They speak of fostering an indomitable spirit, which in itself is praiseworthy, but we have to think of the results if this spirit

6 Jennifer Lawler (2003). p. 18.
7 Jennifer Lawler (2003). p. 194.
8 Patrick McCarthy (1995). p. 32.
9 John Corcoran & John Graden (2001). p. 53.
 Also see, Cezar Borkowski & Marion Manzo (1999). The Complete Idiot's Guide to Martial Arts. p. 177.
10 Shigeru Egami (1976). The Heart of Karate-do. p. 15.

is improperly used. As in the case of a hoodlum or madman wielding a knife, gun or other weapon against innocent people, the results could only be disastrous."[11]

In the above saying, Egami is regretful about the present situation in which karate is becoming a competition sport and winning the match takes precedence over the spiritual aspect of karate. He continues that the underlying purpose of karate is neither to pursue its fighting techniques nor to appeal to man's fighting instinct which is "no less common in humans than in other animals."[12] Egami Shigeru concludes, "In a contest, it is natural for the strongest to be the victor, but a contest is only a contest. In karate-do, there is neither strong man nor weak man. The essence of the art is mutual cooperation. This is the ultimate (aim) in karate-do."[13]

The ultimate goal of karate practice is to build the practitioner's understanding of other people's position, compassion and patience along with his or her mastering skills of blocks, strikes, and kicks. It means that *karate-ka* (those who practice karate) should learn to coexist with his or her opponent (attacker) and understand the fact that "human beings were made to cooperate with each other... Practice will never be complete until this state of mind is achieved."[14]

This philosophy lying behind the practice of karate can be specifically achieved only when the karate-ka realizes "that body and spirit are not two things but one."[15] Jennifer Lawler in her book, *Martial Arts for Dummies* more systematically defines making the connection between mind, body, and spirit as follows:[16]

> Mind: Learn concentration, focus, and self-discipline.
> Body: Become more fit and you learn to defend yourself.
> Spirit: Try to live in harmony and balance with the world around you.

In short, karate is a unique self-defense and self-perfection program which can help you improve yourself physically, mentally, and spiritually.[17]

11 Shigeru Egami (1976). p. 13.
12 Shigeru Egami (1976). p. 13.
13 Shigeru Egami (1976). p. 14.
14 Shigeru Egami (1976). p. 15.
15 Shigeru Egami (1976). p. 15.
16 Jennifer Lawler (2003). p. 186.
17 Cezar Borkowski & Marion Manzo (1999). p. 192.

3) Techniques

Although karate has many different styles or schools, each emphasizing different approaches to fighting, most kinds of karate share some similarities. For example, all styles teach stances, blocks, punches, and kicks.

a) stances

Stances in karate provide the foundation for all techniques. The stance is your base where your power comes from.

Low stance This stance (one with the knees more bent) gives more stability while a high stance (one with the knees less bent) gives more mobility. How high or low your stance depends on what you are trying to accomplish. For example, in kata training, low stances allow you to generate power and show your proper technique.

High stance In sparring, it allows you to generate speed and move into and out of range more easily.[18]

Attention stance (*musubi dachi*) This stance is performed with heels together and arms at your sides. It's used while listening to the instructor or before bowing to him or her. It puts you mentally and physically in the right position to start training.

Front stance (*zenkutsu dachi*) The legs are kept about a shoulder's width apart in the front stance. Both feet face forward. The front leg is bent at a 90-degree angle. The back leg is kept straight. The front leg bears much more weight than the back leg.

Back stance (*kokutsu dachi*) This stance is often used in sparring. A side-facing stance, it is performed by pointing one foot forward and the other at a 90-degree angle to it—pointing to the side. Most of the weight is on the back leg.

Hourglass stance (*sanchin dachi*) In this stance, toes and knees are turned inward to give extra stability to the fighter. Not a mobile stance, this stance is mostly used in kata.

18 Jennifer Lawler (2003). p. 187.

Horse stance (*kiba dachi*) The horse stance is used in almost every style of martial arts, and in all cases, this stance is one of the first stances taught to beginners. The knees are bent and feet are positioned parallel to each other with toes pointing forward in this solid stance. Weight is distributed equally onto both legs.

b) blocks

To block an attack, you simply use your arm to push the attack away. This prevents a kick or punch from striking to a more vulnerable part of your anatomy. A block is a sweeping motion designed to move an attacker's hand, foot, or whatever out of the way.

Upper block (*jodan uke*) Sometimes called a high block, in this technique, the arm comes up to protect the head and deflect a strike to the high target area of the body.

Crescent block (*soto ude uke*) In this technique, the arm moves from the outside to the inside to protect the midsection and sweep away any technique. When this block is performed from the inside to the outside, it's called uchi ude uke.

Downward block (*gedan barai uke*) In the downward block, the arm sweeps across the lower part of the body to defend against a kick to the legs.

Blocks use a twist of the wrist at the end of the technique in order to add more power and to ensure that the correct part of the arm meets the attack.

c) punches

In a Karate-style punch, you make your hand into a fist, chamber your arm at your waist with your elbow bent and your palm facing upward, and thrust toward the target straight from the waist, twisting your wrist as your punch lands so that your palm now faces down.

Boxers argue that punches should start from the shoulder—not the waist—but that is boxing, not Karate.

High punches are always performed at eye level, not over the top of someone's head; middle punches are always performed to the solar plexus (between the rib cage and the navel); and low punches are always performed to the groin.

Straight punch (*oi tsuki*) A straight punch is done on the same side as the forward leg in any stance. For example, if you are in a front stance with your left leg forward, then you would do a straight punch by striking with your left hand.

Reverse punch (*gyaku tsuki*) The reverse punch is done with the hand on the same side as the back leg in any stance. For example, if you're in a front stance with your left leg forward and right leg back, a reverse punch would be done with your right hand.

Knife-hand strike (*shuto uchi*) Knife-hand strike is done with an open hand. The palm and the fingers are kept straight, and the fingers are held tightly together. The thumb is bent, and the side of the hand is used as the striking surface.

Punching with your bare knuckles is different from punching with gloves or sparring gear on. If you bop or punch someone in the jaw with your bare knuckles, you are going to have some pretty swollen knuckles. Instead, strike to the softer parts of your attacker's anatomy, such as nose, throat, groin, or solar plexus—not the sternum or rib cage. Bone against bone breaks bones.

You can hit someone with pretty much any part of your hand. You can use the back of your hand, the back of your fist, and the palm of your hand.

d) kicks

Karate has five basic kicks. Kicks should be performed quickly and you pull your leg back as fast as possible so that your opponent does not grab it and dump you on your head.

Front kick (*mae geri*) To perform a front kick, chamber your leg (bending it at the knee) and thrust your leg directly forward. You strike with the ball of your foot.

Roundhouse kick (*mawashi geri*) The roundhouse kick sweeps from the side to a low, middle, or high target, using the instep or ball of your foot as the striking stance.

Side kick (*yoko geri*) The side kick is done by chambering your leg, pivoting on your supporting foot, and striking with the heel or edge of your kicking foot.

Back kick (*ushiro geri*) The back kick is also called the reverse kick, the turn-back kick, or the reverse-side kick. To do it, you pivot backward on your supporting foot, chambering your kicking leg as you turn, and then strike out with the heel of your kicking foot.

Crescent kick (*mikazuki geri*) This kick does not require a chamber. You simply swing your leg up and to the inside (or outside) and then sweep your leg across and down. The heel or the ball of the foot can be used to strike the target.

e) smashes

You can also use your knees and elbows to strike your opponent in Karate. These techniques are often called smashes. Essentially, you just smash your knee or elbow into a soft portion of the opponent's anatomy such as the underside of the jaw, the groin, or the solar plexus.

f) sweeps, throws, and takedowns

Karate also teach the use of the following techniques:

Sweeps: You sweep the opponent's legs out from under.
Throws: Pushing or pulling the opponent off his feet.
Takedowns: Any other method of forcing the opponent to hit the deck.

Sweeps, throws, and takedowns are sometimes allowed in Karate competitions. You do not necessarily have to be bigger than your opponent to knock him to the floor. You just have to apply the correct leverage at the right time. These techniques are also extremely effective in self-defensive situations.

g) weapons (*kobudo*: "ancient warrior ways")

In the old days, swords, the weapons for samurai were forbidden to commoners such as merchants and farmers. Thus, they learned to use anything that they could get their hands on as weapons. In addition to hand-to-hand self-defense techniques, the natives in the Ryukyu Kingdom (old Okinawa) practiced their traditional Karate weapons. The Japanese overlords of Okinawa could not ban simple farming tools.

Since the weapons of Karate are very unusual, using them effectively requires special training. There are special kata for weapons and they show the correct use of

the weapons. Some empty-hand techniques are closely related to the weapon training and they are prerequisites of the traditional weapons. Practitioners need to identify which empty-hand skills can also be done with which weapon. There were five main commonly used Ryukyu (Okinawa) weapons some of which are still taught in Karate as follows:

Nunchuku It came about when the natives of Ryukyu (now Okinawans) were banned from possessing weapons. The nunchuku or nunchuk is based on the rice flail which was actually used for threshing rice.[19] This flail consists of two short pieces of wood about eighteen inches long attached with a short length of rope or chain. It can be used to crush, poke, or jab.[20]

Tonfa Originated in Okinawa, this two-foot baton with a handle attached at a right angle to it was originally a crank or handle on a hand mill that was used to grind rice. It can be used to strike and thrust and used against the sword or to defend against other sticks.[21] The modern-day side handle batons used by police officers descend from the early tonfa.[22]

Tonfa

Sai The sai is a tool used to make furrows in the ground for seed planting. It was a pronged truncheon with a main stem about fifteen to twenty inches long and tapered to a sharp point. On both sides of the main stem are shorter prongs that are about three inches long and two inches apart from the main prong. The sai could be used to strike or stab. The

Sai

19 Jennifer Lawler (2003). p. 16.
20 Jennifer Lawler (2003). pp. 161 & 164.
21 Jennifer Lawler (2003). pp. 17 & 164.
22 John Corcoran & John Graden (2001). p. 6.

shorter prongs could also be used to catch a sword blade or spear shaft. At times, the sai was also thrown like a knife.[23]

Kama The kama was a sickle-type bladed tool used to cut rice or other grains. It has a heavy hardwood handle of about twenty inches or more with slightly curved blade affixed near one end. In combat, kama were used with powerful slashing movements. Kama were effective against long-range attacks such as those from the staff, since the rear kama could be used to block while the front sickle slices or hooks an opponent's head or arm. Traditional kama kata consists of focused blocking, striking, and slicing motions.[24]

Bo

Bo and jo The bo staff is five or six feet long. The much shorter jo staff is really a stick. Bo and jo are used to thrust, strike, and sweep.[25]

In many schools, weapons like the bo or the nunchaku are a part of the curriculum. Other instructors, however, prefer to exclusively teach empty-hand techniques.[26]

4) Training Methods

A karate-ka is a person who practices karate. An instructor is *sensei*. The karate training hall is called a *dojo*. The uniform is *gi*, and the belt that keeps it closed is *obi*. If several schools are organized under one head instructor; the main training hall is called the *hombu dojo*. A head instructor of a group of schools is *shihan*.

An essential component of karate training is kata which is a set of techniques

23 John Corcoran & John Graden (2001). p. 6.
24 John Corcoran & John Graden (2001). pp. 253–254.
25 Jennifer Lawler (2003). p. 163.
26 John Corcoran & John Graden (2001). p. 73.

prearranged like a formula by a number of renowned sensei. There are various types of kata from basic to advanced forms corresponding to the school's curriculum and ranking system. From kata practice, karate-ka not only learn to do different techniques but also to connect them together. The goal of kata practice is, therefore, to help karate-ka develope the flow of movements with grace and agility.

As a beginner, you will likely perform *ippon kumite* (one-step drills) from which you are taught to block and counterattack. Arond the sixth month of training, you may begin participating in a more impromptu version of these exercises called *jiyu kumite* (free sparring).[27]

Another key training technique is *tamashiwara* which involves breaking boards, concrete blocks, and bricks. In addition to helping you develop speed, focus, and power, tamashiwara can also assist you in overcoming your fears and provide a sense of empowerment that can be transferred to other areas of life.[28]

Some instructors agree with the legendary remark of Bruce Lee, "Boards don't hit back," and they do not spend much time on this aspect of karate. Breaking of boards and bricks is a very small part of karate practice. However, it can be a good confidence-builder and looks good in a demonstration showing what a martial arts blow can do.

Punching-bag, focus-pad training (using small or large hand-held targets), and *makiwara* (post striking) practice depending upon the type of karate or school can improve your reaction time and power.

In the past, karate-ka conditioned their bodies using various painful techniques. They struck makiwara boards (padded striking posts) with their hands to condition them. The makiwara was a training device used by the Okinawan karate artists which was a 4" x 4" board that was tapered from bottom to top. The wider part was sunk into the ground and the narrower top was left at shoulder level. The top 12" or so were then wrapped with straw rope. The practitioners would then strike this board several times a day to toughen all the striking surfaces of the body such as knuckles, balls of the feet, and sides of the hands. Since the board was tapered, it would bend, giving just enough resistance to toughen the striking surface and improve strength.[29]

27 Cezar Borkowski & Marion Manzo (1999). pp. 191–192.
28 Cezar Borkowski & Marion Manzo (1999). p. 192.
 See also, John Corcoran & John Graden (2001). p. 74.
29 John Corcoran & John Graden (2001). p. 5.

One of the most common myths attached to karate is the "one punch" kill. No one knows where it originated. Perhaps it started with primarily Okinawan karate-ka, who intensely conditioned their hands by striking progressively harder and coarser objects until they developed a grotesque mass of calluses and calcium deposits that grossly enlarged their knuckles. Tales of Okinawan karate masters killing an attacker with a single blow from these ironlike fists were widely circulated for decades.[30]

Today, the practice of conditioning the hands is considered "prehistoric" and entirely unnecessary in the process of becoming adept at karate. Furthermore, it has been known to cause premature acute arthritis of the hands.

5) Competition

In October 1957, the first Karate-do Tournament was held in Tokyo by Masatoshi Nakayama with the competitions in kata and kumite and used the JKA rules. Currently, there are many competition rules and new standards such as those of WKF, AKF, ISKF, JKA, JKF, and so forth. However, JKF rules are still the base of all standards.[31]

Not all karate students train to compete in tournaments. However, for some, karate tournaments can provide a forum for fostering new ideas and friendships, exchange their martial arts knowledge and skills, and furthermore they can serve as valid barometers for assessing your martial arts skills in a relatively injury-free environment.

There are three popular types of karate competitions: Japanese, Okinawan, or North American.[32]

> ① In Japanese-based competitions, participants compete in four divisions: individual kata (form), kumite (sparring), team kata (three persons), and team fighting (five persons).
> ② Okinawan-based events are conducted in accordance with rules developed by leading karate masters and the Okinawan prefectural government. Contestants compete individually in kata, kumite, and kobudo (weapons) categories.

30 John Corcoran & John Graden (2001). pp. 24–25.
31 http:/Aaratethai.com
32 Cezar Borkowski & Maiion Manzo (1999). pp. 188–189.

③ North American-based tournaments feature a broader range of competitors. Divisions are usually broken down as follows: kata (open and traditional), kumite, and kobudo. Additionally, self-defense and tamashiwara (board-breaking) divisions are sometimes added.

a) rules of the competitions

Rules are slightly different from event to event. However, they are generally as follows:[33]

Kata Kata (form) is a choreographed set of martial arts moves performed without a partner, and it is the aesthetic aspect of Karate competitions. Forms competition is similar to a mix of Olympic gymnastic floor exercises. The moves are usually performed to music. After performing a form, you will receive scores on a ten-point system from a panel of judges. The highest score wins. In case of a tie, you may be required to perform another kata or your score might be recalculated by adding the highest and lowest scores that might have been eliminated. Forms competition also has separate weapons divisions.[34]

Kumite
(i) semi-contact

Most karate sparring competitions are semi-contact. Most commonly referred to as "point karate," the main objective in this type of competition is not to hurt the opponent, but to strike him or her with a controlled blow that could have caused damage if it was meant to do so.

Kumite

In semi-contact fighting, the rules are simple. You can score by tagging your opponent first with a kick or punch that touches specific targets. Generally, there is a referee in the center controlling the match and he or she has the power to issue warnings and penalty points without the

33 Cezar Borkowski & Marion Manzo (1999). pp. 189–190.
34 John Corcoran & John Graden (2001). p. 184.

consent of the other judges. Two to four judges positioned in different corners award a point to you by raising a flag (either a white or red depending on the corner you belong to).

Semi-contact matches consist of two minutes of actual fighting time. The first competitor to reach five points or the one with the most points at the end of regulation time, wins.[35] A point is defined as any legal technique that strikes the body (not the back), face, or head with control and focus. The level of contact is light to the head and medium to the body. Excessive contact to the face or head can result in a warning, loss of points or forfeiting of the match. No takedowns are allowed, but a person may grab an opponent's leg or arm for one second to offset his or her balance or to deliver a blow or kick.

After a technique strikes a legal target area, the referee stops the action and calls for a point. Then a majority vote from the judges determines if a point is awarded. In most tournaments, two points were awarded for a kick and one point for a legal hand technique. Safety equipment is mandatory at many competitions but some traditional tournaments would not permit you to wear any protective gear.

The nature of sport Karate's "pulled blows" often confuses spectators and leave them bewildered, wondering who scored what It is therefore difficult for viewers to determine who is winning a match. As a result, karate might never become a true spectator sport.[36]

(ii) full-contact

However, karate-do competition is different from the semi-contact of sport karate. Its rules and decorum are based on traditional Japanese and Okinawan karate. The bare-knuckled competitors are permitted to deliver full-contact punches or kicks to the body and controlled punches to the head. Full-contact kicks are also allowed to the head and sweeps, takedowns, and leg kicks are usually permitted as well. Some tournaments even allow kicking to the groin.[37] Unless a knockout occurs, the match is won by the first participant achieving three points.

Kobudo Like unarmed divisions, you receive scores from several judges and the highest sum wins.

35 John Corcoran & John Graden (2001). p. 183.
36 John Corcoran & John Graden (2001). p. 186.
37 John Corcoran & John Graden (2001). p. 187.

Self-defense Judges will score the efficacy of one or more self-defense routines.

Tamashiwara You and other competitors will receive scores for breaking one or more objects such as boards, concrete blocks, and bricks.

6) The Grading and Belt System

Karate is one of the martial arts that utilizes colored belts or "obi" to rank the students of the art. Each rank simply means that the individual has met whatever criteria that dojo has set for that rank. Students have to pass the tests required to verify the student's meeting of those criteria.

a) kyu

The ten levels below black belt are called kyu grades. Kyu signifies rank below black belt and karate-ka at different levels of kyu grades wear a different color belt or on some levels the same color belt with one or two stripes on it. The lowest rank, white belt, is 10th kyu. The next level is 9th kyu, and so on. The ranks of kyu go in decreasing order. The kyu grade system in Shotokan works as follows:[38]

Kyu Grade	Belt Colors
10th kyu	white
9th	orange
8th	red
7th	yellow
6th	green
5th	purple
4th	purple with white stripe
3rd	brown
2nd	brown with white stripe
1st	brown with two white stripes

[38] Kevin Healy (2000). Karate: A Step-by-step Guide to Shotokan Karate. p. 18.

b) dan

After reaching first kyu, the next rank is the black belt. The ranks of black belt is called *dan*. The ranks of dan go in increasing order, instead of the decreasing order of the kyu ranks. First degree black belt is referred to as "*shodan*," second is "*nidan*," and on up the Japanese numbering system. In general, as a karate-ka moves up in rank, it takes longer to reach the next rank.

c) grading

How long does it take for you to get a black belt? It generally takes most people roughly three to four years. The route to black belt in the Shotokan system of karate involves ten exams under a senior examiner. Clubs usually hold between three and four exams a year and one must wait a minimum of three months between exams. However, the gap between 1st kyu and black belt is at least six months to allow candidates plenty of time to prepare for this very special examination.

The examiner usually comes from outside his or her club. Each examination tests the practitioner's knowledge of basics, kata and kumite, and it is progressively longer and more physically demanding. He or she is also tested on elements from previous exams to make sure that the practitioner is constantly working on the basics. If one passes, he or she receives the next color.

Getting a black belt (shodan) indicates the practitioner has showed dedication and a good grasp of the basic techniques of karate. However, as is said in karate, "a (first degree) black belt is just the beginning."

d) cycle of learning

One will notice as he or she trains that often a "black" belt will have almost faded to white. This occurs when the silk in the belt wears away through years of training, revealing the white cotton beneath. As a result, very senior karate-ka can be seen to wear almost white belts. This colour change represents the evolution of the dan grade. For, as the belt becomes white, the true karate-ka realizes that he/she is always a beginner with new lessons to learn.

2. Styles

Martial historians estimate that, until the seventeenth century, there was one form of China hand combat called di or te which means "hand" in Ryukyu. Weapons bans, imposed on the natives of Ryukyu two times in 1507 and 1609 respectively in their history, encouraged the refinement of empty-hand techniques and, for this reason, was trained in secret until modern times.

1) Old Styles

Over time, three regional Karate systems primarily emerged from three Ryukyu cities: Shuri, Naha, and Tomari. These systems labeled di or te (手) were quickly adopted by Ryukyu's nobles, warriors, merchants, farmers and fishers as a means of personal protection. Each system displayed unique characteristics and forms of self-defense and bore the name of the area in which it was developed: *Shuri-te*, named for the capital of the united Ryukyu Kingdom; *Naha-te*, which originated in the commercial center; and *Tomari-te*, which came from the port of Tomari.[39] Collectively, they were called di or te (hand), and toude or kara-te (Chinese hand).

Shuri-te Shuri was the name of the area surrounded by Shuri-jo, the city's castle. It was the seat of the Sho ruling class. It was populated by Ryukyu nobles called *anji*. The elite social group, such as noble class, scholars and martial arts experts became skilled in this style. Shuri-te was characterized by fast linear movements and agile footwork, performed from a tall, natural stance. The most popular modern Karate style that emerged from the Shuri-te system is Shorin-ryu, which means "young forest style."

Naha-te This system was practiced in Naha, which was then the commercial hub of the Ryukyu Kingdom. This style was known for its circular hand movements (due to the influence of Chinese martial arts), deep breathing and low, rooted stances,

39 Jennifer Lawler (2003). pp. 177–179.

combined with body conditioning drills. The most popular modern Karate style that evolved from the Naha-te system is Goju-ryu, which means "hard and soft style."

Tomari-te As the Ryukyu Kingdom's port and fishing center, Tomari was home to several popular drinking-and-dining establishments. This system employed open-hand strikes, low kicks and sweeping techniques. While no single style emerged from the Tomari-te system, many of its techniques are still easily recognizable in the moves of modern karate.

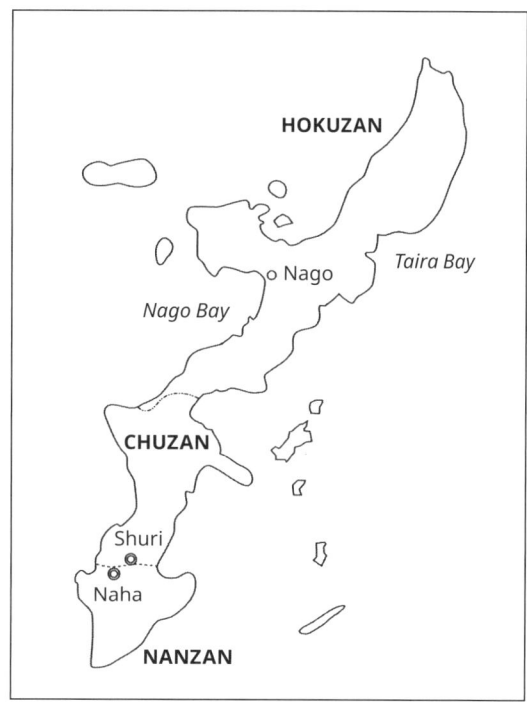

Okinawa (Formerly known as "Ryukyu")

In characteristics, Okinawan karate uses circular techniques due to their Chinese origin. All parts of the body are used as weapons, including elbows and knees, shins, and fingers. Stances are higher and more natural, allowing more mobility but less stability. On the other hand, Japanese karate styles emphasize direct, linear strikes, the use of mostly hands and feet (rather than other body parts) and lower stances that allow the practitioner to maintain stability and generate more power.[40]

2) New Styles

The number of styles is said to total nearly one hundred.[41] Modern karate is, for the most part, the product of a synthesis which has taken place over the centuries. Various methods of Chines kungfu were blended with the indigenous system of

40 Jennifer Lawler (2003). pp. 184–185.
41 Shigeru Egami (1976). p. 13.

Okinawan self-defense known as te. Since te was practised in secrecy, there has existed no evidence to indicate any clear-cut classification of the various styles and types of karate during its formative years in the 18th century. Gradually, however, karate was divided into two main groups: Shorin-ryu and Shorei-ryu. The roots of almost all of the modern karate styles go back to these two original styles. Other than these two types, there are a few others that were developed in the first half of the twentieth century. The following are the styles mostly recognized and dominate the world of karate in the present.

Shorin-ryu This style of Okinawan karate is one of the original styles developed around Shuri and Tomari areas. Its name literally means Shaolin Way after the famed Chinese Shaolin Temple, which according to legend was the birthplace of martial arts. Shorin-ryu was quick and linear with natural breathing and kata is emphasized over other aspects of training. Shorin-ryu is well known in Japan and the US and virtually unknown in Europe.

Shorei-ryu This style is another type of the original Okinawan styles developed around the Naha area. Shorei-ryu emphasizes steady, rooted movements while breathing in synchrony with each movement.

Shotokan This is the most popular karate style practiced by more than six million men, women, and children around the world. Shotokan was Funakoshi Gichin's pen name who founded the school in 1938 and it was further popularized by his students Nakayama Masatoshi and Nishiyama Hidetaka. In 1936, at nearly 79 years of age, he opened his own training hall. Shotokan karate is characterized by powerful linear techniques, deep strong stances, broad open movements, pronounced hip rotation resulting in increased power and thrusting kicks.[42] According to Funakoshi, if you know even one technique very well, you have a better chance to protect yourself from an assailant.

Goju-ryu Developed out of Naha-te, it was founded by Miyagi Chojun (1888–1953) in 1930. This popular Okinawan style is known as one which is characterized as using circular techniques instead of direct, linear strikes under the Chinese influences.

42 Cezar Borkowski & Marion Manzo (1998). pp. 183–184.

In his 1934 Outline of Karate-do, Miyagi mentioned that the source for Goju-ryu was a style of kungfu from China's southern coastal city of Fuzhou to which came to Okinawa in 1828.[43] The name of this style means "hard (*go*) and soft (*ju*)." In Goju-ryu much emphasis is placed on combining soft circular blocking techniques (the indirect and circular moves) with quick strong counter attacks (the direct and linear moves) delivered in rapid succession.

It was popularized by the martial arts legend Yamaguchi Gogen (1909–1989) nicknamed "the Cat" due to his felinelike speed and prowess. As a Goju practitioner, you would use small, narrow steps (designed to protect your groin), open hand strikes and elbow and knee techniques, all of which are appropriate self-defense tactics for in-close combat. Emphasis is on correct breathing and kata.

Shito-ryu Influenced directly by both Naha-te and Shuri-te, Mabuni Kenwa (1889–1952), a Karate genius and Kobu-jutsu expert created this style in the 1940s. The name Shito is constructively derived from the combination of the Japanese characters of Mabuni's teacher's names: Ankoh Itosu and Kanryo Higaonna. He brought together Karate-jutsu's two main streams: the circular movements of Goju-ryu and the straight-line techniques of Shorin-ryu.[44]

If you were studying Shito-ryu, you would use soft blocks and fast counter-strikes and place little emphasis on grappling with your opponent. Instead, you would probably prefer to kick and strike quickly to defend yourself. The Shito-ryu syllabus would include a large number of kata—more than 50 and it is characterized by an emphasis on power in the execution of techniques.

Wado-ryu Wado-ryu, or "way of harmony," founded in 1939 was developed by Otsuka Hidenori (b. 1892). It is a system developed from Jujutsu and Karate. He was trained by Funakoshi Gichin and a variety of Jujutsu teachers. This style of karate combined basic movements of Jujutsu with techniques of evasion, putting a strong emphasis on softness and the way of harmony or spiritual discipline.

If you were practicing Wado-ryu, you would rely on a combination of the direct, linear techniques of Shotokan, together with Jujutsu's softer, grappling movements. This combination, according to Otsuka Hidenori, is "a softer, more natural means of

43 Patrick McCarthy (1995). The Bible of Karate: Bubishi. pp. 32 & 39.
44 Patrick McCarthy (1995). p. 24

self-protection." Evasion and body shifting are also emphasized. Unlike Shotokan, higher stances and shorter punches are used. The name also illustrates its founder's ultimate goal, which was the use of Karate to stop conflicts in a nonviolent way, and to create *wa*, which means a "harmonious existence" or "ultimate peace."

Kyokushin-kai This style of Japanese karate was founded by one of the martial arts most colorful exponents, Oyama Masatatsu. As a practitioner of Kyokushin-kai, you would use deep breathing exercises, striking drills and bare-knuckle sparring bouts to perfect this more modern Japanese martial art. After winning the All Japan Karate Championship in 1947, Oyama embarked on a journey of self-discovery. He traveled into the mountains, where he would smash rocks, kick trees and lift heavy boulders (look out, Outward Bound). Clearly, this new and improved version of Oyama was, to say the least, intimidating to his martial peers. The name of the style he created, Kyokushin-kai, is translated as "the ultimate truth."

3. History

1) Origin

Karate was by strict definition not Japanese at all. As the indigenous fighting methods of Okinawa,[45] Karate was originally developed on the Ryukyu tropical islands (later named Okinawa) located on the Ryukyu archipelago in the East China Sea.

The chain of Ryukyu Islands is approximately 10 km wide and only about 110 km long. It is situated 740 km east of mainland China, and 550 km south of mainland Japan (350 km away from Kagoshima, the southernmost Japanese island) and an equal distance north of Taiwan. The first written record of the name Ryukyu, or Loo Chew in Chinese, appeared in A.D. 608.[46]

Although Ryukyu is the home of Modern karate, little is known about the origins

45 John Corcoran and John Graden (2001). p. 43.
46 Cezar Borkowski & Marion Manzo (1998). p. 176.
 See also, Patrick McCarthy (1995). p. 46.

of its indigenous system of self-defense. There are many myths and hypotheses how this karate came into existence. Fortunately, the majority of these theories are closely connected with Chinese influence. The unarmed self-defense was commonly called te (hand) or kara-te (China hand). In Chinese characters, the ideogram kara is written as *tang* (唐) referring to the Tang Dynasty of China.

In 1816, Basil Chamberlain Hall described Okinawa as "defenseless weaponless island domain" to exiled Emperor Napoleon after his expedition to the west coast of Korea and "Great Loo Chew" (Okinawa).[47] When Hall visited the Ryukyu Kingdom which had been under Japanese rule from the early seventeenth century, a law was passed banning the possession of all weapons. In this sense, Hall's report was entirely right since the natives of the islands had not been allowed to bear any kind of weapons. This law had strictly been imposed by the Satsuma clan, the conquerors from mainland Japan.

In fact, even before recorded history, there was long armed traditions of sword, spear, archery, and horsemanship in Ryukyu. Until it was united under the leadership of King Sho Hashi in 1429, Ryukyu had been divided into three dissenting kingdoms: Nanzan, Chuzan, and Hokuzan.[48] There had been constant bloodshed among the three rival principalities. In fact, the natives of Ryukyu were thoroughly familiar with the ways of war—both armed and unarmed.

Their unarmed combative skills included striking, kicking, elementary grappling, and escape maneuvers.[49] However, the development of the indigenous empty-handed combative traditions started catching on with the influx of the Chinese population into the islands. From 1372 the Ryukyu Kingdom started trade and diplomatic relations with China. By 1393 a Chinese mission was established in Naha, later the capital of Okinawa, where Chinese envoys resided, Chinese immigrants settled and Ryukyu nobles could learn the Chinese language and manners. Young people who spoke and wrote Chinese well received scholarships from the government of China and were accepted to study in China's capital.

Over the next five-hundred-year period, until the Ryukyu Kingdom was annexed by Japan in 1879 and became a prefecture of Japan, Chinese imperial envoys and the exchange students returning home from China contributed a great deal to the

47 Patrick McCarthy (1995). p. 44.
48 Patrick McCarthy (1995). pp. 44–46.
49 Patrick McCarthy (1995). p. 44.

development of the Ruykyu's fighting traditions.[50] Chinese envoys visited the Kingdom more than twenty times during the period. Each stay lasted four to six months and a group of four to five hundred people visited the kingdom. The group included occupational specialists, tradesmen, and security experts.[51] The Chinese fighting traditions were first systematically transmitted into Ryukyu with other skills such as ship-building, making of paper and books, building and architecture and so forth.

In 1507, about a hundred years before the Satsuma family from Japan took over the Ryukyu Kingdom by force, a decree banning the ownership of swords and other

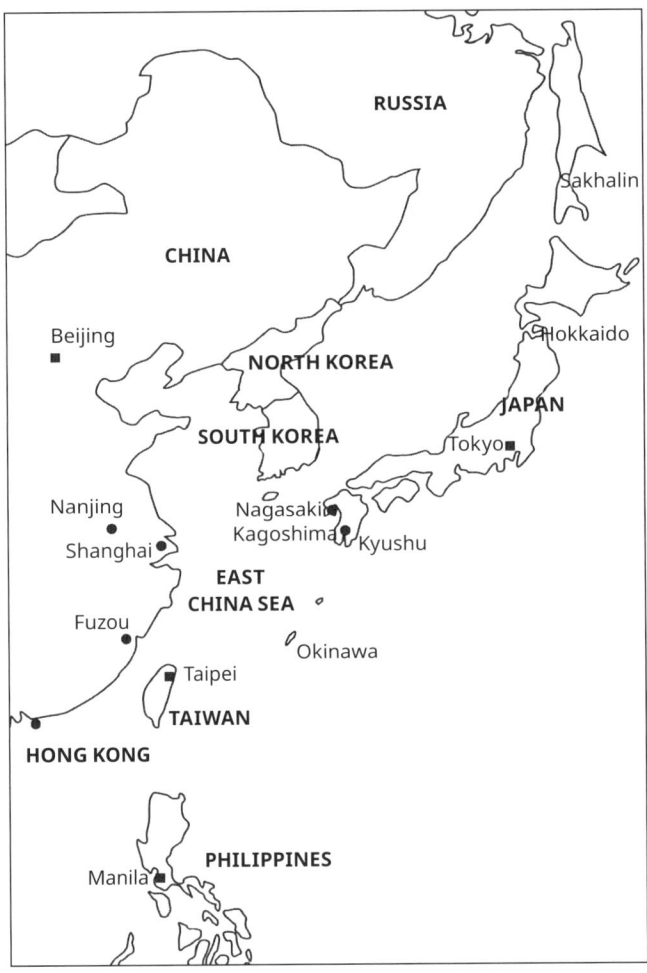

East China Sea Region

50 Patrick McCarthy (1995). pp. 46–47.
51 Patrick McCarthy (1995). pp. 47–48.

weapons of war by anyone other than the ruling class was enacted by King Sho Shin who united the Kingdom for the first time in its history. This was intended to reduce the threat of revolt. This enactment led to an increased need by the members of lower classes for an effective means of defending themselves and their property.

Wealthy landowners, merchants, as well as peasants started developing the skills to use domestic implements or tools for weapons. These weapons included flails (*nunchuku*), staffs (*bo*), sickles (*kama*) and so on.[52] Also, under the influence of the new enacted law, those law enforcers who served writs and summonses, made arrests, took custody of prisoners and ensured court sentences began to cultivate and perpetuate the development of unarmed self-defense disciplines.[53] The traditions using implements in the replacement of weapons and also hand-to-hand self-defense skills continued to be developed until the Ryukyu Kingdom was invaded by Japanese troops from Kyushu prefecture in 1609.

In 1600, in minland Japan, Tokugawa Ieyasu won the Sekigahara Battle against the followers of the deceased Toyotomi Hideyoshi. Consequently, he founded the new Edo (now Tokyo) government and became the Shogun himself in 1603. This historic event in Japan changed the geo political map of Asia and deeply affected the political climate of the Ryukyu Kingdom.

In 1609, Daimyo (feudal lord) Shimazu Yoshihisa (都津), the sixteenth successor of the Kyushu-based Satsuma clan invaded the prosperous Ryukyu Kingdom.[54] At the time he was in financial difficulties and under the surveillance of the new Tokugawa regime. For many years he had supported Toyotomi Hideyoshi's failed campaigns on the Korean Peninsula and it resulted in financial backlog for his clan. To make the situation worse, he fought against Tokugawa at the Sekigahara Battle and was defeated by his forces. As a result, it worsened their bad financial situation and their warriors' morale was very low due to their failures in the last two military campaigns.

The Satsuma family decided to carry out another invasion against the prosperous Ryukyu Kingdom to resolve their problems and appease the Tokugawa Shogun once for all. This time they succeeded in conquering the peaceful islands and the successful campaign was followed by the unarmed policy in the Ryukyu Kingdom.[55] The

52 Jennifer Lawler (2003). p. 195.
53 Patrick McCarthy (1995). p. 49.
54 Patrick McCarthy (1995). p. 49.
55 http://karatethai.com

entire Ryukyu Kingdom was disarmed, leaving the natives of the land with no weapons. This time this unarmed policy was strictly imposed by the Satsuma family in Ryukyu. In later years, the development of Okinawan karate was deeply affected by this policy.

Under the disarmament law, the natives of the islands were discriminated against and were under scrutiny for possible rebellion. From then on, the training of Ryukyu te or karate became a secret activity on the islands and it was practiced behind closed doors. As self-defense techniques under the foreign regime, karate began to take on a new aspect to martial arts—that is, winning in just one strike against a sword or spear.

The tradition of toughening the striking surfaces of their hands and feet started to be taken up. This way the natives of Ryukyu were able to render blows that were powerful enough to break through the bamboo armor the Japanese soldiers wore and kill or maim them.[56] The bare-hand martial arts began to spread throughout the islands and became the backbone of later Okinawan karate. At last the Ryukyu Kingdom was annexed to Japan in 1879 and Ryukyu became a prefecture of mainland Japan. The name of the islands was changed to Okinawa.[57] From this time on, Okinawan karate was now being exported to Japan, where new styles of karate were created.

The Ryukyu natives had also developed some type of improvised weapons. Since they were prohibited from carrying weapons of any kind, they learned to fight with farm tools that they normally had in their possession at any time. And these weapon systems became a part of Okinawan karate traditions. Even today, these weapon skills are often demonstrated in karate events or sometimes they were used to compete in the championships. The five main weapons were the sai, bo, kama, nunchaku, and tonfa.[58] The characteristics of these weapons are introduced in the technique section of this unit. All these forms of the martial art were called and considered a part of "Okinawa Te."

56 John Corcoran and John Graden (2001). The Ultimate Martial Arts: Q&A Book. Contemporary Book. p. 5.
57 Cezar Borkowski & Marion Manzo (1998). p. 176.
58 John Corcoran and John Graden (2001). p. 6.

2) Modern Era

In 1908 under the leadership of Itos Yaszune (1832–1916), karate was for the first time adopted as part of the official curriculum in a teacher's college and a middle school in Okinawa. Itos had many disciples. Among them Funakoshi Gichin (1869–1957) took the Okinawa Te to Tokyo in 1922 and Motobu Zouki (本部朝其: 1871–1944) to Osaka in the same year.

On numerous occasions in the early 1920s, the Okinawan native Funakoshi Gichin was invited to demonstrate Okinawan karate in mainland Japan. During those days, karate was virtually unknown to the Japanese public.[59] In 1922, Funakoshi was invited by the Ministry of Education to hold the first karate demonstration at a traditional martial arts exhibition in Tokyo. Funakoshi and his colleagues made a powerful impression on the Japanese public, and the demonstration was well received by Kano Jigoro, the father of modern Judo and Hakudo Nakayama, a great authority on kendo. They persuaded Funakoshi, whose intention had been to return to Okinawa, to remain in Tokyo to teach his art.

At first, Okinawan karate was introduced as "China hand" (唐手) to mainland Japan. Egami Shigeru, a student of Funakoshi in the early years in Japan, witnessed that "karate in those days had the reputation of being merely a way of fighting, but it did have an aura of secrecy and mystery."[60] He continued, "Consequently, it would appear that what attracted capacity crowds to our demonstrations was nothing more than curiosity."[61]

As a result, Funakoshi had only a small number of students during his early years in Japan and he practically lived in poverty. Funakoshi had to take a great number of odd jobs simply to make ends meet.[62] According to Egami's claims, none of them dared to imagine that their art of self-defense would spread beyond Japan and be practiced by more adherents worldwide than any other Japanese combative art.

For the first fourteen years, Funakoshi taught karate without his own dojo (drill hall). He taught karate in many universities. The first karate club was opened in Keio University which was followed by many universities. Finally, in 1936, after teaching

59 Shirgeni Egami (1976). pp. 11–12.
60 Shirgeni Egami (1976). pp. 11–12.
61 Shirgeru Egami (1976). p. 12
62 Shirgeru Egami (1976). p. 11.

in several universities, Funakoshi established his own dojo known as the Shotokan in Tokyo. His school would bear his pen name, Shoto, meaning "the whispering pines," and kan means "training place." The name "shotokan" took off and soon Funakoshi's followers were known as those who practiced Shotokan karate. After his death in 1957, this became the name of the popular style that is currently practiced by more than six million people worldwide.

Funakoshi Gichin made a significant contribution in systemizing karate in the present form and disseminating the martial art throughout Japan and the world. He was also a prolific writer who wrote two books on karate: *Karate-Do Kyohan*, Kobundo Book Company, Tokyo in 1935 and *Karate-do: My Way of Life*, Kodansha International, Tokyo respectively.

In 1925, most likely under the influence of Judo (柔道), the suffix "do" (道) meaning "way" was added to the name "China hand" (唐手). Once again, in 1933, "The way of China hand" (唐手道) was officially changed to "The way of empty hand" (空手道). As mentioned earlier, the words "China" and "empty" sound the same in the Japanese language. Under the nationalistic ferment in Japan, anything that sounded like it originated from China was not acceptable to the Japanese authority and it certainly did not appeal to the common people alike.

3) Karate in the World

Karate was first publicly taught in Hawaii at the Hawaii Young People's Karate club in 1933. These classes were taught by Thomas Miyashiro, an Okinawan Shorin-ryu stylist. Shorei-ryu stylist Robert Trias established the first Karate school on the mainland United States in Phoenix, Arizona, in 1949.[63]

At the end of the Second World War during the Allied occupation of Japan, Westerners for the first time had a taste of Karate. This led to karate filtering back to the USA and Europe, and soon Japanese masters from the Japan Karate Association (JKA) were being invited to the West to spread the word, such as Funakoshi did back in the 1920s.

Westerners fell in love with this new deadly art—the media, especially, falling for its mystique. In the early 1960s two karate masters arrived in Great Britain to teach.

63 John Corcoran and John Graden (2001). p. 10.

Enoeda and Kanazawa, still teaching and training today, were probably the most important catalysts in Karate's development in the West. Between them, these two masters taught the very first generation of British karate-ka to become black belts, many of whom are now masters of karate in their own right.

Now karate has its international body located in Spain in which 169 countries are registered as member nations. In 1970, karate was adopted as an official sport by the IOC and included in many continental games. For instance, athletes compete for 11 gold medals as an official event of the Asian Games.[64]

[64] http://www.karatedo.wo.to.

Reference

Books

Borkowski, Cezar and Manzo, Marion (1999). The Complete Idiot's Guide to Martial Arts. An Alpha Books/Prentice Hall Canada.

Corcoran, John and Graden, John (2001). The Ultimate Martial Arts Q & A Book. Contemporary Books.

Egami, Shigeru (1976). The Heart of Karate-do. Kodansha International, Ltd.

Lawler, Jennifer (2003). Martial Arts for Dummies. Wiley Publishing, Inc.

McCarthy, Partrick (1995). The Bible of Karate: Bubishi. Tuttle Publishing.

Healy, Kevin (2000). Karate: A Step-by-step Guide to Shotokan Karate.

Web Sites

http://www.karatedo.wo.to

http://karatethai.com

Judo
Japanese Grappling System

What is Judo?

Definition
Purpose
Goals
Principle
Philosophy
Techniques
Training Methods
Competition
Ranking System

History

Origin
Modern Era
Judo in the World

1. What is Judo?

1) Definition

What is *judo*? Literally speaking, judo consists of two Chinese characters, 柔道 (phonetically, *yudo* in Korean). The first character *ju* symbolizes "gentleness" or "softness." The second character, *do* means "the Way." In combination they mean "The Way of Gentleness or Softness."[1] Some *judoka* (those who practice judo) like Walter Yamada think a better translation of ju, that encompasses the meaning, might be "flexibility."[2] Therefore, judo can be defined as "The Way of Flexibility."

However, in reality, judo means different things to different people. For some people it is just an interesting Olympic sport; they simply train *kumite* (free sparring) for fun or competition. Some train for the purpose of self-defense. For others it is a traditional martial art; thus, they study *kata* (forms) and the mental aspects of judo. All these reasons are valid; however, black belts are expected to learn all these aspects of judo.

2) Purpose

There are various reasons people practice judo. Judo is generally recognized as an effective way to defend oneself from the one who attacks and also a way to maintain one's health and stay fit. In addition, there are people who just enjoy the pleasure of doing it and emphasize the mental training of judo. From these points of view judo is certainly one of the best sports both for physical fitness and mental health.

3) Goals

According to Kano Jigoro, the goal of judo discipline was quite specific. He wrote,

1 Jane Lee (1999). "The Principles of Judo". Journal of Martial Arts Studies. Fall 1999. Volume IV. p. 43.
2 Walter Yamada (1994). "A Short Report on Judo: Experience, Philosophy, and Teaching." Monograph: Martial Arts Program. (Vol. 1, May 1994). p. 172.

"Judo is the way to the most effective use of both physical and spiritual strength. By training you in attacks and defenses, it refines your body and your soul and helps you make the spiritual essence of Judo a part of your very being. In this way, you are able to perfect yourself and contribute something of value to the world. This is the final goal of judo discipline."[3] Kano Jigoro saw judo as a *kyoiku*, a method for educating the spirit, mind, and body.

Especially, for young people, judo teaches balance, coordination, self-control, and an awareness of the physical, mental, and emotional aspects of their personalities that encourage a healthy maturation in young people. It also allows youngsters to expend their energies in a safe way: "fighting" in situations where injury is reduced to a minimum and self-confidence is constantly built. Judo, however, does not involve the rapid contractions of muscles seen in karate practice or the joint manipulation in *aikido*.[4] It is thus one of best martial arts suited for children below puberty.

4) Principle

Judo is the art of throwing and grappling with the implication of first giving way to ultimately gain victory. The principles of judo are mainly based on the principle of yielding; that is, to overcome greater strength or size by using the scientific principles of leverage, balance, efficiency, momentum and control.[5] In other words, a small judo practitioner can defeat a large adversary by using body position, footwork, and leverage (referring to making an opponent unbalanced) rather than relying on sheer size and strength. This is the principle and techniques of judo structured on the concept of maximum efficiency with minimum effort. In this sense, judo can be used by anyone—adult or child, man or woman—regardless of size or strength.

There are Three basic components to judo throwing techniques: *kuzushi*, *tsukuri*, and *kake*.[6] The execution of a perfect throw involves all these three parts as follows:

3 Kazuzo Kudo (1967). Judo in Action. Kodansha International. pp. 1 & 3.
 See also, John Corcoran and John Graden (2001). The Ultimate Martial Arts: Q &A Book. Contemporary Book. p. 58.
4 John Corcoran and John Graden (2001). p. 59.
5 Jennifer Lawler (2003). Martial Arts for Dummies. Wiley Publishing Inc. p. 224.
6 Jane Lee (1999). p. 44.

a) kuzushi

Its literal meaning is "breaking" or "off-balancing." It is an act of pushing or pulling someone off-balance. Kuzushi refers to unbalancing your opponent, making it possible to throw him or her with ease. Isano Inokuma and Nobuyuki Sato, both world class judo masters write, "Kuzushi… in judo means forcing the opponent into an unbalanced position. This is an important factor in executing *nage-waza* (throwing techniques), for when the opponent is off-balance he is unable to use his strength aggressively and is virtually under your control… Although you can use a variety of techniques, such as pushing, pulling, or going around the opponent, you should always execute kuzushi not with your hands alone but with your entire body. You must also consider the distance between you and your opponent."[7] In short, kuzushi disrupts your opponent's center of gravity for the purpose of off-balancing him or her to make your attack attainable.

Kano discovered the principle of kuzushi shortly after he opened his own dojo. During this early period, he was still training under Iikubo Tsunetoshi, a master of jujutsu in Kito-ryu. Kano wrote:[8]

Mr. Iikubo was over fifty years old at the time, but he was still strong and I used to work with him often. Although I practiced my technique industriously, I could never vie with him. I think it was about 1885 that I found, while practicing randori (free sparring) with him, that the techniques I tried were extremely effective. Usually it had been he who threw me. Now, instead of being thrown, I was throwing him with increasing regularity. I could do this despite the fact that he was of the Kito-ryu school and was especially adept at throwing techniques… What I had done was quite unusual. But it was the result of my study of how to break the posture of the opponent… I told Mr. Iikubo about this, explaining that the throw should be applied after one has broken the opponent's posture. Then he said to me: "This is right. I am afraid I have nothing more to teach you. From now on you should continue your study with younger men. I will no longer practice with you."

7 Isao Inokuma & Nobuyuki Sato (1991). Best Judo. Kodansha International. p. 14.
8 Jon Bertsch (1999). "The Role of Kata Practice in Judo Training." Journal of Martial Arts Studies. Fall 1999. Vol. IV. p. 170.

b) tsukuri

The literal meaning of tsukuri is "fitting in" or "entry." Tsukuri signifies the planning or preparing stage before the performance or execution of an attack actually takes place. Isao Inokuma and Nobuyuki Sato continues, "Tsukuri is the entry and proper fitting of your body into the position taken just before the moment required for completion of your throwing technique."[9] In other words, tsukuri is the initiating stage of starting the throw and getting into the correct position.

The above two components are often practised separately hundreds of times each, then combined together, and practiced with a partner. Isano Inokuma and Nobuyuki Sato say,[10] "Necessarily, the off-balancing (kuzushi) of your opponent takes place at the same time as tsukuri so that he is helpless and easily controlled."

c) kake

The kake means the execution and the completing movement of your technique. Although we speak of a judo throw in three separate parts, the reality is that all three happen at once. The kake is merely the follow through of your decision to throw. Kano Jigoro writes as follows:[11]

Stated succinctly, the third point is: consider fully, act decisively. The first phrase is closely related to the first point above, that is, a man should meticulously evaluate his adversary before executing a technique. This done, the advice given in the second phrase is followed automatically. To act decisively means to do so without hesitation and without second thoughts.

Isao Inokuma concludes in the following:[12]

Judo techniques work splendidly when these three elements work together almost instantaneously to become a single entity. If any one of them is inadequate or late in coming, your attempt to throw the opponent or bring him down to the mat will likely end in failure.

9 Isao Inokuma & Nobuyuki Sato (1991). p. 14.
10 Isao Inokuma & Nobuyuki Sato (1991). p. 14.
11 Jane Lee (1999). p. 51.
12 Isao Inokuma & Nobuyuki Sato (1991). p. 14.

Many people, especially those who do not know judo believe that fighting a larger opponent is a hopeless cause and that the only way to achieve victory is to be somehow stronger. However, in the principle of ju (giving away), defeating a larger opponent transcends mere physical strength, and the three components (kuzushi, tsukuri, and kake) in the principle of the throwing techniques can guide the small judoka to a big victory. This victory can be achieved as the result of "maximum efficiency with minimum effort" of judo principles.

5) Philosophy

In the 1920s, Kano Jigoro first introduced the concept of seiryoku zenyo (精力善用)—jita kuoei (自他共榮) meaning "mind and strength for good use (cause or purpose)" and "mutual welfare and benefit." It is best known as the philosophy of judo.[13] Kano finally found the philosophy of his art forty years after he started his own martial arts school in Tokyo in 1882. (Initially, Kano spoke of "maximum efficiency" and later he changed it to "mind and strength for good use.")[14]

In fact, Kano was saying that in order to use one's mind and strength for good purpose, he or she must realize that we humans are social beings and we need to constantly seek cooperation among ourselves for the advancement of human kind. Kano believed that this philosophy should be achieved both in the dojo and in the daily life of judoka alike.[15]

It is hard to imagine judo as a sport that promotes mutual welfare and benefit. Judo appears to be quite violent and looks painful when judo practitioners throw each other to the mat. However, it still takes two to do judo. Even in *randori* (free practice) judoka have to watch out for their partner in order to avoid getting hurt. Even judo kata requires two to work together. Thus, the mutual benefit is evident in judo practice—both partners are learning together. Kano Jigoro states:[16]

To sum up, judo is a mental and physical discipline whose lessons are readily appli-

13 Neil Ohlenkamp, "History of Judo: Kodokan Judo," www.judoinfo.com
 See also, Jon Bertsch (1999). p. 169.
14 Jin Su Lee (1999). Hbon Mudo Yeongu (English translation: Studies on Japanese Martial Way). Kyeohakyeongusa. p. 397.
15 Jon Bertsch (1999). p. 169.
16 Jane Lee (1999). pp. 55–56.

cable to the management of our daily affairs... the principle of maximum efficiency, whether applied to the art of attack and defense or to refining and perfecting our daily life, demands above all that there be order and harmony among people. This can be realized only through mutual aid and concession. The result is mutual welfare and benefit.

In this saying, Kano sought human perfection and the betterment of mankind through what he did best, judo. Kano is saying that the principles of judo should be applied to life as well, not just in the dojo: "Life and judo are one."

6) Techniques

Judo techniques consist primarily of two components: *nage-waza* (throws) and *katame-waza* (grappling or groundwork).

a) ukemi

In early training, all beginners must learn *ukemi* (breakfalls). It is a set of techniques you learn to fall or land on the mat safely without any injury. You may be taught to land in a certain way and then to roll across the mat, springing into a standing position. Rolling

Ukemi to the right side

helps absorb some of the impact of the fall and improves your flexibility and agility. Quickly moving to a standing position or immediately assuming a guarded position to prevent your partner from taking advantage of the fall and pinning you to the ground.[17]

In breakfalls your main goal is to keep your head from striking the ground and causing a regrettable loss of consciousness. You learn how to do breakfalls to the front and to the back. So, no matter how your partner throws you, you can land without breaking your nose or your tailbone. In a forward fall, you need to tuck your head and roll forward in a somersault. In a backward fall, it means keeping your

17 Jennifer Lawler (2003). p. 227.

head tucked to your chest. Your secondary goal is to prevent other parts of your body from sustaining damage. So landing on a padded portion of your anatomy—shoulders, buttocks, or hips—are best.

After no longer afraid of falling, beginners learn how to perform basic clothing grips, correct stances, and footwork.

b) gripping the gi

The orthodox judokas use two hands to grip up the partner's *judogi* (Judo uniform) when entering a contest. These hand grips are an important part in judo due to the fact that many of its throwing and grappling techniques rely on gripping the judogi. Once mastering the basics of breakfalls and gripping, novice judokas are expected to learn throws and grappling techniques that become progressively more difficult to do but more effective.

c) nage-waza (throws)

Throwing techniques are called nage-waza. Throwing techniques involve hand, hip, or leg. Every throw has its strengths and weaknesses. When your throw becomes popular, your opponents learn how to defend themselves by exploiting its weaknesses. Even though many throws go in and out of style, there are several basic but fundamental throws that even the most advanced judokas frequently use, described in the following. (In judo terminology, an attacker is called *tori* whereas a defender, *uke*.)[18]

Tai-otoshi (body drop) Tori steps in close to uke's right foot with his left, pivots on it and rotates his right hip counter-clockwise so that his right foot comes down next to uke's right foot. Keeping both feet wide apart and grabbing the opponent's sleeve with his right hand and lapel with left, tori pulls uke over his hip and foot to drop uke in front.[19]

Osoto-gari (big outside clip) When uke retreats or advances, tori takes a step forward and place his left leg near the side of uke's right foot. Then tori brings uke off-balance to the left back corner and places his chest up against that of uke. After

18 Isao Inokuma & Nobuyuki Sato (1991). p. 23. See also, Jennifer Lawler (2003). pp. 229–231.
19 Peter Seisenbacher & Goerge Kerr (1997). Modern Judo: Techniques of East and West. The Crowood Press. p. 116.

that tori raises his right foot high in front of him and swings it backward and clips uke's left leg to bring him down.[20]

Uchi-mata (inner thigh throw) The uchi-mata is a combined technique of the hip and leg. When uke comes forward on his right foot or is standing with legs spread and his upper body bent forward in a defense posture, tori thrusts his left foot deep between uke's legs. Riding uke's inner thigh on his hips, tori keeps the back

Uchi-mata

of his right thigh tight up against uke's right inner thigh and bounce uke on his thigh. Tori twists his upper body sharply to the left and roll uke off and down.[21]

d) katame-waza (grappling)

Grappling systems are self-defense styles that primarily use techniques such as *osaekomi-waza* (pins or takedowns), *shime-waza* (chokes or strangulation techniques), and *kansetsu-waza* (joint locks).[22] The grappling system comes from Japan's jujutsu which is well-known for its use of joint-locks and control holds.

In judo, it is a throw that is usually attempted first before grappling can be done.

Juji-gatame (crossmark hold)

Hon-kesa-gatame (basic scarf hold)

20 Isao Inokuma & Nobuyuki Sato (1991). p. 66.
21 Kazuzu Kudo (1967). pp. 66–67.
22 John Corcoran and John Graden (2001). p. 4.

Although throwing techniques receive a lot of attention in judo competition, the groundwork of grappling is also an essential part of judo. Pinning your opponent preferably for 30 seconds scores a *nippon* (victory) in sport judo. There have been some controversies over the usefulness of grappling techniques. Some skeptics think grappling techniques are less useful because they are more complex to learn than throwing and not glamorous in appearance and that they require greater energy and you need to admit defeat at times.

However, considering the fact that many street fighters go to the ground, that is, an attacker grabs you, throws you down, and starts to pound or choke you, grappling is a vital element in the arena of all-out unarmed combat.[23] Thus, the grappling techniques of judo can be used in real life self-defense situations.

Hon-kesa-gatame (basic scarf hold) After uke is thrown on his back, tori lands on him from his right side. Cover uke's chest with tori's upper body and trap uke's right arm under tori's armpit, and lock tori's hands behind uke's neck. Tori's right leg is stretched to the front and his left leg is conveniently stretched to his left. Tori's head can be pressed against the mat to prevent uke to roll tori over to his left side.[24]

e) combining techniques

Past the beginning stages, the judoka learns how to combine techniques in order to create the opportunity to throw the opponent. A single, well-executed technique can easily throw a beginner, but the more advanced practitioners are not so easy to handle. For this reason, an effective judoka learns how to use more than one technique in succession (*ren-zoku-waza*) to find a weakness in the opponent's defense. The judoka may attempt a throw from one angle, and if unsuccessful, may try a throw from the opposite angle or at least from a different angle.

Continuing with the attack even if initially unsuccessful is what separates the good judoka from the merely competent. This requires a competitive and aggressive instinct to keep going: assuming that at some moment the opponent may relax his guard, that moment of relaxation can be exploited.

23 John Corcoran and John Graden (2001). p. 37.
 Also see, Jennifer Lawler (2003). pp. 232–233.
24 E. J. Hairison (1955). Judo on the Ground: The Oda (9th Dan) Method "Katamewaza." W. Foilsham & Cp. Ltd. p. 24.

7) Training Methods

a) meditation

Since it has developed as *budo* (martial Way), judo cherishes courtesy and adopts a moment for meditation before and after practice by sitting properly and taking a deep breath with the lower part of stomach. This kind of meditation is scientifically proven to be very effective for the human body.

In fact, judo is an individual competitive sport; therefore, judoka may be self-centered and thus become egoistic. This is something that all judoka have to watch out for.

b) randori (free sparring)

Sparring contains dozens of highly effective throws and grappling techniques. It is practiced most often in sport judo. In his own words, Kano Jigoro says, "Judo is taught under two methods, one called *randori*, and the other *kata*. Randori, or free exercise, is practiced under conditions of actual contest. It includes throwing, choking, holding down, and bending or twisting the opponent's arms or legs."[25]

c) kata (form)

Kata is a set of prearranged patterns of techniques which were originally used to practice jujutsu techniques, the predecessor of judo. Kata (本) means "shape" or "form" in Japanese. Kano Jigoro adopted kata as a training tool for his new art and emphasized kata practice as an essential part of judo training. He states, "Kata, which literally means form, is a formal system of prearranged exercises, including besides the aforementioned actions (throwing, choking, holding down, and bending or twisting the opponent's arms or legs), hitting and kicking and the use of weapons, according to rules under which each competitor knows beforehand exactly what his opponent is going to do."[26]

Kata, the idea of a set form, is endemic in Japanese civilization. All the arts of Japan, including the tea ceremony, flower arranging, and the martial arts, have kata as a central precept.[27] The role of kata plays an enormous role in Japanese daily life.

25 Jon Bertsch (1999). p. 167.
26 Jon Bertsch (1999). p. 167.
27 John Corcoran and John Graden (2001). p. 55.

Traditionally, the Japanese have believed that outer form is as important, if not more so, than inner feelings.[28]

In the budo (武道), kata consists of predetermined sequences of movements that may be thought of as the "grammar" of budo. Some kata may be practiced solo; and others are done in pairs as in the case of judo, with an attacker and a defender.

Most Japanese martial arts considered kata practice an important part of training. For almost three centuries, from the time when the Tokugawa clan became the sole political authority in Japan (A.D. 1600) until Kano opened his dojo in 1882, Japan was at peace and martial skills were rarely utilized. During this period, the method of learning to fight through a perfection of the kata was the sole way the samurai learned to fight. That alone should explain how effective kata may play a role of grammar; once the rules of grammar have been thoroughly learned, the *budoka* (budo practitioners) can create his own "sentences" spontaneously. Since the jujutsu systems that preceded judo had little opportunity to use their techniques except in the dojo, kata were employed to pass on techniques within different schools.[29]

Nowadays only highly effective techniques that can be performed in the competition are being taught. Most other judo techniques are only found in the kata. Kano writes, "The use of weapons and hitting and kicking is taught in kata and not in randori, because if these practices were resorted to in randori injury might well arise, while when taught in kata no injury is likely to happen as all the attacks and defenses are prearranged." Kata training also ensures that dangerous techniques were performed under controlled circumstances—reducing the possibility of injury and permanent damage.[30]

Although Kano placed emphasis on kata training, it tends to be neglected and "most judoka concentrate on randori and see kata as an anachronism that is best avoided."[31] Kata is disappearing from judo practice. Kata barely survives in the world of judo because judoka is expected to perform a kata to attain the rank of shodan (first degree of black belt); most of them without ever having seen a kata performed. However, some of the techniques taught in kata would be also powerful; therefore, useful in competition.

28 John Corcoran and John Graden (2001). p. 56.
29 Jon Bertsch (1999). p. 170.
30 Jon Bertsch (1999). p. 170.
31 Jon Bertsch (1999). p. 168.

d) kime-no-kata (weapon kata)

Kano also taught kata which is a self-defense form that incorporates weapons. The *kime-no-kata* contains many elements of the Tenjin shinyo-ryu that Kano trained in before forming judo. Until Kano died in 1938, the Kodokan was also a martial arts center, not just a judo dojo, and as such a wide number of weapons and weapon kata were taught to students, but today most of this knowledge is forgotten.[32]

e) uchi komi

The term means "throwing practice." Rather than performing an entire technique a few times, you will learn more efficiently if you dissect a complete sequence, analyzing each of its components, and practice every section dozens of time. The two primary elements of this rapid practice of small components are the entry (initiating the throw) and breaking (ascertaining your partner's center of gravity for the purpose of off-balancing him or her).[33]

8) Competition

Unlike other martial arts, judo has no style or school variation, such as karate. Also, all the techniques and commands are taught using Japanese, and people from countries all around the world can participate in competition without difficulty.

The word shiai is Japanese for competition. Unlike other traditional martial arts, competition has become one of the most important elements in judo. In judo competition, fighters are paired with people of the same gender and age group and in the same weight class. Judo competitions are conducted on mats, and the contests are officiated by one referee and two judges. Matches, on an international level, are four minutes in duration for women and five minutes for men.

a) scoring system

Ippon The object in a judo match is to score an *ippon* (one point), the equivalent of a pin in wrestling or a knockout in boxing. An ippon is awarded for either throw-

32 Jon Bertsch (1999). pp. 172–173.
33 Cezar Borkowski & Marion Maiizo (1999). The Complete Idiot's Guide to Martial Arts. p. 201.

ing an opponent onto his or her back with force and speed, or for holding an opponent for thirty seconds or by forcing the opponent to "tap out." (When your opponent has reached his or her maximum pain threshold while being pinned or restrained, he or she will make the tapping sound by striking the mat or your shoulder.) An ippon scores one full point and constitutes an automatic victory. If an ippon is not achieved, cumulative points decide the match.[34]

Wazzari The scoring system in judo also awards a *wazzari* (a half point) for a technique which is less powerful than an ippon or lacking in maximum extension, or a contestant holds his or her opponent for 25 seconds. Two wazzaris score one full point and constitute an automatic victory.

Yuko and koka A competitor can also receive a quarter point for a *yuko* and an eighth point for a *koka*, depending on the level of technical quality demonstrated.

Shido and hansoku Contestants who commit minor fouls are cautioned with a *shido* and more severe offenses receive a *hansoku*. In the event of a tie, these can keep you from winning a match.

If a match ends with no score or in a tie, the winner is determined by a majority vote as decided by the referee and judges, based upon the athletes' performances. This type of decision is similar to an award made to the more aggressive and dominant athlete at the conclusion of a boxing match.

b) rules
The rules of competition are dictated by the International Judo Federation. They are provided in this book at the end of this unit on judo.

c) match
Once the match begins, judges will indicate points awarded to competitors by raising a white or red flag. Score keepers record these points.

[34] John Corcoran and John Graden (2001). p. 194.
See also, Cezar Borkowski & Marion Manzo (1999). p. 202.

9) Ranking System

The modern use of colored belts comes from the judo system at the turn of the twentieth century. Judo practitioners were awarded belts of varying colors as symbols of rank advancement. In Kodokan Judo, there was only one kind of belt system with three variations: white, brown, and black.[35] The beginner levels are as follows:[36]

Kyu	Level
Jukyu	Tenth
Ku kyu	Ninth
Hachikyu	Eighth
Shichikyu	Seventh
Rokukyu	Sixth
Gokyu	Fifth
Yonkyu	Fourth
Sankyu	Third
Nikyu	Second
Ikkyu	First

All black belt holders belong to the intermediate, expert levels and master levels respectively as follows:[37]

Level	Dan	Degree
Intermediate	Shodan Nidan Sandan Yondan	First Degree Second Degree Third Degree Fourth Degree
Expert	Godan Rokudan Shichidan Hachidan	Fifth Degree Sixth Degree Seventh Degree Eighth Degree
Master	Kyudan Judan	Ninth Degree Tenth Degree

35 John Corcoran and John Graden (2001). p. 8
36 Cezar Borkowski & Marion Manzo (1999). p. 169.
37 Cezar Borkowski & Marion Manzo (1999). p. 170.

From first to fifth dan, you would wear a plain black belt. At the level of sixth, seventh, or eighth dan, you would wear a belt made of alternating red and white squares of fabric. At the master's level, a red belt would generally be worn.[38] In his later years, judo founder Kano Jigoro returned to the white belt as the highest rank, signifying that he transcended the system he created and was starting anew.[39]

2. History

1) Origin

a) historical background

In ancient times, Japan was a country comprised of small clans, largely isolated by geographic boundaries of rivers and mountains. The only central government, in the city of Nara, was regional, based upon a succession of emperors selected from a few families. From the ninth century through the early seventeenth century; feudal lords expanded their power through military forces and fighting men played a significant cultural role. Thus was born the concept of the *bushi* (武士). Its literal meaning is martial gentleman who later came to be known as the *samurai*.

All martial arts in Japan around the Edo period (1603–1868) were known as *bujutsu* (武術). The term literally means "martial skill or art." In the schools of those martial arts, only combat skills were taught.

In 1600, a warrior-general Tokugawa Ieyasu, gained military and political control over the entire land of Japan. The warring period of the Sengoku (1477–1603) was finally over with the last battle Sekigahara between Tokugawa and his foes. Now the Tokugawa Edo *bakufu* (Shogunate) was to bring a long-lasting peace to Japan over the next two hundred years.

Internally, the Tokugawa regime enforced a ban on battlefield combat within the country and externally forbade any foreign trade or any official dealings with other

38 Cezar Borkowski & Marion Manzo (1999). pp. 197–198.
39 John Corcoran and John Graden (2001). p. 33.

nations. From this time on, a new concept of martial system began to surface and replace the old one.

During this peaceful era, the fighting arts of the bushi (武士) or samurai were converted from its grand scale of military disciplines into a personal scale: individual duels replaced large-scale encounters. They began to put an emphasis on the development of pure technique, and the practicality of combat skills in the battlefield became secondary: thus, form and style superseded combat efficiency.[40] In addition, the spiritual, moral, and aesthetic dimensions of these arts were more fully added to the warrior's teaching and practice.

From 1853, after almost two hundred fifty years of seclusion from the rest of the world, Japan opened her doors to the West. The Western concepts of military strategy and armament started replacing the centuries old Japanese fighting traditions: the gun replaced the sword. In this great time of change, the traditional fighting arts of Japan were to survive in two ways. On one hand, the classical schools of swordsmanship and other combative arts were kept alive by those families and clans that had founded them centuries before. On the other hand, some of these arts were transformed and shifted their emphasis from their battlefield practicalities to their mental components.[41]

In 1868, the Tokugawa regime peacefully handed over their political power to the Japanese emperor. The feudal period was finally over and the new Meiji era began. As the structure of the Japanese society changed, so did the emphasis of the martial arts. Bujutsu (武術)was changed to budo (武道). The suffix, *jutsu* meaning "skills" was replaced by *do* (translated "Way") meaning "a path" or "a road." A bujutsu or martial art which has application in the warfare of the feudal period in Japan was modified with the more modern version of martial Way (budo). Now a budo is an art that is more concerned with the moral development and physical fitness of practitioners and the aesthetic form of martial arts.[42]

b) jujutsu, the prototype of judo

No one knows exactly how and when jujutsu skills started in Japan. Some martial historians say that it closely resembles its Chinese predecessor, Shaolin kungfu.[43]

40 Bruce P. Boren (1994). "The History and Philosophy of Judo." Monograph: Martial Arts Program. p. 3.
41 John Corcoran and John Graden (2001). pp. 41–43.
42 John Corcoran and John Graden (2001). p. 45.
43 Cezar Borkowski & Marion Manzo (1999). p. 164.

However, one thing for sure is that jujutsu existed in Japan for centuries. The first recorded learning center for jujutsu was Take-ryu (the suffix *ryu* means school), founded by Takenouchi Hisamori in the seventeenth century. Its curriculum included kicking, striking, kneeing, throwing, choking, joint-locking, using weapons, and restraining an enemy.[44]

This jujutsu was systematically developed from the sixteenth century when wars among different clans or regions continued to break out and they were studied for the purpose of killing their foes more effectively in the battlefield.[45] From the late seventeenth to the mid-nineteenth century, this period can be called jujutsu's "Golden Age." During this period, hundreds of jujutsu schools appeared, all teaching their version of this martial art.

During this period there were two different kinds of jujutsu that evolved: classical and modern forms. Classical jujutsu stemmed from samurai arts that were based on battlefield strategies. In ancient days in Japan, bujutsu (martial arts) was totally a different concept from that of modern days. Bujutsu referred to combative arts used in battlefields. Martial arts were only practiced by a member of a professional warrior class, that is, the samurai.

Bujutsu was not for the purpose of self-defense as it is today. The samurai had no concept of self-defense as people today think of it. They were employed in the service of their feudal lord to promote their interests—whether political or economic.[46] People who were not professional military men, like merchants or farmers, did not practice martial arts in Japan. Since they were not involved in combat on the battlefield, they had no use for them. Martial arts in Japan those days were made up of offensive techniques.

Modern jujutsu began to arise, as guns made their appearance and the need for hand-to-hand combat skills among the military faded away. Particularly, the preservation of jujutsu techniques was entrusted to the civilian population. This modern jujutsu was born of a need for people to defend themselves against violence of a more personal nature.[47]

With the dawn of the twentieth century, styles like *taijitsu* (a method of throwing an opponent to the ground) and *nihon kempo* (specialized methods of striking

44 Cezar Borkowski & Marion Manzo (1999). p. 165.
45 Jin Su Lee (1999). p. 396.
46 John Corcoran and John Graden (2001). p. 44.
47 Cezar Borkowski & Marion Manzo (1999). pp. 166–167.

an adversary) started to emerge.[48] During this period, practitioners would have migrated from teacher to teacher, rather than bonding with a single teacher. This migration would give rise to a great number of hybrid systems. Over time, methods of grappling and striking would be fused together and renamed *nihon* (Japanese) jujutsu. This replaced classical jujutsu. Kano Jigoro also studied different styles of jujutsu under a number of teachers.

As peace was achieved and the weapons became more advanced, martial arts were no longer justified as a means of combat arts. Thus, the quasi-martial, sport type of martial art such as judo (the way of throwing and grappling), *kendo* (the way of the sword), and *aikido* (the way of locking the joints) have been evolved from ancient fighting disciplines—*jujutsu, kenjutsu,* and *aikijutsu*. The suffix *-do* replaced *-jutsu* as late as the late nineteenth century and mid of twentieth century—judo (柔道: 1882), kendo (劍道: 1911), *kyudo* (弓道: 1930s), karate-do (空手道: 1935), aikido (合氣道), *Iaido* (the way of drawing and cutting with the sword) and *jukendo* (the way of fencing with a bayonet: 1956).[49]

They originated from a time when the practical martial arts were being transformed into the more holistic martial ways. The basic purpose of these martial ways is to learn how to defeat an opponent within the accepted rules of engagement. It is different from the old martial arts where the goal was to simply win.[50] A martial scholar Dave Lowry characterized the modern martial arts as such, "There are a number of Ways in Japan for various disciplines, but all of them have similar goals: a perfection of character, a pursuit of life's truths, and a polishing for the spirit." More precisely speaking, today's martial arts are martial ways.[51]

2) Modern Era

Modern judo had evolved around the time of transition in Japanese history. It was shortly after the Emperor Meiji was restored to power and Japanese society was going through a complete transformation. Judo was created mainly based on the

48 Cezar Borkowski & Marion Manzo (1999). p. 166.
49 Jin Su Lee (1999). p. 395.
 Also see, John Corcoran & John Graden (2001). p. 47.
50 Walter Yamada (1994). A Short Report on Judo: Experience, Philosophy, and Teaching. p. 171.
51 John Corcoran and John Graden (2001). p. 43.

techniques of jujutsu (柔術).⁵² As an ancient combat art of grappling in armor, jujutsu was meant primarily for combat.

Judo was systematically developed into its present form by a Japanese martial artist, Kano Jigoro (1860–1938).⁵³ Kano Jigoro was born of a merchant class. He created judo not for combat but for the personal cultivation of physical and mental fitness and for the beauty of its aesthetic form.

In his youth, Kano Jigoro diligently studied several styles of jujutsu such as Yagyu-ryu under Yagi Teinosuke and Tenjin shinyo-ryu under Fukuda Hachinosuke and later Masamoto Iso. After Masamoto Iso died in 1881, he moved onto Kito-ryu (起倒流) under Iikubo Tsunetoshi. Tenjin-ryu was known for its *atemi-waza* (striking) and *katame-waza* (groundwork). Kito-ryu was a form of aiki-jujutsu which incorporated throwing techniques with internal energy and the blending of one's energy and movements with one's opponent. Later, Kano Jigoro blended these groups of techniques into his own system.

In 1882, Kano opened up his own dojo. In the early years Kano was teaching a blend of different jujutsu styles while developing his own art.⁵⁴ After studying various schools and forms, Kano adopted only smooth and gentle movements of jujutsu into his new style of techniques. He attempted realizing Laotze's philosophy that "Gentleness can subdue toughness." All dangerous holds and techniques were either eliminated or modified.⁵⁵ He meant to make his new martial art pro-social and educational and tried eliminating unscientific factors while developing new ways of teaching it.

As part of his effort to develop a new pedagogical method and to fulfil an educational purpose, he adopted randori (free practice) and kata (本: floor patterns or forms). Kano also earned a doctorate in Physical Education and developed jujutsu skills into his own system based on modern sports principle.

Kano first eliminated all the vicious aspects of jujutsu and made it into a modern form of discipline that was "safe, sound and enjoyable to anyone."⁵⁶ It featured techniques that would not permanently injure the judo practitioners and provided them with the opportunity to test their combative skills in a setting that posed minimal

52 Bruce P. Boren (1994). p. 3.
53 Jennifer Lawler (2004). p. 223.
54 Jon Bertsch (1999). p. 168.
55 Bruce P. Boren (1994). p. 4.
56 Ibid.
 See also, Cezar Borkowski & Marion Manzo (1999). p. 196.

risk. Kano named his unified martial art "judo."

To distinguish judo from jujutsu, Kano added the ending "do," meaning way or path, implying that judo was more than just a new form of jujutsu. He felt that judo should be both a method of self-defense and physical exercise as well as a way of life. He also thought that lessons learnt in the physical art of judo should be transferred to one's life outside the judo training hall. Following his philosophy he named his school Kodokan Judo Institute (講道館) founded on the ground of the Eisho-ji Temple in Tokyo, Japan.[57] The name means "an enlightened place where one studies the 'way.'"[58] Kano later writes:[59]

"I drew up, in 1882, my Kodokan Judo, assimilating all the good qualities found in all jujutsu schools, and formulated a method of instruction in conformity with the teachings of modern sciences. In this I did not attach exclusive importance to the contesting side of the exercise, as had been the case formerly (in jujutsu), but aimed at a combination of contest exercises and the training of the mind and body."

At the time the Kodokan was founded, Kano Jigoro was only twenty-three years old. He began teaching his new art to about nine students in a small dojo of twelve *tatami* (Japanese mats made of rice straw, whose modern equivalent is the foam-covered mat). Twelve tatami refers to an area 16 by 16 feet (5 by 5 meters). By 1964, the Kodokan was made up of over 500 tatami, and approximately one half million registered black belt holders.

From its humble beginnings, Kodokan has grown to the international judo headquarters. Most dojo around the world take its word as the foremost authority on the principles of judo. Since judo itself is constantly changing, the Kodokan takes responsibility for sanctioning any changes of the art's rules. The Kodokan is an impressive complex—a city block wide and seven stories tall. It houses several dojo, administrative offices, shops, a museum and an arena for competition.[60]

Since its outset, judo became regarded as a primary source of learning self-defense in Japan. Thus, the Tokyo Metropolitan Police Department began training its officers

57 Don Speakman (1997). Kodokan Judo: A Physical Education Activity. Monograph: Martial Arts Program. p. 203.
58 Cezar Borkowski & Marion Manzo (1999). p. 197.
59 Walter Yamaha (1994). "A Short Report on Judo: Experience, Philosophy, and Teaching," Monograph: Martial Arts Program, Vol. 1, May 1994. pp. 171–172.
60 Cezar Borkowski & Marion Manzo (1999). p. 198.

in Kano's school so that they would develop a strong sense of physical and mental education. By the 1930s, almost all secondary schools and colleges in Japan had established judo as one of their foremost physical education classes. However, judo's popularity in Japan reached a pinnacle at that time which has not been equaled since.

In addition to being credited with judo's development, Kano worked tirelessly, traveling the globe for more than 50 years, propagating his unique martial art. It was on a return trip from Cairo, where he had attended an International Olympic Committee meeting, that Kano died aboard ship. After his death in 1938, an army of skilled teachers continued his mission to spread judo throughout the world.[61]

Immediately after World War II, the practice and teaching of judo was primarily limited and in some ways restricted to law enforcement agencies. People began to shy away from disciplines and practices that reminded them of feudal Japan.

3) Judo in the World

Since then, judo has been developed into a modern sport and disseminated to the rest of the world. Judo's first Western dojo was established in Marseilles, France in 1889. Jean-Joseph Renaud and Guy de Montgrillard became the world's first non-Japanese judo instructors. In 1918, the first British dojo was founded under the leadership of E.J. Harrison. Japanese immigrants brought their Judo skills to North America with them. One of the first Americans to study at the Kodokan in Japan was Walter E. Todd, who received his *godan* (fifth degree black belt) in 1949.[62]

In 1964, when the Olympics were held in Tokyo, Judo became an Olympic sport. Since then, it has become a very popular sport throughout the world today. Presently, judo is practiced all around the world and there are championship eliminations in eight categories ranging from 60kg to over 95kg. From 1964 to 1968, the victorious record of two heavyweight Dutchmen, Anton Geesink and William Ruska marked an end to Japan's domination of the sport. The significance of their victories paved the way for numerous non-Japanese champions who would follow in their steps.[63] Historically, Japan has dominated international competition in judo. However, today

61 Cezar Borkowski & Marion Manzo (1999). p. 196.
62 Cezar Borkowski & Marion Manzo (1999). p. 199.
63 Cezar Borkowski & Marion Manzo (1999). p. 199.

the Japanese are receiving intense competition from East European countries, Korea and some of the central European countries like France and Germany.[64]

The popularity of judo now seems eclipsed by other martial arts. Doubtlessly, other martial arts such as karate, tai-chi, and taekwondo possibly seemed more exotic and have become more popular. Another reason judo lost some of its popularity was, surprisingly, its inclusion as an Olympic sport. Such an emphasis on competition led to a rapid disintegration of judo technique and the adoption of cruder, wrestling-type strategies where physical force superseded skill. Today, many judoka have become dismayed over what they perceive as the corruption of their Way (道) and are working to restore its integrity.[65]

Judo was the first Asian martial art taught publicly in America. It was taught in New York in 1902 by the late professor Yoshiaki Yamashita who studied under Kano Jigoro. Yoshiaki Yamashita came to the United States at the request of President Theodore Roosevelt and he was also the president's personal instructor.[66]

The most important breakthrough came when Kano attended the Los Angeles Olympic Games in 1932. As a result of his visit, four black belt associations were formed in southern and northern California, Seattle, and Hawaii, respectively.

After World War II, many servicemen began returning to the United States having studied at the Kodokan. This was the true beginning of the sport's rise in popularity in the United States.

In May 1948, the Japan Karate Association (JKA) was established by students of Funakoshi Gichin with the standards of training (kihon, kata, and kumite) and competition.[67] By the end of 1953, judo had begun its surge as a popular national sport at both the public and collegiate level. At that time, the first ever national high school and collegiate tournaments were held.[68]

In 1970, Karate was approved as an international sport by the IOC. Since then it has become an official event in various regional games such as the Asian Games and so forth.[69] Presently, there are 169 member nations affiliated with the World Karate Federation.

64 Bruce P. Boren (1994). p. 5.
65 John Corcoran and John Graden (2001). pp. 57–58.
66 John Corcoran and John Graden (2001). pp. 4 & 10.
67 http://karatethai.com
68 Bruce P. Boren (1994). p. 6
69 http://www.karatedo.wo.to

Reference

Books

Bertsch, Jon. "The Role of Kata Practice in Judo Training." Journal of Martial Arts Studies. Fall 1999. Vol. IV.

Boren, Bruce P. "The History and Philosophy of Judo." Monograph: Martial Arts Program. (Vol. 1, May 1994). p. 3.

Borkowski, Cezar and Manzo, Marion (1999). The Complete Idiot's Guide to Martial Arts. An Alpha Books/Prentice Hall Canada.

Corcoran, John and Graden, John (2001). The Ultimate Martial Arts Q & A Book. Contemporary Books.

Harrison, E. J. (1955). Judo on the Ground: The Oda (9th Dan) Method "Katamewaza." W. Foilsham & Cp. Ltd.

Inokuma, Isao & Sato, Nobuyuki (1991). Best Judo. Kodansha International.

Lawler, Jennifer (2003). Martial Arts for Dummies. Wiley Publishing, Inc.

Lee, Jane. "The Principles of Judo". Journal of Martial Arts Studies. Fall 1999. Volume IV.

Lee, Jin Su (1999). Ilbon Mudo Yeongu (English translation: Studies on Japanes Martial Way). Kyeohakyeongusa.

Kudo, Kazuzo (1967). Judo in Action. Kodansha International.

Seisenbacher, Peter & Kerr, George (1997). Modern Judo: Techniques of East and West. The Crowood Press.

Speakman, Don. "Kodokan Judo: A Physical Education Activity." Monograph: Martial Arts Program, 1997

Yamada, Kudo. "A Short Report on Judo: Experience, Philosophy, and Teaching." Monograph: Martial Arts Program, (Vol. 1, May 1994).

Yamaha, Walter. "A Short Report on Judo: Experience, Philosophy, and Teaching," Monograph: Martial Arts Program, Vol. 1, May 1994.

Web Sites

Ohlenkamp, Neil, "History of Judo: Kodokan Judo," www.judoinfo.com

Sumo
Japanese Traditional National Sport

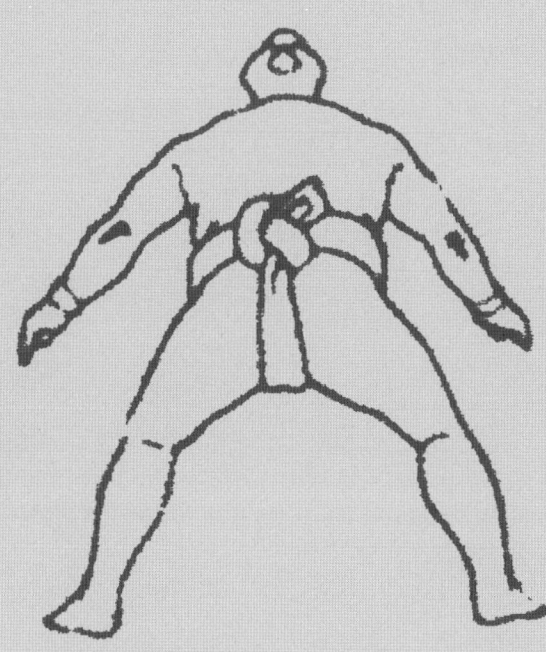

What is Sumo?

Definition
Lifestyle

Techniques

Basic Techniques
Training Methods
Competition
Ranking System

History

Origin
Medieval Period
Modern Era

1. What is Sumo?

1) Definition

Sumo is the traditional national sport of Japan. The sport is noted for the giant size of its participants, who sometimes weigh over five hundred pounds.

Sumo was originally known as *sumai* (相撲), which is the ancient Japanese word for "struggle."[1] As a grappling form of combat art, it was quite a different entity in ancient days. Fully effective in combat, the object of this ancient fighting was to cause the opponent to surrender unconditionally. Different from the modern version, the range of techniques included kicking, butting, and striking; injuries often happened and deaths occurred occasionally. Sumo was used as a means of settling disputes between two groups of people and chosen fighters representing both sides engaged in the fight.

Obviously, times have changed and now injuries are rare inside the sumo ring. Nowadays, sumo is viewed more as a form of entertainment than as martial arts.[2] Sumo is big business in Japan today and sumo wrestlers are all professional and make substantial incomes. Today, sumo is Japan's traditional sport which involves many ancient rituals. Yokozuna, the grand champions of sumo are treated with awe and they are respected by the media, politicians, their fellow wrestlers, and their adoring fans. Outside Japan, however, it is almost impossible to find any amateur sumo competitors or schools.

2) Lifestyle

Sumo is very much a way of life as well as a sport. The practitioners must live a rigid, hierarchical lifestyle. They also have a communal life that is completely dedicated to the sport. In the life of a *rikishi* (力士: sumo wrestler), there is little time off.

Novices begin their day in the early morning, around half-past five with a practice session, and then they start their assigned duties, which include cooking and

[1] Donn F. Draeger & Robert W. Smith (1969). Comprehensive Asian Fighting Arts. Kodansha International Ltd. p. 131.
[2] Cezar Borkowski (1999). The Complete Idiot's Guide to Martial Arts. Prentice Hall Canada Inc. p. 23.

cleaning their *heya* (training facilities or stables). They also have a duty of *tsukebito* (personal manservant) to their seniors (*sekitori* wrestlers) or coaches. There is no breakfast, neither eating nor drinking of any kind, before practice. Throughout the day, they train, eat, and nap. In the evening, they are permitted to enjoy some personal freedom outside of the barracks up until the time of their curfew.[3]

The senior rikishi sleep in until a more reasonable hour. Warm-up exercises and practice in the stable are also undertaken in order of rank, lowest to highest.[4]

The size of rikishi is based on a diet mainly consisting of rice—the heavier the wrestler, the lower his center of gravity and therefore harder to push or toss out of the ring. The grand champions weigh many hundreds of pounds and eat heavily while the younger and junior wrestlers are slim in appearance.

Popular sekitori (higher-ranked wrestlers in the *juryo* or *makuuchi*) make *tegata*, the valuable autographed hand prints so eagerly sought by fans and sponsors.[5] It is made on a white paper. Sekitori pats his palm on the pad of ink and stamps it on the paper, leaving a hand print. Then the sekitori autograph it with a black brush pen with *kanji* (Chinese) characters on it.

Shitatenage

2. Techniques

1) Basic Techniques

Officially, there are 78 techniques, but only about 48 are commonly seen. Many are thrusting or pushing techniques, arm throws, or leg trips.

Yorikiri (force out) A rikishi uses both hands on his opponent's belt to force him out.

3 John Corcoran and John Graden (2001). The Ultimate Martial Arts Q&A Book. Contemporary Books. p. 196.
4 David Shapiro (1998). Sumo: A Pocket Guide. Charles E. Tuttle Company. p. 34.
5 Mina Hall (1997). The Big Book of Sumo. Stone Bridge Press. p. 25.

Uwetenage (overarm throw) This is the most common throw technique. A rikishi, using an outside grip on the belt, throws his opponent down.

Shitatenage (underarm throw) It is similar to *uwatenage*, except the rikishi uses an inside grip on the belt to throw his opponent down.

Hatakikomi (pull down) A rikishi grabs his opponent's hands, arms, shoulders, or neck and pulls him down.

Sukuinage (beltless arm throw) A rikishi forces his arm under his opponent's armpit and then, without gripping the belt, throws him down.

Tsuridashi (carry out) A rikishi, using two hands, grabs his opponent by the belt and carries him out.

Kubinage (headlock throw) A rikishi wraps his arm around his opponent's neck, as in a headlock, and throws his opponent down.

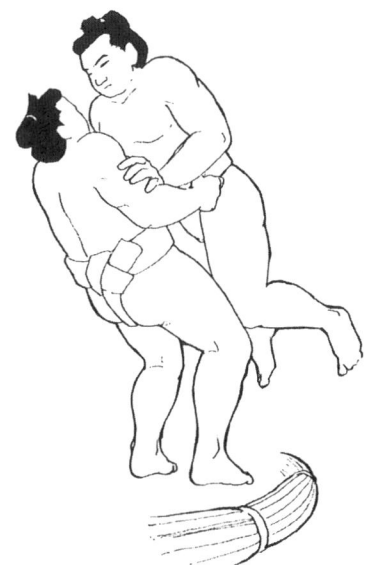

Tsuridashi

Sotogage (outside leg trip) A rikishi wraps his leg around the outside of his opponent's and trips him or immobilizes the leg so that the opponent loses balance.

Uchigake (inside leg trip) It is similar to sotogage, except a rikishi wraps his leg around the inside of his opponent's leg and trips him.

Kimedashi (lock and push out) A rikishi locks his arms around his opponent's and forces him out.

Tsukidashi (thrust out) Alternating arms at a very quick pace, a wrestler thrusts blows at his opponent's chest, forcing him out.

Uttchari (twist out) A rikishi pushed to the edge and nearly out grabs his opponent and, in a desperate move, twists and pushes his opponent out first.

2) Training Methods

The training schedule rarely changes. The youngest and lowest-ranked wrestlers start practice first, usually around 4:30 or 5:00 o'clock in the morning. Wearing dark-colored cotton *mawashi* (belt), they warm up in the *dohyo* (ring) by themselves until a coach or the stablemaster arrives.

Around 8:00 a.m., the sekitori (wrestlers ranked in the juryo division or above) make their way down from their private rooms and join practice. Wearing white mawashi, they are very easy to recognize. The lower-ranked wrestlers who are assigned to kitchen duty for the day then leave to begin their chores and to prepare lunch.

a) stretching and strengthening exercises

A variety of movements are designed to stretch and loosen the muscles and to increase strength. The two most basic exercises are *shiko* and *matawari*.

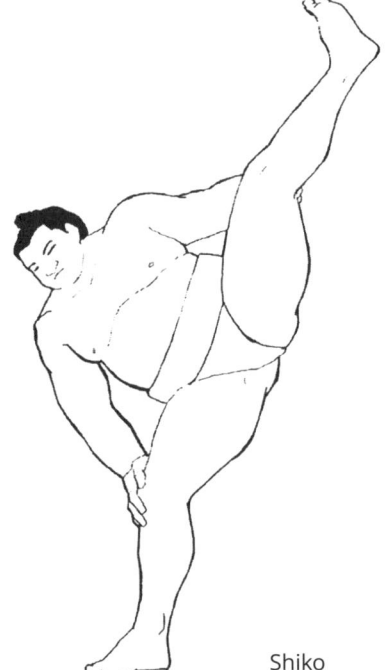
Shiko

Shiko A Rikish lifts his leg straight up to the side (alternating both right and left legs), as high as possible, then slams his foot to the ground, slapping his hands on his knees, and exhaling, ending in a crouched position. Its purpose is to loosen and strengthen the muscles and joints of the hips and legs.[6] Wrestlers sometimes do hundreds of them in a day.[7] Shiko is also performed repeatedly during the rituals of a tournament: "The hard thumping has symbolic significance and figures promi-

6 David Shapiro (1998). p. 35.
7 MinaHaU (1997). p. 19.

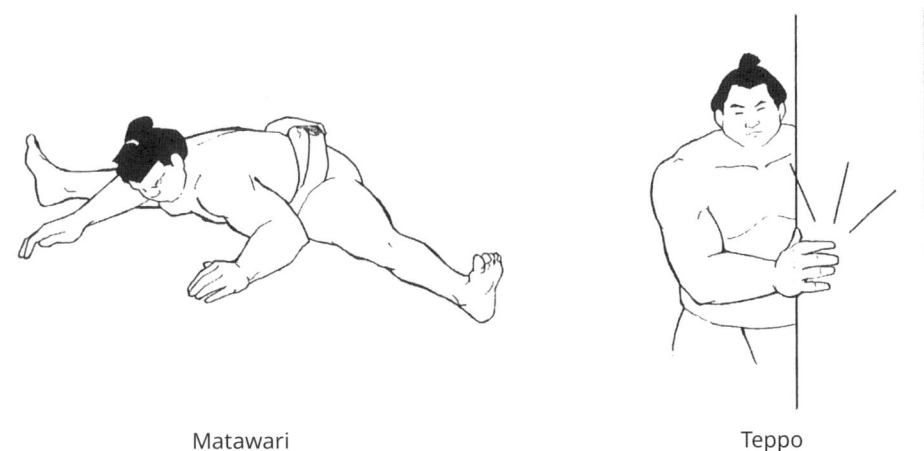

Matawari Teppo

nently in the pre-bout ceremony at tournaments."[8]

Matawari (thigh splits) This is a common stretching exercise, sometimes referred to as "sumo splits."[9] Seated on the ground the rikishi spreads both legs as far as possible to the sides and then leans forward until his upper chest and shoulders touch the ground.

Teppo (slapping exercise) This is another exercise found only in sumo. The rikish faces a tall wooden pillar and slaps it with his open hands, one after the other. While striking it with one palm he makes a foot sweeping motion—when pushing with the right hand, follow with the right foot and vice versa. This exercise helps coordinate arm and leg movements.

Shiko and teppo are normally performed before practice bouts while matawari is performed after.[10]

b) practice bouts
After warming up, rikishi take part in challenge matches.

8 David Shapiro (1998). p. 35.
9 David Shapiro (1998). p. 35.
10 David Shapiro (1998). p. 36.

Moshiai-geiko *Moshiai-geiko* is usually the first type of match.[11] *Geiko* means all types of training. It is a real match played in dohyo (ring) similar to the competitive bouts seen on TV, but without the elaborate rituals and preparation time.[12] Two kirishi square off and fight; the winner picks his next opponent and continues to fight until he is defeated. Theoretically speaking, the winner gets stronger and more skillful because he gets more exercise with various types of opponents. It is at this time that lower-ranked wrestlers may be given the chance to fight against higher-ranked ones.

Butsukari-geiko Near the end of practice, one rikishi charges and runs into another and tries to push him out of the dohyo (ring). The defender, while yelling, tries to hold the attacker as he slides backward toward the edge. Oftentimes he throws him down so the attacker can practice falling. The exercise is repeated by the same wrestlers until they are unable to stand and are covered in sweat and sand. Around 8:00 o'clock, the sekitori make their appearance and lower-ranked wrestlers must stand aside to watch and assist them.

Sanban-geiko This exercise is favored by the sekitori. As a means of stamina training and honing technical skills, the two same wrestlers can challenge each other for a series of matches. Often rikishi of different visions have training together and this exercise provides an excellent training opportunity for lower-ranked wrestlers to get fighting tips from their seniors.

Jog-shuffling After the matches and drills are over, the wrestlers will line up around the dohyo with their knees bent, holding the belt of the person directly in front They slowly jog-shuffle around the dohyo while chanting, "*Yoisho, yoisho, yoisho!*" Their feet do not leave the ground. This is a great leg strengthener.

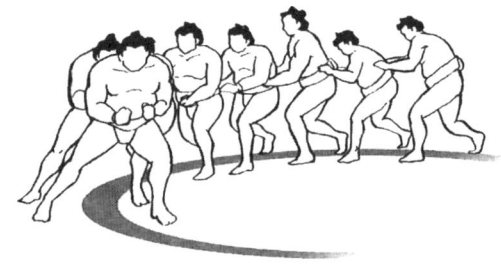

Jog-shuffling around the *dohyo* after practice

11 David Shapiro (1998). p. 36.
12 Mina Hall (1997). p. 21.

Sonkyo Training concludes before noon, generally with stretching exercises and with *sonkyo*. This is breathing deeply, almost in a meditative state, while squatting down with straight back and hands placed on the knees.

3) Competition

Each year six Grand Sumo tournaments are held, in each odd-number month. Three are held in the capital, Tokyo, and one is held in Osaka, Nagoya, and Fukuoka, respectively.[13]

Upon entering the ring, the contestants toss salt around the ring to purify it; sumo still holds to its religious roots strongly and each wrestler asks for the help of the gods to win the battle. The ring is also blessed by a priest as well before and after every battle. The winner shows no expression of joy or adulation, unlike many other sports—sumo wrestlers never jump up and down in happiness or scream for the crowd's approval.

The bouts are a demonstration of a wrestler's sheer strength or clever technique. Because there are no height or weight restrictions, some of the most interesting matches occur when a smaller wrestler is matched against an opponent twice his size.

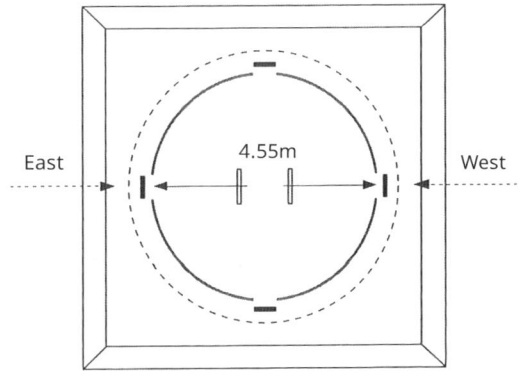

Dohyo (the ring)

Tying the mawashi (belt)

13 John Corcoran and John Graden (2001). The Ultimate Martial Arts Q&A Book. Contemporary Books. p. 195.

The rules of sumo are simple. Each match consists of two wrestlers of gargantuan size and weight who enter the circular dohyo wearing nothing except mawashi (a thick silk belt that passes beneath the legs and around the waist). Their objective is to force the opponent out of the ring, or to make any part of the opponent's body (except the soles of the feet) touch the playing surface. The competitors are permitted to push, slap, leg trip, and arm throw. They are not allowed to pull hair, gouge eyes, choke, grab in the groin area, or strike with a closed fist.[14]

The matches are overseen by a referee and several judges who ultimately decide the winner. Normally, these bouts are very brief, averaging only a few seconds in length. However, some matches actually go on for two or three minutes.

Much of sumo is a mental affair; the art of winning before the first move is even made. Wrestlers stare at each other for long minutes to try and gain the advantage before any actual physical contact.

At the end of a bout, the competitors stand on their sides of the ring and lower their heads to each other. Customarily, the loser exits the ring first. The winner stays behind to express his gratitude to the three gods of creation. He does so by swiftly swinging his hand in the four cardinal points while crouching on his heels before the referee's paddle. He then receives a white envelope containing a predetermined monetary reward.[15]

4) Ranking System

Sumo wrestling is interesting to watch and follow as the rankings are directly based on production—you win, you go up in rank. You lose, you are demoted. There are no second chances and no appeals. Your worth is directly related to your results.

The sumo ranking system represents a hierarchical pyramid. There are a fewer number of rikish at the top levels and the majority at the bottom. For instance, there are over 850 rikishi at about fifty heya (stables) in Tokyo competing in the struggle upward through the pyramidal, hierarchical system.[16] However, less than one out of ten westlers reaches the first two top divisions: the Makuuchi and Juyro divi-

14 Mina Hall (1997). p. 16.
15 John Corcoran and John Graden (2001). The Ultimate Martial Arts Q&A Book. Contemporary Books. p. 196.
16 David Shapiro (1998). p. 8.

Ranking System

Source: Mina Hall (1997), The Big Book of Sumo. Stone Bridge Press. Berkeley, California, p. 31.

sions.[17] The Makuuchi division has about 38 to 40 wrestlers and juyro has 26.[18]

Rikishi in these top two divisions are referred to as sekitori and becoming one brings with it a huge leap in status. They are considered "professional" sumo wrestlers and no longer apprentices. They also get paid every month starting from $9,570 (Juryo division) to $26,060 (Yokozuna rank in the Makuuchi division) in 1998;[19] whereas, the rishiki in the lower four divisions are guaranteed "nothing more than a roof, three square meals, long hours of hard work, and a chance for stardom."[20] There are 120 fixed number of rikishi in the Makushita division, 200 fixed number of rikishi in the Sandanme division, about 300 the Jonidan division, and about 100 the Jonokuchi division. [21]

From their appearance, it is very easy to distinguish the sekitori wrestlers from others since they have different apparel and hairstyles. During tournaments, sekitori wear pure silk mawashi in bright colors whereas lower division rikishi wear a prac-

17 Mina Hall (1997). p. 34.
18 David Shapiro (1998). p. 30.
19 Mina Hall (1997). pp. 35 & 41.
20 David Shapiro (1998). p. 8.
21 Mina Hall (1997). pp. 32–33.

A sekitori's oichomage

tice mawashi of cotton canvas.[22] Sekitori also do a more elaborate *chonmage* (topnot) hairstyle.

Part of a sekitori's job is to help train the lower-ranked wrestlers. In return, the apprentices respectfully act as his servants, continuously wiping him down and offering him water.

3. History

1) Origin

The origin of sumo is bedded in mythology. According to the ancient chronicle *Kojiki* (古事記: Record of Ancient Matters) written in A.D. 712, the fate of the Japanese islands once rested upon the outcome of a Sumo bout between a divine wrestler, Takemikazuchi and a commoner wrestler, Takeminakata. The former emerged victorious and thus the disputed land went over to the divine race.[23] This mythological fight implies that Japanese wrestling in its early period had a functional aspect of early combat and that it also played a role of settling disputes stirred up between two groups of people and chosen fighters representing both sides engaged in the fight.

Sumo in its early days tended to be violent. The *Nihon Shoki* (日本書記: Chronicles of Japan) written in A.D. 720, bore witness to the first historic combat sumo match held on a beach at Izumo in Shimane Prefecture. In 23 B.C., the Emperor made a special request to Nomi no Sukune, a potter from Izumo to fight the undefeated Tajima no Kehaya. In the fierce fight Sukune defeated Kehaya by fracturing the latter's ribs with a kick from a standing position, knocking him to the ground. Sukune then trampled

22 Mina Hall (1997). p. 21.
23 Mina Hall (1997). p. 11.

Kehaya and crushed his hipbone. Kehaya died from these injuries.[24] Sukene, the victor has been immortalized ever since as the Father of Sumo. A shrine in Shimane Prefecture today marks the site of the first sumo match ever recorded in a history book.[25]

Legend aside, the sport of sumo dates back some fifteen hundred years. Its origins were religious, based on *shinto* rituals. Matches were held at shinto shrines and dedicated to the gods in hopes of good harvests. The bouts took place along with music, poetry reading, sacred dancing, and drama.

During the Nara (645–794) period, sumo known as *sechiezumo* was patronized by the imperial family and was ceremonially performed once a year on the seventh day of the seventh lunar month (early August) at the imperial court in the presence of royalty. Court officials were always on the lookout for exceptionally strong men or skilled wrestlers who could participate in the yearly event. Rikishi attained special social status and many were appointed as guards to the court. At the time, sumo was a combination of wrestling, boxing, and judo. Maches were quite violent and had few rules. A survey of tactics was made during these times with a view to reducing dangerous elements in sumo combat.[26]

In Heian times (794–1185), sumo became popular as a spectator sport and Emperor Mimmyo issued an edict which stated sumo was to revert to its original combat form (*sumai*) and was to be regarded as a symbol of the nation's military strength. With the rise of the bushi (武士)class in the late Heian period witnessed the warrior take notice of sumo as a practice for combat. In the shift of political power from the Heian Imperial Court in Kyoto to the bushi class, sumo took on new and invigorating dimensions.

2) Medieval Period

During the Kamakura period (1185–1334), a *shogunate* (military dictatorship) was established and bloody wars were fought throughout Japan. It was at this time that sumo was implemented as part of the military's training program and it turned into full combat effectiveness. Many of the wrestling techniques practiced were used to force an enemy down to the ground where he could easily be restrained for capture

24 Donn F. Draeger & Robert W. Smith (1969). p. 131.
25 Mina Hall (1997). p. 11.
26 Donn F. Draeger & Robert W. Smith (1969). p. 132.

or he could be killed, usually with the blade. The sport sumo—simply throwing the opponent to the ground to win the game—was abandoned. Jujutsu, an ancient Japanese fighting system in which one holds, throws, and hits one's opponent, developed from the sumo of this period.[27]

In the Muromachi period (1392–1573), as well as in the following Azuchi-Momoyama period (1573–1600), the bushi government brought the combat development of sumo to its zenith. Toward the end of the latter period, as Japan stabilized its politics, combat sumo had little opportunity for outlet in war and sport sumo again became popular.

However, the sport aspect of sumo was not forgotten at all during this period. Over the years sumo grew to become the favorite sport of feudal lords and aristocrats. The powerful warlord Oda Nobunaga (1534–1582) was one of the most famous patrons and a great sumo enthusiast. He organized several tournaments at his Azuchi Castle. In February 1578, he assembled over fifteen hundred wrestlers gathered to take part in a competition. Until then there had been no definite boundaries to the arena in which sumo was held; the space was delineated simply by the people standing around in a circle watching or waiting for their own turn to fight. Apparently, because many bouts were held on the ground and to speed up the proceedings, a circle boundary was designated and the wrestling ring was drawn for the first time. Years later rice straw bales began to be placed around the edges of the circle, keeping the boundaries secure. This continues to the present day.

The civil wars of Japan finally ended in 1603 when Tokugawa Ieyasu became *shogun* and united the entire country under his rule. Over the next 250 years the land was mostly at peace. Combat sumo had seen its end. Instead, "street sumo" became very popular. Men would challenge each other as crowds gathered to watch and cheer for their favorite fighters. The winner of a bout was the wrestler who threw his opponent down to the ground or into the crowd. But because the fighting was so violent, it was often difficult to clearly determine the winner. Arguments broke out, forcing the authorities to intervene.

As a result, the Tokugawa shogunate banned street sumo and passed a new law that permitted sumo only for the benefit of the gods. The resulting matches were called *kanjin-zumo* (勧進相搏: benefit sumo) and were used to raise money for the construction of new temples and shrines and for the repairing of old ones. Tourna-

27 Donn F. Draeger & Robert W. Smith (1969). p. 132.

ment promoters were either *ronin* (masterless samurai) or former wrestlers and they were required to obtain special permission from a temple in order to hold a tournament. These promoters came to be known as *toshiyori* (elders) and they acted as liaisons between the government and temple officials and the wrestlers.

Sumo's popularity was mainly concentrated in Kyoto and Osaka and did not extend to Edo where the shogunate was located. (In 1868 the name of the city was changed to Tokyo). Women at the time were not allowed to watch official tournaments. Later the Sumo Association of Edo was formed and became dominant in Japan. Young wrestlers from all over the country would travel to Edo to train. *Daimyo* (feudal lords) sponsored exceptionally strong wrestlers.

During this period *kesho-mawashi* (special ceremonial apron) was designed for and given to the mightiest sumo wrestlers. The apron was embroidered with the family crest of the feudal lord they served and a large allowance and samurai status were given to the wrestler if he did not already come from a warrior background. Being chosen to carry the name of a daimyo into a battle held prestige and fame, and many fought for the right to obtain and wear these aprons. This tradition passed down to the present day where at the opening ceremonies of each tournament (*basho* in Japanese) the contestants parade for the audience wearing the apron that denotes their birthplace and their ranking, along with the school they belong to. Wrestlers participated in tournaments and were ranked accordingly on *banzuke* (ranking sheet).

In 1789, Yoshida Oikaze, a referee from Kumamoto, established himself as the chief representative of the sumo world. He developed the *dohyo-iri*, a series of purification rituals that were to be performed prior to the matches. He introduced the *yokozuna menkyo* (grand champion license). At this time, however, *yokozuna* (grand champion) was not an official rank. The highest rank was *ozeki*. Having a yokozuna license only certified that a champion wrestler could perform the dohyo-iri (ring-entering ceremony). It was not until 1909 that the rank of yokozuna was officially established.

3) Modern Era

In 1868, the Tokugawa shogunate peacefully turned its power to the imperial court of Japan and Emperor Meiji was restored to the throne. The Meiji (1868–1912) era began and the Japanese realized that after centuries of being a closed country, many people

started putting away their *kimono* and began wearing Western clothes. Samurai were no longer allowed to carry swords and were ordered to cut off their chonmage (topnots) in favor of short, Western hair styles. An exception, however, was made for sumo wrestlers, who were able to keep their chonmage because it served as a head protector in case of a fall during a bout.

The Sumo Association itself underwent major reform, changing its name to Tokyo Grand Sumo Association. Directors were elected, wrestlers' wages were set, and the final authority of bouts went from the *gyoji* (referee) to the ringside *shinpan* (judges). By 1872, women were allowed to watch official tournaments. Instead of feudal lords, it was now politicians and captains of industry who sponsored the matches.

Later, in 1925, a cup was awarded to tournament champions in the name of the prince who would soon become Emperor Hirohito. This trophy is known today as the Tenno-hai (Emperor's Cup). Soon after, the Osaka and Tokyo sumo associations merged to form All-Japan Grand Sumo Association. Sumo was once again sponsored by the imperial court of Japan and sport sumo thrived, revolving around the popularity of the yokozuna (grand champions) with the public masses.

Today, the Japan Sumo Association, with more than 1,000 employees, is the organization that runs every aspect of professional sumo. In 1957, the name of the association was changed to Nihon Sumo Kyokai (Japan Sumo Association).

With the growth of its popularity outside of Japan, there have also been changes. The 1993 Grand Champion is a man called Akebono, a Hawaiian who took up the sport at a young age and excelled in it. His victory surprised Japanese and Americans alike who wondered at this stranger taking on the Japanese traditional sport and becoming a Grand Champion. Due to Akebono's success, more international competitors are now entering the ring.[28]

28 Mina Hall (1997). pp. 128–129.

Reference

Books

Borkowski, Cezar and Manzo, Marion (1999). The Complete Idiot's Guide to Martial Arts. An Alpha Books/Prentice Hall Canada.

Corcoran, John and Graden, John (2001). The Ultimate Martial Arts Q & A Book. Contemporary Books.

Draeger, Donn F. & Smith, Robert W. (1980). Contemporary Asian Fighting Arts. Kodansha International.

Hall, Mina (1997). The Big Book of Sumo. Stone Bridge Press.

Shapiro, David (1998). Sumo: A Pocket Guide. Charles E. Tuttle Company.

Ssireum
Korean Traditional National Sport

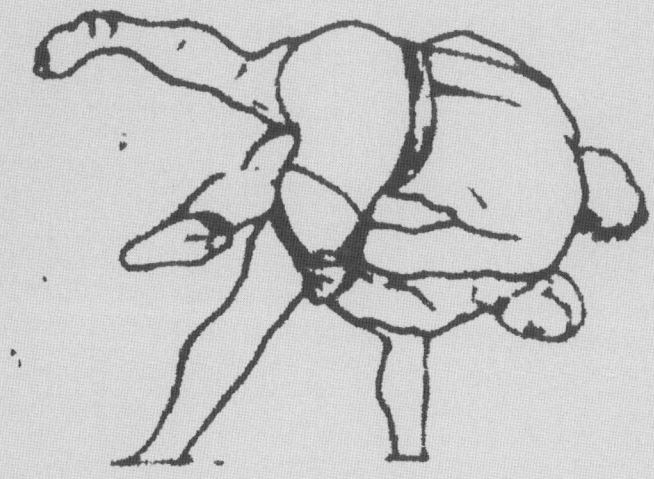

What is Ssireum?
Definition
Characteristics
Styles

Techniques
Types
Competition

History
Origin
Modern Era
Future

1. What is Ssireum?

1) Definition

Ssireum is a traditional Korean folk sport in which two contestants compete in direct contact against one another in a circular sand pit in a contest of physical strength, strategy, technique and will power. To put it more simply, ssireum is a Korean form of wrestling based on grappling techniques which has become an indigenous folk sport—simple enough for any onlookers to understand and take part in the bouts. The sole objective of the match is to force the opponent to the ground before he or she does the same to you.[1]

Originally, ssireum was practiced as a hand-to-hand combat for self-defense reasons as well as a part of rituals carried on in the ancient tribal states.[2] Through the years, it became a popular folk pastime, often performed at festivals and celebrations. Today, ssireum is widely practiced in Korea, beginning in the public-school system and continuing on thorough college and professional team competitions. Professional teams are sponsored by some of the multi-national corporations such as Hyundai and LG, enabling professional ssireum athletes to earn large sums as prize money and to make a living at ssireum.[3]

No historical documents clearly explain the origin of the word ssireum. However, some martial historians like Donn F. Draeger and Robert W. Smith assume that the word ssireum probably has had some connection with ssilnem, a Mongolian grappling form of combat.[4] Also, there is another theory that ssireum came from the word "*ssirunda*" from a southern dialect (Yeongnam region in Korea) meaning "contend" or "fight" to display one's physical strength.[5]

In ancient Chinese literature, ssireum was called various other names such as Gakjeo (角觝), Gakjeo (角牴), Gakhi (角戲), Gakryeok (角力), Sangbak (相撲), and Jaenggyo (爭校).[6] The Chinese character *gak* (角) seems to have originated from figures of

1 http://www.turtlepress.com
2 http://ynucc.yeungnam.ac.kr
3 http://www.turtlepress.com
4 D. Draeger & R. Smith. Comprehensive Asian Fighting Arts. Kodansha International. p. 76.
5 Man Ki Lee (2002). Ssireum. Daewon-sa. p. 12.
6 Man Ki Lee (2002). Ssireum. Daewon-sa. p. 12.

horned animals such as bulls fighting against one another to display the superiority of their physically strength.[7] In Chinese *Sagi* (事記), the prefix gak (角) is referred to as "skill" and *jeo* (牴), "confront" or "fight." The Chinese people used to call the Korean form of grappling combat system Goryeogi (高麗技) or Yogyo (撩跤).[8] However, it has been unanimously called ssireum since 1920.

2) Characteristics

Ssireum is played by grasping the opponent's *satba* (a loincloth-style belt) tied around the waist and thigh. Then the two contestants try to pull and lift each other; and it normally requires considerable muscular strength and endurance. Also, the technical aspects of the sport are as important as raw strength. Furthermore, good tactics that help take advantage of the opponent's next move are essential to win the match. In addition, ssireum requires perseverance and fighting spirit on the part of the participant because one cannot expect to win the bout unless he strives up to the last moment.

From the viewpoint of recreation, ssireum as a folk sport, is entertaining to the participants as well as to the spectators. As a favorite pastime for the public, ssireum, in fact, is one of the most popular spectator sports in Korea. The opportunity to participate in ssireum is due to its simplicity and availability. A mere sand box, a patch of ground on a lawn or even a corner of a school playground is more than enough for ssireum.

3) Styles

There are three different styles of ssireum. The first is left-sided (satba) style. The left-sided style is performed by taking hold of the satba (a cloth band) on the left thigh of the opponent. This type prevailed in some Korean provinces such as Hamkyeong, Gyeongsang, and Chungcheong. The second is right-sided (satba) style which is performed vice-versa and was predominantly practiced in parts of Gyeonggi and southwestern Jeolla provinces.[9] Since the left- and right-sided (satba) styles caused a

7 http://ynucc.yeungnam.ac.kr
8 Man Ki Lee (2002). Ssireum. Daewon-sa. p. 22.
9 Man Ki Lee (2002). p. 34.

problem, both types have been unified into the left-sided (satba) style in 1994 under the direction of the Korean Ssireum Federation.[10]

The third style is *tti-ssireum*. It also has different names like *heori-ssireum* (*heori* means loin) or *tong-ssireum* depending on the regions.[11] *Tti* is equivalent to a "belt" in English. This style is found mainly in Chungcheong province. In this style, no satba is used on the thigh—the cloth band is confined to the loins only. According to D. Draeger and R. Smith, the latter style is more akin to Mongolian wrestling forms.[12]

In North Korea, the left-sided style of ssireum is commonly used; however, unlike in the South, they hold the satba while competitors remain standing.[13]

2. Techniques

The techniques in ssireum involve two contestants grasping, pulling, lifting, twisting, pushing, tackling, tripping, and throwing, as each competitor attempts to throw the opponent to the ground. The major distinction between ssireum and other combat sports such as judo or wrestling is a competitor wins if he or she can force any part of the opponent's body above the knee to touch the ground.[14] The most similar grappling sport to ssireum is its Japanese counterpart, sumo wrestling. Even though there are many similarities in both sports, there is a big difference between the two: the contestant who successfully pushes the opponent out of the ring is declared a winner in sumo while there is no such a rule in ssireum.

1) Types

Over all, there are about 106 techniques in ssireum divided into hand (*son*), leg

10 Man Ki Lee (2002). p. 34.
11 Man Ki Lee (2002). p. 34.
12 Donn F. Draeger & Robert W. Smith (1969). p. 77.
13 Man Ki Lee (2002). p. 42.
14 http://ynucc.yeungnam.ac.kr

(*dari*), waist (*heori*), and combined techniques (*jonghap gisul*). Out of these 4 divisions, the techniques can be further divided into the category of attack, defense, and counterattack. All techniques have developed over many time periods and especially through many ssireum events and matches.

Literature such as the *Kyungdojapji* (京都雜記) and *Dongguksesigi* written during the Joseon Dynasty all witnessed that there were only 3 ssireum techniques (postures) such as *naegu* (內句), *yeiogu* (外句), and *yungi* (輪起) existing at the time. It seemed the ssireum techniques were very simple and the contemporaries were only interested in the results of the games (At the time there were no time limits in each bout and the contenders were supposed to be defeated one by one until the last person standing became the grand champion).[15] In Korean terms, the grand champion is called *cheonha jangsa*.

In the 1970s, ssireum techniques were much diversified; however, for instance, there were only about ten techniques existing using the waist area. Also, there were no unified names for ssireum techniques until the beginning of the 1980s: different names were used by different people and in different regions. Thus, under the auspices of the Korea Ssireum Association, some 70 names were unified with the help of the Korean Language Society in January 1984.

The names of techniques are mostly based on human anatomy. However, many names are taken from those of implements, plants and even fish. All these names, for example, *yeonjang geori* (tool), *homigeori* (hoe), and *nakshi geori* (act of fishing), *kong kkeokgi* (bean), *jaban dwijipgi* (salted fish), etc. intend to carry the values of ancient Korean society with an agricultural background.[16]

a) hand techniques

By using hands, you can pull or push the opponent or trip him to the side.

Ap mureup chigi This is one of the signature ssireum techniques.[17] In confronting a shoulder-to-shoulder situation with your opponent, wait until the moment he makes an advance or changes

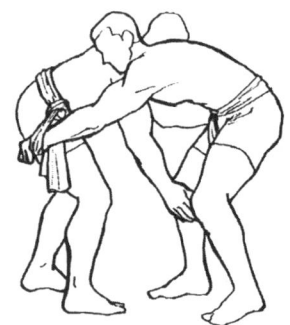

Ap mureup chigi

15 Man Ki Lee (2002). p. 59.
16 Man Ki Lee (2002). pp. 59–60.
17 Man Ki Lee (2002). p. 62.

his center of gravity towards you. Then, place your right hand on the opponent's left knee joint and lift his knee toward your left; however, it is very important to pull back your right shoulder at the same time and push your opponent with your head to the right side.

Duit mureup chigi This is the technique most widely used next to Ap mureup chigi.[18] This technique is usually applied when your opponent's left leg is forward or his center of gravity is placed towards his back. Pull the opponent's leg satba with your left hand towards you and release his waist satba and hold the opponent's left knee joint. While his left knee is locked, press your shoulders and upper body toward the opponent or towards a 45-degree angle to your right.

Kkok dwijipgi This technique is usually performed as a counter-attack against the opponent's attack such as Mireo chigi. First, release the satba held by your right hand; then use the free hand to hold down the back of the opponent's neck. Meantime, step back with your right foot and lift the satba tied around your opponent's left thigh with your left hand. After that, turn the opponent to your right side in a rotating motion.

There are 16 standard hand techniques listed is as follows:[19]

Names (16 kinds)	Ap mureup chigi Duit mureup chigi Ogeum danggigi Yeop mureup chigi Deung chaegi Kkok dwijipgi Kong kkeokgi Ap mureup jipgi Ap mureupjipgo milgi Deul ana nohki Deungcheo gama dolligi Deungcheo gama jeochigi Aemok japchagi Ap mureup dwijipgi Paljapba dolligi Apeuro nurugi

18 Man Ki Lee (2002). p. 63.
19 Man Ki Lee (2002). p. 61.

b) leg techniques

Leg techniques are mainly employed when you try to trip the opponent with your leg or foot. They are assault techniques. If you are not swift enough, you can easily be counterattacked. Since you are lifting one of your legs or feet off the ground to execute a leg technique, there is a good chance of losing your balance. Even if you maintain relatively good balance on one leg, the other leg is too vulnerable to your opponent's counterattack. Leg techniques have many advantages for taller players to use over shorter ones.

Batdari hurigi This technique is similar to a judo technique called *o-soto gari* (big outside clip). When your opponent's right leg comes forward close to your left leg, swiftly move your right leg to trap his right leg and pull it all the way back in a swing motion. While executing it you need to turn your opponent's center of gravity to the left along with yours.

Homi geori When the opponent is trying to lift you or has his right foot in front, hook the back of the opponent's right ankle with the heel of your right foot and pull it towards you. While pulling, try to lower your center of gravity and push your head under the opponent's armpit. You need to pull the satba tied around the opponent's thigh and twist the opponent to the left.

Mureupdaeo dolligi While lifting the opponent, place your left foot forward between the opponent's legs. Then place the sole of your right foot on the opponent's left knee and pull him to the right as you are moving in a circular motion.

There are 18 standard techniques associated with leg or foot as follows:[20]

Names (18 kinds)	Batdari geolgi Andari geolgi Homi geori Bitjang geori Deop geori Batdari hurigi Batdari gama dolligi

20 Man Ki Lee (2002). p. 75.

Names (18 kinds)	Nakshi geori Duitbalmok geori Balmok georeo teulgi Apdari chagi Modumdaeo apmureup chigi Mureupdaeo dolligi Ogeum geori Yeonjang geori Balmok georeo milgi Mureup teulgi Duitchuk georeo milgi

c) waist techniques

You are pulling the opponent and turning him to the right or left and applying techniques using your hips to throw him to the sides or to the back.

Deulbae jigi This is one of the trademarks of ssireum. With your hands pull both sides of your opponent's satba, however, with more force at the left satba tied around the thigh towards you. Then lift him off the ground, use your hips to make a turning motion to the right, and throw him all the way to the right.

Mireo chigi When your opponent seems to have run out of strength, or moves his left foot forward or when you judge that his center of gravity is at the back, pull the satba with both hands and push him with your upper body towards his back. This technique requires a certain swiftness of movement on your part.

Jaban dwijipgi This is one of the most difficult and fancy techniques. The name *jaban* means "salted fish" and the technique takes after the motion of flipping a fish on a pan. When the opponent releases the satba around your waist, go underneath the opponent's stomach immediately and hold his legs with your hands. Then

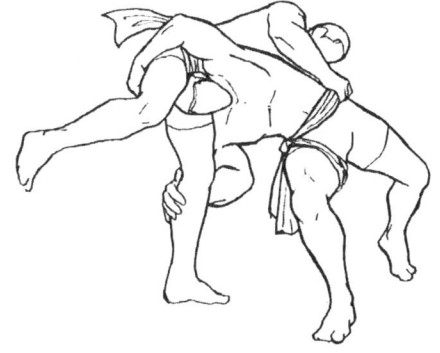

Jaban dwijipgi

flip the opponent to one side by pushing his upper body on top of you and using your head as a lever. This technique is a sophisticated, fancy technique that requires flexibility of the hips and a swift movement with plenty of practice.

The names of 19 standard waist techniques are as follows:[21]

Names (19 kinds)	
	Deulbae jigi
	Baejigi
	Dollim baejigi
	Oreun baejigi
	Eongdong baejigi
	Mat baejigi
	Deulleo notgi
	Dollyeo bburyeochigi
	Gongjung Deonjigi
	Heori ggeokgi
	Mireo chigi
	Cha deolligi
	Jap chaegi
	Eoggae deonjigi
	Jaban dwijipgi
	Jeongmyeon dwijipgi
	Yeop chaegi
	Satdeureo chigi
	Eoggae neomeo deonjigi

d) Combined techniques

Some techniques are the combinations of one hand technique to another hand technique, one leg technique to another leg technique, or one waist technique to another waist technique. At the expert level, these techniques flow from one another smoothly without much interruption. From hand to leg, leg to waist, or waist to leg techniques all can be creatively combined by yourself as your skills in these individual and combined techniques mature.

21 Man Ki Lee (2002). p. 89.

2) Competition

a) uniform

The competition uniform for ssireum consists of a pair of regulation shorts with the team name on the back or side and the satba (a strap made of loincloth) which is an integral part of the competition.

b) satba

The satba is a loincloth-style belt worn by the competitors. It is made of cotton cloth. Different colors are used to help identify the athletes for the spectators. Red and blue are being used for both amateurs and professionals since professional ssireum competitions have started taking place from 1983.[22] The colored satba is used to identify the competitors with one wearing red and other wearing blue.[23]

The satba is tied loosely around the competitor's waist and right upper thigh, providing the opponent a place to grab onto for throws and takedowns. Length is not important but there are regulations governing the width of the satba. The width has to be 114 centimeters wide.[24]

c) arena

The arena in which ssireum is contested is called the *ssireum jang*. The term *jang* means a "place" or "contest area." It is a circular sand pit that measures 7 meters in

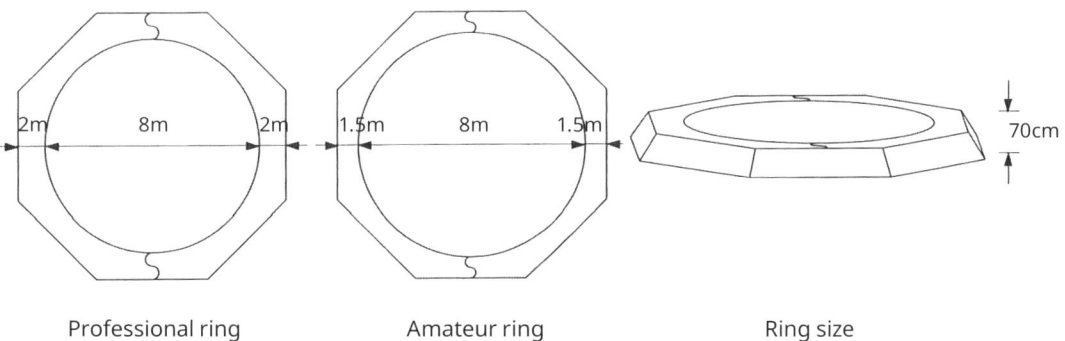

Professional ring Amateur ring Ring size

22 Man Ki Lee (2002). p. 49.
23 Man Ki Lee (2002). p. 50.
24 Man Ki Lee (2002). p. 50.

diameter. Ssireum competitions are popular spectator events in Korea, so they are often held in large arenas or stadiums.

d) weight divisions

Both individual and team competitions are conducted according to weight classifications. At the amateur level for individual competition, there are seven divisions. For professionals, there are only two, named after Korea's two highest mountains: Baekdu (over 100kg) and Halla (below 100kg).[25]

The Weight Divisions for Amateurs

Weight Divisions	Elementary School	Middle School	High School	University & Adults
Kyeongjang	under 40kg	under 60kg	under 70kg	under 75 kg
Sojang	under 45 kg	under 65 kg	under 75kg	under 80kg
Cheongjang	under 50kg	under 70kg	under 80kg	under 85 kg
Yongjang	under 55 kg	under75kg	under 85 kg	under 90kg
Yongsa	under 60kg	under 80kg	under 90kg	under 95 kg
Yeoksa	under 65 kg	under 90kg	under 100kg	under 105 kg
Jangsa	70kg over	90kg over	100kg over	105 kg over

Source: Man Ki Lee (2002). p. 53.

e) referees

There should be three officials available to supervise a ssireum match: a referee and two judges. Each match is officiated by a referee who moves freely about the ring and two judges who sit around the ring to assist the referee in close decisions. The referee's primary job is to declare a winner in the event of a fall and to stop the match in the event of an injury. However, when the referee cannot decide a fall, such as when both competitors fall to the ground simultaneously, he may consult the judges.

f) match

Each ssireum match is begun with the wrestlers kneeling in the center of the ring, facing each other. Each grips the opponent's satba at the waist with the right hand and at the thigh with the left hand remaining kneeling. The wrestlers then stand,

25 www.korea.net

locked in this position until the referee gives the signal to begin.

Once the competition is under way, the wrestlers have three minutes to score a fall. The first to cause the other to fall is declared the winner and the match is over. The first to score three out of five falls advances to the next round. If a fall is not scored in three minutes, a three-minute over-time is played. If a fall is still not scored, the lighter wrestler is awarded the victory.

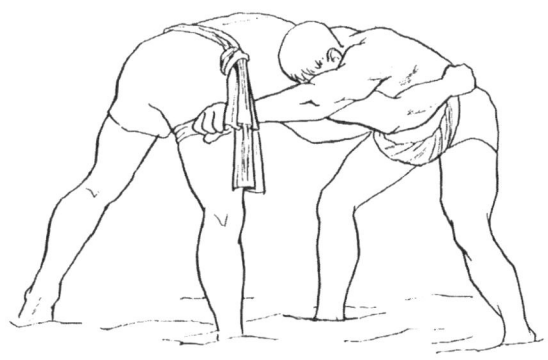

Ready Stance for competition

A fall is defined as the event in which any part of the wrestler above the knee touches the ground. Falls can be as simple as causing the other wrestler to fall backwards and sit down or as stunning as one wrestler lifting another and throwing him clear over his head while arching and spinning his body to avoid hitting the ground first.

To preserve the pure throwing nature of the art, techniques that involve striking, kicking, and butting are prohibited. Wrestlers are permitted to use their hands, arms, and torso to jockey for position and attempt to unbalance each other. They may not, however, apply pressure against a joint, such as a finger lock or arm bar, to cause a fall. Tactics to avoid fighting such as stalling, avoiding contact or deliberately going out of bounds are prohibited. These rules keep the competition active and prevent the match from becoming a boring stalemate.[26]

Presently, in Korea, there is one grand championship and six regional championships being held every year.[27]

26 http://turtlepress.co
27 Man Ki Lee (2002). p. 33.

3. History

1) Origin

The origin of ssireum in Korea is not precisely known. Some say it came from Mongolia through the northeastern area of China, however, there is no clear evidence for this theory. Nevertheless, the oldest evidence pertaining to ssireum in Korean history is a mural painting discovered in 1905 on a wall of a royal tomb in Hwando (丸都), the old capital city of the Goguryeo Dynasty in southern Manchura. This mural painting was later named Gakjeochong Byeokhwa in which viewers can see two fighters wearing shorts, and topless with satba around their waistlines resembling traditional ssireum. This tomb is believed to have been built around the end of the 4th century.[28] From this fact one can verify that tti-ssireum was practiced during the Three Kingdoms Period in ancient Korea.

In view of the fact that the two contestants in the mural painting are wearing only shorts with straps around their waists but nothing on the top, one can assume that the early form of satba was used and tti-ssireum was popular at the end of the 4th century. From this fact, we can imagine that the ancient ssireum style was similar to that of contemporary ssireum and it was popular among the people of Goguryeo.

The first official records on ssireum can be found in *Goryeosa* (*History of Goryeo Dynasty*: 高麗史). According to the literature, in March, 1330, King Chunghe entrusted major affairs of state to his aides each day so that he could practice ssireum with an errand boy. The king was criticized for disregarding his royal duties to practice ssireum within the palace grounds. Nonetheless, the king ignored the criticism and continued his participation in the sport.[29]

The Chronicles of the Joseon Dynasty bears more witness to the practice of ssireum than the Three Kingdoms or Goryeo Dynasty.[30] It is documented that in 1430 during the reign of King Sejong, a man was killed in a ssireum bout but the opponent was not prosecuted. Instead, the incident was settled by holding the opponent liable for funeral expenses. In the 15th year of King Myeongjong (1560), his Majesty prohib-

28 Man Ki Lee (2002). pp. 10 & 15.
29 www.korea.net
30 Man Ki Lee (2002). p. 21.

ited his imperial servants from participating in ssireum on the palace grounds. Also, in 1664 during the reign of King Hyunjong, a servant named "Seon" (先) living on Jeoja-do (island) stabbed his opponent named "Sehyeon" (世玄) out of vexation after he lost a ssireum match.[31]

According to other accounts, such as the *Dongguksesigi* written by Hong Seok Mo in the early 19 century, *Kyungdojapji* (京都雜誌) by Yu Deuk Gong in the reign of King Jeongjo, ssireum took deep root among the populace and became a popular form of folk recreation to relieve fatigue. At that time, ssireum was established as part of traditional community festivals.[32]

According to the above mentioned literature, Korean ancestors held ssireum contests as an annual sports event on national holidays such as Dano day (which falls on May 5 in the lunar calendar), Jungwon-jol (中元節; on July 15), Chusok (Korean version of Thanksgiving Day in mid-August), and Daeboreum (Full Moon on January 15).[33]

Traditionally, the champion of these contests was awarded an ox as the first-place prize. This tradition is attributed to the fact that the participants were peasants and agriculture was the dominant industry of Korea at the time. By giving an ox to the winner, he was encouraged to do farming even more diligently.

2) Modern Era

The first modern ssireum competition took place at the Danseongsa theater in central Seoul in October, 1912 under the auspices of Yugakkwon-gurakbu (柔角拳具樂部).[34] Yugakkwon stems from Yudo (Judo), Gakgi (Ssireum), and Kwontu (Boxing) and *gurakbu* means "club." In the early years of the sport, there were no weight divisions. As a result, a ssireum competitor had to defeat challengers of all weights to be named champion. It usually took until the last day of a three-day tournament to determine the champion.

The more systematic ssireum competitions began to be held after the Joseon (Korea) Ssireum Federation was founded in 1927. In the same year, the 1st pan-Joseon Ssireum Championships was held at the playground of Hwimoon High School

31 Man Ki Lee (2002). p. 21.
32 Man Ki Lee (2002). p. 22.
33 Man Ki Lee (2002). p. 22.
34 Man Ki Lee (2002). p. 24.

in Seoul in commemoration of the inauguration of the Federation. There were both group and individual divisions. It became the annual event of the Federation for many years to follow.[35]

Again, in the same year, in the auspices of the Joseon Central Christian Youth Federation and sponsored by the *Dong-A Daily*, another Joseon Ssireum Championships was held for 4 days in Seoul Jongro YMCA auditorium. For the first time, the rules and regulations of ssireum was announced in the form of 12 articles. Officially, the championships adopted satba-ssireum; however, tong-ssireum was played at the same time and a champion was born in both categories.[36]

In 1935, ssireum was included in the then Joseon Athletic Meet (presently, the National Athletic Meet) for the first time in its history.[37]

Beginning with the 12th National Ssireum Championships in 1953, competitions were based on a weight division system consisting of a heavyweight division (over 71.25kg) and a lightweight division (under 71.25kg).[38]

The National Grand Championships was first held under the co-sponsorship of the Hankook llbo and the Korea Ssireum Federation in June, 1959, with annual championships continuing until 1963. Winners received a certificate of merit and an ox as a prize.

In 1967, the number of weight divisions was increased to five: These were named Seojang (under 60kg), Jeongjang (under 65.5kg), Yeongsa (under 75kg), Yeoksa (under 82.5kg), and Jangsa (over 82.5kg).

In 1975, this was simplified to three weight divisions: lightweight (under 70kg), middleweight (under 80kg), and heavyweight (over 80kg).[39]

In 1983, professional ssireum took place under the auspices of the Korea Folk Ssireum Federation. There were four different weight divisions that came into being—named after the famous mountains in Korea: Taebaek (under 75kg), Geumgang (75.1–85kg), Halla (85.1–95kg), and Baekdu (95.1kg).[40]

Taebaek and Geumgang weight divisions were abolished in 1985 and 1991, respectively, but were revived in 2003 for Taebaek and 2005 for Geumgang.

In 1994, the Korean Ssireum Federation deliberated the unification of ssireum

35 Man Ki Lee (2002). p. 25.
36 Man Ki Lee (2002). pp. 26–27.
37 Man Ki Lee (2002). p. 27.
38 Man Ki Lee (2002). p. 52.
39 www.korea.net
40 Man Ki Lee (2002). pp. 33 &51.

styles. As a result of a heated discussion, left-sided ssireum was unanimously adopted as the official style to be used by all competitors.

In 2024, the Sobaek division was created and is now divided into five weight divisions—Sobaek (under 72kg), Taebaek (72.1–80kg), Geumgang (80.1–90kg), Halla (90.1–105kg), and Baekdu (105.1–140kg)—and the Cheonha Jangsa Competition is open to competitors of any weight.

3) Future

As described thus far, ssireum is a brilliant national sport which has long been enjoyed and cherished by Korean people as a folk sport. Not only can ssireum help improve the physical strength and fitness of the participants but it also provides a pleasant pastime and healthy lifestyle to spectators as a whole.

Ssireum, unknown outside of Korea until recently, is undergoing a global expansion. It is a sport that is both simple to learn and challenging to master. It is easy to understand the rules, requires no gear or other special equipment and can be practiced almost anywhere. As a martial art, it has practical applications for close quarters combat and is an excellent means of learning strategy and the redirection of force. As ssireum continues to grow in popularity, it will surely make an impact on the global martial arts world.[41]

41 Man Ki Lee (2002). p. 52.

Reference

Books

Draeger, Donn F. & Smith, Robert W. (1980). Contemporary Asian Fighting Arts. Kodansha International.

Lee, Man Ki (2002). Ssireum. Daewon-sa.

Web Sites

http://www.turtlepress.com

http://ynucc.yeungnam.ac.kr

www.korea.net

Special Thesis

Taekwondo
History, Philosophy & Training Methods

Introduction

History of Taekwondo

Historical and Geographical Background of Korea
Migration Routes of Inhabitants of the Korean Peninsula
Migration and Settlement of the Korean Peninsula
The History of Taekwondo

Eastern Philosophies and Taekwondo

Traditional Religion and Thoughts of Korea
Eastern Philosophy
Philosophy of Taekwondo

Techniques and Training Methods

Components of Taekwondo
Training Methods for Taekwondo Competition

Appendix

Difference between Sports and Mudo
Important Events in the History of Taekwondo

Introduction

I have been practicing Taekwondo for more than 68 years both as a competitor and an educator. When I first started taekwondo, the most fun part was to use its skills to beat other kids in the street. However, soon I realized there was more than just mastering "street-fighting skills" in taekwondo. As I became a mature taekwondo practitioner, my life evolved around taekwondo. After graduating from university with a degree in Business Administration, I pursued a masters' degree in Physical Education with a specialization in Taekwondo. Upon receiving my degree, I became a professor of Taekwondo.

I am presenting this article to share with other Taekwondo lovers the result of my research. I sincerely hope that this article serves as an inspiration for tomorrow's scholars and students of Taekwondo and others with interest in Taekwondo for further research in the field. Finally, I would like to express my sincere gratitude to Mr. Choe, Man Seek, Ms. Lee, Sang Rim, Prof. David B.C. Kim, and Mr. and Mrs. Kim, Il Joo for making this thesis possible.

I. History of Taekwondo

Before the history of Taekwondo is discussed, the historical and geographical background of Korea and its people need to be reviewed. Only when the historical and geographical background of Korea is placed in proper context can the history of Taekwondo be better understood with a greater appreciation.

This part of the thesis will begin by sketching the historical and geographical background of Korea and the surrounding region. Then, the migration routes of inhabitants of the Korean Peninsula and the dialects of the people who lived in and nearby the regions will be introduced. Finally, the early settlement on the Korean Peninsula will be discussed.

1. Historical and Geographical Background of Korea

The original population of the Korean Peninsula has been commonly called the united race of the white-clad folk. Until as recently as 1974, when studies were finally published, few people other than a handful of scholars really know of the antiquity of the Korean race. Paleolithic bone fossils and bone instruments dating back to the Pleistocene Cooch were discovered by archaeologists in the Paleolithic ruins of Chongkwanjin, Chongsungkun in Hamkyongbukdo as early as 1935. Further exploration around 1964 of the Sokchangri civilization created by Pithecanthropus erectus, including Sinanthropus pekinensis, showed the Sokchangri civilization which appears to have existed during the first interglacial period (700,000 to 650,000 years ago) of the Pleistocene Epoch. These primitive people appeared to be hunters and gatherers and were a nomadic race. Later, during the Neolithic Age, life styles changed radically as the civilization of the early Korean people became more agricultural cultivation.

The Map of the Korean Mountain Range

The adoption of an agricultural lifestyle both stabilized the formerly nomadic people and allowed for much larger populations to survive on the Korean Peninsula. These Neolithic people appear to be the real ancestors of the Korean race. As tribes settled into more less permanent communities a social organization developed. Together with the social organization the unique form of Korean martial arts, now known as Taekwondo came into being. Every culture appears to have had its own style of martial arts and, as with those other cultures, the type of martial arts, which developed on the Korean Peninsula, reflects the spirit of the Korean people. Taekwondo

was characterized by both excellent physical skills and high moral principles. It has continued to improve throughout the centuries in Korea and is now recognized worldwide as a truly sophisticated form of martial arts.

The Korean Peninsula is bordered by China, to the west and north, by Manchuria, to the north and by the East Sea, and the island of Japan to the southeast. We find the Altai Mountains located in the north near the 50th latitude north and the 90th longitude east, in Central Asia. The Mongol Desert lies to the southeast, China to the South and Manchuria to the east. South of the Altai Mountains we find "the roof of the world," the Tensan Range which includes the Tibetan Highlands, the Himalayas, the Hind Kush and Kurakorum Mountains. These vast mountain ranges form a natural boundary line between Central Asia and China.

China is separated from the outside world by natural obstacles on all sides with the Tarim Basin Desert to the North, the Tensan and Hind Kush Mountain Ranges to the east, the Dzungarian Desert to the south and east, the green plains and the Desert of Central Asia to the west. Only one main route connects Peking with the boundary districts of Southern & Western Manchuria and Inner Mongolia, but these northern and southern passages are so narrow that they are generally used only by caravans.

Within continental Northeast Asia, Hunganryong occupies the northeast part of China, Mongolia the northwest, and the Manchurian plain, the southeast. The Yoha and Songwha Rivers that flow through the region from north to south shape Hunganryong, Sohunganryong and the Changbeak Mountains and surround Manchuria and its fertile plains. From prehistoric times southern Manchuria was heavily populated because of its good weather, while northern Manchuria, because of its harsh and unfavorable climate, was sparsely populated. The foothills of the Changbaek Mountains are suitable for both hunting and agriculture. Manchuria is separated from the Korean Peninsula by the natural boundary line formed by the Apnok and Duman Rivers which flow east and west of the Baekdu Mountain Range. The Baekdu Range extends to the north alongside a tributary of the Songwha River, connecting Manchuria to the Korean Peninsula.

Although the Korean Peninsula is presently divided into two countries, the continental regions of Manchuria and the Kaema Hts., now a part of China, and the former districts of Hamkyongbukdo and Pyonganbukdo were all originally settled by the Korean people. The Korean Peninsula is characterized by an abundance of fertile, arable land, making it ideal for human habitation. Series of mountain ranges cross the center of the Korean Peninsula. The Nanglim Mountain Range begins in the

north, narrowing slightly at the Kaema Hts. and broadening again in the northern part of Kangwon Province. There the Taebaek Moutain Range stretches from the east coast, near the Nakdong River to southern sea where the mountain range is called the Chongryang Range. A narrow stretch of arable land runs from the north to south along the east coast while a vast area of the same can be found to the west. Additional plains lie between some of the mountains and skirt many of the major rivers like the Taedong, Imjin, Han, Kum, and the Nakdong.

The eastern shore line is short and rugged and the sea is deep. In contrast, the southern and western shorelines are long, with many ports and numerous islands. Although the tides frequently made access to the ports difficult, the south and west coastlines provided reasonably convenient trade routes to China. One direct route stretched from China across the Yellow Sea and a second route led from the Shantung region of China to the Pyongyang district of Korea through the Changsan archipelago and Yodong Peninsula. Namyang Bay, known as the China district, was the main port of both the Silla and Baekje dynasties. Later, a new route from the Yangtze River along the coastal line formed by the Huksan Islands promoted further economic and cultural development in western Korea.

The east coast regions provided many routes to Japan. The Korean Peninsula had easy access to Japan at the district of Yongil Bay and further along the southern coastal area. Ocean currents around Yongil Bay made the Tokunhyon district on the mainland of Japan accessible. The Kimhae district in the Nakdong estuary has a narrow strip of shoreline that allowed easy access to northern and western parts of Japan via Tsushima Island. It has been a center of trade, navigation and fishing with Japan since the very early days.

Archaeological Sites

With the exception of the southern regions of Kyongsang province and Cholla province, southern Manchuria and the southern part of Siberia, the climate of most of the Korean Peninsula is seasonably cold. It is cold in the winter with hot temperatures and heavy rains in the summer. Climate zones fall between the coniferous plant zones to the north, and the subtropical evergreen plant zones to the south. The Korean Peninsula has an environment well suited for the cultivation of rice, which requires a growing period of at least 150 days without frost. Rice grows abundantly in fact throughout Korea except for the Hamkyongdo district.

2. Migration Routes of Inhabitants of the Korean Peninsula

North of the frost line of the Eurasian continent is generally harsh and uninhabitable and unsuitable for rice cultivation. The frost line is formed by the Kanin Peninsula, the junctions of the Irutish and of the Anggara and Yenisei Rivers and the northern part of Baicar, in Habaropusk. North of this line, the monthly mean temperature rises above the freezing point for only a few months of the year, between May and September. The average temperature from October to April is below 0°C. South of this frost line, the climate is milder, but the region from outer Mongolia and Tibet to the Caspian Sea is the driest desert in the world, with under 250mm of annual rainfall. Except for the forested strip from the Altai Mountains to Hind Kush, cultivation of the land is virtually impossible.

Administrative Classes

Nation Ranking	Goguryeo	Baekje	Silla	
			Kyong Wi	Yoe Wi
1	Taedaero (tochiwi)	Choapyong	Leebolchan (kakyu, palhan)	
2	Taedaehyong	Talsol	Leebolchan (leechan)	
3	Wuljol	Unsol	Yongchan (sopan)	
4	Taedaesaja (taesang)	Toksol	Pajinchan (heawu)	
5	Chouidudeahyong	Hansol	Tea-achan	
6	Teasaja (chon hdaesang)	Nasol	Achan (achokwu)	

7	Taehyong	Changdok	Ilgilachan (ulgilwu)	Akwu	1
8	Suwisaja (yusang)	Sidok	Sachan (salchan)	Sulwu	2
9	Sangwisaja (choksang)	Kodok	Kupholchan (kupchan)	Kowu	3
10	Sosaja (sosang)	Kyedok	Taenama (teanamal)	Kwiwu	4
11	Sohyong	Taedok	Nama (namal)	Sunwu	5
12	Chehyong	Mundok	Taesa (hansa)	Sangwu	6
13	Sonin	Mudok	Saji (sosa)	Wu	7
14	Chawi	Choakun	Kilsa (kyeji·kilcha·tang)	Ilbol	8
15		Chinmu	Tae-o (tae-oji)	Ilchuk	9
16		Kukwu	So-o (so-oji)	Pi-il	10
17			Chowi (sonjoji)	Achok	11

This forested strip supported a small number of migratory inhabitants who followed the seasonal movements of animals and fish. These inhabitants had probably been driven from the southern, more hospitable, regions. Because of this probable south to north migration, southern cultural characteristics can be found in the North. Through the process known as passive decentralization, the people migrated slowly, passing on their ancestral culture and traditions from generation to generation. The inhabitants of the northern regions included the Yakut in the northern Altai Mountains, the Tungus in the northwest and the Kouyak on the Kamchaka Peninsula.

As a result of the larger northbound migration, the Mongolian tribes traveled into many areas surrounding the northern polar ice cap. Today its descendants include the Samoyed, the Lapps and the Finn tribes. These same peoples crossed the Bering Straits and migrated south again into North and then South America. Their descendants include the Dene, Incut and Innu in North America and the Aztec, Maya, and Inca in South America.

The climate of southern Asia is milder and, except for the deserts and arid highlands, supported a large population. The inhabitants of the sparsely populated deserts and arid highlands survived by hunting with bows and arrows and breeding cattle, moving around according to the availability of water and vegetation. These hardy and aggressive tribes maintained well-trained armies and organized raids into

The map of the migration and aboriginality from Central Asia

settlements of the fertile South. Their migration route is called the Active Integration Route.

One heavily armed tribe who occupied Mongolia and Central Asia was the Hyungno tribe. The Hyungno tribes were also known as Yung, a name that was interpreted by many westerners as Hun. Migratory patterns are often first determined by tracing language patterns, that is by finding similar words for common objects and ideas. The Korean language family is known as the Altaic language. We find traces of both Hun and Han in the names of current countries: Hungary and Hankook (Korean), and in the names of many ancient countries of central Asia: Chagataihanguk, Ogotaihanguk, Kipchakhanguk and Ilhanguk. The Altaic language of the inhabitants of Central Asia spread from the coast of the Black Sea in the continental west to the peninsula of Korea and the islands of Japan in the east of Asia and to the American continents far to the east.

With close inspection of the following chart, names of many familiar, modern countries which are part of the Altaic language family can be recognized. Scientists believe that each of these groups of people has been related from ancient times; all appear to be the descendants of the early tribes of Central Asia.

An even more complete chart would include the Yagut, Yukagil, Koryak and Chuchi

Taekwondo 275

Dialects of the Altaic Tongue

languages found in the far north and a long list of Native American languages. The dissemination of the Altaic language coincides perfectly with the migration patterns of the people. Pottery and other artifacts discovered by archaeologists prove this.

3. Migration and Settlement of the Korean Peninsula

These Altaic tribes, in fact, migrated in all directions in pursuit of more hospitable living conditions. They have been traced to, among other locations, the basin of the Yellow River in China, the Indus and Ganges Rivers in India, the Tigris and Euphrates River in the Middle East, the Nile River in Egypt, the Danube River in Central Europe and the Dneper, Don, Yenice, Songwha and Yoha river basins. Although these fertile basins were already inhabited, each new wave of migration brought other well-armed and war-like tribes to replace the people who were already settled there. This cycle of conquest continued for ages. An early Chinese text, *The Book of Poetry*, relates the tale of a flying horse that came from the west: a parable of the trauma suffered by the Chinese from the invasion of the Hyungno (Hun).

The ancestors of the Korean people migrated to the Korean Peninsula in several waves during the Paleolithic period. The three major routes of migration were the west coast from the Yodong Peninsula via a tributary of the Apnok River: the west coast from the Sandung Peninsula in China: and, at Dongsamdong in Busan by following the east coast from eastern Manchuria. Considering the harshness of these early people's lives, having to contend with wild animal attacks and repeated invasions from other well-armed and competitive tribes, it seems no exaggeration to say that some form of martial arts was absolutely necessary for their survival. The development of unarmed fighting techniques, as well as various weapons, must have been an integral part of their lives.

Evidence of the existence of Paleolithic civilizations on the Korean Peninsula is well documented. An archaeological expedition in 1935 unearthed a relic at Congsong in Hambuk province. Between 1962 and 1963 more relics were found under a heap of rubbish located at Sopohang, Gulpori, Wungigun in that province. The 1964 expedition of Sokchangri, Gongjugun and Chungbuk in the northern region of the Kum River generated published accounts of the findings and carbon-dating identified the age of the relics at around 30,000 years ago. There are various theories regarding the expanse of territory occupied by the early Koreans, but judging from descriptions found in ancient literature, it seems likely that the regions they inhabited were much more expansive than at present. The earliest account of the Korean people is found in *The Book of the General View on Successive Taoism* written by King Kanghi of the Qing Dynasty of China. He says,

> A human being named Hwangno was created after the formation of heaven and earth. Hwangno with Wonshi, who was created subsequently, advanced toward Yonghuh, the Holy land of the Donghae (also known as Balhae, Baedal country and Joseon) braving the cloud and mist of the Easter blue sky, eventually reaching the Bongrae Mountain, Bangjang Mountain, and Yongju Mountain, having traversed 3,000ri of the Heungyong River. (Note: unit of distance, 1 ri = 393 meters)

Since early times Korea and the Korean people have been known by various names. The country has been called Peadal, Balhae, and Joseon and the people have been called the Peadal race, the Sukshin and the Shikshin. Three famous mountains have been mentioned in several ancient historical texts. These mountains were, in some texts, even thought to be holy. Lee Soo Kwang, in *Chibongyusol*, identifies the three

mountains as Bongrae for Kumgang, Bangjang for Chiri and Yongju for Halla Mountain. These names are later confirmed by the poet Doobo who writes, "Bangjang is located outside of the three Han states." He writes, "Bangjang lies outside of the Three Han States. The Three Holy Mountains are located in the eastern part of the country: Bangjang is Chiri Mountain, Yongju is Halla Mountain, and Bongrae is Kumgang Mountains." Moreover, in *The Book of Osansulim*, written by Cha Chun No, we find an historical account, "King So of the Youn Dynasty tried to find the Three Holy Mountains known to be located in the middle of the sea by dispatching an administrator, Bangsa, but it was in vain. The Emperor Shi of the Chin Dynasty also tried to obtain an elixir of life from these mountains by sending Seoshi, but in vain, either due to violent wind."

Other ancient authors and books mention Korea and its people as well. According to the geography book titled *JiJi*, "there was a white mountain in the south of Malgal which was old Sukshin and there all the animals and trees were white." Yoji of *Yeobyoongne* said, "Changbaek Mountain, where the white-dressed Kwan Yin lives, is located to the southeast of Nanglim Mountain; there all the birds and animals are white, so people do not ascend the mountain for fear of making it dirty. The black water originates from this mountain." *Bongsunsuh*, a history book, also said that, "the Three Holy mountains were located in the center of Balhae, and there was a man who had been there, a god, lived in the mountains with an elixir of life."

Although the names of the mountains often differ because of regional dialects, there are many similarities. Some names of the mountains are Kaema, Taebaek, Changbaek, and Datae. "Hae" and "Hee" which have a similar meaning to "Baek" "Ma" and "Du" which can also be interpreted as "Mari." Therefore, both Kaema and Paekje have the same meaning, in spite of their different Chinese characters. It is apparent then, that the name Baekdu has been used since ancient times. There is a relationship among the names for the mountains in the east: Mai and Duak, or Dusan (also called Marisan or Morisan) have mistakenly been called Mari or Mori. Taebaek has also been called Duakmarisan, Marimoe, and Manisan, since Gapbukkocha (formerly known as Ganghwagun, Gapko, and Gapkoji) was the place to perform the ritual service to the Heavens. Wherever the Dangun performed the Rites to the Heavens, the mountains were called "Mari" or "Mori," meaning the top, or the leader.

The Korean people have also been called the Dong-i race as well as numerous variations of Dong-i. According to Ahn Ho Sang in his article entitled "Baedal and Dong-i are the Cradle of Dong-i Race and the East Asian Culture," the inhabitants dwelling

in Suksin [Joseon] are called Dongbukmin, Dongbangmin, Dongbuki, Dong-i, or simply "I," because Suksin is located in the northeast of Manchuria. In other words, "I" means Dong-i and Dong represents the Northeast. The Dongbukmin, called the Joseon people of the Peadal race or the Suksin people, are found in the Northeast. On the Changbaek Mountain where the Baedal-Dong-i (Dandong-i or Joseondong-i) dwelled, there were the Cho-i, a branch of the Dong-i race. These Cho-i hunted birds and animals and were the first to wear fur in the northeastern area of Joseon.

The same article shows the transformation of the Chinese characters for "I." The original meaning of "I" was "barbarian." The first character for "I" was "I" (夷) and then "I (尼)," and next "I (夷)." A different I character (尼) is "In (仁)," meaning good-natured. According to old Chinese history books, "The Baedal-Dong-i race are a good-natured people, and their country is an immortal land of gentlemen." It is said that these Baedal-Dong-i people were the first people to bow, so the word "夷" was amended to contain the words "大" big and "弓" bow, yet later becoming "夷." This new word "夷" represents good-naturedness and Dong-i literally means good-natured man in the eastern land. Old history books, including *Sojyon* and *Sagi*, clearly says that the Cho-i people dwelled in Hambalsan in the east of Hwangju since 4,300 years ago. The Dong-i race had a wide range of activity in China from the earliest records of Asian history. According to books recently written by Chinese scholars, Nakyang (as it was then called) of Hanam province was the capital city for the King Song and Chugong (Governmental Ruler) during the Chu Dynasty (the 13th century of the Dangun era). Factions of the Dong-i race—including Naei, Moi, and Kaei—occupied Dongkyong, and in the neighboring province, the manners of the Dong-i were used. In those days, Chinese people compromised only a fifth of the total population of the region.

The history of this region begins with its settlement by a branch of the Altaic race which many ancient historians and poets record as the early ancestors of the Korean people. In the old history book *Choajon*, the Dong-i people were mentioned by Sohoshi; Mencius also stated that Sun were Dong-i, whereas King Mun referred to them as So-i. *Sagi* (a history book) regarded Hahussi and the Huns to be of the same race. *The Book of Poetry* described the constant attacks of the Huns on China. China's early kings are known to have been Altaic sovereigns who had migrated from the East.

Lim He Sang described in his writings on the Chinese race, that the Dong-i race, Yomjesinnong (the 33rd century B.C, 9th century before the Dangun era), and Yomyo

tribe, a faction of the Dong-i race at the time of Hwang Sokhonwon, occupied the southern part of China. The Yo race inhabited the region of the Hansu and Yangtze Rivers in ancient times. A Japanese scholar wrote that the Myo tribe, the brethren of the Dong-i, dwelled in the middle and southern parts of China before the Han race entered the area; they confronted each other when the Han people migrated into China.

Of the tribes found in China in the period of Warring States, Nae-i in Sandong area, Hoe-i and Suhyung in Taesan (between the Yangtze river and the Yellow River), and the Doi in the region of Tenzin and Shanghai were all of the Dong-i race. The Myolmaek, mentioned in the ancient history of China, were also a faction of the Dong-i people.

According to the theory proposed by Seoryangji, a Chinese scholar, the legendary tribe of Yomjesinnong who dwelled near Lake Baikal were the ancestors of the Dojoi, Wui, Nae-i and Hoe-i peoples, all factions of the Dong-i race. They are mentioned in the Chapter "Wugong" of *Sojon, Ibang, Sabang and Kilbang* in the inscriptions on bones and tortoise shells of the Yin Dynasty, and *Chok* of the Zhou Dynasty, *Yemaek* and *Hyungno* at the time of Taehan, and *Owhan* and *Sunbi* in Wijin. Thus, it is apparent that the range of the Dong-i race during the Yin and Zhou Dynasties extends to Sandong and Hanam Province (the district of Beijing), the Balhae coastal area, the southern, Hanam, the northwestern region of Kangso, the eastern area of Hobuk, Yodong and the Korean Peninsula.

4. The History of Taekwondo

Unarmed combat in primeval culture was primarily for self-defense, not only against wild animals, but also against other invading tribes. Wars developed frequently when various tribes vied for dominance and control of land. In this primitive form of Taekwondo, practitioners studied and imitated the attacking movements of animals.

As civilization progressed, two important aspects of culture were also developed: religion and the military. In the early days, religion and the military were closely interrelated. The religion of early Korean civilization was Shamanism, the worship of natural phenomena like the sun, mountains, water, and rocks. The people prayed to these entities for good fortune and an abundant harvest. They carved totem poles, wooden or stone representations of the gods. Rituals and ceremonies like Yeonggo,

Mucheon, and Dongmaeng were conducted regularly, and the display of fighting techniques played an important role in the ceremonies.

As the tribal states were established, the military became increasingly more important. Formal military units were established; fighting techniques were improved, and the finest and fittest warriors ascended to greater power.

The system of conscription of young soldiers arose spontaneously as the most efficient method to establish and maintain standing armies. The establishment of standing armies allowed the soldiers to devote all of their time to developing fighting techniques, and the development of iron weapons flourished as artisans' craftsmanship improved with experience. The military spirit of camaraderie, bravery, loyalty, and courtesy grew. Individual practitioners sought to develop not only physical skills, but also spiritual and moral qualities through the pursuit of "Do." "Do" literally means "the way,". Hence, they cultivated both the mind and the body through physical training. Tribal leaders were chosen from among the bravest fighters, and the loyalty, and the obedience to these leaders became fundamental societal values.

All of the primitive tribes held regular ritual feasts to the gods. One rite to heaven, known as Yeonggo, was performed yearly in the state of Buyeo in the first month of the lunar calendar. In Goguryeo, the feast, Dongmaeng, took place in the tenth lunar month, and in Yemaek and Mahan, they conducted a feast known as Mucheon.

Demonstrations of such sports as Subak (a precursor to Taekwondo), Seokjeon (stone battle), Sae (archery), Gima (horse riding), and Ssireum (Korean wrestling) were an important part of these ceremonies. All the finest warriors gathered to display the excellence of their fighting styles and techniques and, of course, a natural competitive spirit arose. Taekwondo, like other martial arts, was adopted as a means of strengthening military power.

The same kinds of festivals continued into the Silla Dynasty with a national feast day called Gabae held between the seventh and eighth months of the lunar calendar. Many other similar sports like Gakjeo (a form of Subak resembling Taekwondo) were displayed and other sports like Tuho (arrow-throwing game), Chukguk (ancient Korean soccer), Gisa (archery), and Chukma (mock cavalry game) were demonstrated.

1) Three Kingdoms and the Unified Silla Dynasty

The Three Kingdoms era began about 1,300 years ago when the Korean Peninsula was divided into the three kingdoms of Goguryeo, Silla and Baekje. Abundant information about Goguryeo and Silla has survived the ages, but little written history of Baekje remains. Historians generally believe, however, that the three kingdoms were quite similar in social and political structure. Each kingdom was comprised of numerous tribes that had either been conquered or had been subjugated or had, by means of treaty agreements, willingly joined forces with the most powerful warlord leaders. These nations faced frequent confrontations with neighboring nations such as Okjeo, Dongye, Nakrang, Taebang, Wi, Kaya, Malgal, and Japan.

The Three Kingdoms were constantly at war with each other, each trying to extend its territory and power-base. Additionally, internal strife was almost constant as a result of the impact of unstable alliances between the numerous tribes. In each kingdom, successful and skilled warriors were most highly prized. The military and the government were, for all intents and purposes, the same. Warriors were the governing class and martial arts skills were very important. The Prime Minister, called Makriji in Goguryeo and Pyongbukyong in Silla, wielded military power as well. The district governors, called Yoksal in Goguryeo, Kunkyu in Silla and Pangyong in Baekje, were both military commanders and administrators.

Goguryeo was the most outward looking of the three kingdoms and occupied the largest mass of land, extending into North Korea and into Manchuria. The officially recognized date of its founding is 57 B.C., but some say that it actually became a nation sometime between A.D. 234 and 286. Goguryeo was the largest among the three kingdoms. The warriors of Goguryeo were under the direct command of the King, and were selected based on their military skills, and martial arts had a great influence on the military spirit.

The system of Seonbae was established in Goguryeo in the days of the two kings, Tae and Cha. The two founding principles were a belief in the gods who control the universe and the light, and faith in the warriors' successful defense of the nation, reflecting the dual spirit of the philosopher/warrior. Warriors in the Seonbae (senior) system were selected from all levels of society. At the top of the pyramidal structure was the teacher, a man of outstanding character and outstanding proficiency in military skills. The general members of the Seonbae shaved their heads and wore

black velvet clothing. Anyone who excelled in studies and skills could obtain a high rank. Those who died in battle were bestowed the highest honors and those who were defeated were disgraced. Two such honorable generals, Yeongaesomun and Namsaeng, were described in *Haesang Chamnok*. Yeongaesomun was a hermit philosopher/warrior who always wore all-black clothes. Namsaeng was the son of Yeongaesomun. It is recorded that he was so brilliant and had such wisdom that he lived like a hermit at the early age of nine and was recommended to be an official by his father.

The Silla Kingdom, in the southwest area of the peninsula established sometime between A.D. 356 and 402, had a system similar to Goguryeo's Seonbae called Hwarang. The history of the Hwarang system can be traced to the Doo-rae system from ancient tribal societies. Doo-rae represented the common society of a village. There were two classes of Doo-rae. One was female; the other was male, called Yakja Doo-rae. Historical evidence shows the system existed in Chinhan and there were probably similar systems in the states of Mahan and Byonhan. "Do" referring to the "Doo-rae" means "association" from the Chinese character. We find "Do" as part of many expressions such as Wonhwado, Hwarangdo, Hyangdo, Twelve Do (disciples), Donghakdo (used before the period of the Three Hans states), and Sanghogaewido, mentioned in the *Wiji*.

Samguk-yusa (*The Chronicle of the Three Kingdoms*) recounts that Geochilbu, who held the official title of Tae-achan, took public office in Silla following a lecture from the priest Heryang from Goguryeo. Geochilbu was a very ambitious man. After a war with Goguryeo, he instructed Heryang to arrange a sports festival called Palgwanhoe. Palgwanhoe was a ritual celebration to the Heavens for which the Hwarangdo were to perform demonstrations of their military skills. This was the first time Hwarangdo was mentioned historically. An ancient history book written by Shin Chae Ho speaks of Subak, Kyokkom, Saye, Dokoni, Taekwondo, Angamjil (a water sport), Ssireum (wrestling), and the Hwarang practiced Kima (horse riding). This account also indicates that hand and foot techniques were classified into specific styles. Dokoni was divided into Taekyoni, Taekwon, and Takkyon.

Further evidence of this division is also apparent in the embossed carvings and mural paintings found in the ruins of the royal tombs built during the Goguryeo Dynasty where scenes from Taekwondo during the Three Kingdoms are depicted. Mural paintings which show Taekwondo scenes were found on the western wall of the third room of Samilchong of Goguryeo, on the ceiling of Muyongchong and the

walls of Gakjeochong. The ceiling of Muyongchong contains a painting of two men facing each other while sparring, and the mural paintings of Gakjeochong show two men performing Ssireum. The eight guardian gods carved in the four gates of the stone tower at Punhwangsa Temple, built during the Silla Dynasty, and the statues of the Kumgang warriors at Sokkuram illustrate that the fist positions in the fighting are similar to those presently used in Taekwondo.

The Hwarang of Silla was a system organized by King Chin-heung in A.D. 576, modeled after the Seonbae system of Goguryeo. The most obvious difference was that the Seonbae system was open to all men, regardless of rank or class, but the Hwarang was open only to the sons of noble families. The members were, nonetheless, selected through a competition performed in front of the Shinsudu altar in which the greatest emphasis was on both the performance and the display of bravery. The Hwarang were required to study poetry, music, and other cultural arts and to practice and attain high levels of expertise in the martial arts, like Subak, Kokkom, Saye, Kima, Dokoni, Angamjil, and Ssireum. Their first duty was to go into battle in wartime, placing their country above all else and living by their creed, "Dying in the course of justice rather than living in the face of injustice." Their commanders were called Kukson (national seniors), adding the letter "Kuk" to distinguish them from the Sonin (senior or superior person) of Goguryeo. When they were not at war, they explored the mountains, helping one another, helping those with difficulties, and repairing castles and roadways. They cultivated morality and studied the precepts of Confucianism, Buddhism, and Taoism, as well as the five commandments of the Buddhist priest Wonkwang.

Superior members of the Hwarang were often recommended for government positions. Although there were thousands of Hwarang altogether, they were generally organized into groups of either three to four or seven to eight under the leadership of a Kukson Hwarang.

Although no historical evidence remains concerning the Baekje Dynasty, they almost certainly also had an organization similar to the Seonbae and Hwarang. *Samguk-yusa* recounts that a launch platform for the practice of archery was built in the western area of the palace in August of A.D. 230, the seventeenth year of King Piryu. Also, according to *The Book of Japanese History*, the Japanese royal court invited Taeyapyong and Chijuk from Baekje to compete with Japan's most vigorous youths. Finally, in *The Korean History of Physical Culture*, Hyon Song writes that martial arts such as Gakjeo (like Jujitsu and Subak) were commonly practiced for

sport and self-defense during the Period of the Three Kingdoms.

The period from the fall of Baekje and Goguryeo to the early 10th century A.D. brought about the Unified Silla Period. Both international and domestic affairs remained stable during this period, and scholarly pursuit replaced the study of martial arts. The political system changed, with civil administration being the guiding principle of government. But, by the last stages of Unified Silla, martial arts practice had almost entirely disappeared and people lived in a state of moral and social decay, which eventually led to the fall of the Kingdom.

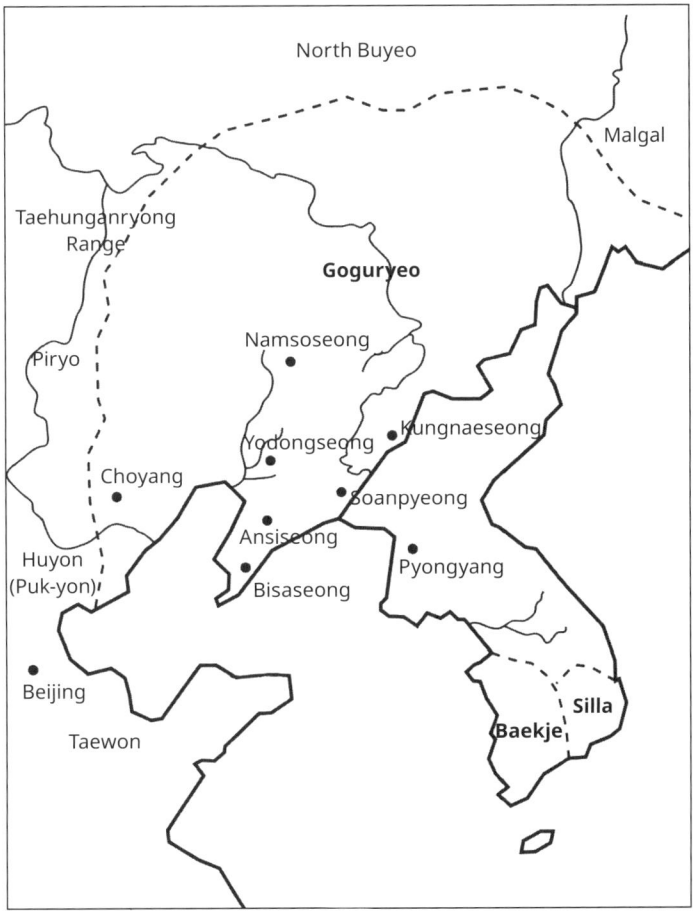

Three Kingdoms

2) Goryeo Dynasty

The basic strategy of King Wanggon, the founder of Goryeo, for the establishment of the new dynasty was to adopt the merits of the old system, to take a conciliatory stance toward Silla, and to face Baekje with military power. As a result, both Buddhism and the Hwarangdo were revived, and the new government employed many officers and soldiers from the old kingdoms of Balhae, Silla, and later Baekje.

The Book of Goryeo History relates that the festival Palgwanhoe was conducted every year from the first year of King Wanggon's reign. *The Book of Goryeo History* and *Goryeosajolyo* tell that in the sixth year of King Wanggon's reign, he formulated ten admonitions aimed to serve Cheonryong, the heavenly god; Oak, the famous Myongansan Mountain, the Dakcheon River, and the dragon god, Yongseon, with the festival Palgwan. Conducting these festivals was the primary responsibility of the Hwarangdo. As evidence of this fact, Lee In Ro, in his book *Pahanjib*, wrote, "It was a custom of Gyerim [the capital of the Silla Dynasty] to select men of noble appearance and to decorate them with jewels; they were called Hwarang and numbered as many as three thousand. In winter, Palgwanhoe was performed, and four people from noble families danced in the garden."

Many accounts of the revival of the Hwarangdo, and thus the revival of martial arts, are found in Korean literature. *The Book of Korean History* says, "Wi Man was good at Subak. King Uijong liked it and promoted him to a position of Byeoljang [a high government position]." And it is stated later, in the chapter "Jeong Jung-bu", "The king ordered military retainers to perform Obyeong Subakhi [a demonstration of free sparring against five soldiers] in front of Omun [a palace gate] on the way to Bohyeonwon [an area of the palace]." The biography of Choe Chung-heon recounts that at a banquet, a match before King Taejong was awarded to the winner of a Subak contest.

According to *The Ancient History of Joseon*, written by Shin Chae Ho, the origin of Subak came about as follows: "After the collapse of Goguryeo, the followers of Seonbae kept their duties by secretly preserving their customs in villages. The Confucian people deprived them of the Seonbae title, so they used an assumed name of Chaega Hwasang. Their descendants did not keep their customs since they could not afford to study because of their poverty. Subak of Gaeseong was a part of the Seonbae sport system, and it developed into a kind of fist-fighting form in China and Judo in Japan.

During the Joseon Dynasty, it almost ceased to exist because it was viewed with contempt."

After the days of King Seongjong, contempt for military officers increased and martial arts became little more than a form of entertainment for the sons of high-ranking civil servants. Finally, after no longer being able to bear the discrimination against them by government officials, the military officers staged a rebellion in the 24th year of King Yejong's reign. Such military officers as Jeong Jung-bu and Choe Chung-heon seized power: they encouraged martial arts training in their own private army. Subak lost much of its spirituality to the increased focus on techniques. Following the assassination of Choe Ui, the military officers who then controlled the government, in the 45th year of King Gojong's reign, both the ongoing process of the revival of martial arts and military rule came to an end.

3) Joseon Dynasty

The establishment of the Joseon Dynasty brought the reorganization of a social system, which had been in turmoil since the final stages of the Goryeo Dynasty. As in the Goryeo Dynasty, martial arts were taken seriously in the early days of the new dynasty as it stabilized. However, civil servants held the important government positions and controlled military affairs. Hulryonwon, the national office in charge of military affairs, selected army recruits, trained them in martial arts, and lectured them on military tactics to a limited extent. Realistically, those who wished to become military officers had to study martial arts and books on military strategy by themselves.

According to an account of the criteria for the selection of Kapsa, military officers, in June of the 11th year of King Taejong's reign, A.D. 1411, "Yehyong-bu and Byong-jo, the Minister of Defense, gathered warriors within the State of Heungin in spring and winter and selected the Kapsas according to their ability to shoot with a bow while riding a horse. Those who failed competed in running and Subak. Warriors who won more than three times were accepted, while those who lost were weeded out." On the birthday of the former king in July of the 16th year of King Taejong's reign, A.D. 1416, the Kapsas and a shield army performed Subakhi at a banquet for the prince and the royal relatives. "Byong-jo and Yehyong-bu recruited the shield army by selection of qualified persons in a Subakhi contest." Another account says, "Many servants of the

government and local officials of Tamyang got together and competed in Subakhi having been told that the government would conduct an examination of Subakhi." And finally, in the chapter concerning June of the 3rd year of King Danjong's reign, the writer says, "The King observed a military drill of a battle on the water at Hiwunjong on the 19th day. His majesty ordered royal guards to perform Subakhi and he awarded prizes." All these quotes make it evident that Subaki was the compulsory martial art for warriors.

Stories abound on the exploits of martial artists and martial arts techniques. One ancient book, *Taedongyejib*, tells the story of O Ham-jong. "O Ham-jong was very strong from childhood on. He gathered together with a group who indulged themselves in practicing Subak. Such noted Confucianists as Kwan-chon, Kwang-won, Chung-maek and Hyon-bo could not prevent his fearless behavior." The section on tradition in the revised *Dongguk Yojisunglam* states, "Inhabitants of both provinces got together on July 15th every year to compete in Subakhi." More detailed information about technique is discussed in "Sokyoyuhi Tae Kyunjo" of *Haedongjookji*. "There are three levels of kicking skills. The least skilled people kick up to the leg; intermediates kick up to the shoulder, and those who have flying kicking skills kick up to the top-knot [the knot of hair tied up on top of the head]. This art is named Taekgyeon." Also, from the chapter entitled "Subyoktaje" in the same book: "Hand skills of the old tradition originated from the art of Kendo. The method is to beat one's opponent with both hands, and if even one illegal strike is found, the violator is disqualified. This fighting style is called Subyok Chigi [beating]. The art of fencing is basically such a hand skill." These accounts are proof that Subakhi and Taekgyeon were popular and appreciated by the public at large.

Once again, with the stabilizing political situation and the rise of Confucianism, the role of martial arts diminished. *Muyedobotongji* (the general textbook of all ancient martial arts) is a series of books published over an extended period of time throughout the reigns of Kings Sunjo, Yongjo and Jeongjo. References are cited from a wide variety of other epistles, letters, proprieties, Chinese classics, history books, martial arts books, military strategy books and medical science books, resulting in four volumes, four books in each volume. Its purpose was to try to revive the study of martial arts complete with its sense of moral conviction, its goal of self-cultivation and its devotion to the defense of the fatherland for the ultimate goal of strengthening national power. This publication describes historical military preparations and provided explanatory diagrams of twenty-four classes of martial arts. Forms

of Taekwondo are described in great detail in Volume 4, "The Art of Fist Fighting." Samples of the references cited for this volume alone include *Chuyok* (*The Book of Changes*), *Kongjakaoh* (*The Familiar Quotation of Confucius*), *Samgukji* (history book), *Samguksagi* (historic chronicle), *The History of Japan*, *Wiji*, *Kihyosins*, *Mupiji*, *Myongebyolnok*, and *Munson,* more than 150 sources in total.

During the colonization of Korea by the Japanese, Taekwondo was suppressed in an effort to deprive Koreans of their traditional heritage. During that period, it was called Gwonbeop (the art of fist-fighting), Dangsudo or Gongsudo. However, many people continued to practice Taekwondo in secret and worked to recognize and promote Taekwondo as the national martial art.

4) Modern and Present

After the liberation of Korea, in 1945, Taekwondo was once again recognized as the traditional form of martial art of Korea. The name Taekwondo was officially chosen in 1955, and in 1971 it was officially recognized as the Korean national martial art. Thereafter, Taekwondo spread worldwide. The international popularity of Taekwondo had the diplomatic function of promoting Korean national pride throughout the world. The Korean Taekwondo Association was established in 1961 in an effort to systematize the sport and to unite its domestic and overseas practitioners and their methods of teaching. The World Taekwondo (WT) was founded in 1973 and later in 1978 the Asian Taekwondo Union (ATU) was also founded. The 24th Olympics were held in Seoul, Korea in 1988 and Taekwondo was introduced as a demonstration sport competition. In 1994, the International Olympic Committee accepted Taekwondo as a full-fledged Olympic sport. Taekwondo made its debut as a mandatory sport in the Sydney 2000 Olympics in Australia.

Nowadays, Taekwondo has spread worldwide and is promoting the spirit of Korea everywhere. By so doing, a great contribution is made to the spiritual and physical development of the Korean people. Much more research is needed on Taekwondo so that everyone around the world is aware of its educational value. Now about 213 countries around the world are joined to the WT.

II. Eastern Philosophies and Taekwondo

To understand the philosophy behind Taekwondo, a prior understanding of Korea's traditional religion and way of thinking is essential. Therefore, before Eastern philosophy and the philosophy of Taekwondo are discussed at length, a brief overview of Korea's traditional religion and way of thinking will begin this chapter. The second part of the chapter discusses major Eastern philosophies and religions, which have, in one way or the other, influenced the philosophy of Taekwondo. These traditions or religions are Confucianism, Taoism, and Buddhism. How they affected the philosophy of Taekwondo and how they, in effect, helped Taekwondo to establish its own philosophy are the main concerns of this chapter.

1. Traditional Religion and Thoughts of Korea

Since the practice of martial arts had traditionally been keenly influenced, for better or worse, by the religions and philosophies practiced by the Korean people, it seems necessary to examine the influence of each of these schools of thought on Taekwondo. It is, after all, the underlying spirituality of the Taekwondo practitioners that set Taekwondo apart from other well-known forms of martial arts like boxing or wrestling and from a myriad of other "sports." The major schools of Eastern thought that have influenced the development of Taekwondo are Animism, Shamanism, Confucianism, Taoism and Buddhism.

The earliest forms of religion in primitive Korea were much like that of all other primitive cultures. They were generally known as Animism or Shamanism. These two share such interrelated practices as Totemism, Tabooism and Hero Worship.

Religion seems to spring naturally from the quest of the human being to make sense of his surroundings and natural phenomena. Humans speculate on the hows and whys of life. If the subject of such pondering may be called a soul; a thought is just a realization of the soul. "So, we believe that the human is the only animal endowed with reasoning, thought and a 'soul'."

Primitive Koreans believed in the spiritual power held by all things in nature Animism. The weather came from the sky and the sun, moon and stars held great

power. Food came from the earth including mountains, rivers, and streams, and even oddly shaped rocks held great power as well. They held rituals to placate these spirits and to ensure their beneficence. Floods "obviously" occurred because the "god of the river" was angered. So, rituals were performed to prevent his anger and thus prevent the rivers from flooding.

So many tribes adopted a specific plant or animal as their tutelary deity. This practice is known as Totemism. Statues and paintings on totem poles abounded. The people believed that the totem they worshipped would protect them from evil.

Certain plants and animals or human behaviors became associated with bad luck or evil and the people were admonished for coming into contact with them or practicing these "evil" habits. This belief system is known as Tabooism. Also, magic, the ability to fulfill a desire or escape a disaster by aid of supernatural power or incantation, played a major role in the lives of primitive people.

The legendary founder of Gojoseon, Dangun, is reputedly the son of the God of the Heavens, Hwanung, and a female bear who became a woman only after she proved her faith and obedience to Hwanung. This legend was so powerful that Dangunism, a form of Hero Worship, was also a common primitive belief. As other more sophisticated and powerful belief systems captured the mind and heart of the Korean people, remnants of these old beliefs could still be found in modern society.

Shamanism was the single most important guiding force of Korean religion and politics until foreign civilization encroached upon it and brought about Confucianism, Taoism and Buddhism. Shamanism is a folk religion centered on a belief in good or evil spirits who can only be influenced by Shamans. These religions were partly joined with Shamanism in Korea and, as with other primitive belief systems, still remain today in Korean culture.

The Shaman was a man or woman of great spiritual power whose job was to intermediate between humans and the Gods. The Shaman had the power to defeat evil spirits and to assure the safety of the community by soliciting the beneficence of the Gods. To this purpose the shaman performed rituals and held feasts for the Gods on behalf of the nation, a village, or an individual family.

The term Shaman, meaning exorcist, originated from the word "saman" in Tunguze. The word "kam" appears in Turkish and other Altaic languages and is just a phonemic variation of the word "sam," the root of the word "saman," and "samsin" in Korean means "sam god." In Mongolian the "moodang," exorcist, is also called "buga," "udagan," and "ikadon"; Tunguze also used the words "ikadon," "saman"

and "udagan." The Korean word "moodang" may be the same word as "udagan" in respect to its derivation. Incidentally, the Japanese word for shaman is "yuda" or "ikado" which also resembles the original word "ikadon." The Korean terms for shaman, "sinsun" and "sunkwan" came from the influence of Taoism, whereas the terms "bosal" and "bubsa" came from Buddhism.

Shamans were called by names, reflecting both dialectal differences and differentiation between male and female forms.

These names are:
Female shamans: Mudang, Mansin, Sinson, Songwan, Bubsa, Munyeo, Sinsun, Myongdo, Jeomjangi, Dangol, Bosal.
Male shamans: Baksu, Boksa, Jeomjangi, Jaein, Hwarang, Gwangdae, Sinjang, Sinbang.

The shaman could communicate with all four kinds of spirits:
① Sun, including religious ceremonies to the heavens.
② Star, faith in the lord of the heavens.
③ Mountains, villages, waters, mother earth.
④ Ancestors and heroes, such as Dangun.

They gave medical treatment and conducted ceremonies for divination and repose of souls as well as feasts to the gods. These group activities fostered a group consciousness and a spirit of solidarity in early Korean communities.

National feasts are described in a history of the later Han period as follows. "A person was selected from each of several provinces of the three Han tribes to conduct rituals to the heavens and was given the title Cheongun." Another spring-time festival is described, "After weeding in May, a feast to the souls was performed, and a group got together to sing, dance, and drink through the day and night." Another chapter tells, "A big pole from which hung bells and drums was erected in Sodo, a city to serve the souls."

In Sodo, the shaman was called "Sonin," "Sinin" or "Cheongun." He controlled both religious and political affairs. He was familiar with astronomy, geography and medicine as well as religious activities. The "Sinin" was also called "Sinsun" in keeping with the belief that they "cultivated their spiritual power in the mountains and they could live forever young." As well as controlling supernatural powers, shamans

also practiced asceticism, utilizing methods of bodily control. Their training area was regarded as sacred and even if a criminal entered the area, they were given sanctuary and were not arrested or punished. The shamans also most probably were engaged in training the warriors who would protect and serve the community, and oversaw their intensive self-discipline as well.

Shamanism, the guiding force of very early Korean society, was driven underground during the five hundred years of the Joseon Dynasty and in recent times because of imported western culture. But Shamanism today still is a part of the Korean psyche. Even today, fishermen perform the Dragon God ritual before they head out to sea and there are numerous prayers for a good harvest, for children's university entrance examinations and a ritual to the mountain god by mountain climbers. Its influence still runs deep in the fabric of Korean society.

Shamanism's influence on Korean culture is evident in traditional dance and music as well as in the way imported religions and philosophies, such as Buddhism and Confucianism, have been "Koreanized" over the centuries. Many scholars see Shamanism as the spiritual core of the Korean character, even in modern times.

While Confucianism provided a scholarly vision of a moral social order and Buddhism offered the wisdom to overcome emptiness of earthly existence, neither supplied an immediate response to the urgent needs of everyday life. Shamanism did. It remains a means of expressing daily needs and the desire for a better life. The shaman links the everyday world with the world of the spirits, offering a direct connection to forces influencing the lives of the common people.

2. Eastern Philosophy

Of all Eastern philosophies the following three have had the greatest influence on Taekwondo: Confucianism, Taoism, and Buddhism. As far as Buddhism is concerned, for the purpose of this research, it will be treated as a philosophical system rather than as a religion, as many people seem to believe.

1) Buddhism

Around the 7th century B.C., agriculture developed in the central districts of the

Ganges River of India, alongside commerce in the small cities. Political power was in the hands of the royal family, and the rich merchants controlled economic power. The weakening of the caste system was accomplished by a weakening of Brahmanism, the traditional religion. This was a time of unrest, and wars frequently broke out among the small countries. Freedom of speech flourished, resulting in many newly risen thinkers, and permitting the development of Buddhist thoughts.

In those times, Buddha introduced the concept that pain and agony could be overcome and, when done successfully, that a delightful enlightened peace of mind would follow. This philosophy merged with and branched off from the "mutation theory of Upanishad" (one kind of traditional Indian thought) and the "materialistic element theory of Charbaka." This marked a turning point in people's minds, and Buddhism spread throughout Asia.

The Fourfold Holy Truths form the basis of Buddhism. They are the Truth of Suffering, the Truth of the Cause of Suffering, the Truth of Termination of Suffering and the Truth of the Noble Path to the Termination of Desire. The Buddha explained them in the following way.

The world is full of suffering. Birth is suffering; getting old is suffering; sickness and death are suffering. To be obsessed with hatred is suffering; to be separated from a beloved one is suffering; to experience frustration is suffering. In fact, any action that is not free from desire and passion always involves distress and disappointment. This is called the Truth of Suffering.

The cause of suffering is undoubtedly rooted in the cravings of the physical body and in the illusions of worldly passions. If these cravings and illusions are traced to their source, they are found to be rooted in the intense desires of physical instincts. Thus, desire, with the survival instinct as its basis, seeks that which it feels desirable or necessary. This is called the Truth of the Cause of Suffering.

If desire, which lies at the root of all human passion, can be removed, then passion will be extinguished and all human suffering will cease. This is called the Truth of the Termination of Suffering.

A human being, because of his/her human limitations, lives in agony, unable to obtain supreme bliss. Such agony originates from Tanha. Tanha is human suffering: it is the craving for existence, pleasure, and success. In order to enter into a state where there is no desire and no suffering, one must follow a specific path. The Disciplines of the Eight Right Ways are: Right View, Right Thought, Right Speech, Right Behavior, Right Livelihood, Right Effort, Right Mindfulness, and Right Concentration.

This is called the Truth of the Right Path towards the Termination of Desire in human life.

2) Confucianism

At the heart of Confucianism lies ritual. But its actual origin is in the religious ceremonies of primitive times. These ceremonies are, in essence, the description of myth by performance and myth is, as such, the description of religious ceremony by language. People in the primitive ages believed that religious ceremonies and myth played decisively important roles in the maintenance of public order, in the spheres of nature and living, as well as in the creative process. As a result, they valued these ceremonies and repeated their performance.

Ritual originated from the Feast to the Heavens. Primitive faith identified certain customs as sacred. These customs became rituals, which were an important part of primitive ceremonies. The letter "禮" (ritual) illustrates this relationship. "禮" consists of "示" and "豊" which originally meant ritual vessels, and the god of heaven respectively. Since the origin of the character for ritual was the Feast to the Heavens, the concept of ritual has always had a hierarchical nature.

From the initial stages of the Zhou Dynasty, ritual was an important component of a feudal society. Consciousness of order came to be maintained in social, religious, and private affairs. Ritual was established in a hierarchical order by the aristocratic, noble class and originated in the Feast to the Heavens. Ritual naturally inclined toward a hierarchical order in society. By the middle of the Zhou Dynasty, ritual had spread downward to the feudal states and by the Period of the Warring States at the end of the Zhou Dynasty, it had spread to the common people.

a) the origin of the Confucian scholar

In the Zhou Dynasty the feudal states enjoyed relative prosperity as a result of the weakening of the imperial family. When the feudal lords selected men of ability for important positions, they stressed both academics and athletic skills. Those who aspired to rise to the highest positions were compelled to pursue their studies as well as improve their athletic skills. The fields of study included ritual, music, archery, ethics, calligraphy, and mathematics. Those men who became very proficient in a particular area of study became, for example, outstanding historians and musicians

of the nation. The man who taught ritual to the common people was called Sangryeja and was known as "Yoo," the Confucian scholar.

The Book of Rites, published during the Zhou Dynasty compares the character Yoo (儒) to Sa (師), teacher. During the Zhou Dynasty society was divided into nine classes. The third class was Sa, teacher, and the fourth class, Yoo, ritual. In another chapter of the same book it is stated that common people could become Sa, teachers, if they had both the necessary education and were individuals with high morals. A distinction is drawn between wisdom and morality. "Wisdom" is to lead people with insight and profundity whereas "morality" is to lead people with integrity and righteousness.

"東夷" represented the intellectuals of the times, including such people as Confucius. Confucius was the royal ancestor of the school of thought, which came to be known as Confucianism. He taught people to put ritual into practice and clarified its ethical basis and meaning. Confucianism is the intellectual pursuit of morality, and the religion of Confucianism is the movement aimed at spreading its ideals.

Confucius aimed for the salvation of all people, including family, friends, and society, through completion of social virtue. Toward this end, he compiled all of the data on morality from the countries of Yu, Sun, Wu, Tang, Mun, Mu, and Chu.

Confucius, the highest saint of the Orient, had the family name Kong and the given name Ku; Chungni was his nickname. He was born in Shantung province of Noh, in the 20th year (B.C. 552) of the reign of King Yong of the Zhou Dynasty. The time of the Zhou Dynasty's reign was a time of confusion, and Confucius firmly believed that the salvation of the people was his mission. He felt that he needed to achieve a higher position in the government in order to realize his goal. He administered state affairs very diligently, but in vain. He later returned to his hometown to devote himself to the education of his students. He then developed his philosophical thoughts and committed his ideas to paper.

The books written by Confucius include the following:
- *The Book of Changes*: Descriptions of the philosophy of life.
- *The Book of Poetry*: A compilation of ancient poems and songs.
- *The Book of Ritual*: Descriptions of the culture and institutions of the Zhou Dynasty.
- *The Scripture of Documents*: A collection and arrangement of the political books published from ancient times to the Xia, Yin, and Zhou
- *The Chronicles of Lu*: Descriptions of yearly affairs for the 232 years of Lu

Dynasty.

The Book of Music: Descriptions of the influence of music in politics.

These writings were called the Six Books, and were used by Confucius as textbooks for his students. Before his time, the government had been in charge of education. After Confucius began teaching, the sole privilege of the aristocratic class to receive an education ended. Now, members of any social class could study.

Confucius stressed ritual in social life, and the ultimate goal of ritual was moderation. He insisted that ethics should be placed ahead of politics. He supported the concept that society should be based on the five levels of human relationship (sovereign and subject, father and son, young and old, wife and husband, and friends). Confucius insisted that anyone could achieve a state of godhood, provided that he pursued self-cultivation and followed a righteous way of living. He also emphasized that the realization of love for humanitarianism, social order by morality, and the practice of moderation were the way to achieve a harmonious relationship between nature and human being, and material and soul.

According to Confucius, the politics which govern human society should be guided by ritual, the cultural system regarding the ways of heaven and pleasure, influenced by natural beauty, truth, and goodness. Politics should be exercised according to the ideals drawn from the unity of politics and ritual and the unity of politics and education. That is to say, the enlightenment of humanity by following the ways of heaven, would bring about a benevolent and just government.

Confucianism aims to realize the basic ideals of moral culture, home management, and government of a country and of the world. Confucius emphasized the concept of filial piety, based on the love between parents and children, and the concept of morality based on humanism, the social cooperative love for humanity.

b) development of Confucianism

Confucius defined the basic ideals of the former Han State with respect to politics and religion. The five books (Poetry, Scripture of Documents, Changes, Rites, and Chronicles of Lu) were officially recognized as classics at the time of King Mu, and were compulsory subjects for the national examination of civil servants. They were the core subjects for study at the university, and those scholars who specialized in these subjects were called Doctors of the Five Books.

In those times, Confucianism was combined with the ideology of the cosmic dual

forces (Yin and Yang). Dong Chung-sa (B.C. 177–107), who was the teacher of King Mu, expressed the opinion that universal harmony based on the cosmic dual forces would be revealed by the social and political harmony of the Five Ethics of Confucianism. But during the time of the latter Han state, scholarly opinions took on the character of Taoism rather than Confucianism regarding the concept of the cosmic dual forces. King Yusu, who completed the unification of the Han State in the 25th year, explained that "the way heaven moves by itself and its moving is in inactivity." Wise men, the Emperor and Lao-Tzu, believed that one can find what Truth is by surrendering the self to nature in accordance with Heaven's will. Nonetheless, in the field of Taoism, Confucius was more highly regarded than Lao-Tzu.

During the Song Dynasty (960–1279) woodblock printing was invented and the cultural arts flourished. Intellectuals inclined to accept Buddhism and Taoism, and the basic concept of the Zen sect, which adhered to the most creative concept of Buddhist principles and scriptures related only to the human being itself. This turn towards the ascetic practices of the Zen sect led to a revival of Confucianist thoughts. This is known as Neo-Confucianism, and although this new Confucianism was drawn from the teachings of Confucius, those who followed it were mainly converts from Taoism or Buddhism.

Neo-Confucianism opposed the idea that Buddhist meditation was subjective in its philosophy and denied the existence of other thoughts. The basic ideal of new Confucianism was that the concept of reason, when proved by the human mind, should be universally valid. In short, Neo-Confucianism was the moral faith of the past, updated to correspond with current trends in thought.

Neo-Confucianism developed through the following three stages: First, the period during the Song Dynasty (960–1279) when the Zhu Xi school arose, laying stress on the physical sciences. Second, the period of the Wang Ming School of learning, during the Ming Dynasty (1368–1644), stressing psychological study. Third, the time of bibliographical study, during the Qing Dynasty (1644–1911).

The spirit of Neo-Confucianism is described as "respectful living for cultivation of morality, and pursuit of the ultimate truth to foster knowledge." This may have been a religious movement as well as an intellectual one. The scholars of Confucianism took the Four Books as the basis of their studies. These included *Great Learning*, *The Doctrine of the Mean*, *The Discourses of Confucius*, and *The Discourses of Mencius*. In contrast, Han Yu had used the following Five Classics as texts: *The Book of Poetry*, *The Scripture of Documents*, *The Book of Changes*, *The Book of Ritual*, and *The Chronicles*

of Lu.

Early Confucianism dealt with human relationships and human responsibilities in a society, but Neo-Confucianism stressed the comprehension of the universal principle. On this account, the intrinsic value of morality lies in transcending morality itself.

Zhu Xi, the most famous scientist during the Song Dynasty, studied Buddhism in his early years, but later came to be critical of it. He explained that the basic rule underlying all things was the principle, which had already existed before the creation of the universe: that the ultimate standard of the universe was the Great Absolute. "Taking a view of all things from the principle, all things lead each into the one comprising the Great Absolute. In other words, the unity of all things is the Great Absolute." This concept agreed with the belief laid down in the "science section" of Neo-Confucianism, which held the "thoroughly perfect knowledge of the natural laws would create the whole mind of a human being."

In the 13th century, China was under the control of the Mongolian tribes whose religious beliefs were based on Shamanism and Animism. Nonetheless, after Genghis Khan's conquest over an extensive area, a generous policy was applied to all religions. The classics of Confucianism were part of the material studied for the selection of governmental officials, and the newly established dynasty followed the Confucian system regardless of the king's religious faith.

During the Ming Dynasty (1368–1644), the centralization of administrative power strengthened and Confucianism was adopted as the national religion. Furthermore, Neo-Confucian tradition was encouraged with the adoption of the Confucian classics as a subject for the national examination. Though the doctrine of Zhu Xi was also active during the era, Wang Yang Ming (1472–1593) spread the practical ethics of Confucianism, resisting a trend towards Zhu Xi's ideology. In contrast to Zhu Xi's doctrine of gaining a perfect knowledge of natural laws, Wang Yang Ming reasoned that it is the whole mind which makes the reason for all things clear, and that there is neither reason nor fact without mind. He understood that the substance of the mind is the embodiment of the laws of nature, and that intuition itself is the enlightened spiritual comprehension of the laws of nature.

In response to the new Confucianism of the Song and Ming Dynasties, there arose an influential group who insisted on a restoration of the pure Confucianism of the Han Dynasty, which had not been influenced by Buddhism. This group included Dai Zhen, the most creative of the many Confucian scholars of the Qing Dynasty who

stuck to a position of positivism. For example, he insisted that desire was a part of the true character of human beings, and that there was a good reason for its existing.

3) Taoism

The founder of Taoism was Lao-Tzu. He was born in Kohyon of Lü County, located in the southern region of China. Whereas Confucius was an idealist representing the northern region, Lao-Tzu represented the southern region of China. Some say that Lao-Tzu was engaged in the management of the royal library for some time, and that he fled his country for political reasons. By comparing the ideals of Confucius and Lao-Tzu, one can see that Lao-Tzu was more of a mystic than Confucius.

The Taoist school arose during the Period of the Warring States, with Lao-Tzu as its central figure. There is an anecdote about Lao-Tzu's *Book of Tao*, which goes as follows: When Lao-Tzu was about to leave the Hangu Pass riding a cow in his old age, a government officer who admired him approached and said, "I look up to you like heaven. Please give me a book." So, Lao-Tzu wrote the *Book of Tao Te Ching*, a book of five thousand characters, and gave it to him. The book described Lao-Tzu's philosophical and political thoughts.

These thoughts offered a philosophy of detachment and reason for scholars who were disillusioned by the pursuit of power and wealth, and who were weary of the continuous wars among the states. The tendency toward mysticism, a core element of Taoism, may have originated from Shamanism. The shaman made direct contact with the spirit world by inspiring a state of ecstasy in themselves. Taoists sought to directly perceive the Universal Unity by achieving a similar state of ecstasy through selflessness and mental abstraction, freed from all concepts and desires.

Lao-Tzu insisted that the state of namelessness was the origin of heaven and earth, while the state of naming was the mother of all things. All things were born from nothing, or from the Absolute Truth (Tao). He said that the Tao produced One, One produced Two, Two produced Three, and Three produced all things. One stands for undivided unity, Two for heaven and earth, and Three for the cosmic dual forces and energy. In this way, all existence came into being through the interplay of cosmic dual forces. Absolute Truth turned the cosmic dual forces against each other, causing all things to transform and come into existence. Ultimately, he stated that Absolute Truth, the concept of nothing, is the origin of the universe, which decides the exis-

tence, and development of all things. Since Lao-Tzu's concept of "absolute morality" is extrasensory and absolutely beyond description, it is simply known as Absolute Truth or the Great One.

Such descriptions of Absolute Truth, nothingness, existence, and one are one single concept. Chuang-Tzu commented about it in his chapter on the Universe: "Their thought system consisted of permanence, nothing, and existence, and their views were led by the Great One." Here, the Great One stands for, simply, Absolute Truth. Also, in the chapter on "Heaven and Earth" of the same book, it is stated, "There was nothing in the early times without name, but one came to be born from it. Even though there was one, it was without form." One came from Absolute Truth. That is, Absolute Truth formed one. The Absolute Truth represents the Great One. Permanence and change are relative to each other. All things are changeable, but the Absolute Truth remains unchanged. So, the Absolute Truth is called the way of changes of all living creatures. The law that governs the changes of things is called Permanence. For instance, obtaining the world will always require tranquility, or most people will be frustrated in the final stage of attempting a task. All of these are the rules of nature, which remain unchanged. So, it is called Permanence.

The most basic law of nature is that returning is the movement of Absolute Truth, and because the Great One can spread and reach to the greatest extent, it just returns.

If the quality of anything is developed to the absolute, it is simply inverted into its opposite. This process is called return to the Great One. According to the philosophy of Lao-Tzu, all things will return to the root of Absolute Truth since everything originated from the Absolute Truth. Returning to the origin or Absolute Truth is called Permanence. Permanence is the law by which all things of the universe remain unchanged for eternity. A human being shall conceive and abide by this law of universal movement since man is one of all things in the universe.

The Absolute Truth is the origin of all things, which cannot be named or figured out, and if the cause of existence of everything is the Absolute Truth, such Truth cannot both exist and be the reason for the existence of all things. Thus, Lao-Tzu conceived that Absolute Truth is nothing.

The substance of Absolute Truth is namelessness, ambiguity, immateriality, invisibility, and its act is one of inactivity. Judging that nothing small can be free from avarice, one cannot possess such a capacious mind without being overtaken by it. Absolute Truth, even without any human activity, can accomplish everything. This is the basic concept of Lao-Tzu's philosophy, and Lao-Tzu's expression "Inactivity is

Activity," explains the reconciliation of all things. The Absolute Truth can be abided by human beings, as it is in appreciation of such natural reconciliation.

Freedom from avarice and ignorance allows one to ultimately reach the stage of selflessness through non-thinking and disinterested observation: this is the concept of inactivity. Nature is the ultimate stage where there is no consciousness of the existence of changes. The stage of inactivity, freedom from avarice, and selflessness is wholly natural. Therefore, nature and inactivity are indivisibly connected, which is why the philosophy of Lao-Tzu is called the concept of the inactivity of nature.

The chapter of "The World" in *The Book of Chuang-Tzu* relates the story: "After the Emperor Hwang took a walk on the northern area of the Red Stream, he mistakenly lost a black pearl on his way to the royal palace. He made Gi search for it, but in vain, and then made Riyu and Kikhu do so, but also in vain. So, he tried again to find it through Sangmang, and this time he succeeded."

Here, Gi represents normal knowledge, Riyu represents sense, and Kikhu represents speech skills. Though the first three people could not find the lost pearl, Sangmang, representing the transcended stage of formation, found it. The moral of this story is that one can reach the Absolute Truth only by transcendence of formation. The knowledge obtained by transcending any formation is Knowledge of Ignorance, which is the highest level of knowledge.

To enter into the stage of morals, all knowledge must be abandoned, so that Knowledge of Ignorance may be obtained. Only a person united as one with Truth can reach the stage of tranquility in the midst of struggle, evading harm by transcending human distinction. The way to be united with morals is inactivity, which is achieved in accordance with the providence of nature. Working in accordance with nature means that there is no "doing," and that there is no "not doing" as well. The universe will proceed as it does naturally.

Lao-Tzu insisted upon logic of denial and antithesis, contrary to worldly values. He insisted upon the effectiveness of nothing and denied the effectiveness of existence, while emphasizing immobility over mobility and emptiness over fullness. He saw that black is more valuable than white, retreat more valuable than advance, an infant more valuable than an adult, and weakness more valuable than strength. He thought that people should live, valuing weakness, emptiness, inactivity, and nothingness, thereby assuming a natural attitude.

The way to reach the highest stage of Taoism is to achieve ignorance, abandoning all knowledge. There are two ways to do so. First, some are born reckless, and there-

fore they exist in a natural boundary. Second, those who have forgotten the distinction of all things and have forsaken knowledge, being united together with all things, are in the boundary between heaven and earth.

Taoists oppose the Confucianist concepts of humanity and justice. Those who exercise only humanity and justice fall inside a moral boundary, a social point of view, whereas those who have transcended the social sphere are outsiders. The Confucianist saints see all people as their brothers and all things as their friends, and they are united with all things by overcoming selfish desires and by behaving justly; therefore, Confucianist saints have passionate minds. Taoist saints, however, are very cool and dispassionate because they are detached and independent.

According to Taoist philosophy, a true human is one who has attained the ultimate happiness of having reached the absolute stage of immortality, and the union with all things in harmony with heaven and earth. Such a person has become a real Taoist, having reached the union between heaven and human.

The Taoist philosophy of Lao-Tzu is surrealistic; its followers believe that corruption of society is attributable to human beings' behaving under false, self-centered judgment. People have incomplete reasoning and are not guided by moral principles. Rather, human beings should live in a rational manner, free from the artificial ethics and control of society.

3. Philosophy of Taekwondo

The traditional Korean religion appears to have originated in the earliest time of the Korean people, when the first Koreans migrated across the Altai Mountains and settled on the peninsula. Religion has been historically influenced by the three major schools of Eastern thought, namely Confucianism, Taoism, and Buddhism. Proof of this fact can be seen in the names of the ancient Shamans and the Rituals of the Heavens. Those faiths, along with new schools of thought, including Eastern Studies, Jeunsan and the Great Religion, have all contributed to traditional Korean philosophy. Korean traditional philosophy does, however, vary in interpretation, with different interpretations among scholars. The formation of Dangun thought can be traced to the worship of heaven and the concept of humanitarianism. It is reminiscent of the

Buddhist concept of mercy and Nirvana, Confucian humanitarianism and observance of courtesy, and the Taoist nature of inactivity and concept of a supernatural being. These concepts have formed an unbroken tradition in Korean philosophical thought and are, even today, a part of any religion Koreans may embrace. Accordingly, Taekwondo philosophical thought has also been influenced by these concepts.

Korean traditional religion promoted the creation of martial arts such as Taekwondo in the performance of the Feast to the Heavens. The practice of martial arts involves mental concentration much like that required by the Shaman practicing their traditional rituals. A person who could perform acts beyond normal human control was thought to have been possessed by a supernatural spirit. While the offering of sacrifice is not a part of traditional Korean religion. And the abandonment of the disciple's private life for that of the religious life has also been espoused by Taekwondo practitioners. Taekwondo and other Eastern martial arts were highly influenced by such ideas such as the belief that the state of divinity can be found in the condition of perfect self-effacement and impassivity. Buddhism influenced Taekwondo through its beliefs in contemplation and mental concentration. Above all, as shown in the Five Buddhist Commandments, Buddhist ideology greatly influenced the manner in which the practitioner could use their acquired skills. The code of conduct practiced by all Taekwondo practitioners, which requires that the juniors respect and learn from their seniors, was influenced by Confucianism. These codes, also highly influenced by other Eastern schools of thought, provided the solid organizational character of Taekwondo.

Taoist ideology helped to define the ultimate goal of Taekwondo practitioners, namely to rise to the state of the pure martial artist, and taught Taekwondo that meditation, as well as physical training, could help its practitioners to achieve that cherished state. Taoist philosophy teaches that no one can become a true human being except through contemplation, impassivity, and inactivity. There are many Korean tales of masters who were very severe with new students. So severe that only the truest man could develop the right mental attitude and could be accepted as a true student. This test of character is often found in the teaching of Taekwondo even today. Taekwondo practitioners are often very self-motivated in practicing for self-development, self-defense, and good health. But every Taekwondo practitioner must understand that they must study long and diligently to develop the proper mental discipline. To learn Taekwondo is to gain physical skills, while simultaneously intensifying spiritual strength.

The necessary virtues of a Taekwondo practitioner include, among others, courage, boldness, thoughtfulness, composure, endurance and promptness. The most important codes of behavior are self-control, taking initiative, and the observance of courtesy. Self-control means overcoming such faults as avarice, impulse and passion. Taekwondo practitioners must resist idleness and distraction and, instead, plan their goals and wholeheartedly give their best efforts to achieve those goals.

Taekwondo practitioners must take the initiative to set a good example to both their seniors and juniors, not only by their Taekwondo skills, but by all of their words and deeds as well. Seniors and instructors must take the initiative to pass on Taekwondo as more than a set of skills to be mastered, but even more importantly, as a tradition and a philosophy of life. The practitioner must embrace a humanitarian code of ethics to strive for spiritual cultivation. Courtesy must be observed so that social order can be maintained. This right behavior will foster mutual respect for all things so that the strong will not always have their way at the expense of the weak. The observance of manners is extremely important to Taekwondo practitioners to temper the strength and skill gained through daily practice.

Other basic codes the practitioners must follow are protecting the weak, fighting for justice and always keeping faith. As each individual benefits from their service and instruction to others, society as a whole will also benefit. Perhaps the ultimate goal of Taekwondo philosophy is to play a central role in national development through individual development.

In conclusion, the final aim of Taekwondo training is the "Hongik Ingan" that can be explained as the devotion to the welfare of mankind. Spiritual strengths of Taekwondo are Self-control, Observance of courtesy, and Taking initiative. The way to achieve the cherished high state through martial art is by building up the habits and content listed below.

① Analysis of the current situation
② Identification of the target
③ Development of a plan
④ Implementation of the plan
⑤ Evaluation and analysis
⑥ Supplementation (reflection and lesson creation)

If you practice the three spiritual strengths and the six training methods, you will

become successful not only in martial arts but also in your social life.

The ultimate goal of Taekwondo training is to share the abilities acquired through the practice of Taekwondo with others. it should be the final objective of Taekwondo practitioners to contribute to others and society all the time. Within the scope of their abilities, regardless of the scale. This entails daily acts of kindness and contribution to others with one's capabilities, fostering the idea.

III. Techniques and Training Methods

1. Components of Taekwondo

The aim of Taekwondo Training – Devotion to the Welfare of Mankind

Division	Contents	Purpose
1. Spirit	1) Self-control	Manage one's spirit Make consistent and planned efforts
	2) Observance of courtesy	① Respect others ② Improve social order consciousness ③ Strengthen cooperative spirit
	3) Taking the initiative	Take the initiative in doing challenging and difficult work
2. Physical Strength	Basic physical strength: speed, endurance, strength, flexibility Special physical strength: leg strength, endurance, flexibility, power, agility	Strengthen the power to live one's daily life Strengthen the power to get trained in taekwondo
Dan Test	After getting trained in taekwondo at a *dojang* or similar club under the guidance of a taekwondo master or alone for a certain period of time, one gets to take a test about poomsae, breaking, self-defense, sparring, and humanity on a designated date by examiners who would pass or fail the applicants.	

3. Technique	Basic motions	These are the basic motions you learn in taekwondo. Taekwondo: stance, sparing, Jireugi (punching), Chireugi (thrusting), Chigi (hitting), Chagi (kick), Kkukki (inflecting), Numgigi (throwing down), Jabki (grasp), Makki (blocking)	
3. Technique	Hand techniques	① Stance – Ap Seogi, Dwi Seogi, Juchum Seogi, Moa Seogi, Junbi Seogi, Koa Seogi, Bum Seogi ② Jireugi – Yop Jireugi, Narye Jireugi, Chi Jireugi, Dolryo Jireugi, Sewo Jireugi, Juthye Jireugi ③ Tzireugi – Sewo Tzireugi, Upeo Tzireugi, Jeacho Tzireugi ④ Chigi – Ap Chigi, An Chigi, Bakak Chigi, Yop Chigi, Naryo Chigi, Yolyeo Chigi, Dolryo Chigi ⑤ Kkukki – Snmok Kkukki, Palkuk Kkukki, Murub Kkukki ⑥ Numgigi – Balkory Numgigi, Baldulyo Numgigi ⑦ Makki – Arae Makki, Momtong Makki, Yeolgul Makki, Biteale Makki, Santel Makki, Kawe Makki, Whangso Makki kimkang Makki, Pyojek Makki ⑧ Jabki – Aguisonpalmok Jabki, Sonmok Jabki, Palmokbitelyo Jabak Kulki, Balmok Jabki, Mori Jabki, Yogae Jabki, Mok Jabki	Basic knowledge you need to know to learn taekwondo
	Foot techniques	1) Chagi ① basic technique – Ap Chagi, Yop Chagi, Dolryo Chagi, Mom Dolryo Chagi, ② Practical technique – Bandal Chagi, Biteullo Chagi, Dwi Chagi, Bandae Chagi, Milyo Chagi, Nakka Chagi, Huryeo Chagi, Naeryo Chagi, An Chagi, Bankak Chagi, Chigi Uiwha Chagi (Yil Danchuk), Eobeoldangsung Chagi, Modeum Chagi, Gawi Chagi, Geodeup Chagi, Sogeumyo Chagi, Iryeo Chagi, Numyo Chagi, Ilja Chagi, Dabanghyeong Chagi	

3. Technique	Special Poom	It can be used both in attack and defense, but is more for preparing these motions. It contains the function Strengthening physical power (improving muscles, and operating scope). Geundong Jjegi, Jakun Jjeog, Hakdareul, Jjeongi, Bawi Milki, Taesan Milki, Nalgae	
	Poomsae	Definition – You apply taekwondo's basic motions into combat scenarios against imaginary opponents and practice the attack and defense skills by yourself. Trainees get to use several different kinds of motions and improve their taekwondo techniques. It also helps them to create their own original poomsae techniques.	
		Taekuk 1 jang ~ 8 jang, Goryo, Keumgang, Taebaek, Pyongwon, Sipjin, Jitae, Chonkwon, Hansu, Ilyeo	Purpose - Precision in fundamental techniques - Range of movement - Body balance - Speed and strength - Contrast of tension and relaxation, tempo, and rhythm - Postural stability - Aesthetic quality of movement - Defensive application ① Knowledge – based on fundamental techniques ② Practice – imitate the teacher's techniques through observation or during seminars ③ Ultimate goal – practice poomsae with confidence ④ References – Chinese Wushu, Japanese Kata of Karate, Korean and modern dance, gymnastics, and theoretical knowledge ⑤ Final aim – development of creativity
	Kyukpa (breaking technique)	Definition – It is to break objects through taekwondo techniques using feet, fingertips, knife-hand, fists, elbows, and forehead, etc. You can develop accuracy, power, speed, and mental concentration.	

3. Technique	Kyukpa (breaking technique)	Intensity – wooden board, tile, brick etc. Ways to train kyukpa - Powerful kyukpa - Technical kyukpa - Hand kyukpa - Foot kyukpa - Aerial kyukpa - Combination kyukpa Technique - Hand technique - Maejumok kyukpa - Sonnal kyukpa - Batangson kyukpa - Palkuk kyukpa - Jumok kyukpa - Eungjumok kyukpa - Sonnal-deung kyukpa Foot technique - Basic kyukpa (basic foot kick) - Technical kyukpa (technical foot kick)	Purpose - Stable position - Accurate motion - Power transmission - Achievement ① Mental control ② Consistent and planned effort to achieve one's higher goal ③ Improved self-confidence
	Self-defense	Definition – It enables you to protect yourself in any situation and at any time from unexpected attacks.	
		Oppress the opponent while standing Yosul falling down – Apduijawu, obstruction Kkukki – Jorugi Using stick – both hands or one hand with one stick Defense when the opponent uses foot technique Forward rolling break fall (front, back, sides) Grabbing (front, side, back, sides) Kkukki (front, side, back, sides) Knock Self-defense - Against knife - Against holding - Against foot technique - Grabbing and twisting - Against many opponents	Purpose - Stable position - Accurate motion - Power delivery - Beauty ① Continual and planned effort ② Train to use every part of the body (left and right, up and down, back and forth) ③ Higher goal ④ Self-defense ⑤ Perfect readiness

3. Technique	Kyorugi	Definition – Kyorugi is an activity you can use in making positive habits to lead a successful social life by strengthening your physical and mental conditioning and techniques. You get to learn these by using basic taekwondo motions, poomsae, kyukpa, self-defense, physical strength, and spiritual strength to create your own strategy and to study your opponents' technique, physical strength, mental power, and strategy.	
		Three step Kyorugi (left and rightside) One step Kyorugi (left and rightside) Freestyle Kyorugi - traditional style - competition style One against multiple opponents fight	Purpose - Develop a balanced body - Develop self-confidence ① Study about regulations and make plans after analyzing yourself and the opponent. ② Train yourself using technique and physical and mental strength ③ Analyze the result after taking action and correct the flaws ④ Oppress the opponent ⑤ Final Aim: The advancement of human knowledge

Habituation
1) Analyzing one's surrounding condition
2) Identifying one's target
3) Making plan
4) Putting the plan into action
5) Analyzing
6) Compensating the defect

Everything ceases to exist after a certain period of time. So do humans. Therefore, I hope practitioners can constantly strive for self-improvement while practitioners are alive and do things that are even a little helpful to others or society every day.

2. Training Methods for Taekwondo Competition

The concept of sports, beginning with the Olympics of ancient Greece, has evolved over the centuries, with its character shaped by a variety of influences, from medieval knightly games to contemporary competitions. Over the course of the journey through time, the world of sports has grown tremendously and today it is held in high esteem internationally, playing a very important role in educating youth.

The great importance of sports today stems from the fact that modern sports are

deeply intertwined with political, social, and economic structures of society. For instance, Taekwondo, which is the combination of native Korean martial arts and modern sports, today ranks number one in the Korean sports world. As its name implies, Taekwondo is more than just a sport. It is a modern manifestation of Korea's traditional martial heritage, encompassing the virtues and morality of Korea.

Taekwondo's distinctiveness is appreciated by its numerous practitioners, both in Korea and abroad. Currently, Taekwondo, Korea's national sport, is enjoyed by an estimated 100 million enthusiasts in over 213 countries. It began to gain popularity as a competitive sport in 1961. Kyorugi (sparring), one Taekwondo technique, has become an internationally recognized competitive sport, featured in the CISM, the Pan American Games, the Asian Games, and the All-African Games.

Given Taekwondo's great success in these events, the International Olympic Committee, at its 103rd session in Paris in September 1994, decided to include Taekwondo as a medal sport for the Sydney 2000 Olympics. Therefore, developing and implementing effective athlete training methods must be regarded as a high priority.

1) Theoretical Background

Even in prehistoric times, physical activities similar to what we know as sports were used to strengthen the body as well as to promote a sense of camaraderie and community. A strong and healthy body was the most important asset of primitive human beings who had to defend themselves from predators and invaders. Since the natural law of primitive life was the "survival of the fittest," augmenting one's health translated into increased capability to safeguard oneself and decide the tribe's fate in primeval societies. Sports existed in the form of religious festivities, as education or as a part of day-to-day survival. Thus, the tribes developed physical activities bearing similarities to our modern sports, which served as a tool in promoting solidarity.

Ancient civilizations almost invariably began near rivers. Rivers provided fertile soil and water. Waterways also served as passages for early people who lived huddled in small groups and moved from place to place for food. The four main ancient civilizations were born near the following rivers—the Yellow River of China, the Indus River of India, the Tigris and Euphrates Rivers in Mesopotamia and the Nile River in Egypt.

In China, before the nation-system came into being, warriors were a respected class and physical training was an essential part of everyday life. However, as the nation system began to unfold, and Confucianism, Taoism and Buddhism flourished, the pen was valued over the sword. In the climb up the social ladder, reading and philosophy assured a rise to power, in keeping with national policies. Life was centered around scholastic pursuits and sometimes-idiosyncratic pedantry, however, some sparse physical training also existed. A highly systematic national education institution was set up in 1115 B.C. and it contained a curriculum for physical exercise.

In India, physical exercise was neglected in favor of education with a religiously biased character. Yoga and dance became popular as ancient Indians tried to escape from the trials of the climate by developing healthy programs.

The Egyptians were a religiously strong group. With unfettered Eastern mysticism and philosophical education, they were fortunate to only have been invaded a few times. Thus, they were able to live in peace. Under these conditions, Egyptian cultures flourished. Whether one was a soldier or a farmer, physical activity and sports played a very important part in one's life.

Mesopotamia was a blessed land, well situated with fertile land and a good climate. Its location, however, rendered it a travel hub, so there was a constant threat of outside invasion. As a result, literary training was valued, and physical training was primarily limited to soldiers and commanders.

Persia's policy, on the other hand, was to produce a highly trained stock of soldiers. All Persians underwent rigorous physical training starting early in life. The education of aristocrats was limited to physical and military training.

In Greece, education was centered on the ideals of three periods. During the Homeric period, the active man was idolized. Then during the Spartan period, the soldier was the highest ideal. Even a dance could have meaning only if it embodied the spirit of a warrior or a soldier. Finally, in the Athenian period, the active man or man of aretē (excellence) was the supreme ideal. Greece dominated its neighbors, including Persia, giving the region a sense of solidarity: one nation, one race, one language, and one God.

In the Roman Empire, education was centered on nurturing patriotic souls and strong bodies. In sports, there was a special emphasis on health, courage, power, endurance, and technique, rather than on a sense of cooperation.

The Middle Ages was a period of transition between ancient and modern times.

The central focus on man, nature, and the world of ancient times changed to God and the world of the afterlife, which became the axis of the times. The seeds of the Middle Ages were long sown by the Roman Empire and its demise.

The moral corruption of Roman society and its vast empire collapsed when the Germanic people invaded it from the north. The Germanic race, failing to produce a superior culture, ruled a vast empire by military might. Christianity and its institutions seized power by providing what the state system lacked, while placating the aggressive Germanic people.

The monasteries contributed to this phenomenon with their emphasis on cultivating the mind over the body, and on developing the beauty of the soul. Labor in the monastery was the only form of exercise. Against that background, knighthood, which developed separate from monasticism, emphasized sportsmanship. But before it had a chance to blossom, scholarship took hold and religion became the order of the day. For this reason, sports were socially taboo and their growth was stifled.

When the Renaissance period unfolded and the dominant thinking of the times switched from concern for the afterlife to that of the present, sports regained the positive appreciation which allowed them to develop. As pragmatism, humanism, and reason again gained ground, the practice of sports was revived. Renaissance philosophers noted the importance of sporting games once held in Ancient Greece.

The rise of nationalism in the 19th century necessitated the revival of sports. The school system provided sports education. The revival of the ancient Olympic Games marked the rebirth of the Olympic spirit of Ancient Greece. Rallying for friendship and cooperation between nations, in the name of world peace, a French national named Coubertin proposed on June 23, 1894 meeting, that the Olympics be revived. The participants at the Sorbonne University unanimously approved Coubertin's proposal, and the first modern Olympic Games opened in Athens, Greece, its birthplace.

The rise of industrialization in Great Britain played a vital role in expanding the practice of sports. With an increasingly affluent population and an increase in leisure time, sports became more and more popular among British workers. This trend caused sports to become a part of everyday life, not only in Great Britain but also in other nations. After World War I, sports underwent a transformative change, emerging as what we see today.

Sports in the 20th century are for the masses, not just for an elite class of warriors

or soldiers, nor for a privileged noble gentry, as they were in the 19th century. People from all walks of life today enjoy sports. The character of today's sports is, to a certain extent, a result of American culture. In the 1920s, Americans adopted the European form of gymnastics and incorporated the mass appeal of this sport. The continuing nationalism, and intense rivalry between the United States and the Soviet Union, ensured that sports became more than just a means of maintaining health and providing recreation. In the 1960s, competition heated up, and nations were lured into using sports as a tool to inevitably demonstrate national power. As a result of the attention the academic world gave them, sports became scientific.

2) Basic of Training

Instructors and students of Taekwondo, both in Korea and abroad, should be aware of much more than the basics of Taekwondo training. They must also apply the principles of physical education to their training, which are suitable for the characteristics of Taekwondo.

Theoretical Background of Training

Sports Medicine	Anatomical Physiology	Psychology Education, Sociology
Sports Hygienics	Sports Physiology	Physical Education
Health Theories	Evaluation of Physical Strength	Sports Psychology
First Aid Massage	Body Functions Nutrition	Sports Sociology History of Sports
	Theories on the Stages of Growth Theories on Physical Training (Prescription) of Physical Training Planning of Physical Training	

There is a great need for further research in Sports Physiology, Sports Mechanics, and in Sports Psychology with regard to the unique characteristics of Taekwondo. In addition to theoretical research and development, there is a need to re-evaluate and reorganize the practical aspects of Taekwondo.

Taekwondo, the native martial art of Korea, began as an art of self-defense but, now, Kyorugi (sparring), formerly only one aspect of Taekwondo, has developed into

an international sport. As such, there is a greater need for systematic and scientific evaluation of training methods, which traditionally tended to be based solely on the expertise of the instructors. The recent trend has resulted in greater reliance on the expertise of professionals and scientists. As a result, the knowledge base has been steadily broadening and this knowledge has been directly applied to the training of athletes. Through constant re-evaluation and the application of new information more systematic training methods are being created for the future training of athletes.

3) Training Concept

Training is the process whereby technical skills are enhanced. Planned strength training aims to increase basic physical power. By physical strength, we mean the functional capability of the body. Such ability is the basis of physical activity.

Planned strength training is based on theories of how to surpass one's existing level of physical strength. Training schedules are planned according to the past results of tests.

Athletic ability refers to the harmony between physical strength and techniques. Sport techniques are related to physical strength. However, the notion that one's physical strength may be enhanced without any relation to sports techniques implies a goal for the enhancement of the harmonious progress of both physical strength and athletic ability. Any shortcomings in physical strength, which may come from practicing techniques alone, can thereby be counteracted. To attain this goal, planned strength training is applied.

Factors in training include the athlete's age, potential ability, self-readiness for the training, and the level of ability the athlete hopes to attain. Physical, technical, strategic, and psychological factors are mutually relevant to training program. All of these factors affect the physical and technical ability. When each one of these factors in training is equally developed in two competitors, the winner and the loser are determined by the psychological edge.

Physical preparation is one of the most important factors, which must be considered for the enhancement of competitive ability at a higher levels. The main purpose of physical preparation is to increase the functional potential and the development of physical ability to the highest level possible. The first step is to obtain overall physical

readiness; the second step is to obtain specific physical readiness; the third step is to take the body's athletic ability to the highest level. The second step develops through the general practice of basic techniques, and the third step takes place during the game or match. The purpose of the third step is the maintenance of basic techniques required for each game.

Technical training program affects how efficiently the athlete's tasks are carried out. A technique is a method for performing a physical exercise. When the level of techniques rises, the efficiency rises accordingly. In order to raise the efficiency of the technique, the most ideal technical model is not always applied, particularly at the beginner's level. For beginners, the model needs to be simplified. As athletes differ in ability, techniques need to be modified according to individual needs and abilities. Technical preparation is the process of modifying techniques through guided repetition so that each game may be completed with the highest level of skill.

When all facets of training are equally developed in both competitors the winner of the game is determined by the psychological edge. If the athlete is anxious or nervous before the game this problem must be resolved between the competitor and the instructor.

The purpose of training generally lies in the systematic and scientific enhancement of competitive skills. Training towards this goal can be classified according to differences in methodology. Goals may include the increase of physical ability, the adaptation to a given environment, the enhancement of technical ability, and so on. The purpose of training in Taekwondo is to execute techniques more efficiently. Spirit assumes an important role in the enhancement of the overall fitness of the nation's people, as Taekwondo is not only an activity of the body, but its core lies in self-development and the all-around activity of the human body.

In order for the body to adapt to training one must begin with a very vigorous training regimen. That is, the load applied for the improvement of physical strength must be very great for the muscles to handle. By applying the "principle of overload," one attempts to acclimate the body to a higher level by introducing loads beyond the body's present upper limits.

Change in the human body's structure and function occurs slowly, over a long period of time. Deliberate planning is needed for the functional improvement of the nervous system to take place. Therefore, it is important that training methods used to develop sports techniques follow basic principles. That is, one must proceed from simple movements step by step, in order to effectively guide the development of the

body's abilities.

It is important to train consistently. For example, there is no gain in continuously training for six months and then resting for six months. Consistent regular training is essential, and one must aim for the most desirable quality and quantity of training. The proper amount of high caliber regular training done consistently is essential for success.

Everyone has his/her own unique physical qualities. As such, a person with greater physical ability should undergo more intensive training, as compared to someone with less ability in order to achieve maximum efficiency in training. Thus, one must keep in mind individual strengths and weaknesses when designing a training program.

The athlete must carefully plan their own training. The desired results can be attained through constant re-evaluation of the training methods with adjustments suitable for achieving goals.

Training is a process whereby the body is repeatedly exposed to a stimulus in order to develop its responses and thereby enhance its competitive ability. This involves an application of all principles and methods necessary to effectively accomplish training goals. In planning, one must aim for efficiency in the design of the training program.

The following factors must be considered in formulating a plan:

① Potential ability of athletes,
② Primary developmental focus,
③ Access to training facilities and equipment,
④ Performance levels in tests and competitions, and
⑤ Competition schedule.

Other generally required factors in planning include:

① Alignment between long-term and current plans,
② Identifying and emphasizing key training factors, and
③ Timeframes and periodically established goals.

The foremost goal of a training program is maximizing the competitive ability of the Taekwondoist through systematic and planned physical training. The following

indispensable factors, which determine competitive ability, are:

① Optimizing physical capacity through general and specialized training,
② Enhancing technical proficiency through mastery of coordination in basic and applied skills, and
③ Strengthening psychological capacity including willpower and strategic thinking.

A training plan should include methods and tactics required to achieve the targeted goals. It should also take into consideration the athlete's physical condition and the current level of technical skill.

Physical strength training involves enhancing skills such as power, speed, flexibility and agility, and concentrating on specific aspects of endurance and reaction time.

Willpower training involves meditation and mental training, while technical training focuses on sharpening the accuracy of techniques and other skills based on speed. Theoretical training, on the other hand, is concerned with studying and fully comprehending the rules and techniques of Taekwondo.

A combination of the above training factors can be formatted into daily, weekly, monthly, yearly, or sessional training plans. Upon implementing the training plan, one must remember to moderate the intensity, the duration, and the frequency of practice. It is balanced training that enhances the athlete's competition skills.

The following are the four basic principles for establishing a training plan.

① Principle of Entirety: Training should consider the components of physical ability such as muscle power, endurance, agility, quickness, control, and flexibility, in addition to the physiological and mental dimensions unique to Taekwondo.
② Principle of Awareness: A training plan should enhance the athlete's comprehension of the goals and the format in order to augment its effectiveness. For instance, one aims to develop strategic thinking, understanding of the effectiveness of counter-kicking, and so on.
③ Principle of Repetition: The athlete conditions his/her reflexes while improving the body's functional performance through repetition.
④ Principle of Individuality: The training load is assigned with consideration to the individual athlete's capability. This concept can be reflected in the training

plan by adopting a program that aims to increase the athlete's adaptability. This may involve approaches such as practicing with multiple partners, developing individual techniques, and formulating separate programs for men and women.

4) Training Methods for General Practitioner

a) courtesy
① cultivation of patriotism in individuals
② mutual respect
③ unity
④ observance of discipline (to instill a sense of discipline and order)

b) meditation
To harmonize mind and body, regulate breathing, and maximize time management efficiency (to plan what to learn).

c) warming up
To relax joints and muscles by increasing body temperature, preparing the body for sudden or strenuous activity, and preventing injuries..

d) basic movement
Stable posture, accuracy in movement, power, speed, gaze, and shout (*kihap*).

e) one step sparring
Stable posture, distance control, accuracy, power, speed, gaze, and shout.

f) poomsae
To perform continuous attack and defense movements using basic Taekwondo techniques against an imaginary opponent (stable posture, distance control, gaze).

g) hosinsul (self-defense)
Skills to protect yourself from a sudden attack by an opponent (left and right, high and low, front and rear).

h) kyorugi (free sparring)

To practice defensive and offensive techniques, physical skills, and strategy in preparation for actual combat.

Analyze yourself and your opponent.

Learn lessons for the future.

Devise a strategy to overcome your opponent, practice analysis (techniques, physical ability, mental readiness, tactics).

i) breaking

Practice systematically and progressively to break objects using hand, foot, or forehead.

j) cross country

Set a goal, plan and complete the distance, then try to shorten the time by analyzing the entire process.

k) weight training

Improve physical condition and mental focus; plan, practice, and analyze to correct lifestyle habits.

l) cooling down

Return body temperature, muscles, and joints to normal after a workout.

m) meditation

Reflection and replenishment (to harmonize mind and body, regulate breathing).

n) courtesy

Cultivation of patriotism, unity, and mutual respect (to instill a sense of discipline and order).

5) Training Methods for Athletes

Rather than adopting a training method based on scientific knowledge, the athletes of yesterday followed a training regimen based on the experiences of coaches or

former athletes who had long been involved with the sport. Of course, one is not inclined to believe training methods based solely on experience are completely ineffective and useless. As we actively research and apply new training methods, however, we must stress the need for a stronger theoretical background and active scientific research.

Schools of different levels (high-school, university) have their own special Taekwondo training programs. It is helpful to compare training methods of different schools, highlighting the good points, identifying shortcomings and suggesting new training methods.

If we select a time span of one year for the training program, it can be divided into three phases: the preparation, competition, and transition periods. Strategically, training goals can be categorized as technical, physical, and psychological. Let us now examine each school's training plan as it is structured on a daily, weekly, and annual basis.

Table 1. High school "S"

Classification		Preparatory	Strengthening	Perfecting
Goals and Contents of Training		Developing foundations of physical ability	Strengthening Specialized Physical Ability	Training together with others not from the home school
		Developing Specialized Physical Ability	Acquiring Applied Techniques	Video Analysis of Techniques
		Assessing Individual Strengths & Weaknesses	Repetitive Training of Basic Techniques	
Training	Physical Ability	80%	70%	50%
	Techniques	20%	30%	50%
Remarks				

Table 2. High school "T"

Classification		Preparatory	Strengthening	Perfecting
Goals and Contents of Training		Training of Develop Basic Physical Ability	Offensive Strategy Training Ability	Perfecting Specialized Physical Ability
		Training to Develop Developing Mental Power	Strengthening Offensive Strategy Training	Perfecting Specialized Techniques
		Developing Specialized Physical Ability	Maintaining Basic & Specialized Ability	Maintaining a Peak Condition
		Individual Physical Ability Test	Mastering Specialized Techniques	
		Perfecting Basic Techniques	Training Focusing on Kyorugi	
		Specialized Technical Training		
Training	Physical Ability	70%	60%	60%
	Techniques	30%	40%	40%
	Remarks			

Table 3. High school "K"

Classification		Preparatory	Strengthening	Perfecting
Goals and Contents of Training		Basic Technique Training Education Focusing on Building Mental Strength and Courage Developing Specialized Physical Ability Mastering Basic Techniques Applied Kicking	Theory & Practicing Kyorugi Accuracy Training Strategy Training Focused Instruction on Individually Skilled Movements Counterattack & Accuracy Work on Individual Strengths & weaknesses	Instruction on Game Techniques Outdoor Training Strengthening of Physical Ability & Mental Power Acquiring Specialized Kyorugi Techniques
Training	Physical Ability	70%	30%	40%
	Techniques	30%	70%	60%
	Remarks			

Table 4. High school "P"

Classification		Preparatory	Strengthening	Perfecting
Goals and Contents of Training		Developing Basic Physical Ability Developing the Competitor's Sense of Mission, Cooperation & a Sense of Oneness Assessing Individual Strengths & Weaknesses	Developing Specialized Physical Ability Developing a Fighting Spirit & Self-denial Mastering Basic Techniques	Preparing for Actual Competitions Building Self-confidence & Focus Maintaining Specialized Physical Ability Mastering Specialized Techniques Acquiring Combination Strategies Adjusting Training Volume and Intensity Logically
Training	Physical Ability	70%	60%	50%
	Techniques	30%	40%	50%
	Remarks			

Table 5. University "H"

Classification		Preparatory	Strengthening	Perfecting
Goals and Contents of Training		Developing Basic Physical Ability Specialized Physical Ability Training Training for Courage Development	Developing Specialized Physical Ability Strengthening of Competitiveness Developing Specialized Techniques through Weight Training & Flexibility Training Mastering Specialized Techniques	Preparing for Actual Competition Building Self-confidence & Focus Maintaining Specialized Physical Ability Mastering Specialized Techniques Acquiring Combination Strategies Logical Adjustment of Training Volume and Intensity
Training	Physical Ability	70%	60%	50%
	Techniques	30%	40%	50%
Remarks				

Table 6. High school "R"

	Dawn	Afternoon (14:00 – 18:00)	Evening
Mon	- Warm-up - Running around the Namsan circular road - Agility exercises (suddenly changing direction from a seated position to start running), running in coordinated steps followed by sprinting, 30–50m dash, kangaroo jumping, running back and forth, jumping over the back) - Cooling down	- Warm-up - Basic physical training (30–50m dash, running back & forth, running through the "mountain tunnel," jumping, sergeant jumping, rabbit jumping) - Speed kicking practice (kicking drills performed for 25 to 30 seconds each) - Individual exercises (supplementary) - Finish-up exercises - Cooling down	Individual Exercise
Tues	- Warm-up - Running around the gymnasium in rows for 10 minutes - Physical training (50m dash, sergeant jumping, burpee jumping, running and jumping, running back & forth, rabbitjumping, duck walking, kangaroo jumping, hurdle jumps) - Cooling down	- Warm-up - Stretching - Basic target kicking (snap, stationary, lateral) - Advancing and backing with Taekwondo gear on (technicalkicking, rapid repetitive kicking) - Timed Kyorugi (2minutes 5 rounds) - Cooling down	Individual Exercise
Wed	- Warm-up - Individual running: Namsan Road (toward Dongguk Univ.) - Interval (10 Times) - Cooling down	- Warm-up - Step Kyorugi (10 minutes and 8 rounds) - Speed target connection kicking (25 seconds, 30 seconds) - Kyorugi (3 minutes and 3 rounds) - Cooling down	Individual Exercise

Thurs	- Warm-up - Running on Namsan Road in rows - Interval (15 times) - Cooling down	- Warm-up - Rope-jumping (30 minutes) - Basic target kicking (5 times each) - Double target kicking (10 times each for 30 seconds) - Cooling down	Individual Exercise
Fri	- Warm-up - Skip-jump running (individually) - Interval training - Cooling down	- Warm-up - Basic physical training (30–50m dash, running back & forth, jumping over the back, burpee jumping, sergeant jumping) - Step Kyorugi (3 minutes and 3 rounds) - Target kicking (5 times each) - Cooling down	Individual Exercise
Sat	- Warm-up - Running on Namsan Road (done individually) - Cooling down	- Warm up - All team sports played with a ball (soccer, basketball, volleyball, baseball) - Cooling down	Individual Exercise

Table 7. High school "G"

	Dawn	Afternoon (14:00 – 18:00)	Evening
Mon	- Warm-up - Running around the stadium (7 times) - Basic physical training (running back & forth 5 times, 30m dash 5 times, running through the mountain tunnel 10 times, jumping over the back 15 times) - Cooling down	- Warm-up - Basic kicking practicing - Strategy with Taekwondo gear on (counter-attack kicking, offensive, defensive) - Step Kyorugi (4 minutes and 5 rounds) - Tire kicking (kicking 100 times with each leg) - Cooling down	Individual Exercise
Tues	- Warm-up - Basic kicking techniques (front kicking- first striking) - Step Kyorugi (10 minutes and 5 times) - Cooling down	- Warm-up - Basketball, Soccer, Rugby - Cooling down	Individual Exercise
Wed	- Warm-up (running around the school 7 times) - Basic physical training (30m dash, dashing after front jump, kicking after jumping, kangaroo, kicking, side-step) - Cooling down	- Warm-up - Basic kicking techniques - Fixed target roundhouse kicking back and forth - Kicking with Taekwondo gear on - Step Kyorugi (10 minutes and 4 rounds) - Cooling down	Individual Exercise
Thurs	- Warm-up - Running around the stadium (5 times) - Basic kicking techniques - Fist-Striking (10 times) - Step Kyorugi (5 minutes & 5 rounds) - Cooling down	- Warm-up - Basic kicking techniques - Strategical front kicking with Taekwondo gear on - Fixed target speed kicking (60 times) - Kyorugi (10 minutes & 3 rounds) - Cooling down	Individual Exercise

Fri	- Warm-up - "Hill interval" training - Basic physical training - Basic kicking techniques - Cooling down	- Warm-up - Basic kicking techniques - Fixed target applied kicking with Taekwondo gear - 1-step Kyorugi - Kyorugi (3 minutes 3 rounds) - Cooling down	Individual Exercise
Sat	- Warm-up - Running around the stadium (7 times) - Basic physical training (jumping over the back Running back & forth, side-step) - Cooling down	- Warm-up - 1-step Kyorugi - Individual exercises - Cooling down	Individual Exercise

Table 8. High school "K"

	Dawn	Afternoon (14:00 – 18:00)	Evening
Mon	- Warm-up - Running individually around the stadium (30 times; timed running) - Running stairs (single-step, double-step, triple-step, free style, simultaneous step-up, and each foot—3 times each) - Cooling down	- Warm-up - 1-step Kyorugi - Fixed target kicking practice - Execute a "cut," kick the body with the left foot, then immediately kick the body or face with the right foot using a back leg kick - Double kicking to the upper body, followed by fast kick-and-turn drills - Execute a "cut" followed by a reverse hook kick (5 times each); practice Kyorugi (defensive and offensive techniques), tube kicking, and roundhouse kicks (200 reps) - Cooling down	Individual Exercise
Tues	- Warm-up - Hill interval training: uphill running in short, medium, and long distances; duck walk, rabbit jumping, feet-together running, one-foot running, kangaroo jumping, and backward running (3 times each) - Cooling down	- Warm-up - 1-step Kyorugi - Fixed target kicking (front kick 20 times, round kick 20 times, front and round kicks to the upper body 20 times; kick the body with the left foot, then immediately follow with a right-foot kick to the body or face; back kick, quick kick, and turning kick — all 20 times each) - Strategic training with Taekwondo gear (back leg round kick, countering the back leg kick, right leg kick, reverse hook kick combined with fast leg movement, and countering a reverse hook kick after baiting the opponent with a fake motion) - Cooling down	Individual Exercise

Wed	- Warm-up - Running around the stadium three times - Stadium interval runs: 200m × 10 repetitions, each within 30 seconds - Cooling down	- Warm-up - Basic physical training (gymnasium dash, 7 burpees, 7 sergeant jumps, 5 vertical jumps, 5 wide-leg jumps, 5 forward jumps, 5 backward jumps, shuttle runs) - 1-step Kyorugi; round kick target practice in groups of three - Fast leg kicking, rapid footwork; left-foot kick followed immediately by a right-foot kick to the body or face; reverse hook kick — 2 times - Kyorugi, tube kicking - Cooling down	Individual Exercise
Thurs	- Warm-up - Running around the stadium 30 times - Circuit training (arms bending) and straightening, short pitching, vertical jumping, sergeant burpee test, running back and forth within 20 seconds, 5 seconds, break 2 times) - Cooling down	- Warm-up - Step Kyorugi - Fixed target linking kick (give a "cut" and kick the body with the left foot, then immediately kick either the body or the face with the right foot, followed by a back leg kick) - Kick the body twice and then kick the upper body, followed by fast kicking and turning - Give a "cut" and perform reverse hook kicks (5 times each); practice Kyorugi (sparring: defense and attack), tube kicking, and round kicks (220 times) - Cooling down	Individual Exercise

Fri	- Warm-up - Hill interval: going up the hill; short, medium and long-distance running; duck walk, rabbit jumping, running with feet together, one-foot running, kangaroo jumping, and running backward — 3 times each - Cooling down	- Warm-up - Step Kyorugi - Fixed target kicking (front 20, round 20, front-upper body and round-upper body — 20 times each; kick the body with the left foot, then immediately kick either the body or face with the right foot; back kick, quick kick, turn — 20 times each) - Strategic training wearing Taekwondo gear (back leg round kick, countering back leg kick, right leg kick, reverse hook kick while executing fast kicks, countering reverse hook kick after feint — conducted with a protector) - Cooling down	Individual Exercise
Sat	- Warm-up (running around the stadium 3 times) - Stadium interval (200m * 10 times, must arrive within 30 seconds) - Cooling down	- Warm-up - Basic physical training (dash around the gymnasium, burfee test 7 times, sergeant 7 times, vertical jumping 5 times, leg-wide-open jumping 5 times, running back and forth) - Step Kyorugi - Fixed target kicking practice in groups of three: round kick - Fast kicking, quick stepping, reverse hook kick — 2 times - Kyorugi, tube kicking - Cooling down	Individual Exercise

6) Problems with Training Methods & Measures for Improved Training Methods

Examination of each school's annual training plan shows that all the training plans were divided into 3 periods. The following factors are commonly found in the training programs of all the schools:

① During the preparatory period the ratio of overall physical training to technical training was roughly 70 to 30.
② During the strengthening period, the ratio was 30 for physical training to 70 for technical training.
③ During the perfecting period, when specialized physical abilities are maintained and techniques are refined, the ratio between physical and technical training was 50 to 50.

The physical and technical proportions of the training are broken down as follows:

Proportion of Technical and Physical Strength Training by Month

	Physical Strength (%)	Technical Strength (%)
January	60	40
February	60	40
March	50	50
April	40	60
May	40	60
June	40	60
July	40	60
August	40	60
September	50	50
October	50	50
November	50	50
December	60	40

Daily plans are generally designed in the following way.

① Warm-up exercises: Flexibility-focused exercises that enhance joint mobility – stretching, basic kicking techniques (20 to 30 minutes)

② Main exercises: Mastering specialized techniques and strategies, such as combined offensive and counterattack kicking techniques that require speed – 80 to 90 minutes of exercises designed to increase physical strength and endurance

③ Cooling down: Exercises performed in intervals to relieve muscle tension (flexibility-oriented exercises, stretching, massage, etc.) – Most schools allowed 10 minutes for cooling-down exercises

In addition, the daily training program has been divided into three sessions (dawn, afternoon, evening). About 1–2 hours are allotted for each session. A 120-minute session appears to be the most effective duration.

Although this study has provided the training plans for high schools and a university as a sample, "point-oriented training" was particularly emphasized at the high school level. As a result, systematic training was often overlooked in favor of short-term rather than long-term planning.

Technical Training Plan

Flag, Instructor, Senior Courtesy

Meditation

Warm Up

Fixed-target striking practice
Precision striking practice after determining the distance, height, and speed, with the athlete maintaining a fixed position.

Moving-target striking practice
A fixed standing position is maintained at a set distance (50–70 cm). Attacking techniques using both the feet and hands are practiced, including front attacks (50–70 cm), back attacks, and roundhouse attacks to the left and right.

Counterattack practice
Practice involves inducing the opponent to attack, then targeting their weak points after the attack has commenced.

Straight-line consistency
- The athlete repeatedly practices continuous attacks—maintaining speed and a fixed distance—aimed at the opponent's body and face.
- Attacking while moving backward is also practiced.

Cross-kick
- The athlete stands in the middle and practices with targets placed to the front-left, the front-right, rear-left, and rear-right.
- Combination training: Kick
- The ability to attack the opponent from a fixed distance or any angle is developed.

Attacking
When the athlete adopts a Kyorugi position, generally the left foot is pointed forward at the start of the match. The attack is often limited to one direction, so correction is needed.
Left position – leftward attack / rightward attack
Right position – leftward attack / rightward attack
Emphasis is on accuracy, consistency, and the use of both left and right hands and feet.

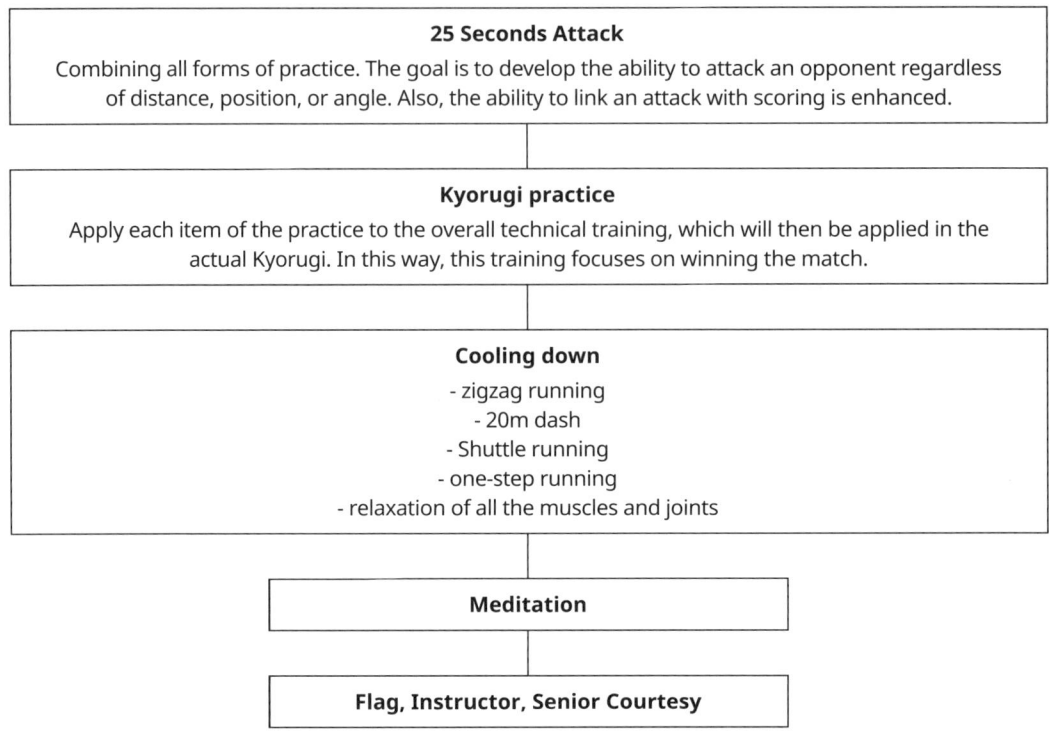

In terms of training, a systematic long-term plan must include a balance between basic physical training and techniques. Also, applied training plans at basic, intermediate, and advanced levels must be formulated. In addition, a detailed training program (annual, monthly, weekly, daily) which takes into account the individual's mental and physical abilities is necessary.

Let us look at an example of a training program in terms of its contents. The following explanation discusses physical ability, mental power, and strategy which affect competitiveness in Taekwondo.

Physical Ability includes a balanced progress by the equal use of the upper and the lower body. Aim for physical fitness befitting the player's age, agility, speed, flexibility, endurance, and quickness through diverse forms of training. Team sports with a ball are played 3 times a week to compensate for solo sports' shortcomings, such as cooperation, agility, and responsibility.

Attachment 1 gives an example of a weight training program which develops muscles used in Taekwondo sparring.

Mental Power Cultivate the power of self-control. Analyze, plan, and put plans into action independently. For example, one must control what one eats, do exercises suited to oneself, and make a constant effort towards higher goals.

Strategy Offensive, defensive, imposing a psychological burden on the opponent

- e.g. ① During the match, induce the opponent to make a mistake, thus imposing psychological pressure.
- e.g. ② Take a position the opponent dislikes or move in a direction that the opponent finds uncomfortable to impose psychological pressure.
- e.g. ③ Thorough analysis of the opponent should include an examination of their strengths to make the opponent's attacks ineffective or weak.
- e.g. ④ Prepare a weekly analysis of the opponent and a self-analysis to be used as a reference for the training plan.

Attachment 1

Exercise Item		Physical Classify	Intensity	Frequency	Duration	Set	Result Remarks
B A R B E L L	1. Bench Press	Pectoral is major, Deltoid					
	2. Clean & Jerk	The whole body Latissimus doris					
	3. Bar Swing	Anterior Deltoid					
D U M B B E L L	4. Two Hand Front Lateral Raise	Anterior Deltoid					
	5. Two Hands Punching with Dumbbell	Biceps					
	6. Back Shoulder Curl	Biceps Triceps					
7. Chest Weight (Left/Right)		Deltoid, Pectoralis major					
8. Sit Up		Abs, Obliques					
9. Prone Butt Lift		Abs, Obliques					
10. Leg Press		Thigh					
11. Cross Country							

Training Schedule During the Semester

Dawn (06:00–07:00)
 ① Long distance run
 ② Hill climbing and descending, kicking and punching practice
 A. Straight live continuous attack
 - 2 times use left side (20 min.)
 - 2 times use left and right side (20 min.)
 B. Moving sideway continuous attack
 - 2 times use left side (20 min.)
 - 2 times use left and right side (20 min)

Afternoon (16:00–17:00) - Technical practice

Evening (20:00–21:30) - Technical, physical and strategical practice
 Supplementary practice and diary entry

Training Schedule During the Vacation

Dawn (06:00–07:00)
 ① Long distance run
 ② Hill climbing and descending, kicking and punching practice
 A. Straight-line continuous attack
 - 2 times using the left side (20 min.)
 - 2 times using both the left and right sides (20 min.)
 B. Sideways continuous attack
 - 2 times using the left side (20 min.)
 - 2 times using both the left and right sides (20 min.)

Morning (10:00–12:00) - Technical practice

Afternoon (15:00–16:00) - 3 days a week, team sports with a ball: soccer, basketball,
 volleyball, etc. 3 days a week, weight lifting.

Evening (20:00–21:30) - Technical, physical, and strategical practice
Supplementary practice and diary entry

Generally, most sportsmen, especially those involved in martial arts, have imbalanced development of the body as a result of overusing certain parts of the body compared to others. Since this situation can cause problems for the body, it must be considered in training plans. Novices to the sport must have discipline to control their body, mind, and behavior, and must observe the manners and etiquette of the sport and of society in general. In training planning, one must make it part of one's everyday life to adequately collect necessary information before the plan is designed, practiced, and analyzed.

For example, if one eats too much in a meal, it will be detrimental to one's health, and eating too little will make it difficult to stay healthy, let alone maintain current condition. Through proper eating, planned in terms of quantity and type of food, one can maintain good health and accomplish whatever one sets out to do. The athlete must thoroughly evaluate himself and be assessed by the instructor. Also, the athlete must analyze the opponent before designing and practicing a training plan. After the training plan is implemented, the plan must be reassessed before a new plan is made and applied. Practicing such a habit will make it easier for instructors and athletes to accomplish their goals in competition and in everyday life.

APPENDIX

1. Difference between Sports and Mudo

Sports	Mudo
Origin: Ancient Olympia Ritual	Origin: Ritual Ceremony
Character: - Provision of Sociality - Nature of Improvement - Truthfulness and Verifiability - Freedom and Equality	Character: - Martial Technique Combined with a Spiritual Way - Mu (武) = Spear and Knife (戈) + Stoppage (止) - Self-control, *Ye-eui-beom-jeol* (Observance of Courtesy), Taking the initiative, courtesy
Etiquette	Self-control, *Ye-eui-beom-jeol* (Observance of Courtesy), Taking the initiative
Athlete: Horizontal Relation (Equality, Friend)	Trainee: Vertical Relation (Master, Senior, Friend, Junior)
Final aims of the matches: Cooperation and victory	Build up your skills through training and academic study until you can move and think for yourself. Every day, do good deeds for others or society within the scope of your abilities.
Gymnasium	*Dojang*
Coach: A person who teaches theoretical knowledge and practical techniques to improve athletes' performance and increase their chances of success.	*Sabeom*: A person who becomes an educator in both academic and practical fields and a role model through their conduct and behavior.

Origin of Etiquette

Louis 14 held banquets everyday at the palace. It was difficult for banquet participants to find the toilet in the palace, so they went to the corner of the building, the grass and under the trees. The palace keeper saw this and set up several sign boards. Louis 14 knew this and ordered participants to check the sign boards and use the toilets, and this is the origin of Etiquette.

Rules of Etiquette

Si (示) means God, Pung (豊) is Utensils for holding a memorial ceremony. Before

relogious existed of in the old days, people bathed their body and purify themselves and controlled clothing, food, words, and behavior when praying to heaven (God) for that they want. In particular, in case of water, they used only the first scooped up water from the well at dawn of the day. The first person who scooped water from the well left the straw at the well and the next person found the well without the straw and scooped the water for the memorial ceremony. Like this, they exerted themselves to the utmost. Human and God are in a vertical relationship. Consideration for the others. The ultimate goal of etiquette is to promote a sense of order.

Sport and Taekwondo

The term "sport" is derived from Latin "disputare," which was later transformed into "desporte" in French and "disport" in English. The original meanings of this word are amusement, consolation, satisfaction, and change for refreshment, and "des" or "dis" imply leaving behind daily routines. Accordingly, the word "sport" stands for all physical activities intended to provide refreshment or satisfaction apart from daily routines.

The characteristics of sports are social engagement, a focus on personal development, truthfulness and verifiability, and freedom and equality. Today, a lot of people enjoy sports and through sporting events, we firmly cultivate friendship and strengthen relations among people and nations. People create rules and regulations for sporting events, and pursue victory through friendly competition.

IOC is in charge of the Olympic Games according to its rules and regulations. Likewise, WT (World Taekwondo) which is recognized by the IOC is in charge of international Taekwondo games according to its rules and regulations.

Taekwondo competitions aim for victory, representing the sporting aspect of Taekwondo. Taekwondo competitions are categorized by divisions based on weight, age, and gender. Taekwondo as Mudo, or martial art, rather than as a sport, evaluates training outcomes by Poom and Dan, not by weight division. Also, the duration of training is an important factor in evaluation. This is one of the factors that differentiates martial art Taekwondo from sport Taekwondo.

Mudo including humanism means a martial technique combined with a spiritual way. The concept of humanitarianism from our traditional religion, the nirvana and mercy of Buddhism, the humanitarianism and observance of courtesy in Confucianism, and Taoism's philosophy of inaction and belief in supernatural power have influenced practitioners of Taekwondo.

The most important spirits of Taekwondo practice today—observance of courtesy, self-control, and taking initiative—are historical manifestations of the prevailing values of their time. As discussed, Taekwondo is Korea's Mudo (martial art), enriched with the most profound Eastern spiritual assets from our traditional thought, Buddhism, Taoism, and Confucianism, which people around the world can enjoy as a lifelong means to improve both physical health and spiritual strength.

Finally, I conclude with the following statement:

The final aim of Taekwondo training is devotion to the well-being of humanity.

Spiritual strength:
 ① Self-control (克己, *Keuk-ki*)
 ② Observance of courtesy (禮儀凡節, *Ye-ui-beom-jeol*)
 ③ Take the initiative (率先垂範, *Sol-sun-su-beom*)

Practitioner should acquire necessary training method:
 ① Analyzing surrounding conditions
 ② Identifying target
 ③ Making a plan
 ④ Putting into action
 ⑤ Analyzing
 ⑥ Addressing shortcomings

If you maintain these three spiritual strengths and apply the six training methods, you will be able to achieve success not only in Mudo (martial arts) but also in everyday social life.

2. Important Events in the History of Taekwondo

Mar. 20, 1971	President Chung-hee Park presented a handwritten calligraphy titled "Kukki Taekwondo" (National Martial Art Taekwondo)
Sept. 4, 1994	Taekwondo was officially adopted as a medal sport for the 2000 Sydney Olympics at the 103rd IOC Session in Paris, France. John D. Coates, IOC member, President of the Sydney Olympic Organizing Committee, and Kye-hyung Noh, then President of the Australian

	Taekwondo Association, proposed that Taekwondo be adopted as an official Olympic sport to the IOC. Un-yong Kim, then IOC Vice President, WT President, and GAISF President, played a significant role.
2003	Taekwondo was first adopted as an optional sport at the 2003 Daegu Universiade by FISU.
	Kyung-ho Min, Professor of UC Buckley played a significant role.
2017	Since 2017, Taekwondo has been a compulsory sport in all Universiades.
Mar. 30, 2018	The National Martial Art Act for Taekwondo was legislated on March 30, 2018, by National Assemblyman Dong-seop Lee.
2018	Poomsae was included as a Taekwondo event for the first time during the 2018 Jakarta-Palembang Asian Games, thanks to the efforts of Marciano Norman, President of the Indonesia Taekwondo Association; Kim Jong, Vice Minister of the Ministry of Culture and Sports of the Republic of Korea; Officer Gwangjong Pyo; Kyu-seok Lee, President of the Asian Taekwondo Union; and Bong Lee, Secretary General of the Asian Taekwondo Union.